THE JUDITH BLACKLOCK ENCYCLOPEDIA OF
FLOWER DESIGN

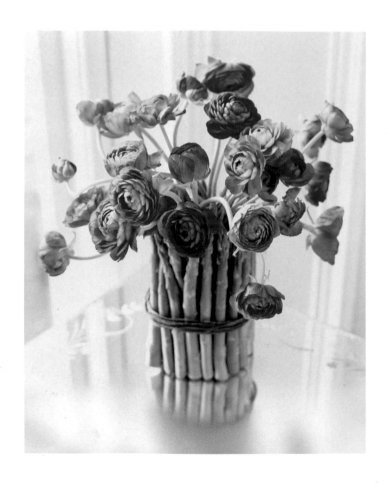

The Flower Press

Published by
The Flower Press Ltd
3 East Avenue
Bournemouth
BH3 7BW

Text Copyright © Judith Blacklock, 2006

This first edition published 2006

The moral right of the author has been asserted.

A CIP catalogue record for this book is available from the British Library.

ISBN -13: 978-0-9552391-0-6

ISBN -10: 0-9552391-0-9

Design: Amanda Hawkes

Colour Reproduction: Imagewrite, Eastleigh, Hants, UK

Printed and bound in Great Britain by Butler and Tanner Ltd, Frome, Somerset

Contents

Introduction 4

1 Elements and principles of design 6

2 Flowers in a vase 40

3 Flowers in season 60

4 Celebrations and festivals 108

5 A history of flower arranging 136

6 Design classics 150

7 Contemporary floral design 182

8 Inspiration from around the world 230

9 Handtieds and posies 246

10 Wedding flowers 266

11 Large scale arranging 304

12 Long-lasting flowers 318

13 Show work 336

14 Flowers around the house 348

15 Flowers and foliage 362

16 Equipment and techniques 386

Useful contacts 409

Acknowledgements 410

Index 413

Introduction

At my flower school and around the world I have taught thousands of students the art of flower design and have developed a way of teaching that really does work. The formula is based on the elements and principles of design which are common to all the arts – whether sculpture, painting, photography, or interior and garden design. I have adapted these principles specifically to the world of flowers in a practical and easy to understand way so that anyone can create pleasing and successful decorative designs without stress and worry.

Many are concerned that they will never be able to arrange flowers because they are not 'artistic'. Few beginners have an inborn talent for creating wonderful designs unless they have training in an allied art. I believe that everyone without exception can be taught to make flowers look beautiful. You only need a passion and a love of flowers.

In order to create good designs you first need to know and understand

- the elements and principles of design – these I have explained logically so that they are easy to understand and put into practice
- the flowers and foliage that are available to you,
- the mechanics – which is jargon for what will keep your stems in place, such as floral foam
- how to combine your flowers and foliage together successfully.

I have called the book *The Judith Blacklock Encyclopedia of Flower Design* but in my view flower design, floral art, flower arranging are all the same. Arranging is what you do to achieve the design. The terms 'floristry' and 'flower arranging' are however different, although both use the term flower design for their creative work. The florist and the flower arranger share a passion for flowers but floristry is for the professional and flower arranging is for those who enjoy flowers in the home, providing work for charitable occasions and for friends and relations on a non-commercial basis. The worlds of floristry and flower arranging are moving closer together but I do not cover wiring technique and wedding design in depth as I believe this work is best left to the professional florist.

Flowers and foliage that are commonly available both from the florist and the garden is presented in chapter 15. Mechanics are covered in chapter 16. The skill of combining the plant material is discussed throughout. The new varieties and colours of our medium mean that it is always a fresh and exciting challenge to bring together new combinations. The elements and principles are covered in depth in chapter 1.

I believe the success of my students who have come to my Knightsbridge flower school is second to none. I like to think that they have all gone home understanding what makes a flower design work and when it has gone wrong. For those of you who want to learn at home I hope that this book will help you to fill your life with flowers elegantly and artistically to create floral art.

Judith Blacklock

I

Elements and principles of design

What is a good design? A good design is one to which no more can be added and from which nothing can be taken away without causing an impression of incompleteness. Good designs become classics, reflecting the age in which they were created, yet they are comfortable in any period.

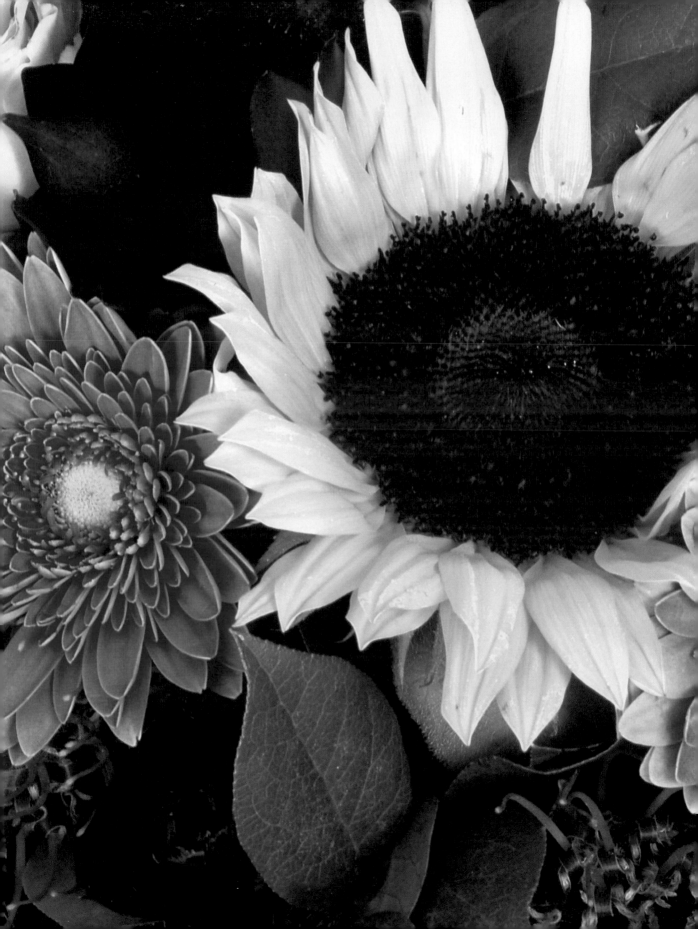

previous page
Texture, form and colour combine to
give good design.

Styles do alter, and appreciation of what is aesthetically pleasing changes according to the nature of society, the economic framework and the technology of the day. Compare, for instance, the over-exuberant use of flowers in Victorian times with their more restrained use in Edwardian times. In both periods the style of flower arranging was closely allied to dress, interior design, the economy and general mood. Certain fundamental criteria, however, remain the same and these have been termed the elements and principles of design.

There are four design elements – form, texture, space and colour. If you use these four elements in accordance with the six principles of design – balance, scale, proportion, rhythm, dominance and contrast – the resulting design will be harmonious.

But are these design points relevant if we wish simply to place a mass of a single variety of flower in a vase? Yes, because if you wish to maximize the effect of these flowers you will have to choose a vase of the right colour, form, texture and size. The flowers will have to be cut to a length that is compatible with the vase and positioned where their beauty can best be appreciated. With practice you will use all the elements and principles instinctively and well.

NB: *"The principles of design are related to the forces of the universe. You feel these forces but they should not be used too obviously. It is only the imperfections and the unexpected that make art what it is."* (K.F. Bates, 1960). That is to say, do not be restricted by conforming too rigidly to theory.

The elements of design

Form

TIP When mixing flowers always include at least one round form, such as a sunflower or an open rose.

Form is the word that describes a three-dimensional object – such as a fresh flower – as opposed to shape, which describes a two-dimensional object such as a pressed flower. When we talk about form in flower arranging we can be referring to the flower arrangement as a whole or to the individual form of each stem of plant material.

The form of individual stems

Flowers and foliage can be loosely categorized as being one of three distinct forms. This knowledge is extremely useful when choosing a mixed selection of flowers and foliage to arrange together. The three forms are:

- round
- line
- spray

right
The round form of the open lilies is complemented by the spray form of the snowball tree (*Viburnum opulus* 'Roseum') and the line form of the pussy willow (*Salix caprea*) and the *Prunus triloba* blossom.

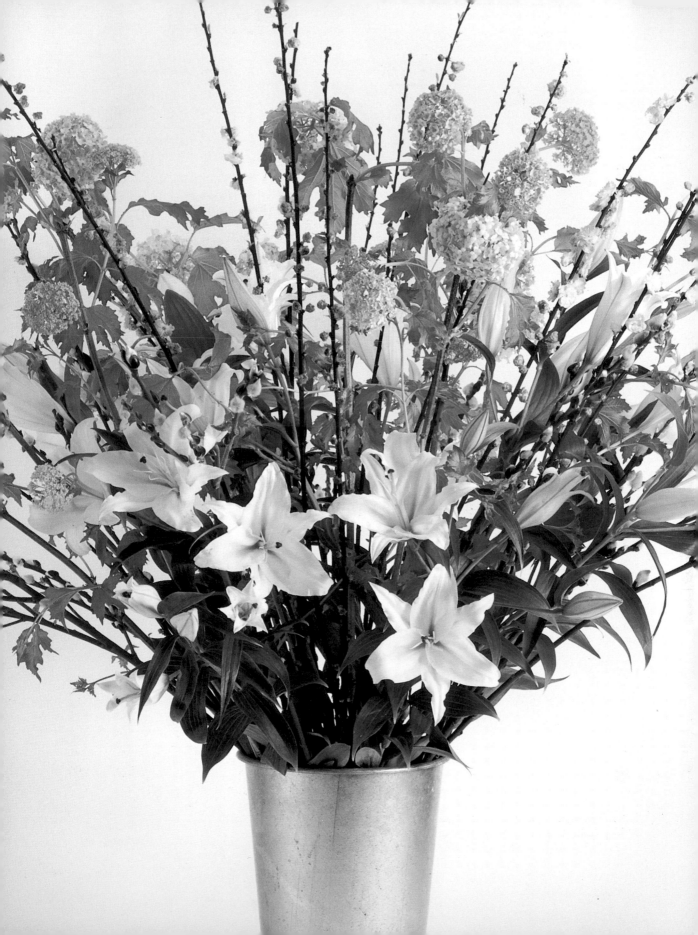

Flower forms

1. Round flowers

Round flowers are the principal players and the most dominant form in design. Their circular form draws the eye and gives it a focal point on which to rest before moving on to absorb the rest of the design. Focal material stabilizes. Examples of round flowers are peonies (*Paeonia*), open roses and lilies, *Gerbera*, chrysanthemums, dahlias and carnations (*Dianthus*).

2. Spray flowers

Spray flowers play the supporting role. They can lighten, soften and give added variation and interest. Spray flowers or berries are on short stems secondary to the main stem. Examples are Michaelmas daisy (*Aster novi-belgii*), baby's breath (*Gypsophila*), spray roses, x *Solidaster*, wax flower (*Chamelaucium uncinatum*), hips, sprays of blackberries (*Rubus*) or privet berries (*Ligustrum*).

3. Line flowers

Line flowers are used to bring colour or interest from the outer limits of the arrangement down into the design. Flowers or berries are located on or close to the main stem. Examples are *Delphinium*, *Gladiolus*, lavender (*Lavendula*) and flowering blossom.

Foliage forms

1. Round foliage
The flat surface of round leaves gives an area of calm repose in contrast to other elements in an arrangement. In small designs the leaves such as ivy (*Hedera*), geranium (*Pelargonium*), flowering currant (*Ribes*), × *Fatshedera* or *Galax* give a completely rounded form. In larger designs – such as a pedestal – the round shape gives way to a longer form but the smooth plain surface remains important. Examples of these are *Fatsia*, *Aspidistra*, *Bergenia* and *Hosta*.

2. Spray foliage
Spray foliage, where short secondary branches lead off the main stem, is used as a filler to soften the design and to give bulk. Variegated forms are useful and give colour and interest. Examples of spray forms are *Skimmia*, *Pittosporum* and ming fern (*Asparagus umbellatus*).

3. Line foliage
Line foliage is important in many designs to create the framework. It is consequently placed in position first. Line foliage can be any straight or gently curved stem or branch. In order to create the three-dimensional skeleton, line foliage must have interest down the stem rather than just at the tip. Examples for smaller arrangements are box (*Buxus*), *Eucalyptus*, privet (*Ligustrum*). Line material for larger designs – which can be more spreading as long as the overall form is linear – could be beech (*Fagus*), whitebeam (*Sorbus aria*), dogwood (*Cornus*) and birch (*Betula*).

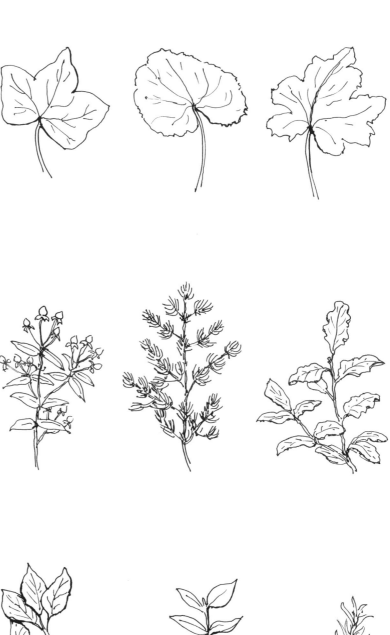

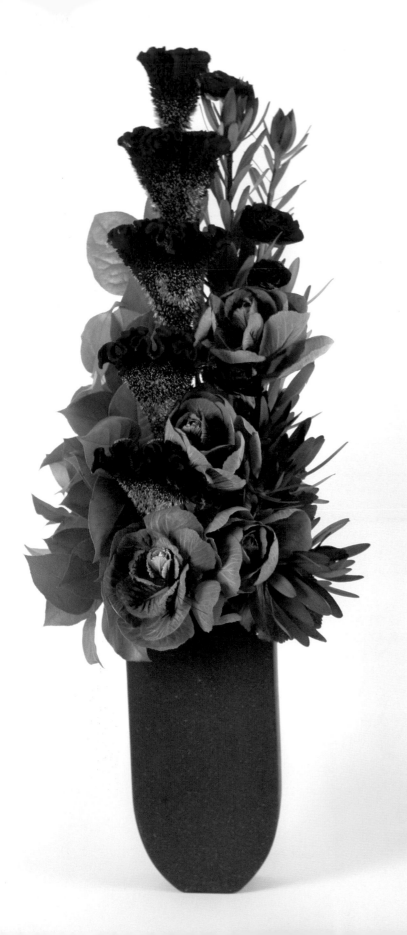

The form of an arrangement

The overall form of an arrangement can be classified as being in one of the following categories:

1. Mass

Mass arrangements originated in Europe, possibly first coming to light in the great Dutch flower paintings of the sixteenth and seventeenth centuries. We must remember, however, that these were not actual arrangements but the invention of the artist with his brush. It was perhaps the Victorians who developed the mass arrangement. With the Victorian love of exuberance, little space is evident.

Today, mass arrangements can best be defined as those that are composed of a large amount of plant material with little or no space between the individual stems. Examples of mass arrangements are seen in the sculptural mass designs (page 198), the Biedermeier posy (page 250) and tapestry designs (page 215). A contemporary feel can be achieved simply with the massing of plant material.

2. Line

Line arrangements have their origin in China and Japan. They characteristically use a sparsity of plant material, with an emphasis on space within the design. It is the line within the arrangement that is important. Examples are classical Japanese Ikebana arrangements, some free-form designs (page 184), Art Nouveau arrangements, many modern spatial and most abstract designs.

A mass design of ornamental cabbage (*Brassica*), *Celosia*, *Leucadendron* 'Safari Sunset' and *Gaultheria* (salal).

3. Line mass

A line mass arrangement bridges the gap between the two styles. It might perhaps be described as a marriage between East and West, a compromise. It can be used to describe many of the geometric styles that originated in the 1950s – the crescent, the Hogarth and any other styles where space exists within the overall form. It is the space that defines the specific form.

A sculptural line mass design by Marian Aaronson reflecting contemporary trends. The solidity of the closely packed plant material at the centre is contrasted by the powerful linear rhythm encircling the mass.

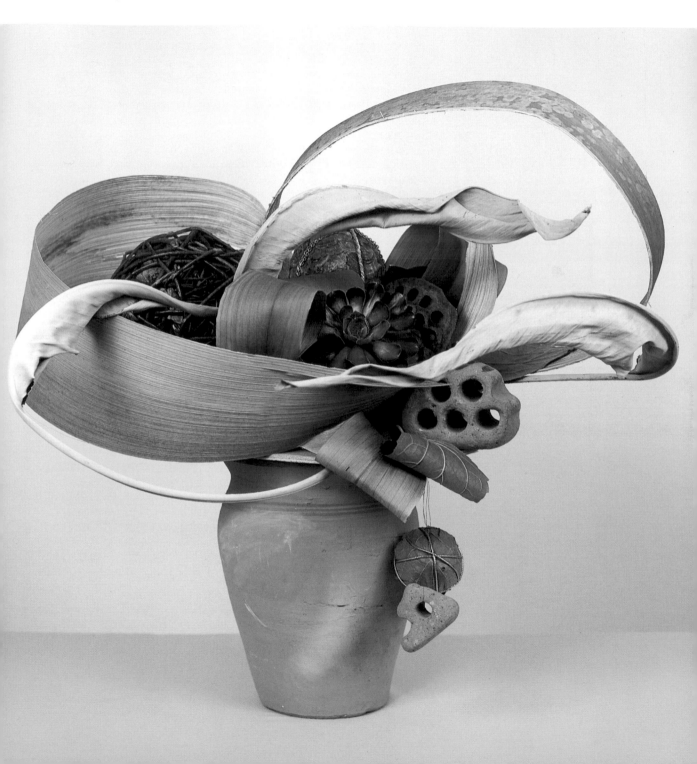

Contrasting textures within an arrangement.

Depth

Depth is an important part of form. It makes the difference between a flat and a three-dimensional arrangement, thus heightening interest and giving a more natural feel to the design.

How to create depth

The easiest way to create depth is to fill in the back of an arrangement. There is no need to use the best-quality flowers, but foliage and a touch of colour will work well. You can also:

1. Gradually use darker or lighter colours, working from the front to the back.
2. Some colours advance, while others recede. Receding colours placed behind advancing colours give greater depth.
3. Turn the flowers or leaves at different angles, particularly at the sides of the arrangement, to lead the eye round to the back of the design.
4. Overlap leaves or half-hide a flower with a leaf.
5. Placing an asymmetrical design at an angle gives a greater impression of depth.
6. Smooth and shiny textures advance, dull and rough recede. Placed next to each other, they will give a greater illusion of depth.

Texture

Contrast of texture is vital for good design. Texture is visual as much as real, and it is this visual perception that is so important in flower arranging.

Texture in plant material can be described in so many ways – waxy, spiky, downy, ridged, needled, silky, downy, to cite but a few.

When more than one texture is being incorporated into the design it is necessary to include a form that is plain and smooth, to give a calm contrast to the other texture(s) in the design. This smooth texture is particularly to be found in:

- leaves such as ivy (*Hedera*), *Fatsia*, *Bergenia* and *Hosta*
- seedheads and berries such as rose, poppy (*Papaver*), Chinese lanterns (*Physalis alkekengi*) and privet (*Ligustrum ovalifolium*)
- many single-petalled flowers, such as the single chrysanthemum, dahlia, *Rudbeckia* and *Cosmos*
- many houseplant leaves, such as *Aspidistra*, croton (*Codiaeum*) and x *Fatshedera*
- many fruits and vegetables, such as green tomatoes (*Lycopersicon*), apples (*Malus sylvestris*), tangerines (*Citrus reticulata*) and aubergines (*Solanum melongena*).

If you look at the multitude of flowers that constitute lady's mantle (*Alchemilla mollis*) you will see that the round, plain leaves with their subtle edging perfectly complement the intricate form of the flowering sprays. This happy combination occurs in nature again and again.

Flower arrangements with a monochromatic colour scheme (see page 19) have a need for strong textural contrasts.

TIP Always include a smooth texture in every design.

Space

Solid is the opposite of space. Without space there is no form. In flower arranging space can be used in the following ways:

1. Beneath the container – this gives a sense of lightness to the design and avoids an arrangement looking rather solid and over-heavy at the base. A small base under a container will raise the arrangement without being seen.
2. Within traditional designs – this often gives a livelier effect. Some areas of the design will require a greater density of material than others. For example, a greater density of solids is needed at the focal area to hold the eye, but more slender plant material is required at the extremities of the design.
3. Within spatial and abstract designs – these designs utilize space as a major feature, and it is as much a part of the design as the solids. Space can have as much eye-pull as the pierced holes in the sculptures of Barbara Hepworth and Henry Moore. When it is used to balance solid placements, it is often enclosed by manipulation of leaves or loops of cane, raffia, ribbon or plant material such as broom (*Cytisus*).
4. As an illusion – the eye can be tricked into an illusion of depth, where little or none exists. This adds to the general impression of space. See Depth on page 14.

TIP Classic designs often utilize space more uniformly than their contemporary equivalents which use space to a bolder effect. Do remember where you have space you save money.

The larger form of the lily is balanced by the long strands of flexigrass tipped with beads.

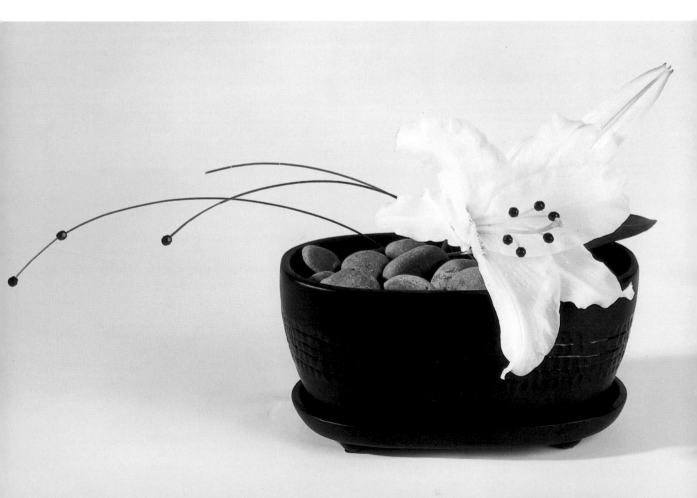

Colour

Colour inspires and is one of the most exciting elements of design. It is emotive and personal; it influences mood and feeling. No one could be seriously interested in flower arranging and be immune to the power and delight of colour. There is no definite right and wrong with colour. Any colour scheme that makes an expressive statement is valid.

There are many aspects of colour theory that are easy to understand and there are others that need a little more application. Perhaps two of the easiest ways of choosing flowers that go together are to:

- Choose flowers that all have the same parent, for example pink, red and burgundy or pale blue, blue and dark blue.
- Ensure that all the flowers have a link with another variety in the arrangement, for example yellow golden rod (*Solidago*) with blue China asters (*Callistephus*) with a dominant yellow centre and blue veronica (*Hebe*).

The following guidelines will help you use the most effective colours together and place them in the most appropriate setting. But colour theory does not lay down specific combinations that must always be followed. Its aim is to encourage you to question colour and to strengthen your own subjective opinions so that you can work and design with a greater understanding. I hope that you will try out striking and varying combinations of colour to find those that work.

So how can words help us learn about the visual act of perceiving colour? Until the early twentieth century many civilizations did not have names for colours. In the Bible there are over 400 references to the skies or the heavens, but the colour blue is never mentioned. It was only in 1912 that Albert H. Munsell expounded the excellent system of colour notation that we use today.

Before we talk about the ubiquitous colour wheel, there are three terms that need to be explained:

1. Hue
This is the quality that distinguishes one colour from another – blue, green, red, and so on. It is simply another word for colour.

2. Value
This is the quality of lightness or darkness in the colour: the amount of white, black or grey that has been added to the pure hue. When white has been added to the pure hue it is called a tint. Another word for tint, with which you may be more familiar, is pastel. If black is added to the pure hue it becomes a shade, and if a mixture of black and white is added it becomes a tone.

3. Chroma
This measures colour intensity. Another way of expressing this is the strength or purity of the colour. A watery colour has a weak chroma. Think of a watercolour seascape with the sea painted a blue-grey colour to which loads of water has been added. This would be a seascape using colours of a weak chroma.

The colour wheel

The colour wheel is the best guide to colour theory. It contains the colours of the rainbow, curved to form a circle, but only six colours are used, as indigo and violet are combined as purple. The continuum colours of the rainbow – red, orange, yellow, green, blue, indigo and violet – were laid down by Isaac Newton, to whom seven was the perfect number. For the purposes of flower arranging, the three primary colours (red, blue and yellow) and the three secondary colours (orange, green and purple) offer all the combinations that you will need.

The primary colours are so called because they cannot be created by mixing other colours. Unbroken areas of these primaries can be stimulating and enlivening, but they can also be overwhelming if no green is added to soften the impact. Bright primaries work well in contemporary mass design, where there are fewer elements to the arrangement.

All other colours can be created by mixing these primary colours. Thus red and blue create purple; red and yellow create orange; and blue and yellow create green. The greater the number of pure colours used in an arrangement, the more chance there is of them overwhelming each other, unless they are well organized.

Because the colour of flowers is seldom at its full intensity, the colour wheel has been developed so that you see some of the variety of colours that arise when degrees of black and white are added (see illustration).

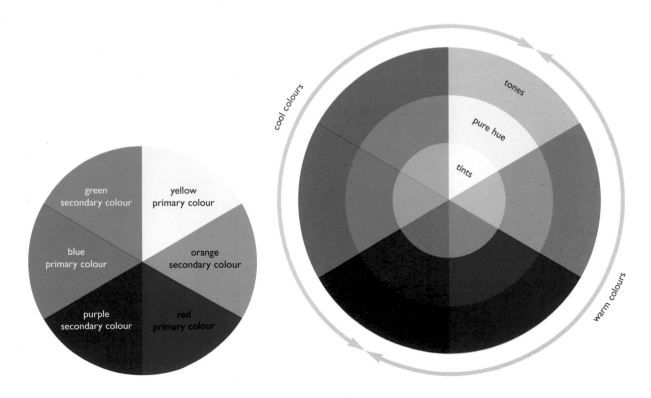

The diversity of colour

To get a feel for the diversity of colour take a walk in the country, along a river bank or in a park and observe the different number of greens that you see. Divide them into green-greens, yellow-greens, blue-greens and red-greens and the colour wheel will start to make sense. It will open your eyes to the intricate detail of nature.

Neutralizing green

Although black and white are considered neutral, green is nature's neutral colour. Green is the harmonizer. It will bring together flowers of a multitude of forms and colours. Dark green gives depth to pastel colours and light green can bring life and vitality to darker flowers.

Effective colour schemes

So what is a good colour scheme? This is a question that has bemused and intrigued people for countless generations, so much so that in 1349 Florentine artists got together to study this very question. Flower arrangers are not actually interested in mixing paints to get a certain colour. They work with existing colours and love to experiment with different colour combinations. The four following colour harmonies are considered to work, because over the centuries they have been found to be pleasing to many people.

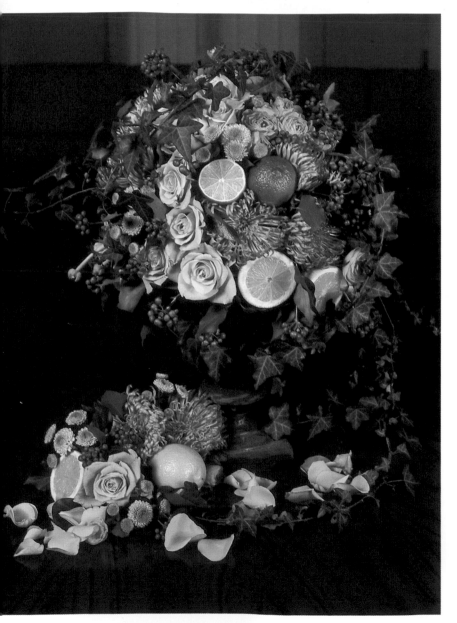

> **TIP** White is dominant – if using a white container, use white, green or pastel coloured flowers so that container and flowers work together rather than in competition.

Lime green goes with every colour and gives zest and vitality.

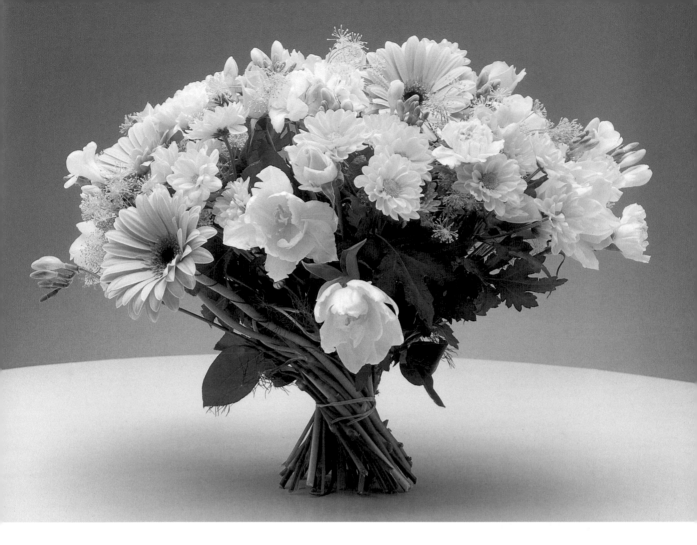

Monochromatic colour schemes

Monochromatic colour schemes are safe, and they can be the most effective colour schemes of all, whether you are arranging one or many types of flowers. If you are mixing your flowers, go for extremes in value and chroma and for lots of exciting textural contrasts. There are many monochromatic designs in this book, but all rely on the addition of the flower arranger's neutral colour, green.

above and right
Two examples of how effective and varied a monochromatic colour scheme can be when using tints, tones, shades and different forms.

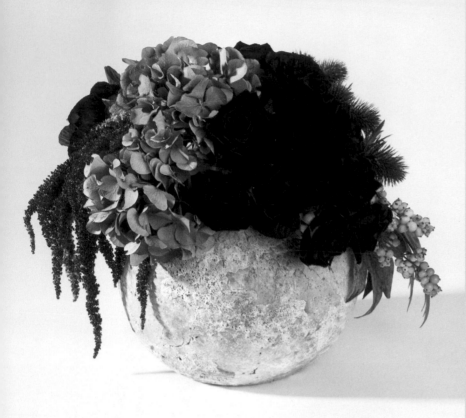

Except for the touch of blue of the *Eryngium* in the background this design is composed of tints and shades of the colour red; from the pink of the *Symphoricarpos* to the darker pink of the *Hydrangea* to the deep red of the *Amaranthus* and the roses.

Adjacent or analogous colour schemes

An adjacent colour scheme uses up to one-third of a twelve-band colour wheel, the colours all being found next to each other, but it is understood that green may also be included. One example would be green-yellow, yellow, yellow-orange and orange, plus green.

This design is a glorious mix of flowers from the garden in a 'Mille Fleurs' style of design. It is a mix of love-in-a-mist (*Nigella*), *Origanum,* sweet-peas and *Scabiosa.* There is a wedge of foam deep in the container to keep the stems stable with water rising half way up the container.

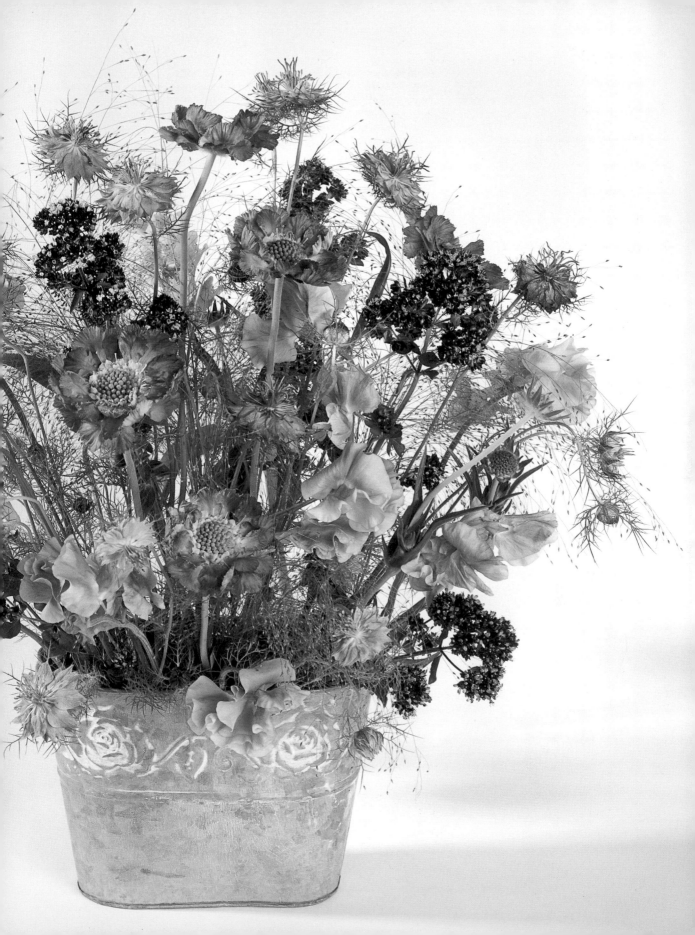

Red and green are opposite or complementary colours. The limes against the red roses give vitality and zest to the design.

Complementary colour schemes

Complementary colours lie directly opposite each other on the colour wheel. Each colour heightens the vitality of the other, and together they provide the maximum energy and vividness. For example, place purple flowers against a yellow wall, or red flowers against a green wall. A mixture of complementary colours in equal amounts, produces grey. The most interesting complementary colour schemes are perhaps those which use tints, tones and shades.

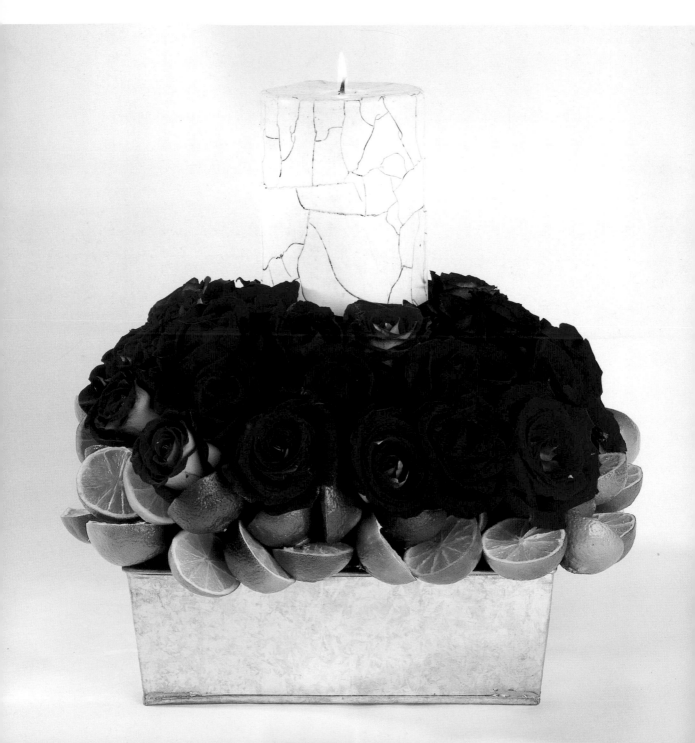

Polychromatic colour schemes

This is the use of many colours together. Such an arrangement is always cheerful and vibrant. To ensure that there is harmony and unity in the design, take care with your choice of form and texture.

Warm and cool colours

Warm and cool colours are equally split on the colour wheel. Reds, oranges and strong yellows are warm colours, recalling the hues of fire and the sun. There is a lot of energy in these colours so they can become tiring to the eye. Blues, greens and violets are cool colours – they are calm and easy on the eye.

Warm and cool colours are both used in flower arranging, just as they are in interior design. Warm colours are often used to give vitality to north and east facing rooms and cool colours will have the opposite effect in south facing rooms.

Warm colours brighten under electric light or candlelight but are deadened under fluorescent lighting. For fluorescent lighting blues are best. The coldest colours lie opposite those that are warmest.

The grey-blue tones of the *Eryngium* and the muted colour and dull textured *Echeveria* combine with the *Agapanthus* and the cream roses which highlight the other colours in the design. The pebbles and water evident at the base complete this cool arrangement for a warm summer's day.

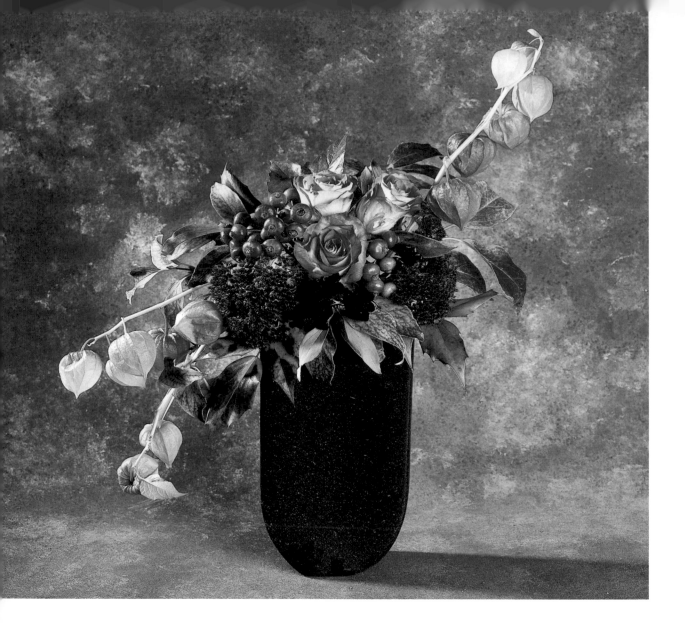

The warm colours of the orange *Physalis alkekengi* var. *franchetti*, the red *Sedum*, and the red and yellow roses are intensified by the arrangement's setting against a cool background of blue.

Advancing and receding colours

Blue, violet and other cool colours recede. This means that they create a feeling of distance. The medieval cathedral builders often painted the ceilings blue to emphasize their lofty height. They also installed blue stained glass to create a feeling of distance. Cool receding colours are best used for camouflage, so if you have ugly pipes or radiators to hide, paint them in blue, mauve, grey or any other receding colour.

The warm colours – orange, strong yellow, red and terracotta – have the opposite effect. They advance or foreshorten.

Just as this colour information is applied to interior design, it can also be applied to flower arranging. Advancing, bright and warm colours are suitable when arranged in a room you wish to make smaller. Conversely, receding and pale colours are suitable for smaller areas. This is called colour movement.

Luminosity

Some colours can be seen more easily than others. Any tint (colours with white in them) can be seen more vividly in dim lighting than those of a pure hue. Conversely, those with black in them (shades) can be seen less easily than those of a pure hue. Of the chromatic colours – white and black being neutrals – yellow is the most luminous, followed by orange, yellow-green, red, blue and lastly purple.

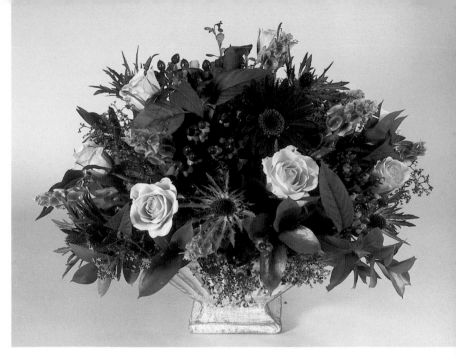

This design shows the luminosity of colour. Look how the dark tones of red and blue recede and the yellow advances and dominates due to its luminosity.

The effect of lighting

Fluorescent lighting

Fluorescent lighting is not as popular as it was in the last century when it was very commonly found in shops, offices, factories and kitchens. Fluorescent lighting is flat, cold, bright, throws little shadow and has a bluish cast.

New technology is now producing fluorescent tubes that produce a light similar to that given by filament lamps. As a consequence fluorescent lighting can now vary considerably. If your kitchen is decorated in blues and greens and you wish to complement this colour scheme with flowers in the same colours, choose a blue tube. If it is decorated in yellows and oranges choose a compatible coloured tube as a blue light will muddy the colours of warm coloured flowers.

Tungsten

Tungsten bulbs are used in ordinary household fittings, such as a table lamp. The colour spectrum contains almost no blue but has a strong red bias. It therefore benefits red, orange and yellow flowers but does nothing for those that are blue.

Mercury

Mercury bulbs emit light with a violet/blue/green bias causing red to become dull. This type of bulb becomes dim with age, further reducing the light level.

Halogen

Halogen down lighters are now used extensively. The wavelengths of light produced by halogen bulbs are very close to that of natural sunlight so any colour looks good.

Candlelight

Yellow, pink or peach-coloured flowers are ideal in candlelight. Receding colours such as blue and violet will disappear. The darker they are the more they will disappear so that you appear to be left with black holes in your design. Generally speaking warm pastels will scintillate and cool dark colours will deaden the overall effect.

Fluorescent Lighting
Blues ✓ Reds ✗

Tungsten
Blues ✗ Reds ✓

Mercury
Blues ✓ Reds ✗

Halogen
Good for all ✓

Candlelight
Yellow-pink, peach colours ✓
Blue and violet ✗

The size of colour

Dark colours reduce size and light colours increase it. Small rooms look larger, the lighter their colour. Similarly, flower arrangements that are composed of light colours maximize the size of a room. As an analogy, dark-coloured clothes are slimming, reducing the apparent size of the wearer, while light colours have the opposite effect. If you wish to use dahlias or a similar large flower in an arrangement, and the other flowers are just too small to be in scale, use dark dahlias rather than those with bright or pale colours, so that they will appear smaller.

The colour of your walls

Grey, blue, soft green and terracotta are the colours that seem to enhance many colour combinations. Grey is the colour against which all colours are truest. Flowers can get lost when placed against a stark white wall. A grey stone wall is far more sympathetic to most colour schemes than a whitewashed wall.

The psychology of colour

Most people have some reaction to colour, which has been recognized as affecting our physical and mental activity. Religious organizations see colour as an important factor in the expression of life, both in ancient and modern times. It is important to remember that colours have a completely different symbolism according to race and religion.

Here are some of the connotations that people associate with colours:

Purple – exoticism, aristocracy, senior clergy, royalty.

Black – mystery and power, night, space, the grim reaper, evil, the black market, a symbol of taste.

Red – thought to be the first colour seen by babies. Exposure to red is said to quicken the heartbeat and gives a sense of warmth. Red is the colour of aristocracy, passion, fire, love, the devil, danger, blood. The effect alters when white is added and pink results – in the pink, everything is rosy – giving a sense of well-being. Red and pink foods are associated with flavour. Red is said to be preferred by ten times as many men as women.

Orange – there was no word for orange in the English language until the orange fruit arrived during the tenth and eleventh centuries. It is an exotic colour – the colour of spices, sunsets and pumpkins.

Yellow – cheerfulness, caution. Yellow cars are less frequently involved in road accidents (probably because they are the most luminous colour). Yellow, particularly a clear yellow, is the colour of spring, the sun, but also illness.

Green – the colour of life. The most restful colour to the eye, representing stability and security, supernatural phenomena, jealousy. Green is the colour that unifies all the elements of a flower design, but green on its own delights the eye.

White – goodness, magic, clinical surroundings, purity.

right
The lively reds and oranges conjure up hot summer days and a sense of well-being.

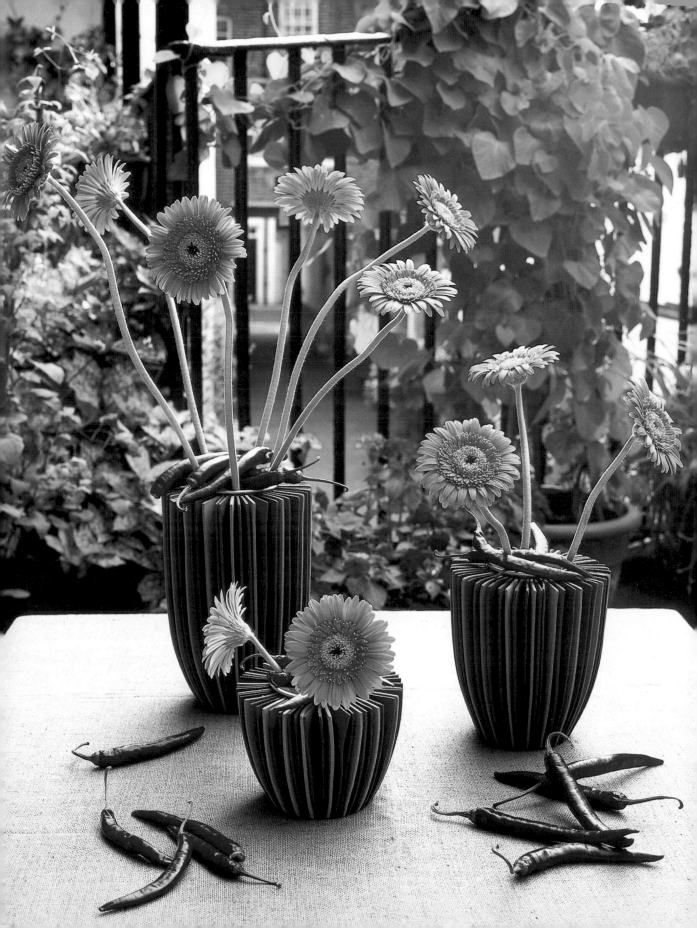

The principles of design

Now we must study *how to use* these elements – form, texture, space and colour – in flower arranging. The principles of design: balance, scale, proportion, contrast, dominance and rhythm need to be applied to the four elements. For example, when creating an arrangement, see that you have balance of form, balance of colour, balance of space and balance of texture. Then apply the other principles to the elements.

Balance

Good balance is crucial in flower arranging. If there were a scale of importance for the principles, then balance would be high, for without good balance an arrangement cannot be successful. Balance in flower arranging takes two forms – physical and visual. Physical balance means that an object will stay upright and not fall over. Visual balance means that the arrangement does not look as if it might topple over. There are two fundamental types of balance – symmetrical and asymmetrical.

Whatever their style, arrangements need to be balanced vertically and horizontally. To check the vertical balance, close one eye and hold a pencil vertically through the centre of the container and see if the eye is pulled to one side or the other. For horizontal balance, close one eye and hold a pencil or stem two-thirds of the way down the arrangement.

Symmetrical balance

Western art, architecture and the human body are based on symmetrical balance. It is our heritage from classical Greek and Roman art forms and is the basis of many traditional arrangements, typified perhaps by the symmetrical triangle.

Symmetrical balance means that the weight and *outline* of the plant material are the same each side of a vertical axis rising from the centre of a symmetrical container. This kind of balance is restful, stately and dignified. In traditional designs, symmetrical balance should be carried through the whole design. For example, a symmetrical arrangement should not have an accessory on just one side. Nor should it be placed against an asymmetrical background or an irregular base.

Asymmetrical balance

Oriental art is based on asymmetrical balance. From the Chinese and Japanese we have learnt much about asymmetrical or informal balance in painting, landscape design and flower arrangement. Some Oriental teachers believe that the seemingly vacant side of a painting or flower arrangement is a place for the imagination, for meditation and rest.

Asymmetrical balance means that the plant material is not similarly arranged on both sides of an imaginary vertical axis. The two sides may, or may not, have equal amounts of plant material. Asymmetrical balance is subtle, creative, emotional and stimulating. Although more difficult to achieve, it can be more personally satisfying than formal

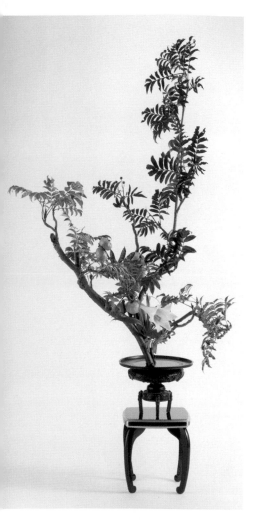

Take an imaginary line through the centre of this Japanese Ikebana Enchu arrangement by Tineke Robertson. Although the container and stand are symmetrically balanced the outline on each side of the central axis is completely different. One side, however, balances the other giving asymmetric balance.

symmetrical balance. Frequently the formal plant material masses do not appear to balance one another, so it is necessary that the voids are significant in order to balance the solids.

Asymmetrical arrangements can be balanced by:

1. Self-balance – in a self-balanced arrangement the lines and masses are so distributed on both sides of a central vertical axis through the centre of the container that, although opposing sides are distinctly different in outline, they have the same visual weight. The result is equilibrium.
2. Using longer, lighter plant material to balance shorter, heavier material.
3. Using space to balance plant material. Enclosed space is visually heavier than open space.
4. Balance by placement – this means that an arrangement is not balanced by itself but is heavier on one side than the other. It appears balanced, however, when placed in the right relationship to its base or site. Ornaments or a lamp can be positioned to balance the design or the arrangement can be positioned on the diagonal. Alternatively, an accessory may be incorporated into the actual design.

TIP Every design must be balanced
- top to bottom
- side to side
- front to back

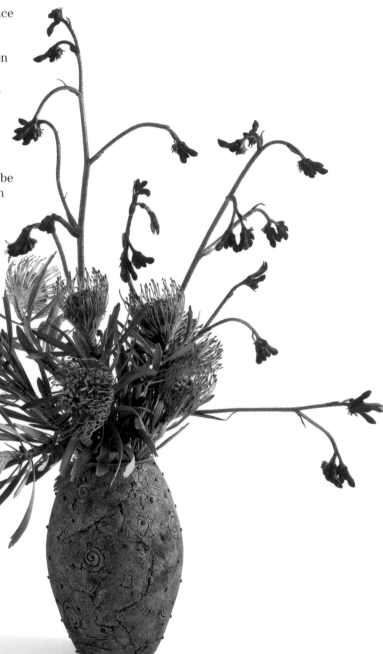

In this design of pincushion protea (*Leucospermum cordifolium*) and kangaroo paw (*Anigozanthos*) the vase is symmetrically balanced but the overall design is asymmetric as the outline is different each side of the central axis.

Visual weight

Whichever type of balance you wish to achieve, the following information on the apparent visual weight and the actual weight of plant material is relevant. This is because you do not want your arrangement to be top-heavy, bottom-heavy or side-heavy. The visual weight of plant material increases:

- The further the materials are from the central axis.
- The higher they are in the composition.
- The more solid, rather than airy, the form.
- The stronger they are in colour.
- The darker they are in colour value.
- The warmer they are in hue.
- The more advancing the colours.
- The greater the luminosity of the colour.
- The larger the form.

Also take into account that:

- Round flowers have more weight than linear ones.
- Shiny surfaces have more weight than dull ones.
- Enclosed space is more compelling than open space.
- Large and shiny plant material is more dominant than rough and small plant material.

Scale

TIP No flower should be more than twice the size of the next largest.

Scale is the relationship between the size of each part of the composition. It is particularly important to consider:

1. The relationship of the arrangement to the room in which it stands. A tiny arrangement would be inappropriate for a sparsely furnished church hall. A large pedestal would be out of scale for a small bedsit, as would a large patterned fabric and huge Victorian furniture. Remember, as you go up in scale, use larger plant material, rather than more plant material.
2. The relationship of the size of the plant material to the container. If you have a large, heavy vase use long stems with large flowers. For small containers use more delicate flowers and foliage. If your flowers are too large for the container you could place it on a large heavy piece of furniture.
3. The relationship of the size of the plant material to each other. Very tiny flowers do not sit well with very large ones, unless they are in a tightly massed spray or group. Flowers must relate to the foliage as well as to the other flowers. As a general guide, do not incorporate flowers that are more than twice the size of the ones next to them in size. Ensure that all your plant material is in scale.

Where is scale particularly important?

1. Miniatures and petites
In the NAFAS competitions manual a miniature is the term given to a tiny arrangement no larger than 10cm (4in) high, wide or deep. A petite arrangement is no larger than 25cm (10in) high, wide or deep. For such small designs even one flower or leaf out of scale will create discord.

2. Pedestals
If the plant material is not as large as required, use groups of smaller plant material to create a stronger effect. In an extra large venue, e.g. an abbey or a cathedral, mass large plant material together to achieve this.

3. Landscapes
Scale is particularly important when creating landscape designs (see page 178). In a realistic landscape design, nature is being copied and reproduced (unless creating a cityscape in contemporary style). Other components should be scaled to the natural scale of life. It is easier if you avoid man-made objects and try to create the effect with natural plant material. If a twig is being used to represent a tree, then any figures introduced into the design should be in the same scale relationship as a real man to a real tree.

Here the flowers are in scale with each other. The individual flowers on the stem (far right) would not be in scale but are when the spray is considered as a whole.

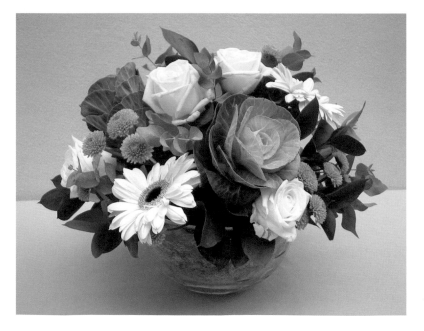

In this design the roses, *Brassica* and mini *Gerbera* are all in scale. All these flowers are more than twice the size of the small *Chrysanthemum* (santini). They have therefore been grouped to give a larger placement, thus correcting the scale.

Proportion

Proportion is the ratio of one area or one part of a structure to another, and to the whole. The Greek mathematician Euclid proposed the formula for perfect proportion around 300 BC. His theory, known as the Golden Section or Golden Mean, has withstood the passage of the centuries. It is the division of a line or area in such a way that the small part is in the same proportion to the greater part as the greater part is to the whole. The formula is based on the proportions of the human body.

AC is to AB as CB is to AC. This theory also applies to areas and volumes.

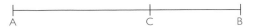

So how can this be related to flower arranging? It simply means that if the flowers are too wide, too low or too high for the container or the arrangement too small or big for the background, then the total effect will be lost. If working to the above formula seems too complicated, then apply one of the guidelines below, which are based on the idea of thirds – close enough to Euclid's formula!

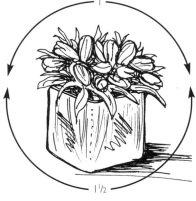

In a contemporary design the proportion of the container to the flowers can be one and a half to one.

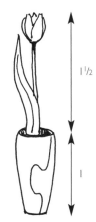

Let your tallest stems be one and a half times the height of a tall container

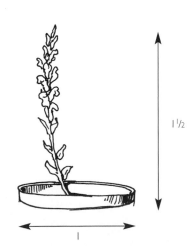

Let your tallest stems be one and a half times the width of a wide container

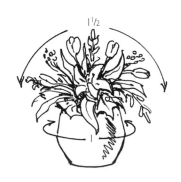

In a classic arrangement, let the volume of plant material be one and a half times that of the container

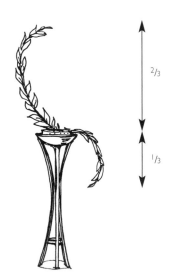

In an S-shaped design, two-thirds of the plant material should be above the rim of the container

Proportion – the general rule of good proportion is that in a mass arrangement in a vase the proportions should be one and a half to one. Where space is incorporated into the design the proportions can be extended because of the lightness of space.

Also remember that:

- Containers that are dark in colour, or constructed of strong material, can support much larger arrangements.
- The weight of plant material affects the proportions. Airy plants may extend much further than strong ones.
- A strong base permits the arrangements to be taller or more volumetric than usual. When the base is larger than the container, the height of the material should be one and a half times the length of the base, rather than the length of the container. The Chinese, however, arrange their flowers so that the container is more dominant than the plant material. You will notice that some of the contemporary containers are more dominant than the flowers. But the proportions still hold true – the proportion of container to plant material is 3:2 rather than 2:3.

NB In the hands of the masters rules can be successfully broken. In some of the contemporary Dutch vertical designs the structure is very tall and the container quite tiny in comparison and it works!

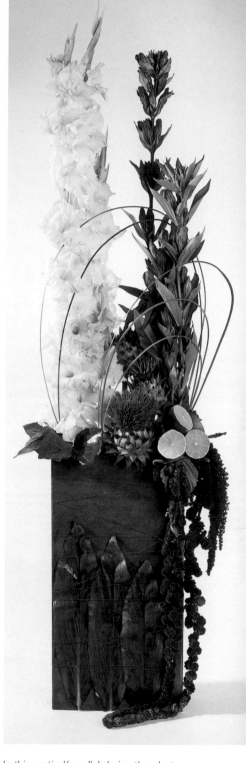

In this vertical/parallel design the plant material above the rim is virtually equal to that below. The wrapping of leaves around the container and the placing of the hanging *Amaranthus* increases the amount of the plant material and therefore offers good proportions.

Contrast

Contrast is the difference shown when objects are placed next to each other. Good use of contrast is exciting and relieves boredom. There can be contrast between different varieties of flowers and foliage or contrast within a bowl of flowers of one variety, where the buds and flowers are at differing degrees of development.

With the amount of contrast available to the flower arranger it is careful selection that calls for skill. If the design is intended to be restful, then the amount of contrast should be small but nevertheless present, for without it the design would be lifeless. At the other end of the spectrum, an exciting, startling design demands great contrast in all aspects, especially form and colour, as these are the most apparent. Textural contrasts can be less dramatic but equally effective.

Nature has provided us with unending variety in contrasting textures and forms, which appeal both to the sense of sight and of touch. Put a shiny leaf against a hairy or woolly one, or a leaf of simple, round form against a long, pointed one. Contrast avoids monotony and can be obtained by changing the direction of lines, the length of stems, the size of the material. Vitality is added to any composition by the inclusion of components that contradict the main effect. For example if a flower arrangement seems too severe then add a softening influence like *Alchemilla mollis*. Well-organized and controlled contrasts make for strong designs.

TIP Contrast may be subtle or strong depending on the style of the arrangement. Contemporary designs tend to use sharper contrasts.

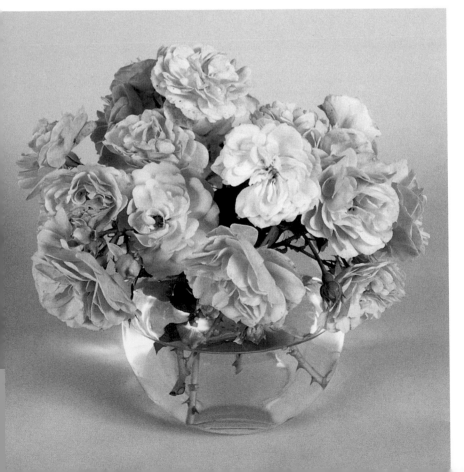

At first there would appear to be no contrast in this design but on close observation you will see the subtle contrast in colour, size and form of the developing buds and flowers.

Contrast in form

This is referred to under form on page 8. When using more than one type of plant material in an arrangement, avoid arranging similar flowers, such as larkspur *(Consolida)* and stocks *(Matthiola)*, unless there are other flowers and foliage to keep them apart. They will create confusion if they are too close together.

Contrast in colour

Much can depend on the visual weight and importance of the colours used, and probably no two people see colour in quite the same way. An arrangement of purples, violets and lavenders that could seem too retiring might need the contrast of creamy blooms to bring it to life. Complementary colours make the strongest possible contrasts. Although there should be variation in the quantities of each colour and in the value, one colour should dominate.

Contrast in texture

It is the inclusion of smooth-textured material that is essential to many successful designs. So much plant material has an intricate structure that it is only calm areas of smooth-textured leaves that can show up its full beauty.

Dominance

Without dominance there is a lack of unity. The following are examples of how you can create the necessary dominance in your arrangement to hold it together. Dominance is often closely linked with proportion.

Dominant movement

The emphasis must be chiefly on one kind of movement, in order to have rhythm in an arrangement. A rhythm of radiation is the most common movement in traditional flower arranging. A dominance of parallel lines is the dominant movement in the parallel style.

Dominant texture

Strong dominance of one kind of texture is advisable in most arrangements so that unity in texture results. For example, shiny texture is more dominant than dull. Even when textural contrast is sought, one kind of texture should predominate.

Dominant colour

Dominance of either warm or cool colours in an arrangement is far better than equal quantities of each. Dominance of a chosen colour is also necessary for beauty. An arrangement that is half-red and half-green has displeasing competition within itself.

Dominant form

Round flowers are more dominant than line and spray plant material. Large form is more dominant than small. A greater quantity is more

dominant than a lesser quantity. In a mixed arrangement one kind of flower should dominate in quantity. Without this dominance interest is divided, scattered and quickly lost. In most arrangements the flowers used for a focal area dominate by virtue of their size and colour.

Dominance of container or flowers

In traditional arranging the flowers are dominant, but where the container is of special interest this may well dominate the flowers. What is important is that one should be the key player, rather than having two contenders for the title. The dominance of flowers over a container or vice versa is usually in the ratio of 3:2 (one to one-and-a-half).

Dominant area

Any planned flower arrangement has at least one area of stronger interest or focal area. In classic designs this is usually located near the place where all the stems of the plant materials converge, because attention is naturally drawn there. In a good abstract design it can appear anywhere. The chief function of the area of strongest interest is to draw together all the separate parts of the design. In all-round designs there will be several dominant areas distributed around the arrangement. In front-facing traditional designs the focal area is found towards the base of the tallest stem. A dominant focal area can be created by:

- Placing the roundest, brightest, most interesting or largest flowers in this area.
- Placing the shiniest, largest, roundest leaves in this area.
- Concentrating the flowers at the area(s) selected, even if there is only one variety of flower in the arrangement.

TIP If a flower arrangement contains two or more equal attractions they will pull the design apart. Dominance provides a sense of order.

The round form and size of the open orange poppy (*Papaver*) give it dominance over the more luminous colour of the lemons.

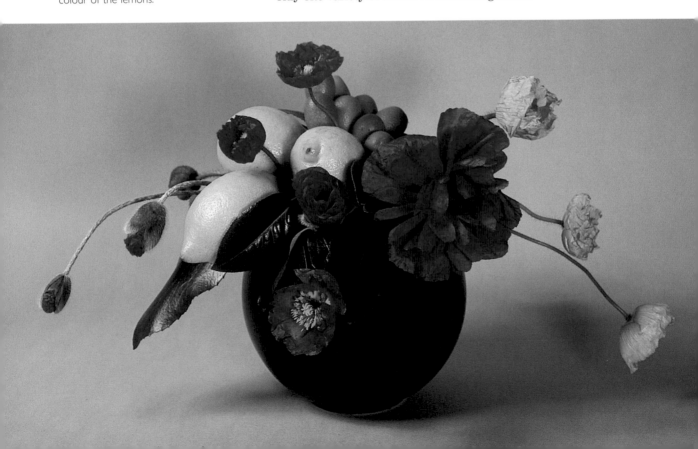

Rhythm

Rhythm is the beat, the pulse, the movement of the design. In music it is the build-up of a good rhythm that enthrals the listener and urges him or her to anticipate with joy the notes that will follow. In flower arranging good rhythm captures the viewer's attention and may be predictable or unpredictable. Good rhythm means that the eye is led through the arrangement from top to bottom, from side to side and from front to back. An arrangement without rhythm cannot hold the viewer's attention for long.

So how can rhythm, perhaps the most elusive of design principles, be harnessed to hold the viewer's attention? It is the employment of line, form, colour and space in such a way that the observer achieves the effect of motion, even though the components are static.

Rhythm is found in all plant material. Flower arrangers should respect growth habits and arrange their flowers and foliage so that they follow their natural rhythmic lines, appearing comfortable rather than awkward.

Some of the ways in which rhythm can successfully be achieved are by:

Rhythm in line

1. Rhythm can be achieved by radiation of line. The most important illustration of radiation is when all lines of an arrangement converge at one place. Nature illustrates radiation in growing plants. Most flower petals and sepals radiate from a centre. Palm leaves have flat radiation. Lines in an arrangement give movement to the design and allow the eye to pass smoothly from one part of the design to the next. Direct line is the term applied to a straight or curved branch. Repetition or radiation of such lines are ways of providing movement.
2. Indirect lines provide more irregular movement or rhythm. These are created by repeating the form of a flower or leaf throughout the design, so that the eye passes from one to the next. Obviously there can be variation in colour and size – with smaller, paler buds closer to the margins and larger, more open, brighter flowers at the focal area.
3. Making the top of a traditional arrangement end in one point only. Do not let two main lines branch off like a Y. When adding colour to your foliage outline, reinforce the central stem rather than positioning colour to form this Y either side of the foliage stem.
4. Repetition of line.

Nature illustrates radiation.

Rhythm in form

1. Repeating the form of a leaf by overlapping leaves of the same variety to get a patchwork effect. This is often seen in parallel and sculptural designs.
2. Repeating the form of your container in the form of the arrangement and of your base. For example, create a round arrangement in a round container on a round rather than an oval surface such as a table.

TIP Repetition and radiation of plant material are perhaps the easiest ways to create good rhythm.

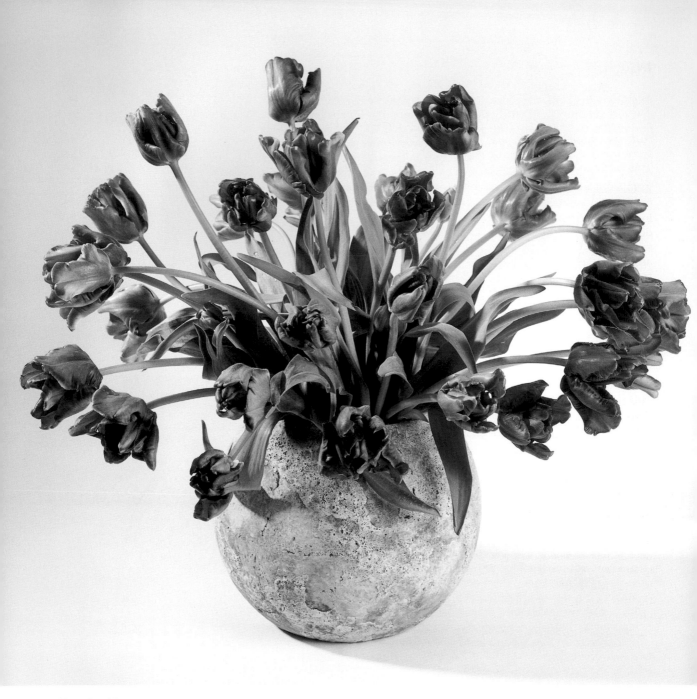

The tulips fall away from the centre of the container as if from a central core. This radiation, combined with repetition, builds up good rhythm.

Rhythm in colour

1. Using adjacent colours and placing them in their correct sequence, as on the colour wheel.
2. Using graduations in value, with the darkest values lower down and the lightest values at the top and sides, and medium values in between them.
3. Repeating a colour in several places in different amounts, so that the eye flows from one area to another of the same colour.

Different sorts of movement that create rhythm

1. Ascending or vertical movement
This movement is seen in tall arrangements. Tall, slender material such as *Iris* gives effective vertical movement. Additional rhythm results from overlapping such flowers, with each one shorter than the next, or from placing each one slightly to one side in a sequence of heights. This tends to push the movement up and up.

2. Curvilinear movement
Circular movement can be found in Hogarth curves (see page 173), downward and upward crescents and the gentle curve of cushion arrangements, tied bunches and round designs. It can also be seen where leaves are manipulated, not only to heighten interest but to create new forms in contemporary designs. Round flowers also give curvilinear movement.

3. Horizontal movement
This is a calm and restful rhythm. Horizontal plant material in a low container usually repeats the directions of the lines of the table.

4. Diagonal movement
A strong diagonal action requires a strong horizontal base to support it. An arrangement that features diagonal lines does not usually welcome any straight horizontal or vertical lines within it. It may, however, have a minor rhythm of circular or semi-circular forms at the focal area.

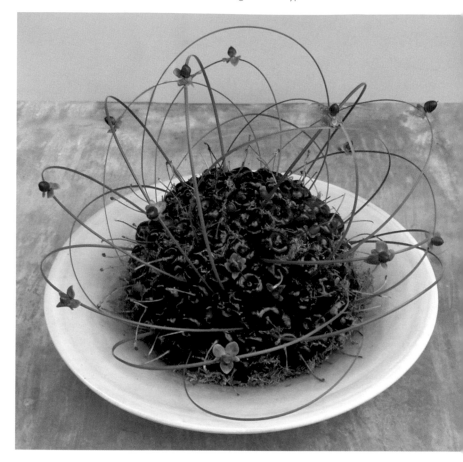

In this highly contemporary design a mound of cherries attached to a bowl-shaped piece of foam has ben made into a frenzy of curvilinear rhythm using flexigrass and *Hypericum* berries.

Harmony

Harmony is the compatibility of all the components in a composition. It refers to the absence of any jarring note in the relationship of the elements that make up the arrangement.

Through the good use of the elements and principles of design, harmony will be achieved. Choose plant material of pleasing colours, with interesting variations in texture and a good combination of form. Place the flowers and foliage so that they are balanced. Give dominance and contrast. Ensure that all the components are in scale with each other and are well-proportioned. Get a good rhythm running through the design. Succeed with all these and you will have a harmonious design.

TIP Harmony is the happy medium between discord and monotony.

2

Flowers in a vase

The dictionary defines 'vase' as an ornamental container for flowers (from the Latin *vasum*, meaning a vessel). 'Ornamental' is itself described as detailing used to add beauty or decoration. But perhaps a vase can best be described as a container, created for flowers, that is taller than the size of its opening.

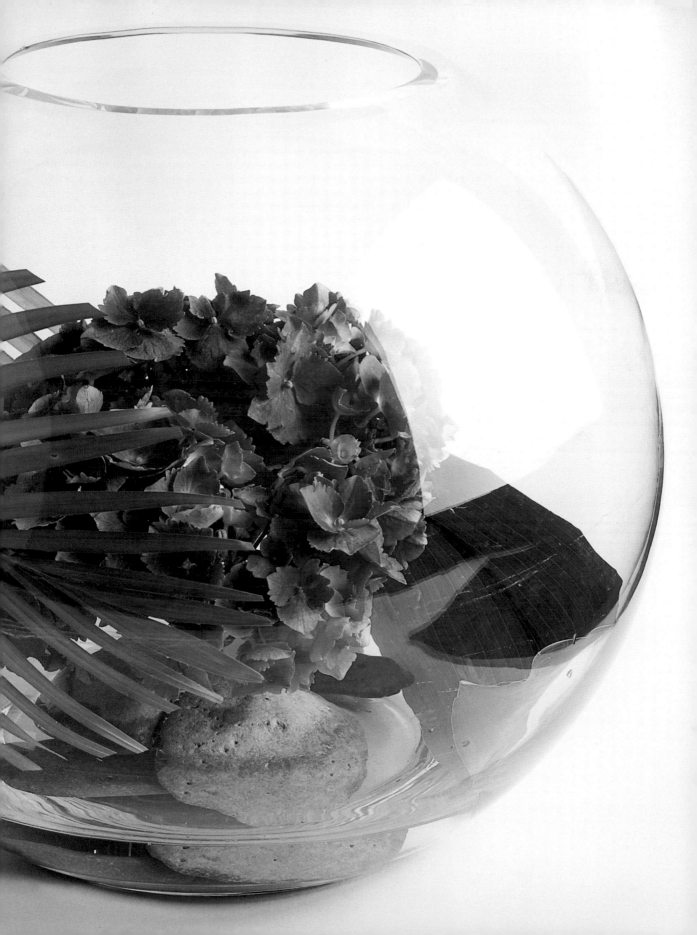

previous page
Place a pinholder at the base of a round glass container and place a few pebbles or slices of slate to cover. Take one head of *Hydrangea*, cut it short and place on the pinholder. Two leaves with great contrast of form – an *Aspidistra* and a small palm – complete the design. Keep your water low but topped up – hydrangeas love water.

The list of materials from which vases are made is seemingly endless. There are traditional materials, such as iron, china, tin and clay, and there are those that are new in the last 100 years starting with Bakelite, the first of the plastics, which was developed in 1907. It is important to respect the properties of each.

If you love flowers in the home you will want to collect inspirational containers. Craft shops and design studios offer a wonderful range. The occasional exciting buy can still be made at car-boot sales, jumble sales, bric-a-brac stalls and antique markets, where a chip on the rim or a faded pattern will affect the price, to the flower arranger's benefit. Indeed, the warmth of age can mellow the container's texture and colour to great advantage.

General guidelines for choosing a vase

- Vases with a wide mouth relative to their base need a generous amount of plant material. Care needs to be taken to ensure good balance.
- Rectangular openings also need a copious amount of plant material, as the stems always seem to fall to one side or into the four corners!
- Shaped vases with a narrow opening need flowing plant material, otherwise the flowers can look stiff and uncomfortable.
- Do not choose a vase that is too tall to be regularly useful. If you can only buy one vase choose one that is about 20cm (8in) high.
- Symmetrically balanced containers are generally easier to fill than an asymmetrically balanced container, such as a teapot.
- If ever in doubt, mass one flower type, perhaps in different tints and tones, with *Eucalyptus*, salal (*Gaultheria*), or simply on its own.

TIP To make a vase waterproof you can:
- line it with a square cut from a black binliner
- insert a smaller waterproof container
- place a plastic freezer bag in round and upright containers.

Sculptural

Sculptural containers are those with a clean, strong, bold form, usually contemporary in style, which on their own or with the addition of flowers create a dramatic look – non-fussy, direct, dynamic and exciting.

The containers themselves can be outstanding pieces of sculpture in their own right, and the flowers must be carefully chosen to complement their texture, form and colour. It is quite possible for the flowers to be subservient to the container and for the container to dominate the design.

Sculptural containers often lend themselves to exotic plant material, such as *Heliconia*, *Anthurium* and *Strelitzia*. When these are difficult

to find, a mass of tulips, roses, carnations or gerberas, or bold leaves such as those of the *Aspidistra*, *Phormium* or *Cordyline* – perhaps twisted or looped – can produce an equally strong effect.

When creating a classic arrangement in a classic container, plant material is generally artfully positioned to fall over the rim, but with many sculptural designs the rim can be an integral part of the container and needs to be left exposed. Plant material can be allowed to soar upwards to complement the line and form of the container and to create rhythm, through extension of the upward movement.

The texture of the container is often of great interest. Pitted, woven, embossed, rough, smooth, and grainy: the whole gamut of textural variations can be combined. Colour is subdued or dramatic, and form can have untold variations. What all have in common is a clear defined form, often angular, never boring. Some of these containers are inexpensive. Others are works of art and priced accordingly.

The peach-pink undertones of the vase are picked up in the choice of summer garden roses and flowering marjoram. A length of ivy (*Hedera helix*) is wound on itself and placed over the rim.

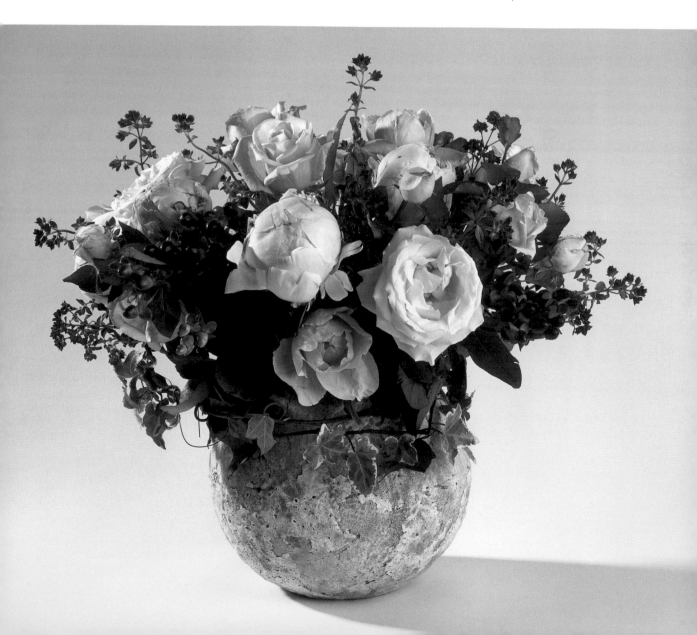

When you are familiar with your container it will be extremely easy to display your flowers quickly and effectively. The boldness of sculptural containers requires flowers of a similar nature, and strong masses of a single flower will always look effective.

Two containers of matching form and texture, but of differing size, hold a mass of fragrant freesia.

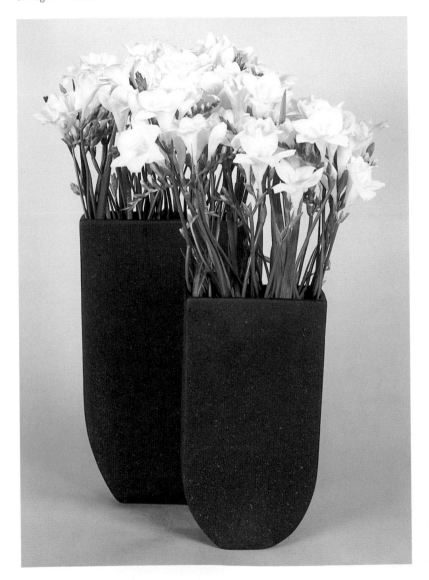

right
Five stems of *Globba* placed in the narrow opening of a vase chosen for its sculptural shape and colour.

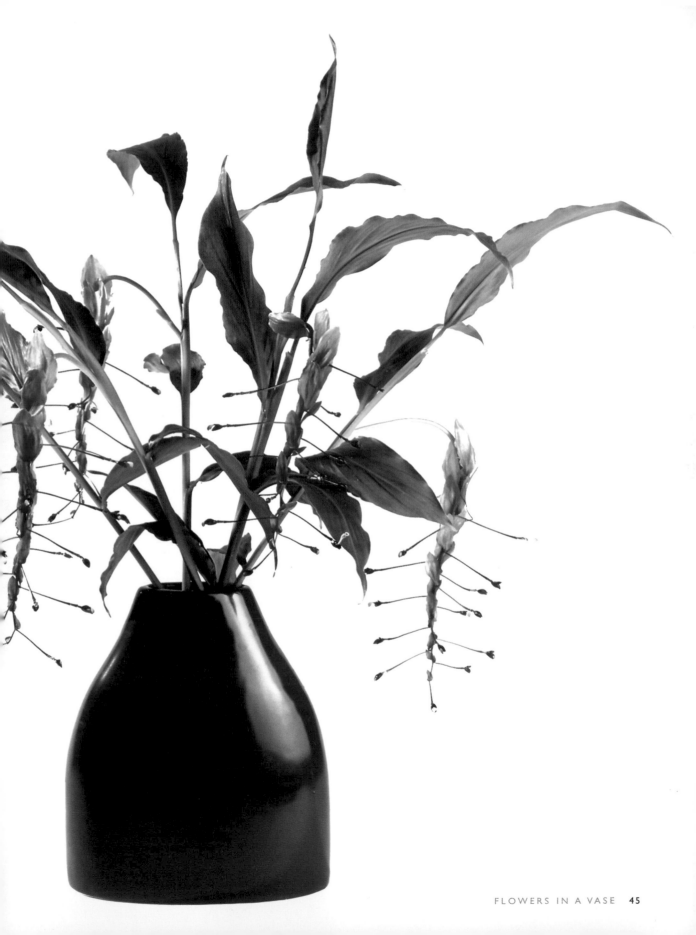

Glass

Glass containers can be found in a vast variety of shapes and sizes, cut and colour. If the glass is clear, rather than opaque or translucent, it is important that the water should always be crystal-clear. When arranging flowers in transparent glass, avoid floral foam, chicken wire or pin holders as a means of holding the stems in place unless they are disguised. This can be done by placing an inner container in the centre of the glass container, ideally one that repeats the form of the outer container. The gap between the two containers can then be filled with pot-pourri, cinnamon sticks, moss, shells, coloured aggregates, sand, gravel or fir cones.

Double tulips in an inner container with attractive seashells filling the area between.

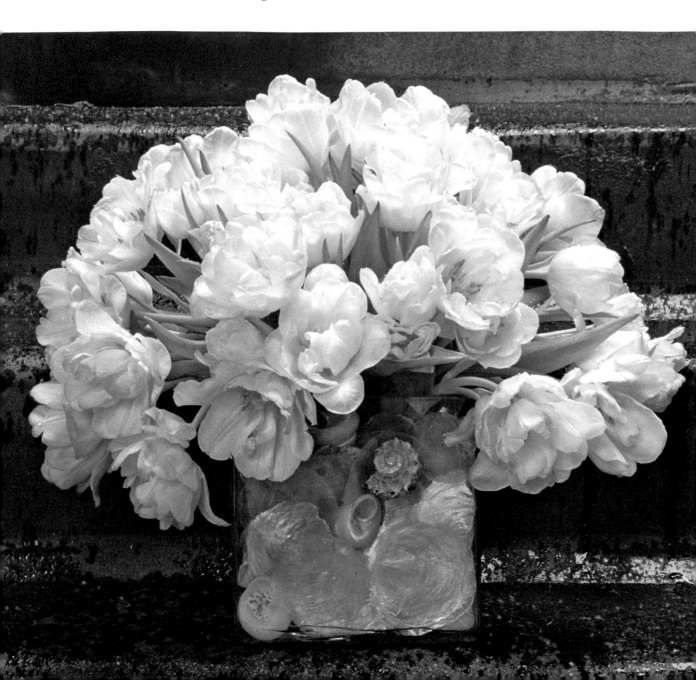

There are many ways of supporting your flowers in glass containers other than with floral foam. Try twisting tough, long-lasting bear grass (*Xerophyllum*) into rings and then allow these to support your stems. Use pebbles or glass marbles to give extra interest to your vase, but take note – it can be difficult to add your stems if you have too many stones or glass nuggets in your vase. Ensure your container is sparkling and clean before you add water. Most water marks can be removed by soaking the containers overnight in warm water and biological detergent.

Red lobster claws (*Heliconia stricta*), *Anthurium andreanum* 'Choco' orange mini *Gerbera,* orange blood flowers (*Asclepias curassavica*) and hairy green fruits (*Gomphocarpus physocarpus* 'Moby Dick') seedheads with frilly *Philodendron* 'Xanadu' leaves and twining kiwi fruit vine (*Actinidia deliciosa*) stems in a clear, glass vase.

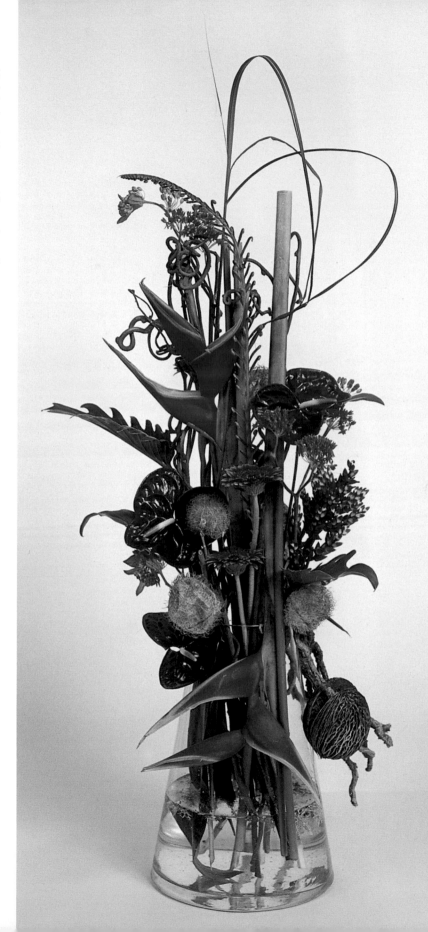

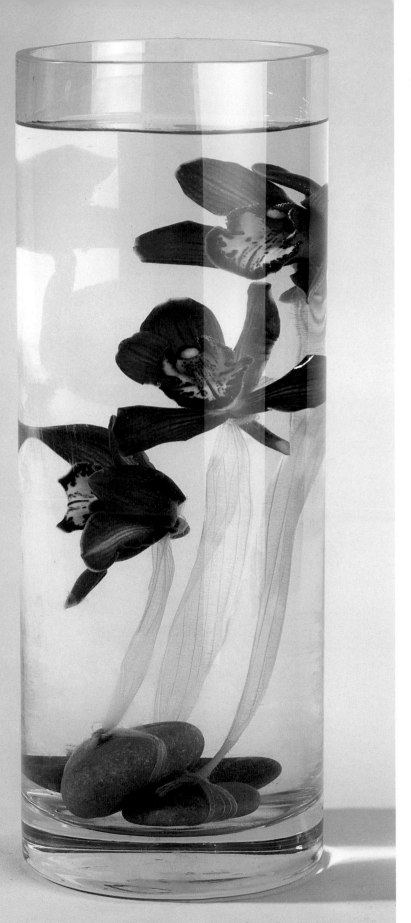

New trends

Some of the latest ways of using glass containers are to:

- Immerse long lasting foliage under water to hide stems and give interest and variety.
- Change the classic proportions so that the flowers rise minimally or not at all above the rim of the container. Sometimes flowers, as well as foliage, are submerged under the water.
- Layer aggregates, cubed or powdered foam (OASIS® Foam Powder) cloves, shells or even coffee beans in an outer tank, using an inner container to hold water.

Three orchid heads are attached to smooth beach pebbles with sisal ribbon and then submerged under water in a tall glass vase.

Classic

Classic vases are those that have stood the passage of time. Although they may be of contemporary origin, their style and feel are conventionally old-world – what most people associate with the typically British style of flower arranging. Jugs, bowls, Constance Spry vases, Victorian washbasins, prettily patterned biscuit jars, blue and white ware – all these lend themselves to a profusion of blooms and foliage.

Classic containers look lovely filled with a mass of flowing blooms, of twigs and berries, of foliage and flowers – perhaps a random selection from the garden, with the addition of a few flowers from the florist.

A mass of grape hyacinths (*Muscari*) in a classic container. As the *Muscari* have short stems, a wedge of floral foam is at the base of the container which is filled with water.

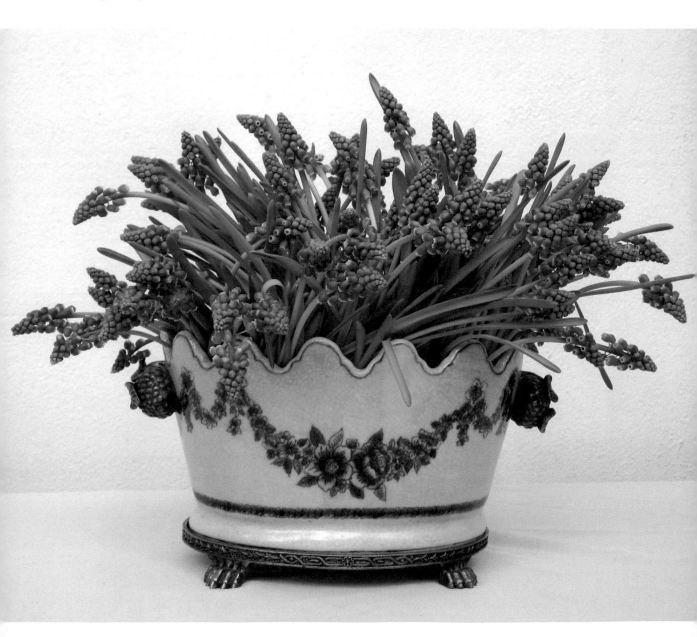

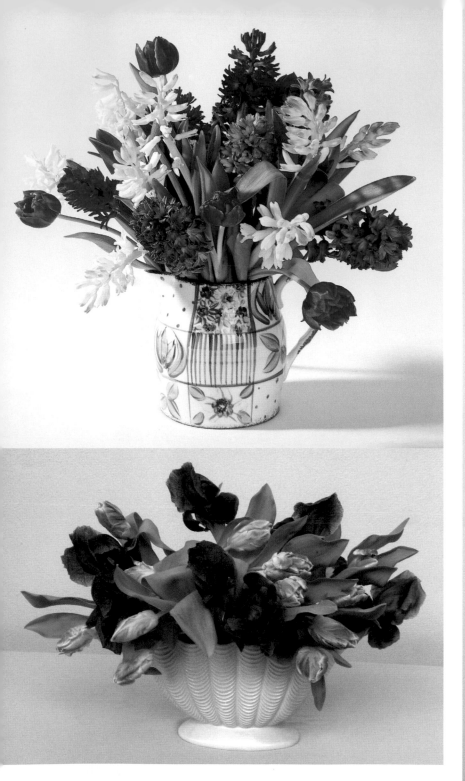

top
A hand-painted jug contains a colourful mass of hyacinths and tulips.

above
Flag iris and parrot tulips in a 1930s classic vase.

right
Viburnum opulus 'Roseum', apple (*Malus sylvestris*) blossom, *Eucalyptus gunnii*, peonies and Queen Anne's lace (*Ammi majus*) arranged in a classic vase.

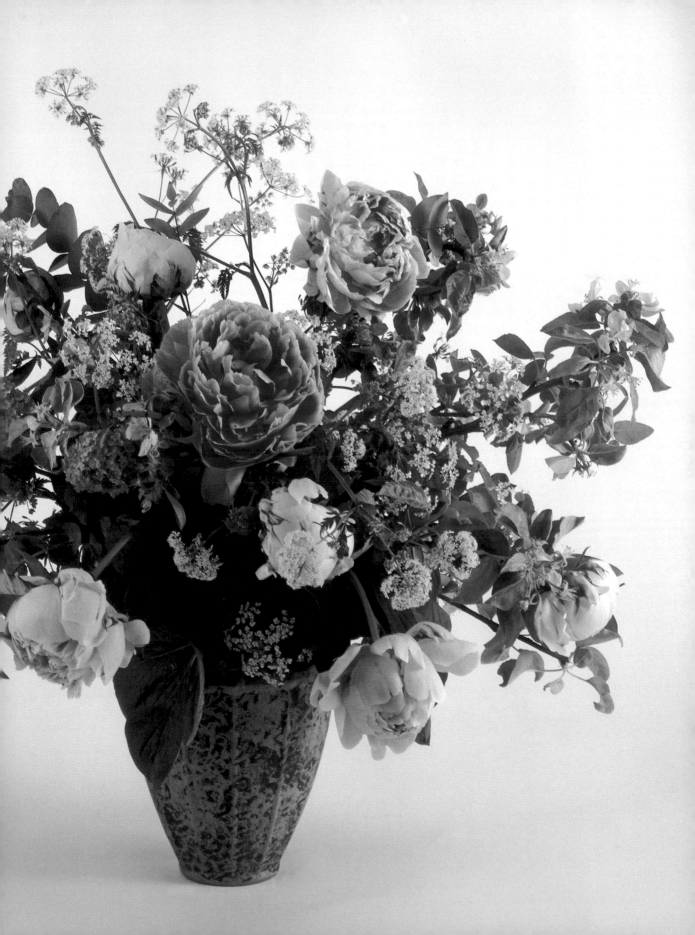

Metal

Silver, pewter, gold, copper and brass are all metals, but their different compositions mean that they enhance different flowers and colours. Mild steel has become very fashionable and is being used to produce a wide variety of containers. As with silver, lead, tin and pewter, its silvery-grey colouring is superb with grey-green or blue-grey foliage and pink, blue and white flowers. Copper, on the other hand, with its warm pink-orange undertones complements pink, terracotta, peach and burnt orange. Brass lends itself to yellows, golds and browns. Wrought-iron stands can be purchased, to hold glass or terracotta, and the combination is extremely effective.

Repetition of metal containers and white flowers provide movement through the design.

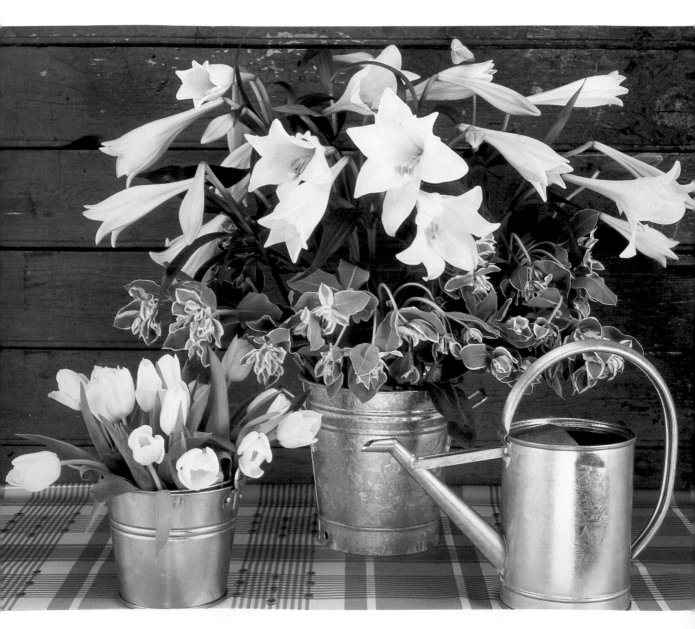

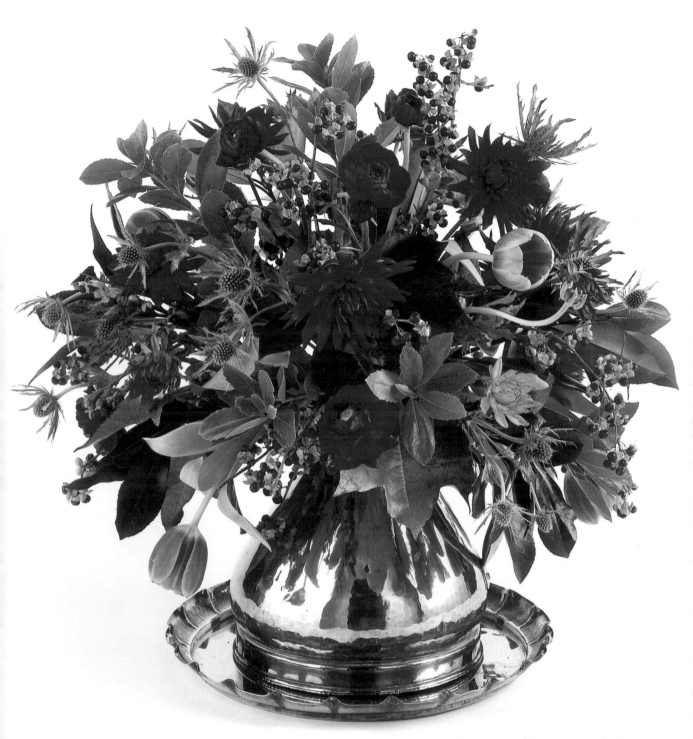

It is said that metals and alloys are ideal as containers, provided of course they are waterproof, because the metals in some way reduce the build-up of bacteria. This is the reasoning behind the old wives' tale that a penny in the water prolongs the life of plant material.

The strength of the copper is reflected in the colour and form of the plant material. Burnt-orange dahlias, tulips, bittersweet and sea holly is combined with foliage from the strawberry tree (*Arbutus unedo*), *Photinus fraseri* 'Red Robin' and Boston ivy leaves.

Other containers

Baskets

Baskets have been associated with flowers from the earliest times. A Roman mosaic has been discovered that shows many different flowers in a basket. Throughout history the rustic simplicity of baskets as containers has been appreciated, not only by those wanting an inexpensive and readily available container, but also by the flamboyant court of Louis XVI and by the orderly Flemish burghers of the seventeenth century.

Today the varieties of basketware seem limitless.

above
This open weave basket has been lined with moss and filled with long lasting *Skimmia* and summer pinks.

left
A mass of garden roses and fragrant herbs.

right
The theme is the beach in this basket arrangement of dahlias, roses, poppy seedheads together with shells and a fishing net.

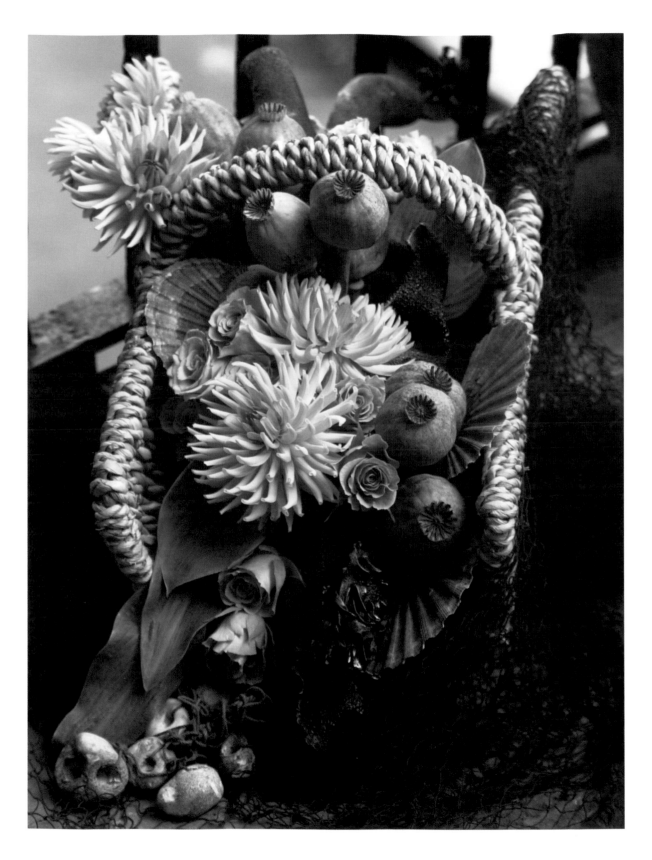

Organic

Vegetative containers can be simple and inexpensive to make and look very effective. It is great fun to have your own fresh asparagus container holding your flowers, as you nibble the asparagus from your plate in the summer. See the arrangement on the front cover of this book. Think of a tropical party with the flowers spilling out of empty coconut shells. With a little bit of imagination exciting original containers can easily be created.

TIP The arrangement below can be kept for a few days in the fridge in the vegetable compartment.

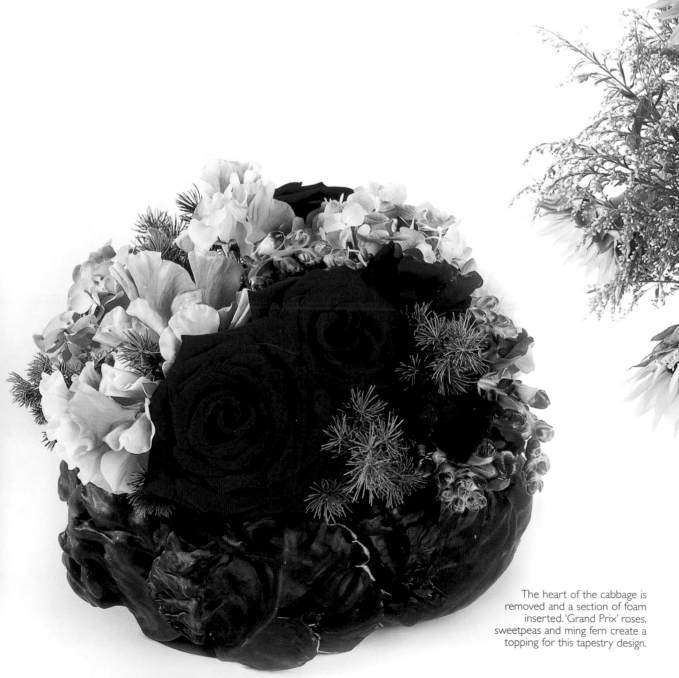

The heart of the cabbage is removed and a section of foam inserted. 'Grand Prix' roses, sweetpeas and ming fern create a topping for this tapestry design.

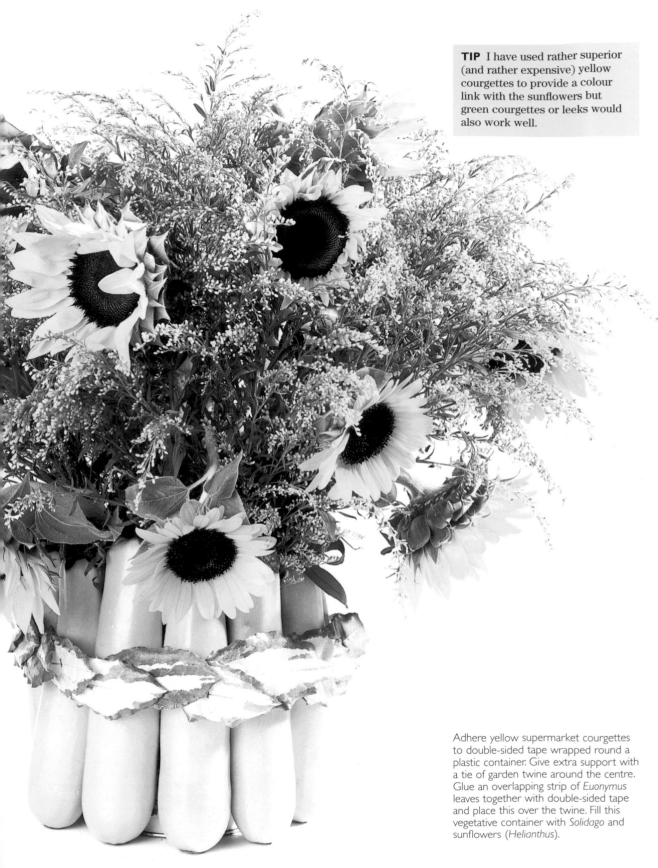

Adhere yellow supermarket courgettes to double-sided tape wrapped round a plastic container. Give extra support with a tie of garden twine around the centre. Glue an overlapping strip of *Euonymus* leaves together with double-sided tape and place this over the twine. Fill this vegetative container with *Solidago* and sunflowers (*Helianthus*).

Terracotta

Terrracotta today comes in the most amazing range of shapes, sizes and colours, although the colour with which it is naturally associated is a reddish brown. It is particularly lovely with yellows, apricots, peaches and oranges – the warm colours of the spectrum. Terracotta is a porous material and needs to be lined, especially if there is a drainage hole at the bottom, but some terracotta containers have been varnished internally and then there is no need for a lining.

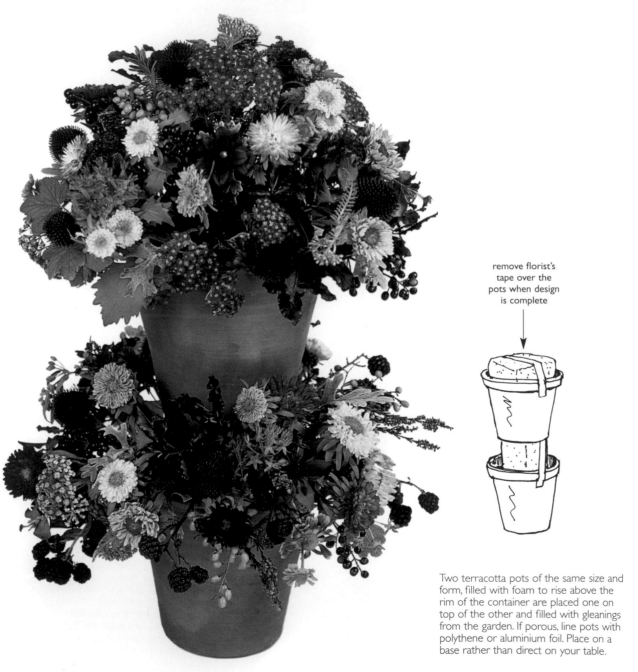

remove florist's tape over the pots when design is complete

Two terracotta pots of the same size and form, filled with foam to rise above the rim of the container are placed one on top of the other and filled with gleanings from the garden. If porous, line pots with polythene or aluminium foil. Place on a base rather than direct on your table.

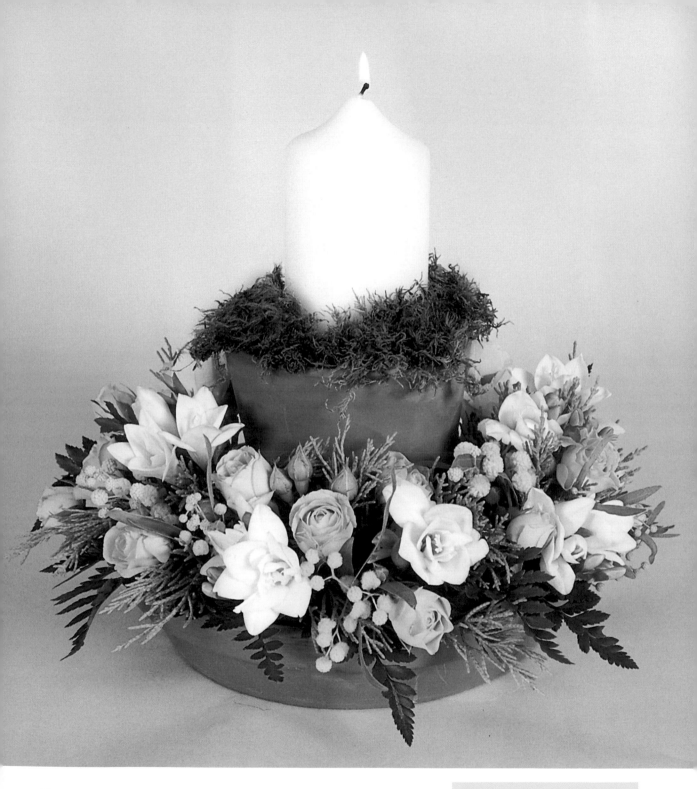

You will need a terracotta pot, which must be lined if not waterproofed, and a glazed terracotta base intended for a much larger pot. Place the pot in the centre of the base and place pieces of foam between the two containers. Position a chunky church candle in the terracotta pot and stabilize by adding moss to the pot. Cover your moss with snippets of foliage. Here I have used conifer and leather leaf. Then add your flowers such as mimosa/wattle (*Acacia*), *Freesia* and spray roses.

TIP If your moss has lost its colour pour a generous amount of very hot water over the foam and place in a good light. The moss will usually turn green once again.

3

Flowers in season

Every month of the year produces plant material –
blossom, flowers, foliage, nuts, fruit, cones and
berries for use by the flower arranger. As the
months change there is a gradual shift in the
availability of plant material, so that spring,
summer, autumn and winter are distinct from
each other in their seasonal variations. Far from
limited availability being a disadvantage, however,
it is the rediscovery of leaves and flowers, as they
burst once more into life that makes gardening
and flower arranging so special.

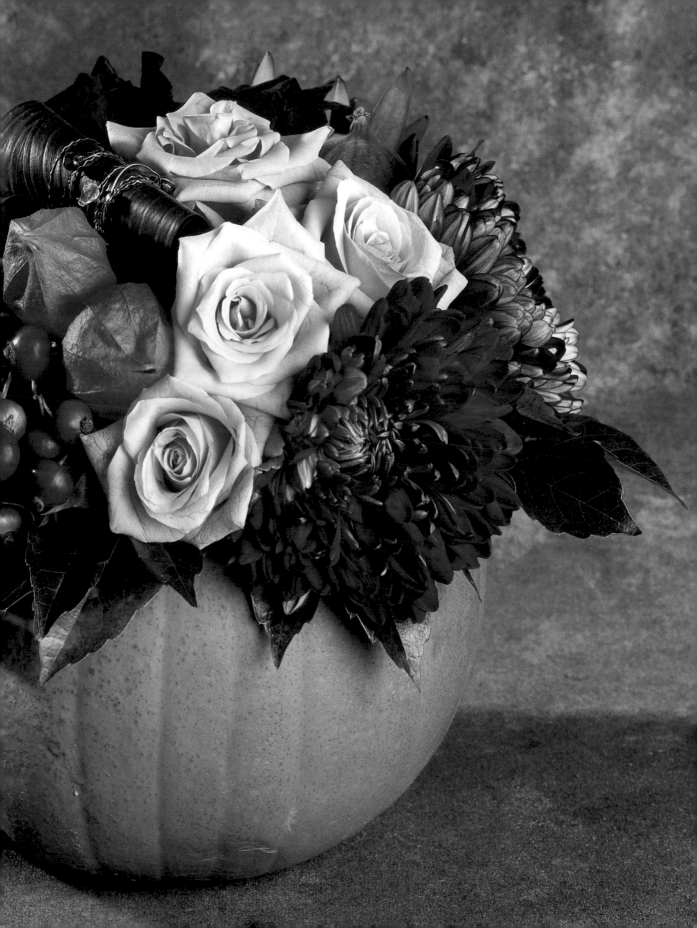

previous page
Insert an inner container containing foam into a hollowed out pumpkin. Create a rich tapestry from rose hips, *Leucospermum,* Chinese lanterns *(Physalis),* rolled *Aspidista* leaves, roses and chrysanthemums together with one of my favourite autumnal leaves – *Parthenocissus tricuspidata.* Once opened pumpkins rot quickly so avoid placing wet foam in direct contact with the flesh as this will speed up the decaying process.

The flower borders in this chapter show garden plant material and its availability season by season. For florist's flowers and foliage refer to chapter 15.

Using the different plant material available, I have come up with some simple designs using seasonal flowers. If you follow the easy step-by-step instructions you may find that flower design is easier than you thought. For those who have managed to work through the book you should find that copying those that are not step-by-step is a piece of cake!

Picking from the garden or the wild

The National Association of Flower Arrangement Societies (NAFAS) promotes the conservation of rare and endangered plants. The use of protected plants (as per Schedule 8 of the Wild Life and Countryside Act 1981) from the wild is forbidden. The use of other rare and endangered species, from the wild, in flower arrangements is discouraged.

- Only pick from the wild if there is an abundance, and do not uproot any plant.

- If picking at a distance from home, place your material in a plastic bag and blow into it before tying, so that the plant will be cushioned and will have its own contained system.

- Pick from the garden first thing in the morning or late in the evening, when plant material is at its most turgid (firm by distension with water).

- Cut your plant material at an angle and immediately place in a bucket of water, so that a seal does not have time to form over the cut end. Leave in a cool place for several hours before arranging. Remove any leaves that would fall below the water line.

right
Kevin Gunnell and Nick Nicholson's garden on the Welsh borders provides a splendid setting for a design of driftwood, foliage and flowers.

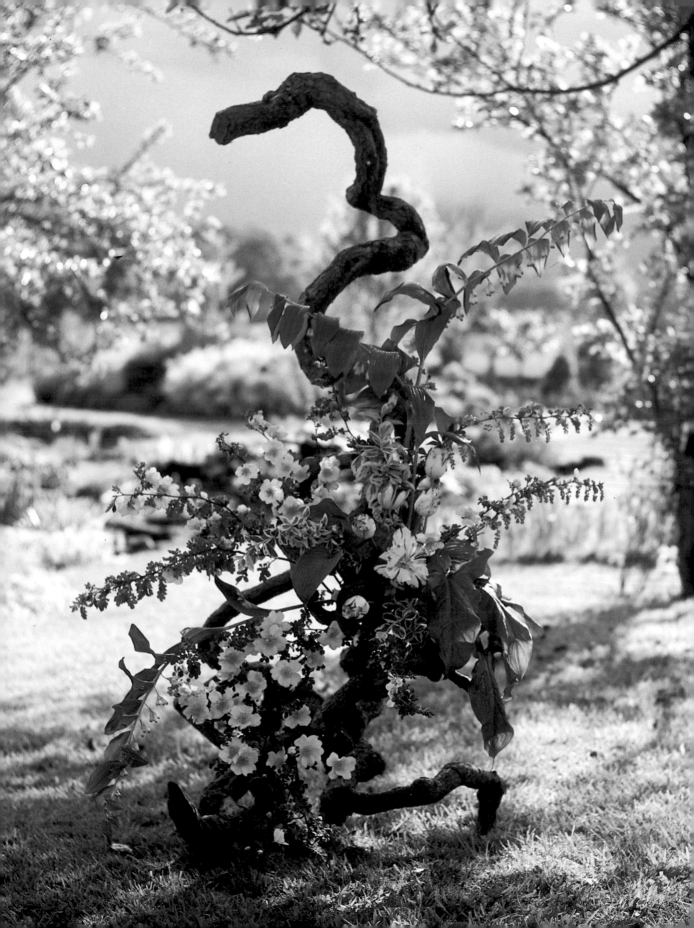

Spring

Although the weather can be unpredictable, this is an exciting time of the year in the garden, when bulbs and early flowering shrubs spring into life. The delicate structure of many early flowers makes them ideal for pressing – *Kerria*, buttercups, daisies and *Forsythia*. Foliage that has just acquired leaves will be immature and may well wilt in water, so be sure to condition it well. Float the heads of hellebores in a low dish of water or wait for the fruits to form in the centre, at which point they will last well, once cut.

Try growing unusual varieties of tulips and daffodils in your garden to complement the more common varieties available at the florist. Remove the leaves of lilac (*Syringa*) and guelder rose (*Viburnum opulus*) which greedily drink water, and prevent it from reaching the flowering heads. Queen Anne's lace (*Ammi majus*), or cow parsley (*Anthriscus sylvestris*) grows rampantly by the river, on verges and along hedgerows. Once mature it will last well and is ideal for large arrangements when the budget is tight.

Cheerful spring flowers of blue, yellow, white and pink fill the florist's shops and market stalls. With change from a pound, you can have a few bunches of cheerful daffodils to brighten up your home. Do remember to cut the ends of daffodils, and to stand them on their own for 24 hours before mixing them with other plant material, as they emit a toxic substance poisonous to other flowers. Alternatively, add special bulb flower food to the water.

Bulb flowers look lovely massed in glass vases. Tulips are widely available, their stems taking on twists and turns as they mature. They continue to grow once cut, so they are ideally suited for arranging in a vase where they will happily do their own thing! A few iris cut at different heights and placed on a pin holder, with several plain leaves to cover the base, will also give a charming effect.

Hyacinths with glamour

Take a glass cube and place a smaller vase inside. Fill the gap between the two containers with green sisal, pushing it well into the corners. Place hyacinths (you could also use tulips or daffodils) in the inner container. Place a strip of double sided tape around the centre of the outer container. Wrap a length of long lasting leaf (here I have used *Aspidistra*) around the container over the tape. Thread beads onto a length of decorative reel wire, twisting the wire around each bead to keep it in position. Wrap this over the leaf.

> **TIP** Instead of the sisal you could use shells, pasta or even coffee beans to link with the colour of the flowers you wish to use.

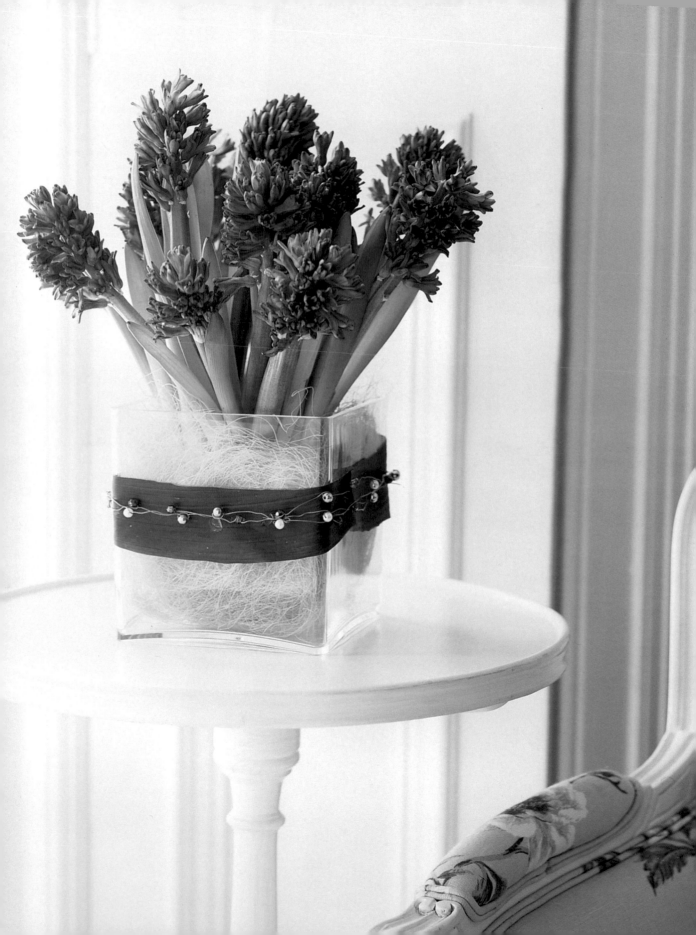

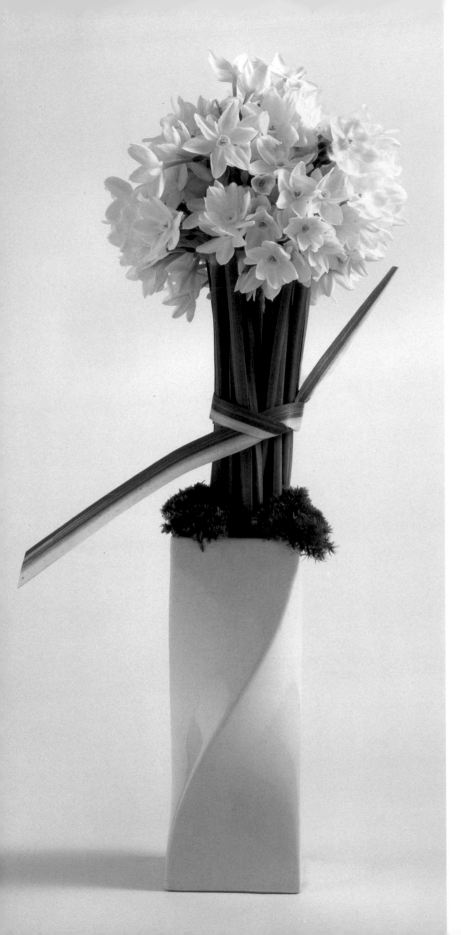

Fragrant narcissi

This is a quick and easy way to display *Narcissus*. Group several bunches in the hand. Take an elastic band up to just below the flower heads and cut the stems level. Impale the stems on a pin holder and wrap a strip of *Phormium* leaf around the stems, inserting the end of the leaf through a slit in the leaf.

TIP *Narcissus* last and last and fill the house with fragrance. *Narcissus* and daffodils are happiest in shallow water and are not happy in foam, but do remember to keep the water topped up.

Pride of the Scillies

This design is a lot easier than it looks. Take 2–3 bunches of double *Narcissus* from the Scilly Isles with reasonably long stems and arrange in the hand to form a cone. Bind with wired paper tie or raffia just under the heads and cut all the stems level. Place in a low dish filled with water and allow the stems to splay out so that they stand on their own.

TIP *Narcissus* come into the flower market in December. Each variety has a different fragrance.

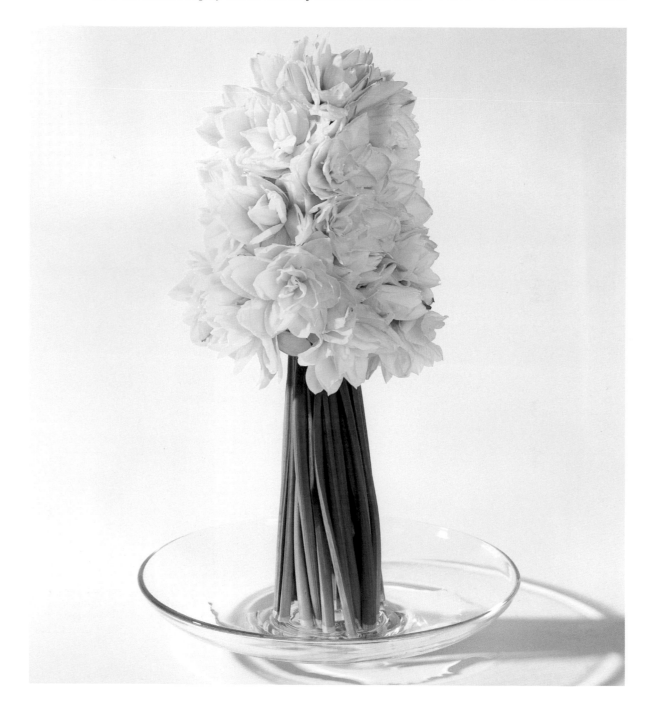

All wrapped up

To make one arrangement place
a length of double sided tape
around a tumbler or plastic
container. Place the container in
the centre of a piece of fabric
and bring the ends up and over
the rim. Cut off any excess fabric
and tie with a length of raffia for
decorative detail and extra
security. Fill with the flower of
your choice.

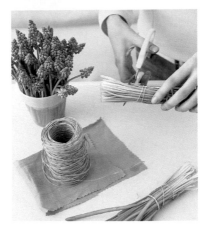

TIP Grape hyacinths (*Muscari*)
are easy to grow and will spread
rapidly. Plant the bulbs in
November. If purchasing from the
florist then check that all the
flowers on the stem are closed.
They will then last for about
five days.

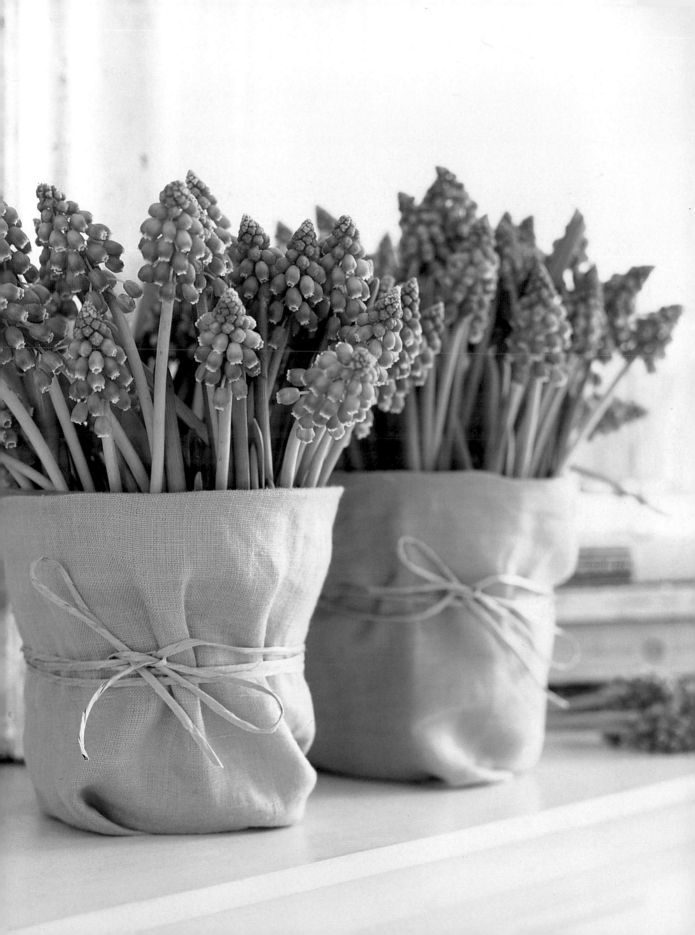

Spring basket

Take an attractive basket and place *Primula* plants in the centre. Place the stem ends of several sprigs of *Helleborus* in tubes and hide under the *Primula* pots. Finally tuck some larch with cones amongst the *Helleborus*.

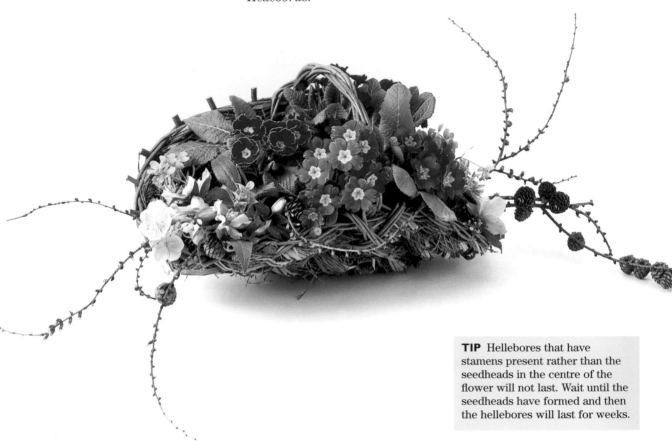

TIP Hellebores that have stamens present rather than the seedheads in the centre of the flower will not last. Wait until the seedheads have formed and then the hellebores will last for weeks.

Floating anemones

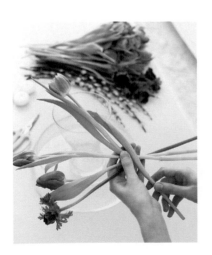

Arrange about 35 stems of tulips and anemones in the hand and place into clean water in a glass vase. Position about 7 stems of pussy willow (*Salix*) amongst the flowers. Add water to a low round bowl and place the vase in the centre. Cut about 5 anemones short just under the frill of leaves and allow them to float in the bowl. Add a few lit floating candles.

TIP Pussy willow will last for weeks and is attractive mixed with most spring flowers. If the buds start low down the stem, cut close above the top bud rather than from the bottom.

A host of golden daffodils

TIP Rows of these along church window ledges at Easter create a glorious sight.

Cut a two litre soft drink or water bottle in two and for safety cover the cut edge with florists tape. Slip a rubber band halfway down the bottom half. Insert thin strips of bark under the rubber band to create a container. Cover the rubber band with raffia or a length of ivy. Fill the container with water and add daffodils.

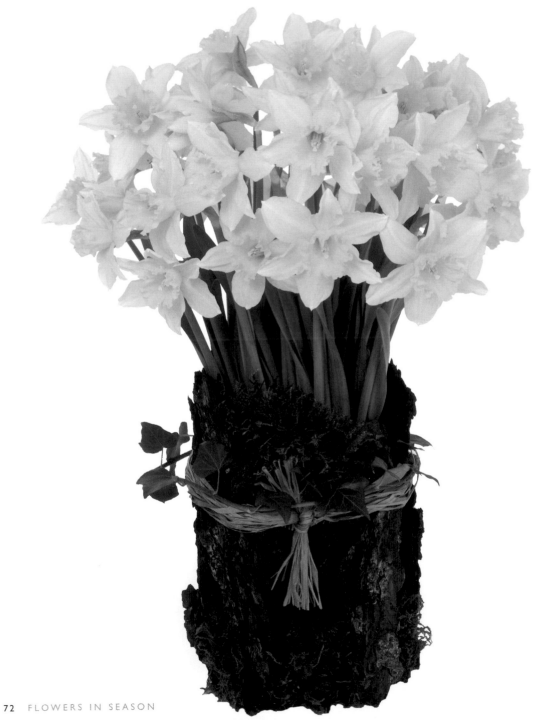

Box of sunshine

Line a box or seed-tray with thick polythene. Take about 12 potted *Narcissus* – this one is 'Tête-à-Tête'. Remove the narcissi from the pots if the top of the pots would otherwise be higher than the sides of the tray. Decorate the top of the soil with bun moss and flat pebbles.

TIP The flowers will take nutrients from the bulbs and if you water the pots before arranging you probably will not need to water them again. When the *Narcissus* die back, plant the bulbs in the garden.

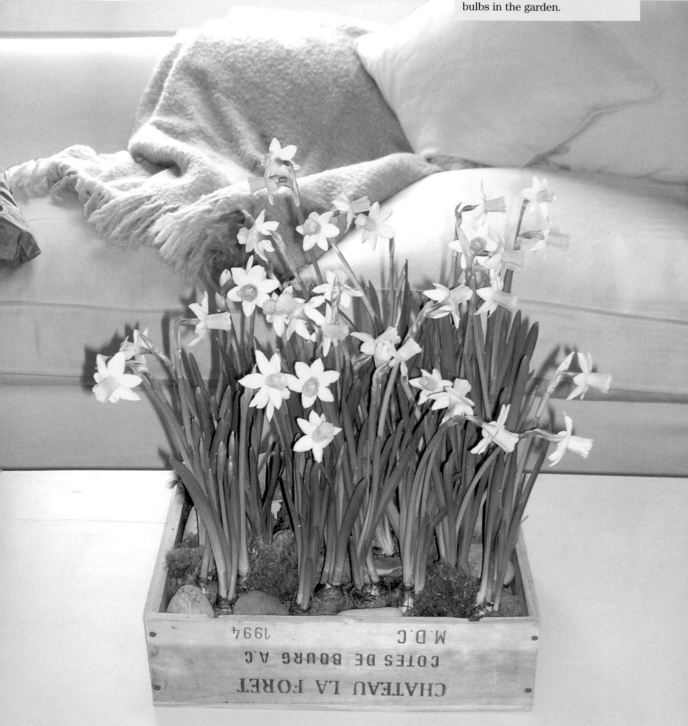

Summer

The long days of early summer are when many gardens are in their prime, with the flowering of numerous perennials. Pick lavender (*Lavendula*) as the flowers open and dry in a warm room away from direct sun. Glycerine (see page 332) deciduous foliage such as beech (*Fagus sylvatica*), which is now mature enough to take up the mixture without wilting as the warmth will enable the mixture to be rapidly absorbed. Glorious garden roses bring colour and fragrance into the home. Lime green *Alchemilla mollis* lightens the flowerbed and gives grace to any design.

The land may be getting parched in late summer, but gardens and hedgerows show their treasures in a rich variety of colours. Scarlet fuchsias, orange firethorn (*Pyracantha*) berries, purple veronica (*Hebe*) and yellow dahlias as well as butterfly bush (*Buddleja*), *Escallonia*, lavender (*Lavendula*) and many other flowering shrubs give a second flush as the days begin to draw in. Annuals continue to provide flowers for cutting. Foliage is still abundant and long lasting when cut. The changing colours give an exciting new dimension to flower arrangements.

There is a wonderful variety of plant material available from the florist at this time of year. Early summer is the moment to buy inexpensive bunches of peonies, larkspur and roses to hang upside-down to dry in a warm place with good air circulation. Take advantage of the colours and forms available to create exuberant arrangements.

Later in the season, chrysanthemums, Michaelmas daisies (*Aster novi-belgii*), dahlias (*Dahlia*) and sword lilies (*Gladioli*) fill the market stalls and the florists with their deep rich colours. Flowers are inexpensive at this time of the year. Add a few fruits and vegetables to give form, colour and texture, but do remember that ripening fruit and vegetables give off ethylene gas to which flowers are vulnerable. Buy statice (*Limonium*) and straw flower (*Xerochrysum*) now and dry them for use in dried floral arrangements in the months to come.

TIP Lavender is one of the easiest plants to grow from cuttings. Cut a non-flowering shoot, remove the leaves and plant in gritty potting compost. At least two of the three should shoot. Plant in a sunny spot. For drying, the varieties 'Hidcote' and 'Munstead' of *L. angustifolia* are excellent with good colour retention.

Lavender and ivy

Position a jam jar inside a more decorative container and fill with lavender from the garden. Cut a trail of plain garden ivy. Wrap the trail around itself and tuck the loose end into the mini wreath you have created. You want the ivy to stay happily suspended around the rim of the container.

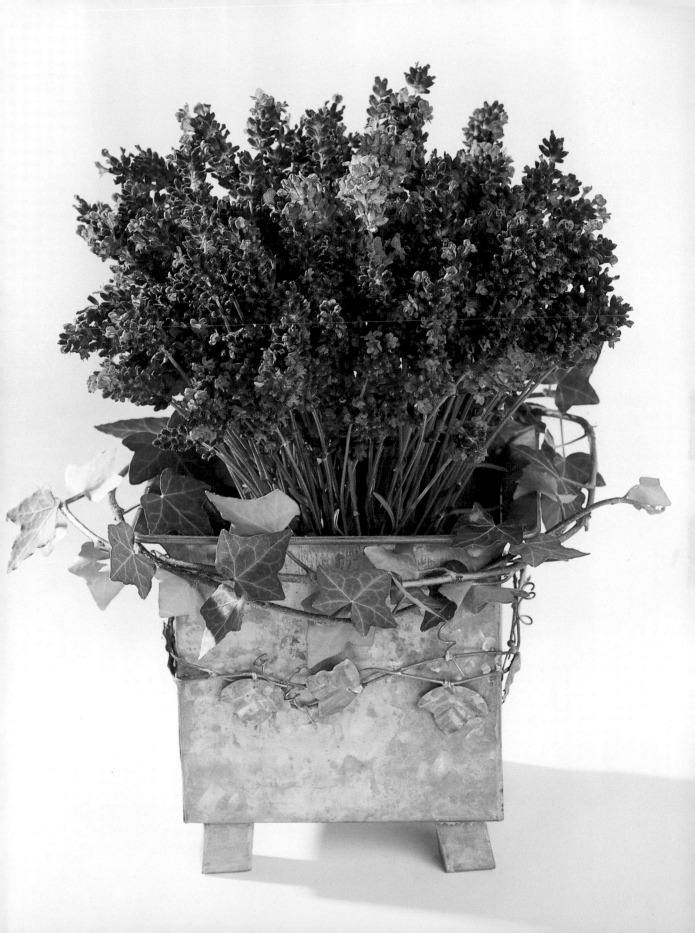

Ice cool

Large chunks of glass surround a church candle. Stems of the velvety 'Vendella' rose, cut short, repeat the cream colour of the candle.

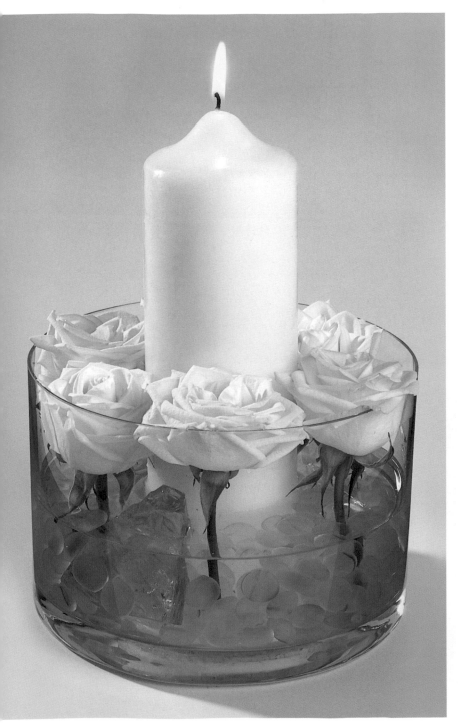

TIP Chunks of glass are not always easy to find but you could always substitute glass nuggets.

Cherry time

Place a wedge of foam in the base of your container to keep your stems of hydrangeas in position. Wire your stems of cherries and place between the hydrangeas and roses.

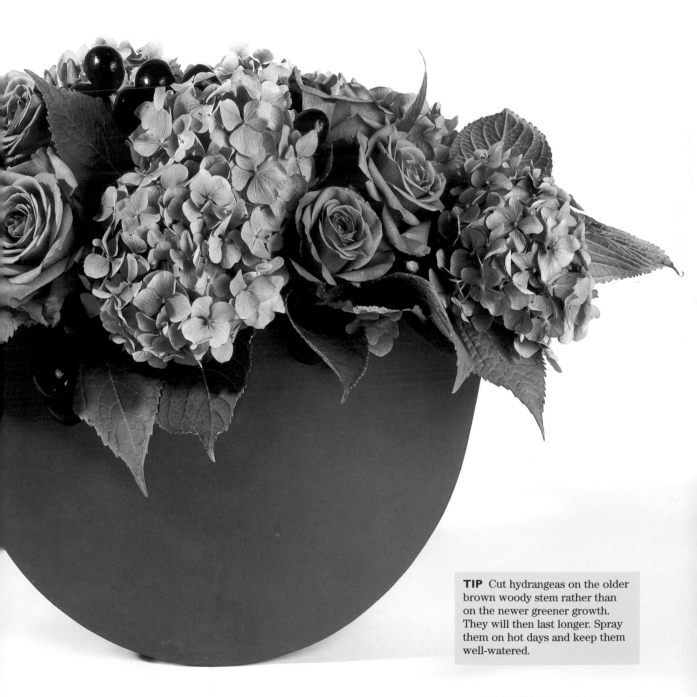

TIP Cut hydrangeas on the older brown woody stem rather than on the newer greener growth. They will then last longer. Spray them on hot days and keep them well-watered.

Watermelon surprise

A watermelon with a difference! Cut out a section from your watermelon and eat. Insert a cocktail stick in the base of some *Hypericum* fruits, crab apples and any other long lasting round summer fruits or berries that you may have available. Create rows of fruits and berries to fill in your section and have this as your outdoor table decoration on hot summer days. You can also do this in the autumn with hips and haws.

TIP This will last several days if you keep it in the fridge when not impressing your friends.

Cool and clear

A cool design for hot summer months. Place a small pinholder centrally in a glass vase of your choice. Gently drop smooth beach pebbles into the bottom of the container. Wrap a single *Aspidistra* leaf, with its stem removed, partially around the bottom of the vase. Take two germini/mini gerbera or *Gerbera* and cut to different heights. Insert the stems on the pinholder. Take 5–7 strands of bear grass (*Xerophyllum tenax*) and bind together with cotton, wool or wire at the two ends. Insert these two ends into the pinholder to create a loop.

TIP Try flexigrass instead of bear grass – unlike bear grass it has a rounded form and not sharp. However, it can sometimes be more difficult to find. If handling bear grass move your hand up the stem. If you take your hand down you may well get a 'paper cut', so take care.

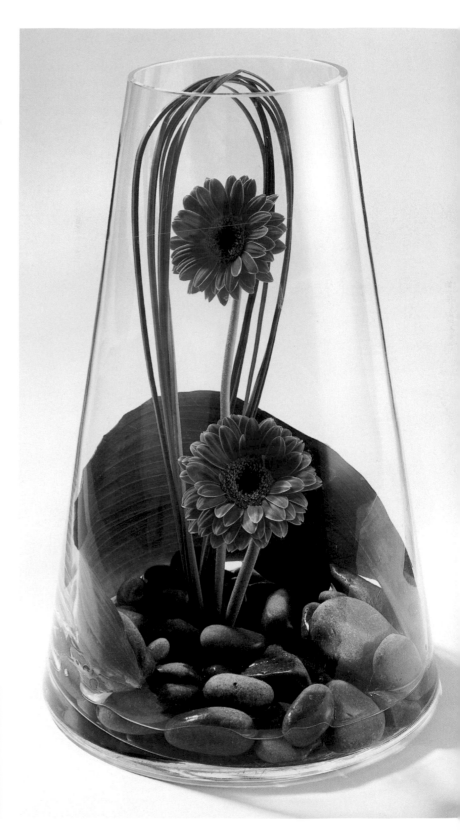

A bed of roses

Although roses are available all year round this is an ideal design for summer with a few short stemmed garden roses. Insert a wedge of foam at the base of your container. Top up with a mixture of beans and/or pulses and place your roses in position. I have added an optional embellishment created with gold bullion wire.

TIP Adding water may make the beans mouldy so place some foil between the foam and the beans. This will also help to retain moisture.

Fresh and fragrant

Fill a glass vase with water. Create a rounded mass of sweet peas in the hand and surround with some *Asparagus* fern. Finish with stems of bear grass threaded with beads.

TIP Sweet peas are easy to grow in a sunny spot in the garden. In order to keep producing flowers the blooms need to be cut regularly.

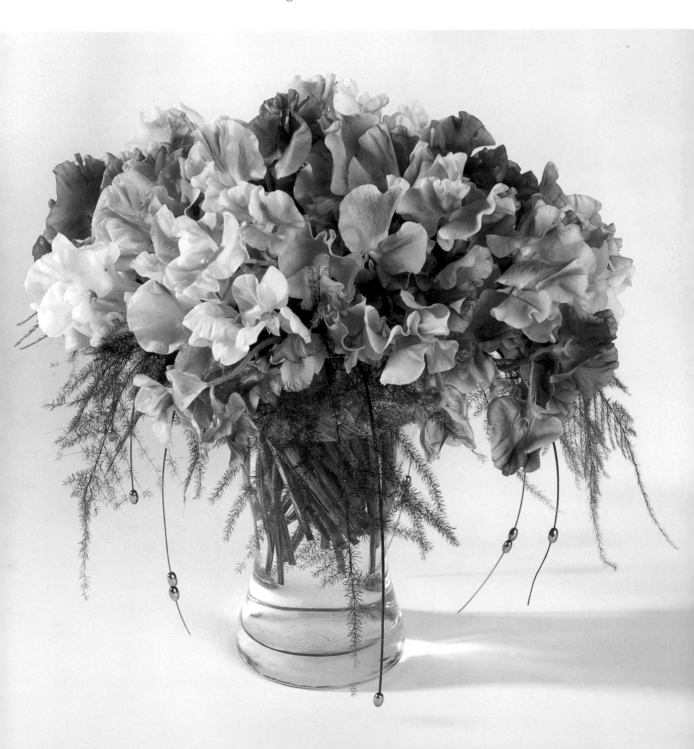

Autumn

In the garden *Choisya*, *Kerria* and *Escallonia* bloom alongside *Fuchsia*, *Dahlia*, Kaffir lily (*Schizostylis*), and geranium (*Pelargonium*). In late autumn *Sedum* and *Hydrangea* need to be picked for drying. Leave them on the plant for as long as possible, but cut before any heavy frost and they will dry easily with good colour retention.

From the hedgerow come privet (*Ligustrum*) berries, hips, hawthorn (*Crataegus*) and *Clematis* seedheads. Apple (*Malus*), pear (*Pyrus*), blackberry (*Rubus*), artichoke (*Cynara*) and green tomato (*Lycopersicon*) all have a wonderful affinity with flowers and foliage.

The florist's shop at this season has a host of magical flowers in vibrant colours – glowing yellow *Solidago*, orange marigolds, vibrant pink, red and gold of chrysanthemums, nerines and dahlias, glorious sprays of × *Solidaster* and *Aster novi-belgii*. A wonderful show of colour can be purchased inexpensively, to give joy and pleasure.

Warm and spicy

Take two vases of similar form but of different size. Place one inside the other and fill the gap between with fragrant cloves. Position a piece of wet foam in the inner container so that it rises above the rim. Create your design with two forms only – *Leucadendron* 'Safari Sunset' and *Rosa* 'Cherry Brandy' allowing little space between the forms.

TIP A herbalist or health food shop is the best place to find large amounts of cloves. Purchase them loose, rather than in small bottles in the supermarkets, to get best value. *Leucadendron* will last and last. Be sure to order *L*. 'Safari Sunset' in order to get the ruby red colour, rather than the green for this particular design.

Pumpkin panache

Place wet floral foam in your chosen container and
position a flat bottomed pumpkin in the centre.
Make sure you do not suffocate your foam with your
pumpkin so that there is insufficient room to insert
your other plant material. Place the plant material
around the pumpkin in groups making sure you
balance your colour and your forms.

TIP You could try this design at
other times of the year substituting
a pineapple for the pumpkin.

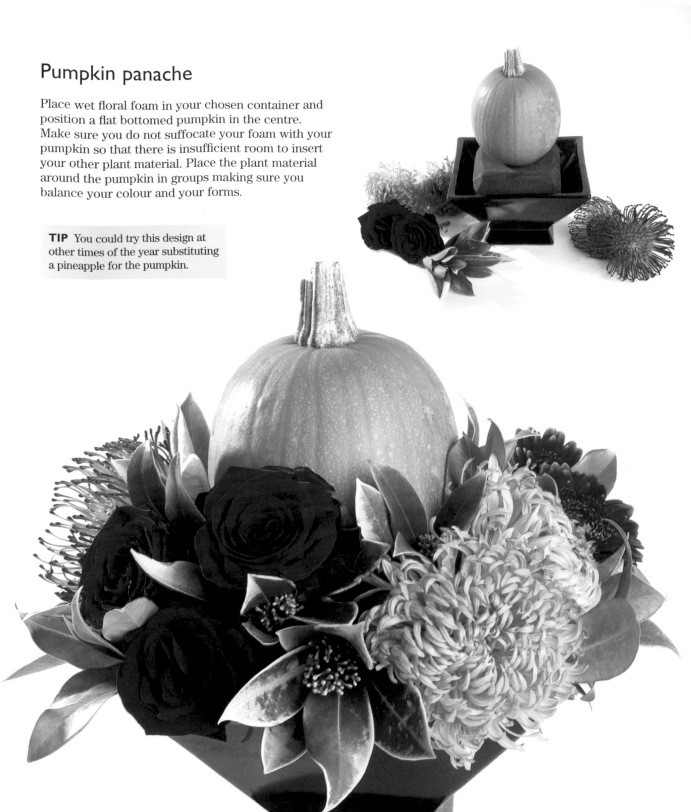

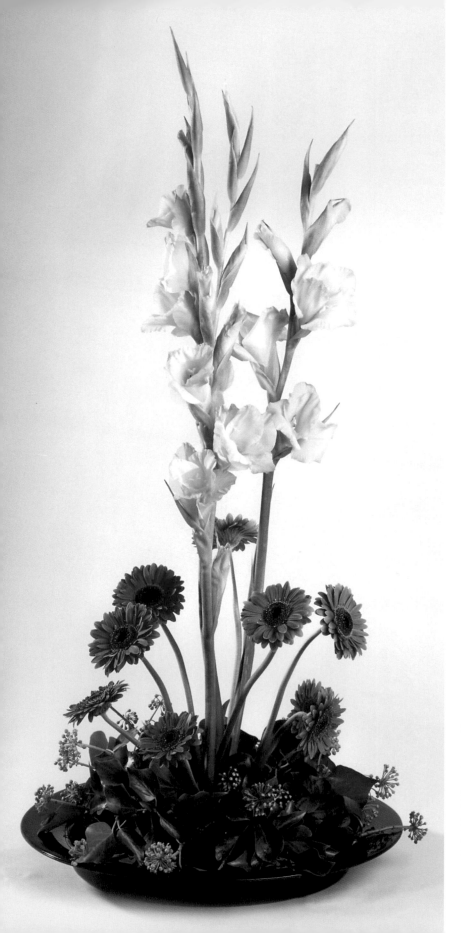

Tall and stately

Place three *Gladiolus* in a square piece of foam, or on a pinholder, in a low bowl. Radiate 7–9 stems of germini out from the centre of the design and add *Hedera helix* fruits to cover the mechanics and give additional interest.

> **TIP** *Hedera helix* 'Arboroscens' develops black fruit in the late autumn which can be used throughout the winter months. The fruits develop when a plant has grown as tall as it can on a given support and produces non-climbing 'adult' branches.

Autumn harvest

Nail together eight equal lengths of birch pole to a hardboard base. Disguise the gaps between the poles with moss. Line the container with plastic binliner and fill the centre with foam. Add flowers, foliage, cones, berries and gourds, grouped to create a pattern of forms, colours and textures.

> **TIP** I chose birch because of the wonderful colour and texture of the bark but any thick tree branch will work.

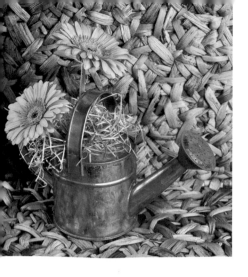

Rustic charm

This quick and simple design would be ideal on the tables at a country wedding. Insert a small water filled glass container into the watering can. Cut two gerberas to varying heights and place in the water. Make a swirl of hay and place over the opening.

TIP There is no need to buy a bale of hay. Just visit your local pet shop and ask for a small bag.

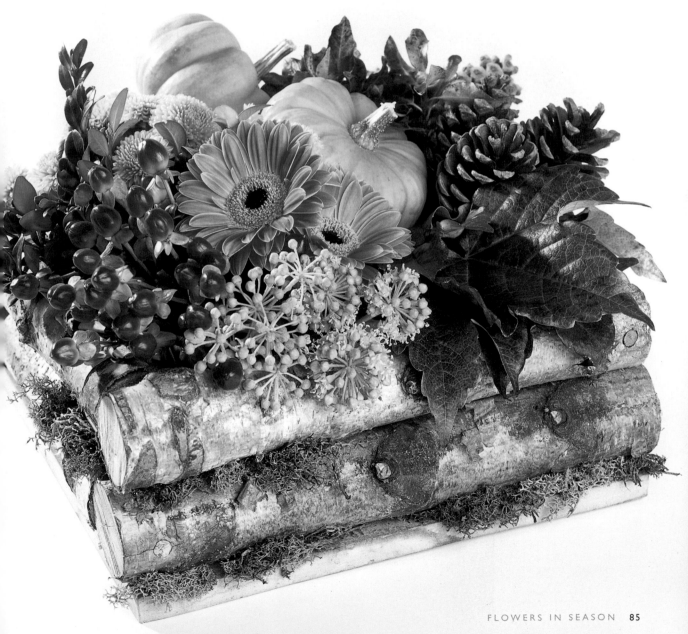

Simple in terracotta

Fill a waterproof terracotta container, or one lined with plastic, with Boston ivy (*Parthenocissus tricuspidata*) leaves. Add *Verbena* from the garden in all its jewel colours.

TIP Try growing *Verbena* in the garden even if you only have a small space. They are easy to grow and provide rich colour through summer to late autumn.

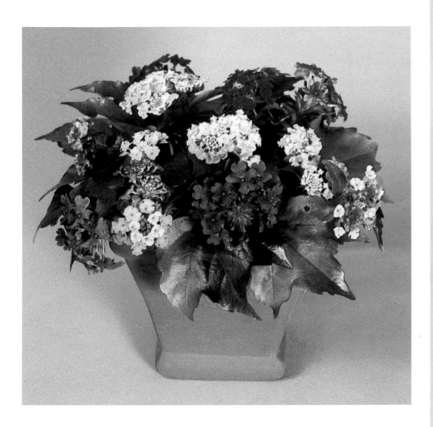

For the table

Cover a wet foam ring with snippets of foliage to cover and add small bunches of black grapes, roses and pink nerines to give vitality. The candle gives a colour link and adds richness to the design.

TIP When soaking a foam ring immerse it in water at a slight angle and wait for the colour to change from light to dark green – this will take about 60 seconds.

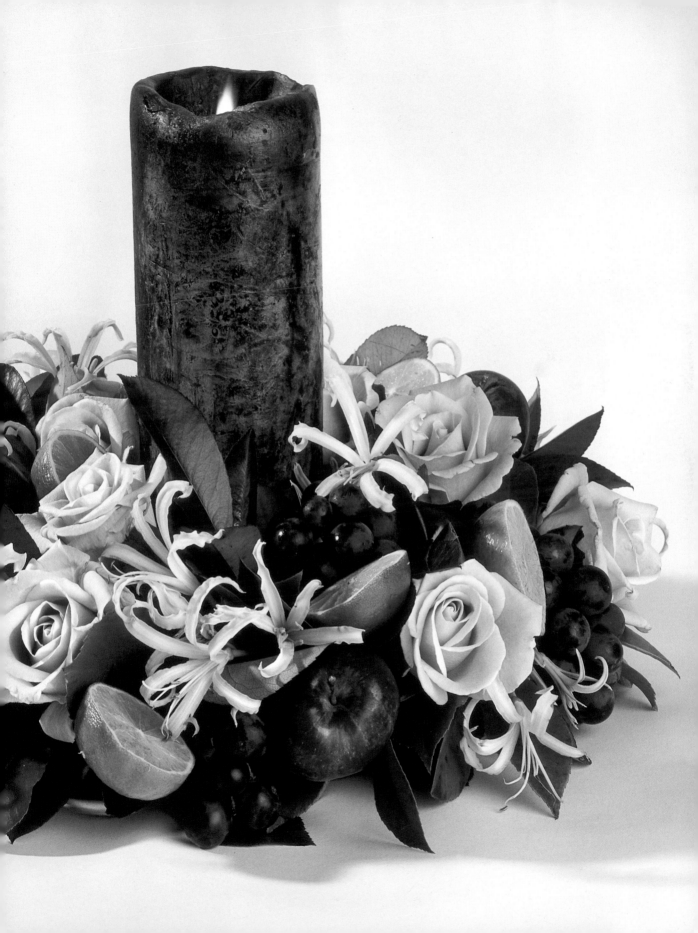

Autumnal wreath

Wire fruits, vegetables, gourds, garlic, cones and seedheads onto a metal frame for autumnal effect.

TIP Do not store dried fruits and vegetables as mice and moths love to eat them during the winter months. Both are extremely difficult to get rid of!

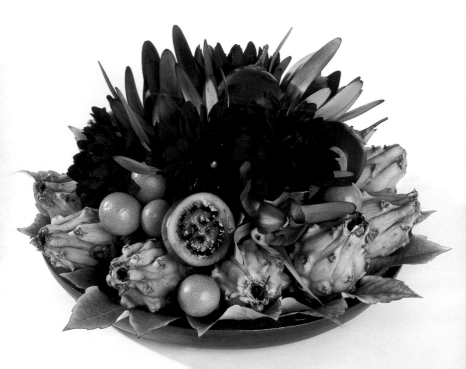

Fruit platter

TIP The ethylene gas given off by ripening fruit does shorten the life of flowers but sometimes the effect is worth it!

Place a piece of foam centrally in a low dish. Edge the rim with colourful leaves. Fill in the area between the foam and the rim with a selection of interesting fruits. Insert the stems of the flowers in the foam.

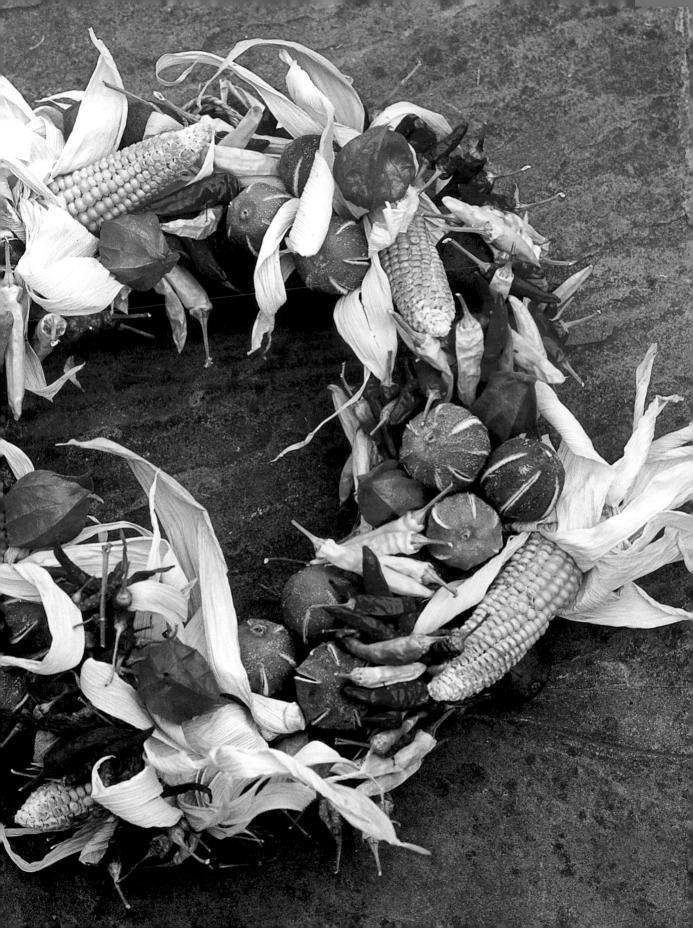

From the hedgerow

Herbs, seedheads and late flowering blooms with sprays of wild blackberries are arranged in water in a ridged tin.

TIP A packet of poppy seeds will produce hundreds of seedheads. Harvest them when they are still green before the insects have a chance to nibble them.

Harvest offering

TIP Dahlias are ideal flowers to grow in the garden for cutting. In milder parts of the country they will flower year after year without lifting.

Easy to give and simple to make. Wrap *Prunus* leaves around a plastic bowl onto double-sided tape, secured with a tie of raffia. Create a tapestry of fruits, foliage and flowers.

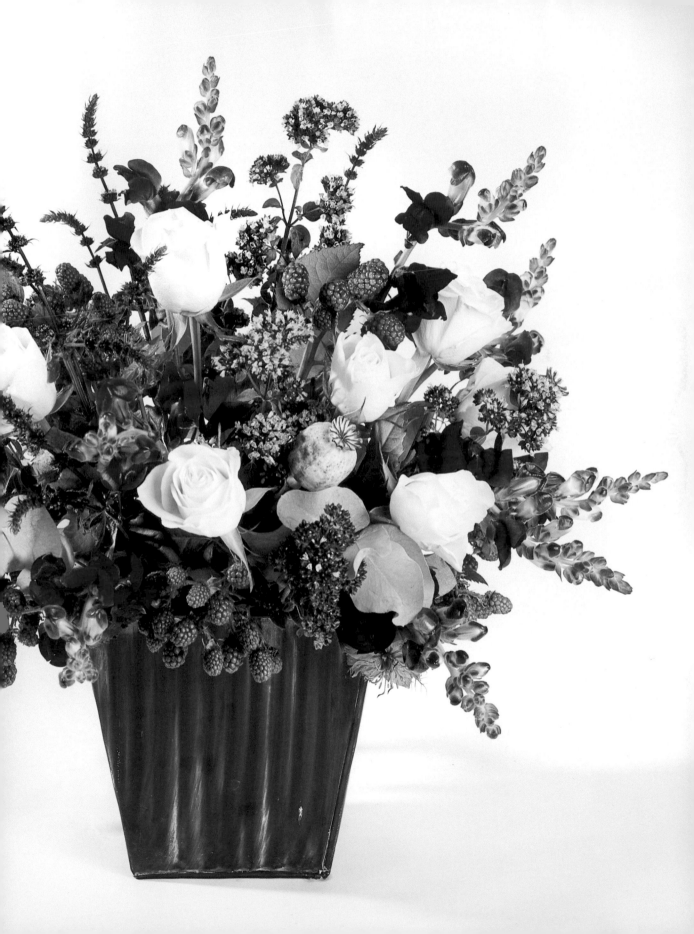

Winter

For December and the festive season much emphasis is placed on evergreens, and in particular on plain and variegated hollies, ivies and conifers. Laurustinus (*Viburnum tinus*) is an invaluable evergreen shrub which carries pretty white/pink flowers throughout the winter months. When ivy leaves the support on which it is climbing it will produce flowers which turn into berries around November. The rich luscious fruits of this ivy are invaluable in winter designs and are available until the early spring.

All the foliage mentioned can of course be used during the winter months, but here you will find those plants that are particularly associated with the depths of winter.

At Christmas time, fir (*Abies*) and spruce (*Picea*) lie at every florist's door. Poinsettia (*Euphorbia pulcherrima*) – the Christmas plant – now comes in a range of colours but beware buying those standing outdoors as poinsettias are susceptible to windy draughts. At the same time daffodil (*Narcissus*), tulip (*Tulipa*) and hyacinth (*Hyacinthus*) make their appearance, heralding spring before the New Year is out.

Circle of gold

Place heated wires through the base of a thick gold candle (see Techniques page 402) and place on the top of a piece of soaked foam that rises above the rim of a tall bowl. Choose a wreath to fit on the rim of the container and place in position.

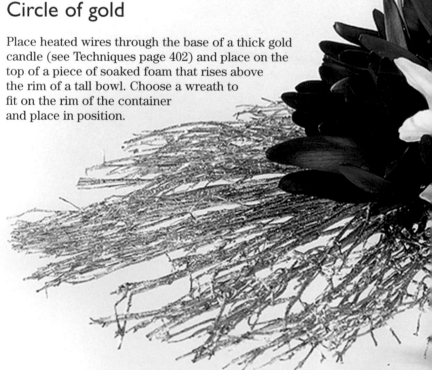

Repeating the movement of the circle group flowers and foliage around the candle.

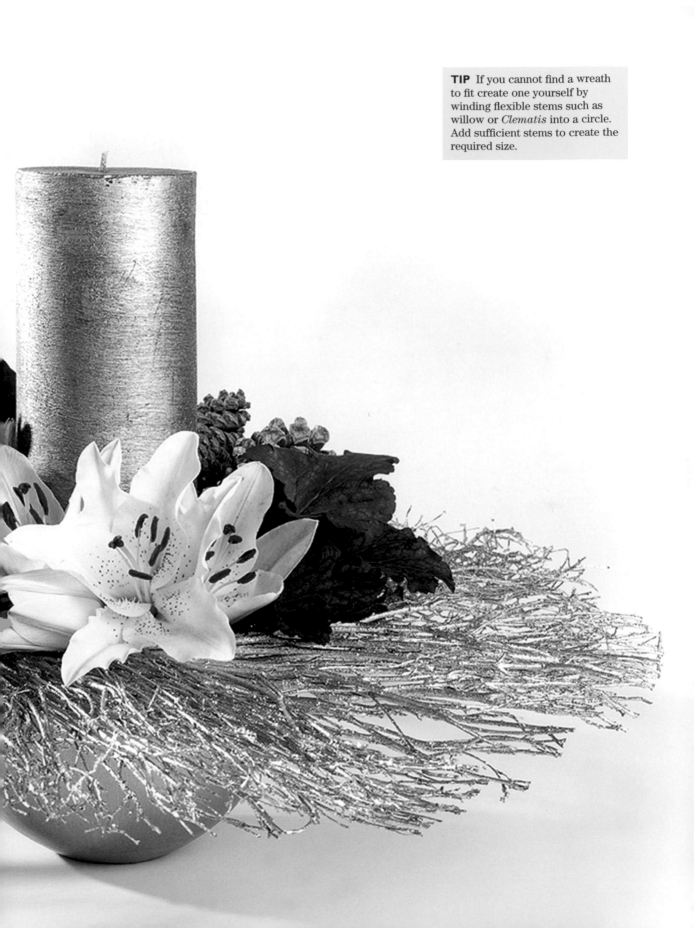

TIP If you cannot find a wreath to fit create one yourself by winding flexible stems such as willow or *Clematis* into a circle. Add sufficient stems to create the required size.

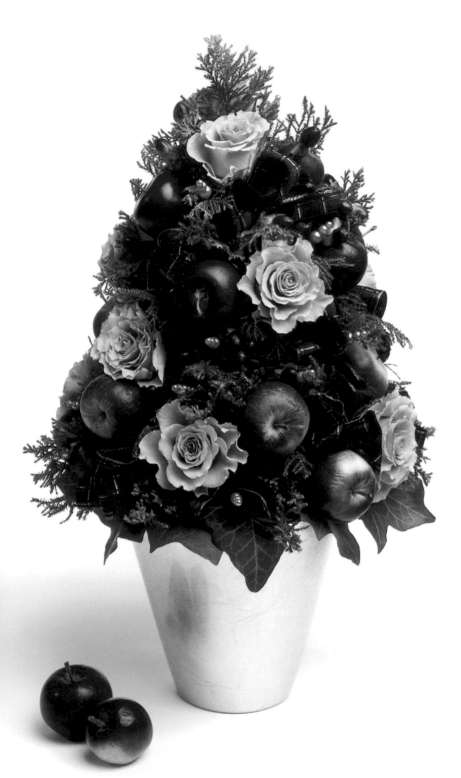

Festive cone

Take a pot with sloping sides and push a block of wet floral foam down into the pot to make stable. Carve the sides of the foam to create a cone. Place a short snippet of conifer out of the top and then other pieces all round the rim angled downwards. Fill the remainder of the cone. Angle the top third upwards and the bottom two thirds gradually downwards.

Wire some apples (see Techniques page 405), make some small ribbon bows and push the wire ends into the foam. Here I have added *Hypericum* berries and decorative green pins with a few ivy leaves at the bottom use what you have available but keep all the elements in scale.

TIP When carving the foam use a long sharp knife and do it gradually, in small slivers, to avoid removing more foam that you want. It is hard to put back!

White Christmas

Place foam in a silver bowl so that it rises above the rim. Wire together some white feathers so they create a garland. Join the ends of the garland together to form a circle. Place this over the rim. Mass pure white roses together and place poppy seed heads in between to fill the spaces and make the roses go further. To decorate the seed heads take a length of decorative reel wire and thread it through a bead. Wrap the wire around the seed head making sure that the bead stays in the centre. Continue wrapping the wire around to secure. Finally cut some plain holly *(Ilex)* and tuck in the area between the roses and the rim.

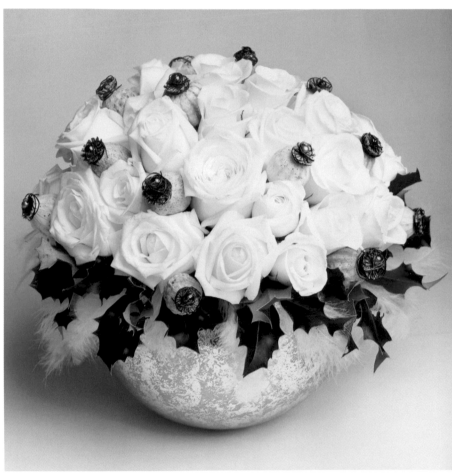

TIP Holly leaves can give a vicious prick so take care when handling. The plain dark green colour gives wonderful contrast to the pristine whiteness of the roses. Variegated holly would not be nearly as effective.

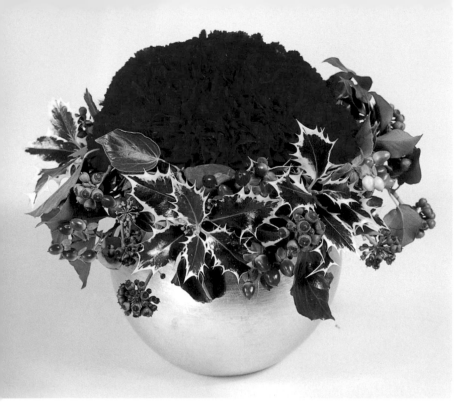

The holly and the ivy

Place a soaked piece of foam so that it rises well above the rim. With a sharp knife create a smooth round top to the foam. Place short stems of berried ivy round the foam in the area close to the rim. Pack carnations into the top of the foam to create a mass. Add red *Hypericum* berries and as a final touch a few sprigs of variegated holly.

TIP If your carnations are tight squeeze the calyx gently and rotate the blooms. You can also try blowing on them but this is not as effective.

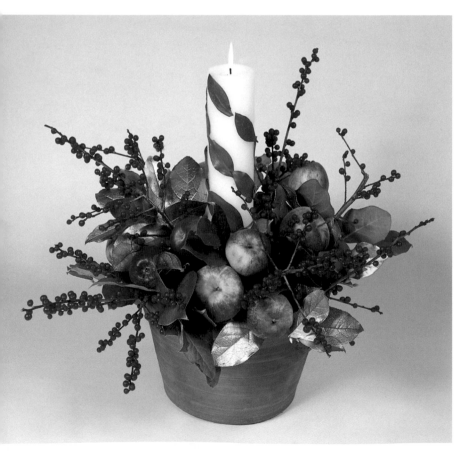

Winter fruits

Adhere small tough leaves such as box (*Buxus sempervirens*) to a candle with adhesive spray, or glue dots, to create a decorative pattern and insert into foam. Arrange deciduous holly, rosy apples (on kebab sticks) and *Gaultheria* or other foliage sprayed lightly with a touch of gold.

TIP Deciduous holly provides a visual feast of bright red berries. To help them stay longer on the stem use hairspray to fix.

Carnation cake

Insert a piece of soaked foam centrally in a low, round glass vase.
Ensure there is sufficient space to wrap an *Aspidistra*, or another long
lasting leaf, between the foam and the container. Add a mass of green
carnations (*Dianthus*) and tuck sprays of fresh or artificial berries in
between. Complete by adding a ribbon around the centre of the vase.
This can be prevented from slipping by tucking a small piece of OASIS®
fix under the ribbon in several places.

TIP Long lasting *Skimmia*
berries would be ideal in this
design or even a few late crab
apples (*Malus*).

The rose bowl

Wrap a small length about 2.5 cm (1 in) of builders' lead around the stem ends of three roses and place in a goldfish bowl. Pour water into the bowl. Wrap a trail of ivy around the inside of the bowl. *NB. Do not handle lead in excess as it is poisonous.*

Place a smaller glass bowl in the opening of the goldfish bowl. Position one or three chunky candles in the centre of the bowl and decorate with ivy and a few berries – these can be fresh or artificial.

You could stop the design after step 1 and still have an attractive decoration for the Christmas table.

TIP If condensation occurs within the bowl remove the upper bowl and allow to breathe for a couple of minutes.

Silver and white

Blue spruce is the foliage base for this design with added interest given with the roses, cones, poppy seedheads and a bunch of black grapes.

TIP Thick candles last and last and reduce the need for large amounts of plant material. Blue spruce covers the foam quickly and economically and gives a great festive feel.

TIP To water this design remove the candle and any dried or artificial material and allow to sink under water for 10 seconds. Dry the base before replacing on the table.

Romantic glow

A rich tapestry of grouped flowers, fruits and foliage covers a 25cm (10in) foam ring. The central candle repeats the depth of colour and provides soft light.

Chilli Christmas

Fill a round container with foam and create a strong structure with conifer. Insert kebab sticks through the base of the chillis and add to the arrangement together with cinnamon sticks bound with raffia, orange slices, *Skimmia* berries and poppy seedheads.

TIP Before you add your flowers, fruits and spices ensure that the foam is well-covered with conifer to a point that you will be able to see the foam but it will not be obvious.

All through the year

Although some deciduous trees and shrubs, such as dogwood (*Cornus*), silver birch (*Betula pendula*) and alder (*Alnus*), are valuable to flower arrangers for their colourful stems, barks or cones, it is evergreens that provide material all year round. Modern glasshouses, packaging technology and improved communications with all parts of the world mean that many flowers can be supplied to the florist all year round. The flowers and foliage seen here are available at florists without enormous fluctuations in price or quality.

Chilli con carnation

TIP Cut the carnations just above the node, not on or below, as this part of the stem takes up water more easily. Take care not to rub the eyes after you have touched the chilli peppers as they will burn.

Take a medium-sized container. Check that it is watertight and fill with foam to just above the rim. Take a long ivy trail and wrap it round upon itself. Place over the rim. To prevent it slipping down the container wind a short wire round the trail in three separate places and push the wire ends into the foam to secure. Cut the carnations short and make a rounded mass of colour form and texture. Thread some chilli peppers onto some decorative metal reelwire and drape over the carnations.

Tower of flowers

Fill a glass tank with sisal. Strap one or two pieces of foam a little wider than the opening onto the top of the tank. Cover the foam with single or double spray chrysanthemums so there is no space between the flowers. Take loops of steelgrass or flexigrass and insert the ends of each stem in the foam, create loops and tuck the second end into the foam.

TIP This design can be created on any size of a square or rectangular tank or tall straight-sided glass container. Co-ordinate the colour of the sisal to the colour of your chrysanthemums. Chrysanthemums are ideal because they will last and last.

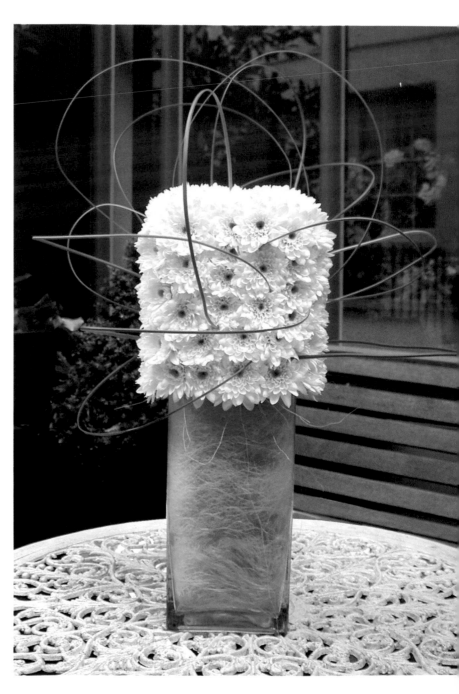

Nest of roses

Spray two bunches of coral fern (*Gleichenia polypodioides*) gold and place in the centre of a round container. Add roses to the centre so that the heads are level with the foam.

TIP Use spray paint in the colour of your choice on fresh coral fern. It will dry in situ and last for years.

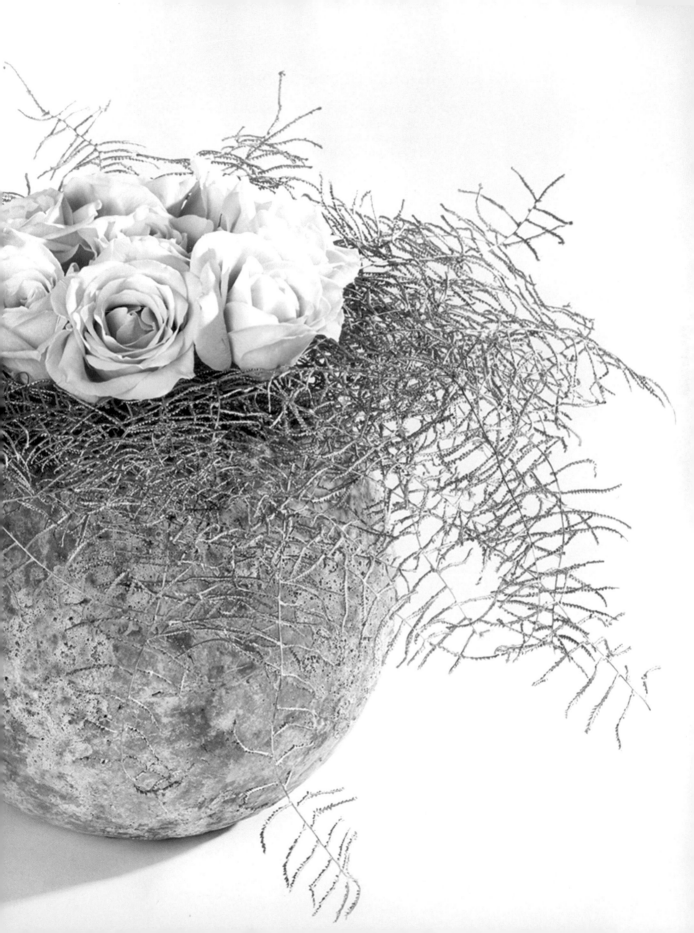

Gypsophila and orchids

Place a little water in the base of a low bowl and fill two thirds with short snippets of *Gypsophila*. Take several strands of bear grass. Remove the soft tips at an angle and thread each strand with a couple of *Cymbidium* orchid heads and loop through the design.

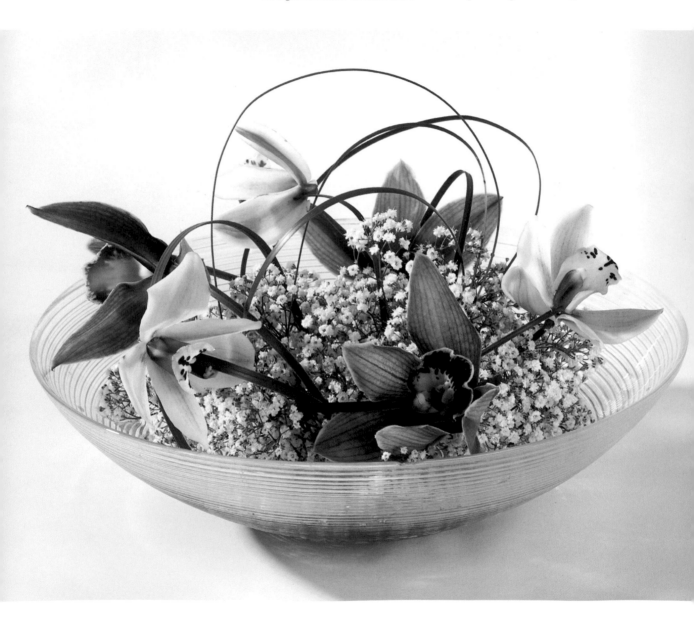

TIP *Cymbidium* heads will last for several days without moisture, but to keep them fresh for longer, spray them with water.

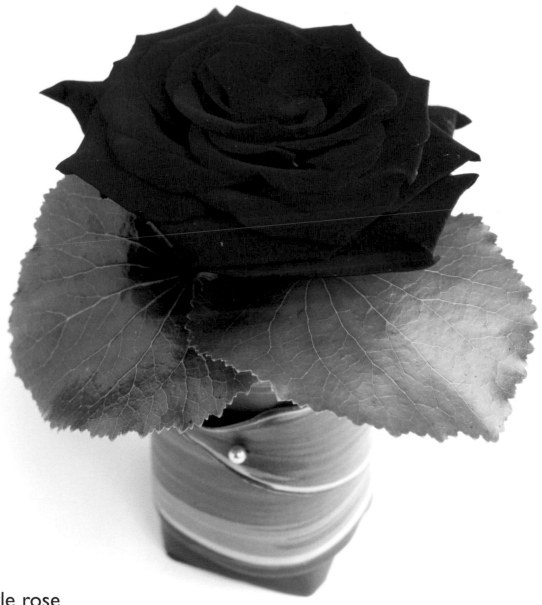

Single rose

You will need a small piece of soaked foam, one long lasting leaf such as a *Cordyline*, *Aspidistra* or *Phormium*, a small square of black plastic (from a binliner), a couple of German pins or a stub wire bent into hairpins, a pin with a decorative head and three round leaves such as *Galax* or ivy.

Place the black plastic over the base of the foam and secure with pins. This is to make your 'container' waterproof so make your pin-holes up the side and not on the base. Cut the stem and rigid part of the *Aspidistra* leaf away and wrap the remainder around the foam. Secure with a pin. The leaf should be flush with the top of the foam so cut any excess away. Cut the *Galax* or ivy leaves short and angle them out of the centre of the foam. Add your single flower. It could be a rose, germini/mini gerbera, marigold – in fact any flower with a strong round form.

TIP The roses will look lovely in a line along a windowsill or long table. They can also create a circle with nightlights in-between. Why not write each guest's name in gold pen on a *Galax* leaf?

4

Celebrations and festivals

Homes are decorated with flowers for many weeks of the year, but there are occasions when flowers have a special significance, symbolism or are displayed to add traditional festivity. Flowers have always been an important part of many festivals throughout the world. We associate spring festivals with the gathering of blossoming boughs and the wearing of garlands, wreaths and circlets. Scattering flowers at the feet of heroes and nobility has long been an established custom. Flowers are an essential part of many Hindu and Buddhist festivals. In this chapter some of our most well known special days or events are described with ideas about how to celebrate them florally.

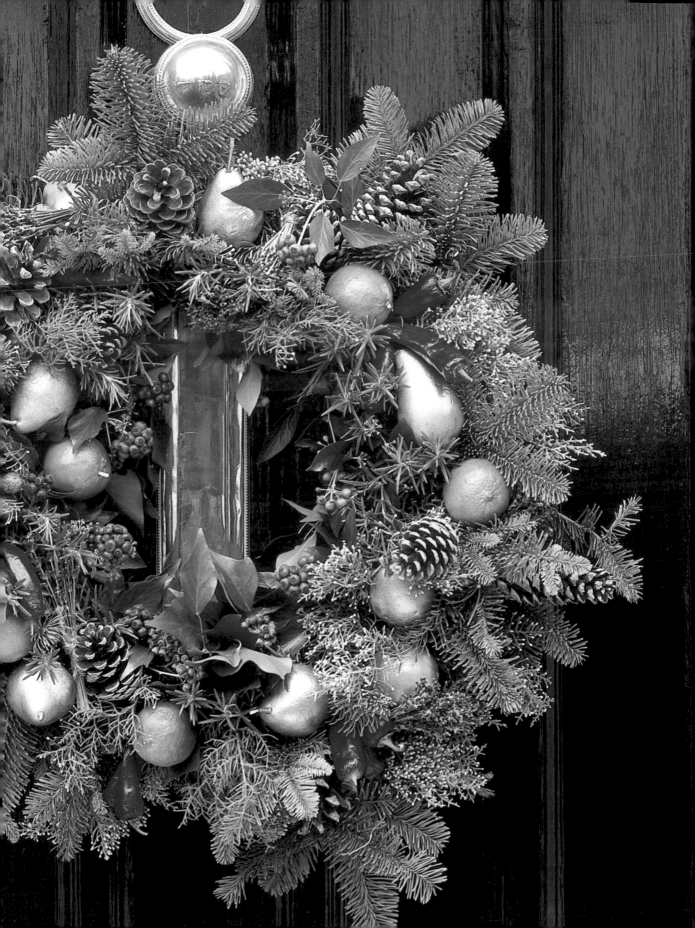

Candlemas

Candlemas is the day when snowdrops (*Galanthus*) are supposed to push their way up through the ground. Their association with this day is also due to the purity of their colour and form.

February 2nd is Candlemas in many churches and it is the day when candles are lit to remember the purification of the Virgin Mary. This day also used to have great significance in the rural calendar, because the date lies half way between the winter solstice and the spring equinox.

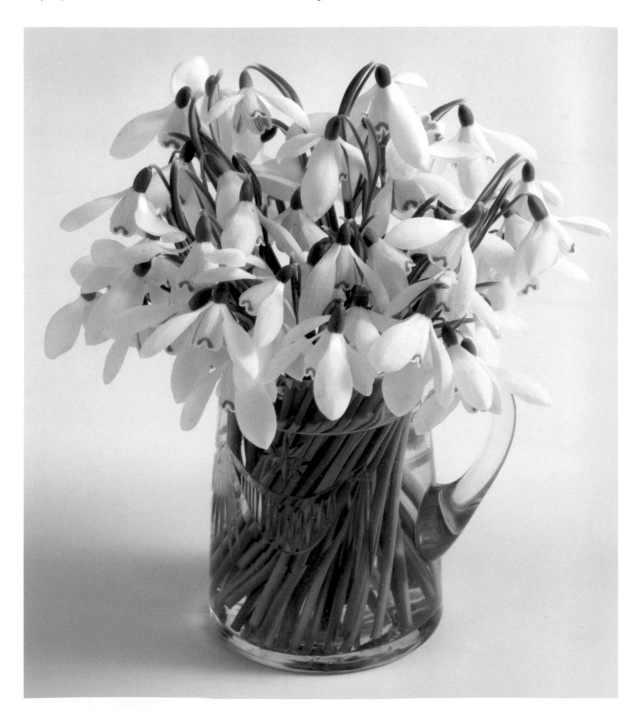

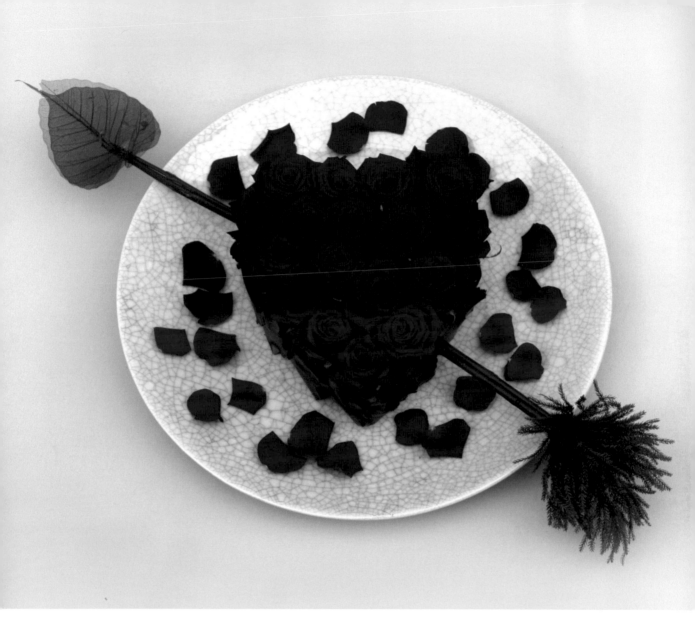

St. Valentine's Day

St. Valentine's Day is steeped in history and folklore. Many believe St. Valentine to have been a Christian priest who was stoned to death on February 14th in the early days of Christianity. Claudius II had decreed marriage illegal for his soldiers, as it sapped their fighting strength, but Valentine performed marriage services clandestinely for the sake of true love. Another legend relates that on the night before he was martyred he restored the sight of the jailor's blind daughter and left her a farewell message "From your Valentine".

It was the Victorians who started the fashion for sending cards on this date. The Penny Post was introduced in 1840 and the decades following became the golden era of the Valentine card. Such cards were not always well-meaning, but today the custom has survived with the best possible sentiments.

Straight to the heart. This easy arrangement uses a block of floral foam carved into a heart shape. The foam is surrounded with *Galax* and covered with 'Grand Prix' roses. An arrow of *Cornus* stems, tipped with skeletonized leaves, completes the picture.

Valentine's Day is one of the high points of the florists' calendar, since flowers are accepted as being a token of affection and love. Red roses were at one time considered the only flower to represent this occasion but now a much wider selection of flowers is given. Red tulips are becoming a more popular gift, as are all other red flowers available at this time of year.

Flowers are more expensive during the run-up to Valentine's Day due to the increase in demand. When purchasing take care that flowers have not been held back too long in cold storage in order to keep them in bud. Such flowers will go over extremely quickly. Look for crisp green foliage and full flower buds.

left
An inspirational design by Stein Are Hansen for Valentine's Day. Redcurrants are bound into a heart shape with orchids providing the accent.

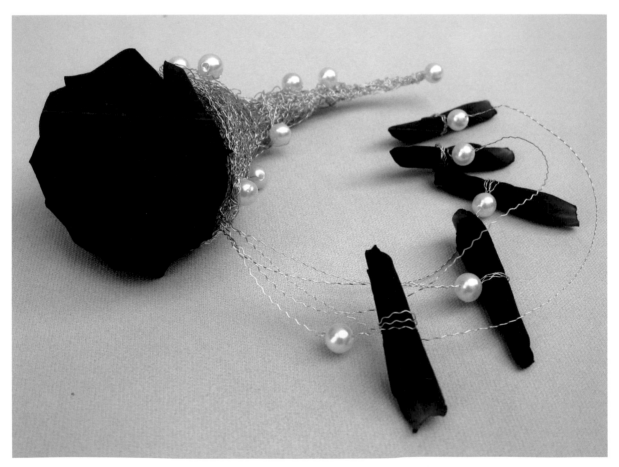

above
A 'Grand Prix' rose in a cornucopia of moulded bouillon wire with petal extensions – ideal as a rather special buttonhole

right
A golden heart-shaped vase bearing red tulips and *Gloriosa superba* 'Rothschildiana' in a woody structure embellished with decorative wire.

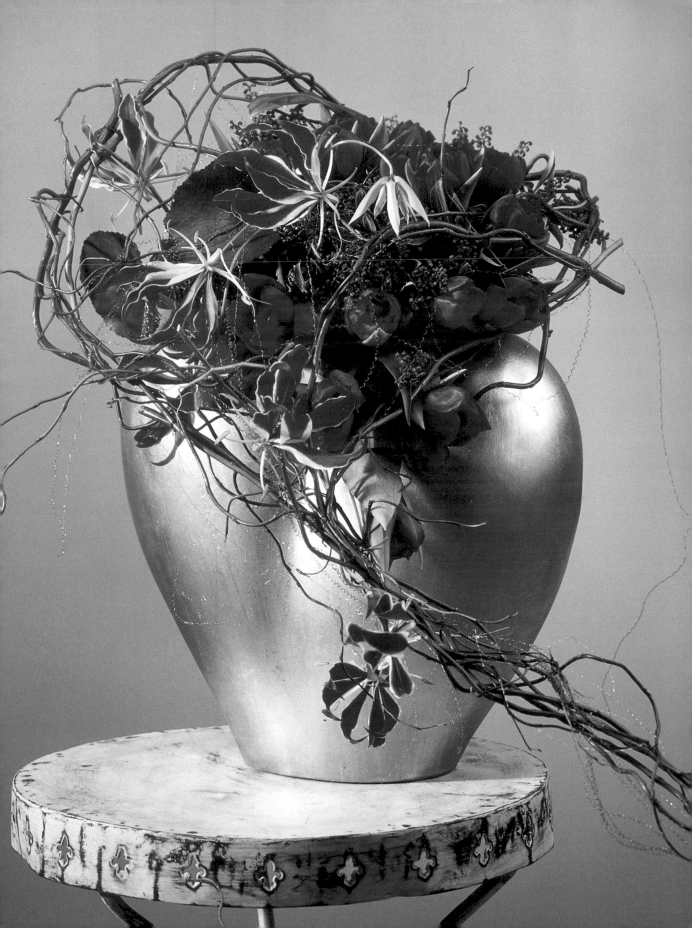

Mother's Day

The idea of honouring motherhood is a long-established custom. In ancient times the Greeks used to have a special three-day festival to honour Cybele, the mother of the Gods.

Traditionally in England servants were allowed one day's leave a year to visit their homes and the church of their birth. This became an established event, which took place on the fourth Sunday in Lent. On their way home the serving girls would gather flowers and leaves from the hedgerows to give to their mothers, and it is from these times that the tradition of giving flowers on Mothering Sunday has arisen.

In America, Anna Jarvis, after the death of her mother, wanted recognition for all mothers. She was able to convince the Government of the need for a special day, which was set up as the second Sunday in May. President Wilson urged all Americans to "display the flag in their homes on this day as a public expression of our love and reverence for the mothers of our country". To express this love Anna Jarvis chose the carnation as the flower to represent the day. White carnations are traditionally sent to the mother whose own mother is no longer living, and pink or red carnations are sent to a lady whose mother is still alive.

A child would find this bowl of concentrically placed petals in a low bowl easy and fun to make. You only need to make sure that the petals you use have a symmetrical shape.

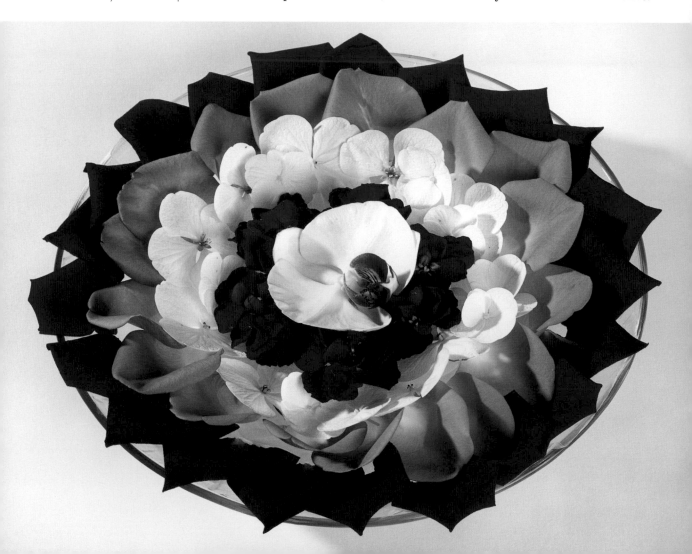

Flowers that are easily transported are ideal on this occasion. Baskets of flowers, tied bunches, flowers presented in cellophane, a few daffodils from the garden bunched with a few stems of *Skimmia* or conifer and tied with a yellow ribbon, are all a delightful present from a child.

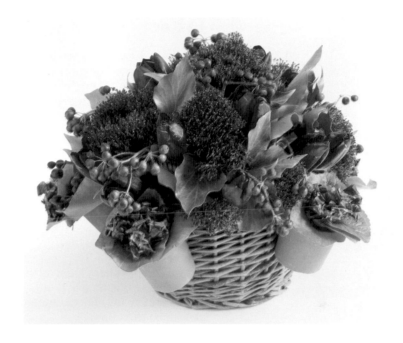

right
Five mini terracotta pots filled with violets are wired to a basket filled with berried ivy, tulips and *Trachelium*.

below
A handtied bouquet is always a popular choice for Mother's Day.

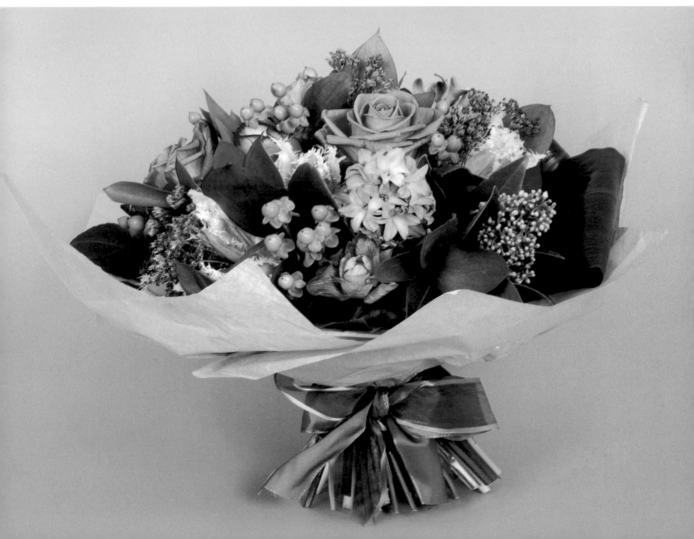

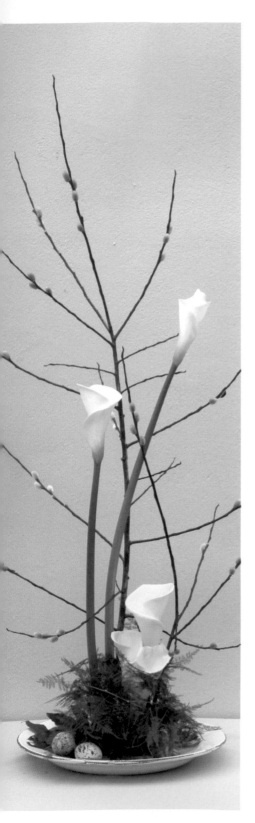

Easter

Easter is the oldest Christian observance after Sunday. Easter Sunday is a movable feast, which usually falls between the middle of March and the middle of April.

The word Easter is a derivative of Eostre – the Anglo-Saxon spring goddess – and is thus derived from pagan rituals. Some 3,500 years ago Egyptians made hot-cross buns, but then the cross represented the four phases of the moon. The Chinese started the custom of presenting eggs as a rite of spring and our tradition of giving chocolate eggs developed from this.

In the Christian faith, Easter is the single most important festival. On Good Friday, Christians remember the Crucifixion and, on the following Sunday, Christ's Resurrection from the dead. Flowers form an important part of Easter celebrations. In most churches flowers are reintroduced into the church after 40 days of absence during Lent. Lilies (*Lilium*) are much in evidence, for their symbolic association with this festival.

The return of spring brings hope and joy to many at this time, at the moment of nature's rebirth. Daffodils (*Narcissus*), tulips and other spring flowers are inexpensive at this time of year and a large bunch in a glass vase needs no other embellishment.

left
White callas and pussy willow (*Salix caprea*) on a pinholder in a low bowl.

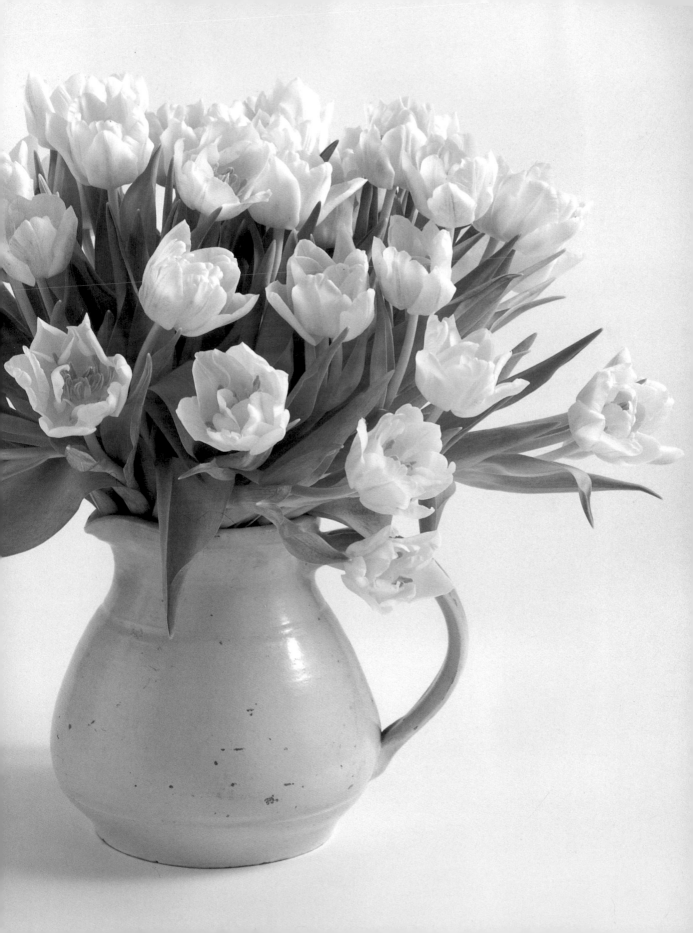

May Day

According to Celtic custom, May 1st was the first day of summer and a day of great festivity. Traditionally long sprays of hawthorn (*Crataegus monogyna*) were gathered from the woods and used by the young people to decorate the church and village. Queen Anne's lace (*Ammi majus*) or cow parsley (*Anthriscus sylvestris*), ox-eye daisies (*Leucanthemum vulgare*) and greenery were also used for decoration and for crowning the May Queen. In Elizabethan times the village youth danced round a maypole that was "covered all over with flowers and herbs".

At the turn of the century girls would decorate their dolls with wild flowers. They would then go 'May dolling' around the village, carrying their doll covered with a cloth. They would knock at doors and ask whether occupants would like to see the May doll, in return for which the children would receive sweets or a farthing.

Mayday was widely celebrated throughout Britain until recent years. Garlands were made in country schools and carried in procession to the church. Such celebrations still continue in places such as Padstow, in Cornwall; Castleton, Derbyshire and West Torrington, Devonshire. Flowers of all kinds were collected from the fields and tied in small bunches onto long sticks. Girls' hats were festooned with flowers, and they carried posies that often included trumpet lilies.

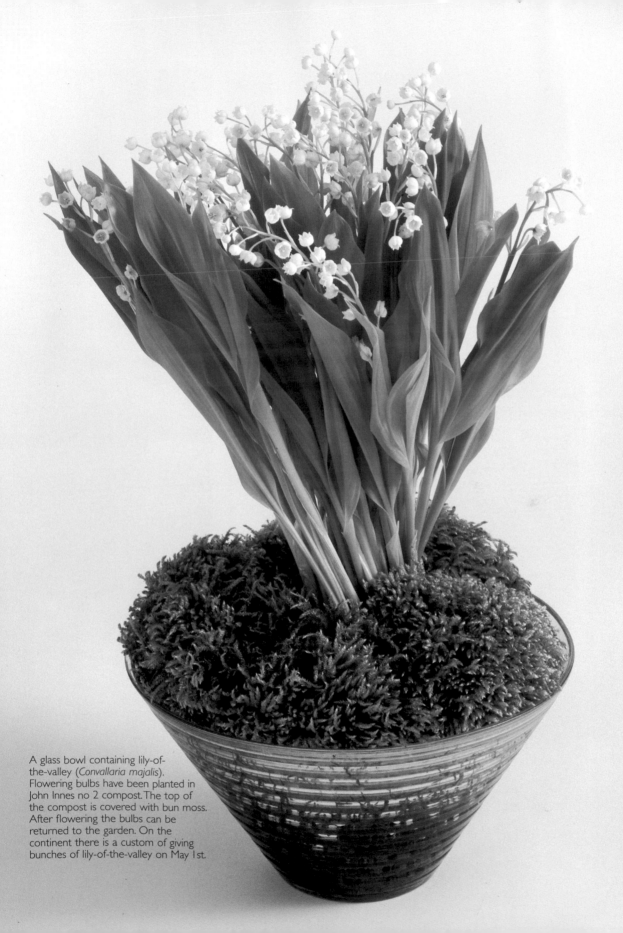

A glass bowl containing lily-of-
the-valley (*Convallaria majalis*).
Flowering bulbs have been planted in
John Innes no 2 compost. The top of
the compost is covered with bun moss.
After flowering the bulbs can be
returned to the garden. On the
continent there is a custom of giving
bunches of lily-of-the-valley on May 1st.

Fourth of July Celebration

Hot dogs grilling at backyard barbecues; parades marching down Main Street; bands playing the 'Stars and Stripes Forever'; fireworks branding the night with streaming stars of red, white and blue. These traditions make the Fourth of July one of America's favourite holidays. Families, friends and neighbours gather to celebrate the day that American declared its independence in 1776.

Picnics in backyards, at parks and on beaches call for informal settings. Tables feature red, white and blue dishes, napkins and tablecloths. Flags fly from homes and towns wrap buildings with red, white and blue bunting and colourful rosettes are worn.

Traditional foods also continue the theme of red, white and blue. Watermelon, strawberries, blueberries and homemade ice cream are favourites. A new tradition is the flag cake covered in whipped cream and decorated with strawberry stripes and blueberry stars.

Flower arrangements continue the theme of red, white and blue with seasonal flowers such as hydrangeas, zinnias, delphiniums, poppies, gerberas, carnations, roses, Queen Anne's lace and snapdragons. Most Fourth of July floral arrangements are casual designs made to adorn picnic tables and porches. Door wreaths are also popular.

A basket of summer flowers by Ann Cotton on the cool piazza of Harold and Jean Wade's Charleston town house.

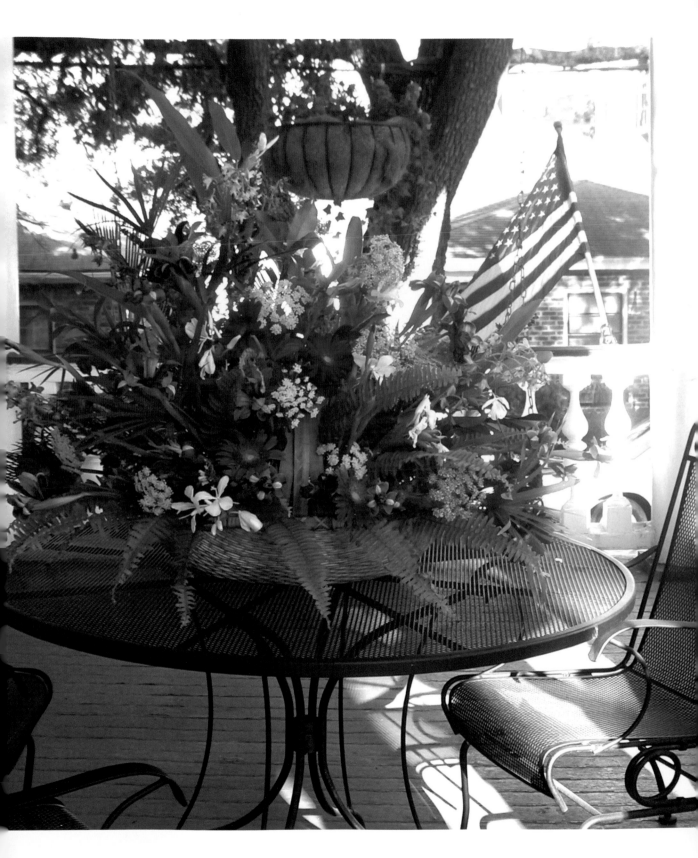

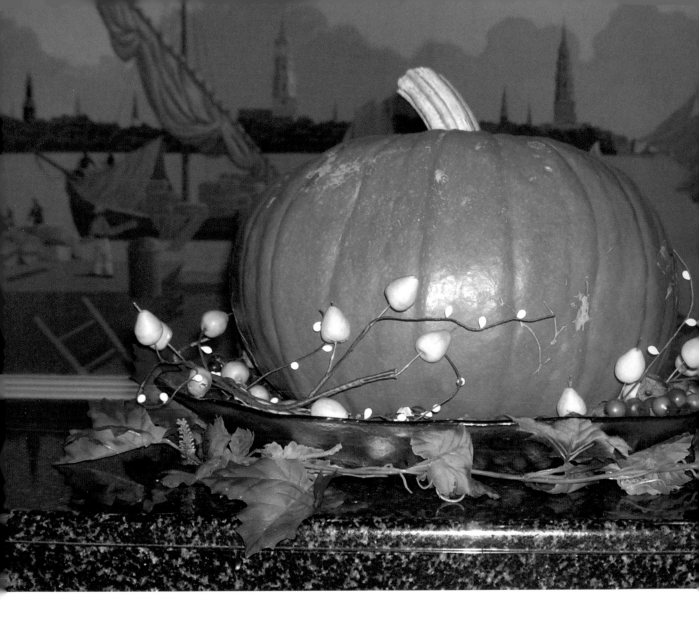

A giant pumpkin on a low dish encircled by some 'faux' berries and leaves makes a simple but effective display in the lobby of the Renaissance Charleston Hotel, Historic District.

Harvest Festival

In many parts of England this custom is often called the 'Harvest-Home'. During the final act of gathering in the harvest, which traditionally took place sometime during September or October, depending on the weather, there was a ceremonial cutting of the last sheaf of corn. The farm workers believed that the Corn Spirit was driven back and took refuge in this last sheaf. Part of the sheaf was then taken and used to weave a corn dolly, in which it was believed the Corn Spirit would reside. In the evening there would be a harvest supper, often held in a large barn so that all the workers could attend. The barn would be decorated with corn, flowers and foliage. A splendid supper would be supplied by the farmer to show thanks for all the hard work. In many parts of England the corn dolly would be kept in a safe place until the sowing of the seed the following year, when it would also be sown, to ensure a successful harvest.

This is an ideal time to combine flowers with fruit and vegetables. Although ripening fruit does give off ethylene gas, which shortens the life of cut flowers, there is an affinity between them that is hard to beat. Cocktail sticks, kebab sticks or special flower arranger's plastic picks can be impaled onto the fruit, which are then inserted into the foam. Red, orange and green peppers (*Capsicum*), blue-black aubergines and yellow bananas (*Musa*) give a smooth texture and strong form. Crinkly-leaved cabbages (*Brassica oleracea*), prickly pineapples (*Ananas*) and ridged melons (*Cucumis mela*) can all be used to create exciting contrasts.

A discarded fruit picking basket is decorated with leaves. A pot plant is placed in the basket and surrounded with an array of fruits and vegetables. A perfect harvest offering.

It is in the autumn that the turning colours of the leaves remind us of the cycle and pattern of life. The green leaves change to brown, through a myriad of different yellows, reds and oranges. Before they turn this final colour they can be enjoyed in mixed arrangements, where they will last up to a week, depending on their development. Leaves of the Boston ivy (*Parthenocissus tricuspidata*) are particularly effective, as are those of members of the maple (*Acer*) family.

Many plants have a second flowering at this time of year to give rich and varied colours in the garden and hedgerow. They can be successfully combined with hips and haws, seedheads, nuts, cones and foliage, in all its autumnal glory, to display the bountiful abundance of Harvest-Home.

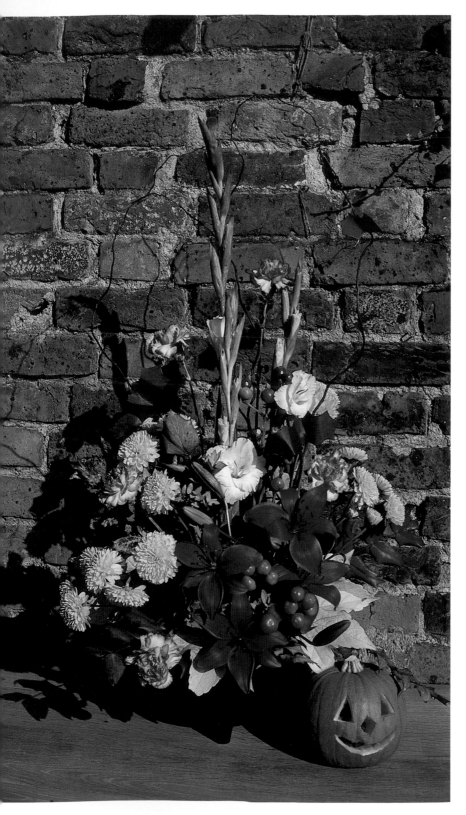

Hallowe'en

Hallowe'en, or the eve of All Hallows (All Saints), occurs on October 31st. It is the night when supernatural forces are supposed to come forth, when spirits walk and witches fly. For many years good-natured fun and games have taken place on this night. In recent years trick-or-treating, an American custom, has also become commonplace in parts of Britain. Children dress up in spooky costumes and go from door to door, soliciting sweets or money. On the other hand, the tradition of bobbing for apples now seems to be lost.

A fun idea at this time of year is to hollow out a pumpkin or turnip (*Brassica rapa*) and place a jam jar or vase inside, in which to place a tumbling mass of autumnal flowers. Such vegetables should last up to a week in a cool place.

Shining apples (*Malus sylvestris*), bright orange, black and red, are the symbols of Hallowe'en.

Halloween. The paper bats and pumpkins (*Cucurbita maxima*) give atmosphere to the design.

Bonfire Night

In Britain, November 5th is the day when bonfires are lit and fireworks are set off in gardens and on open land throughout the country. The tradition recalls 1605, when Guy Fawkes was captured minutes before setting light to a cache of gunpowder deep in the cellars of the Houses of Parliament, in an attempt to rid the country of James I, his government and parliament. Guy Fawkes was tried, found guilty of treason and executed. Effigies are still placed at the top of bonfires and set on fire, to the loud accompaniment of rockets and fireworks.

For an arrangement for a party on this night you could choose plant material that simulates fire – think of red and orange dahlias and carnations. This is one of the few occasions when green foliage does not add to the impact and effect. Use autumnal tinted foliage, such as vine (*Vitis*), Boston ivy (*Parthenocissus tricuspidata*) or the last of the flowering currant (*Ribes sanguineum*). Alternatively, use glycerined or sprayed plant material. The illusion of smoke can be achieved with traveller's joy/old man's beard (*Clematis vitalba*) or pampas grass (*Cortaderia selloana*). Fireworks can be represented by dried exotics, bulrushes (*Typha*), onion seedheads (*Allium*), gay feather (*Liatris*) and twisted cane.

A festive design for any occasion where fireworks are part of the celebrations. Bells of Ireland (*Molucella laevis*), *Euphorbia fulgens, Gloriosa superba* 'Rothschildiana', *Narcissus, Aspidistra* leaves, starfish and pussy pillow (*Salix caprea*) are used to create a firework effect.

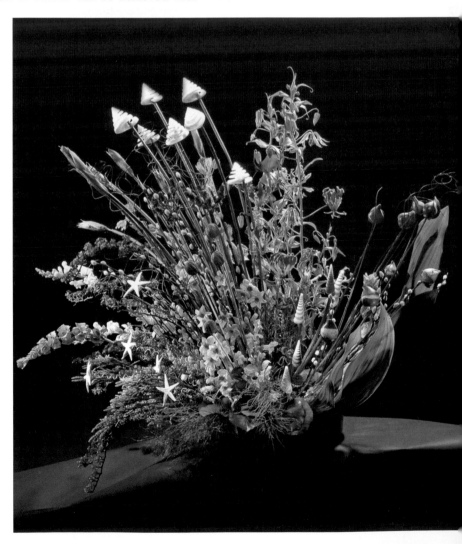

Thanksgiving

Thanksgiving in America is celebrated on the fourth Thursday of November. Families gather around their tables heaped with traditional foods. In homes across the land families give thanks for their blessings and commemorate the bountiful harvest of the pilgrims who survived their first year in America in 1621.

The Pilgrims were English Separatist Puritans who left England to seek religious freedom first in Holland and then in America. They sailed on the Mayflower from Plymouth, England in 1620 and landed in Massachusetts at a site which they named Plymouth. With the help of the Wampanoag tribe of Indians the Pilgrims learned to plant corn, catch fish and gather fruit. They also learned how to prepare roast turkey, cranberries, corn pudding, sweet potatoes, oyster dressing and pumpkin pie which became the traditional American foods that are still served on Thanksgiving Day.

The tradition has endured over the centuries and in 1863 President Lincoln proclaimed Thanksgiving Day a great national holiday for all. In Canada harvest or Thanksgiving takes place on the second Monday of October and flowers are an important part of the festive feast. Long-lasting vegetables such as squash, marrow, pumpkin, carrots and turnips are celebrated before being put away for food during the harsh winter.

A Thanksgiving table setting by Kathy Wade and Ginger Shealy in the home of Harold and Jean Wade, Charleston, South Carolina.

Tables are often set formally with silver, crystal and linen or informally with stoneware and baskets. Each style is enhanced with harvest floral arrangements in vases or cornucopias. Fall (Autumn) foliage with leaves in hues of orange, red, rust, yellow and gold is combined with bittersweet, *Nandina*, Chinese lanterns, sunflowers and chrysanthemums. Accents include dried plant material such as seed pods, cotton, sycamore, gum balls, okra, lotus pods, wheat and ornamental grasses. Fruits and vegetables are added to symbolize the fall harvest. Colourful gourds, squash, pumpkins and Indian corn, nuts, feathers and pine cones give arrangements variety and texture. Along with harvest bounty Thanksgiving retains its traditional nature of family gathering, grateful prayer and good food.

Christmas

Christmas is perhaps the only time of the year when the majority of homes and places of comradeship, business and worship are decorated with evergreens, cones and berries to add to the festive celebrations of this special time.

It was around AD 440 that December 25th was arbitrarily set as the day on which Christ was born. It was, however, established close to the winter solstice – a time when the sun was at its lowest and pagan festivals were celebrated to ensure fertility in the coming year. Evergreens were used to decorate the home, for they represented the continuity of life, and their use has continued uninterrupted to the present day. Before the arrival of the Christmas tree in Queen Victoria's reign, evergreens were formed into circles, globes or wreaths and decorated with ribbons, apples and other fruits. Today Christmas is distinguished from the many other occasions celebrated with flowers by the use of certain colours and plant material accessories.

For traditional Christmas decoration there is one colour scheme that never dates or goes out of fashion. Red and green, sometimes highlighted with a touch of gold or silver, are the colours of Christmas. They conjure up an image of berries against shiny holly (*Ilex*), the robin redbreast in the evergreen tree, the warmth of the fire – nature at its most comforting.

The combination of white and green is also widely used, the imagery being snow on the land and the purity of the Virgin birth. The colour combinations of blue and silver, orange and red, orange and silver, yellow and gold, copper and pink can also give pleasing colour schemes at this time of the year. For the contemporary look try black and silver or add a touch of purple for interest.

Christmas is the time of year when evergreens are of special importance. Many fresh evergreens provide not only a wonderful texture and background to berries, fruits and flowers but also an unforgettable fragrance.

All the conifers are useful. If you can, buy blue spruce (*Pinus pungens*) or noble pine (*Abies procera*). Dark green conifer, Leyland cypress (x *Cupressocyparis leylandii*) is inexpensive and available from most florists. Give it extra pep by adding sprigs of cream or yellow variegated conifer, such as *Thuja plicata* 'Zebrina'. These conifers are readily available from garden centres and grow reasonably quickly.

Wrap double-sided tape around a thick church candle and adhere cinnamon sticks to the tape. Give extra security with a tie of raffia. Place the candle on a low glazed terracotta dish. Take a mix of colour-co-ordinated Christmas baubles and place them randomly around the candle. Add a little water to the dish. Take 2–3 stems of spray chrysanthemums, cut off the individual flowers and tuck them in groups around the baubles. This arrangement will last and last. The warm, two-toned chrysanthemums give added interest and create harmony with the rich colours of the cinnamon and baubles.

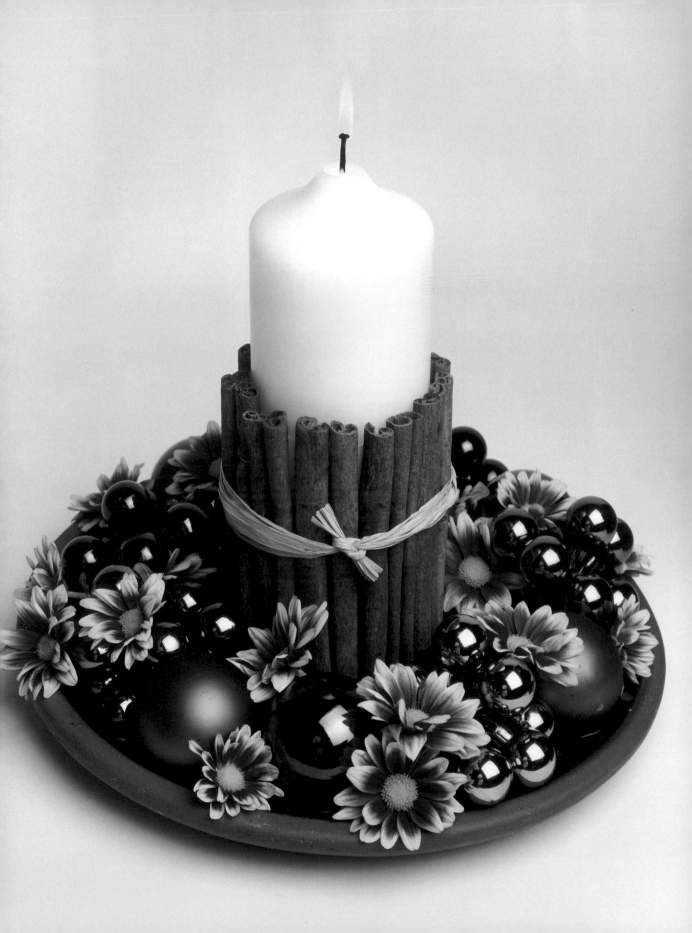

Wreaths

An evergreen backcloth on a metal frame can be decorated in so many ways to make distinctive and attractive door hangings. Turn to 'Techniques' on pages 406–407 for instructions.

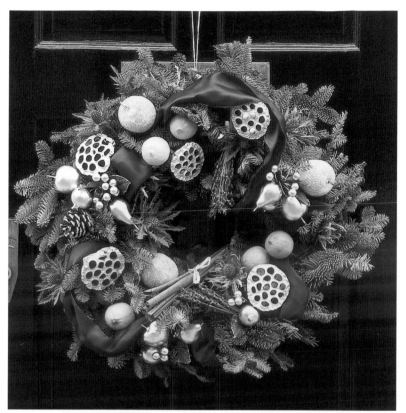

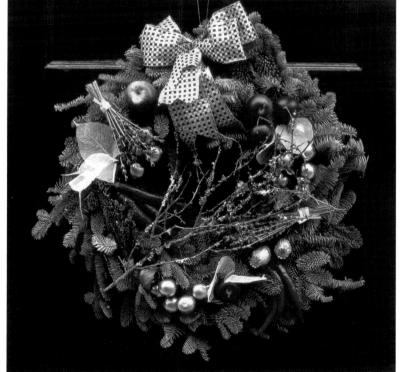

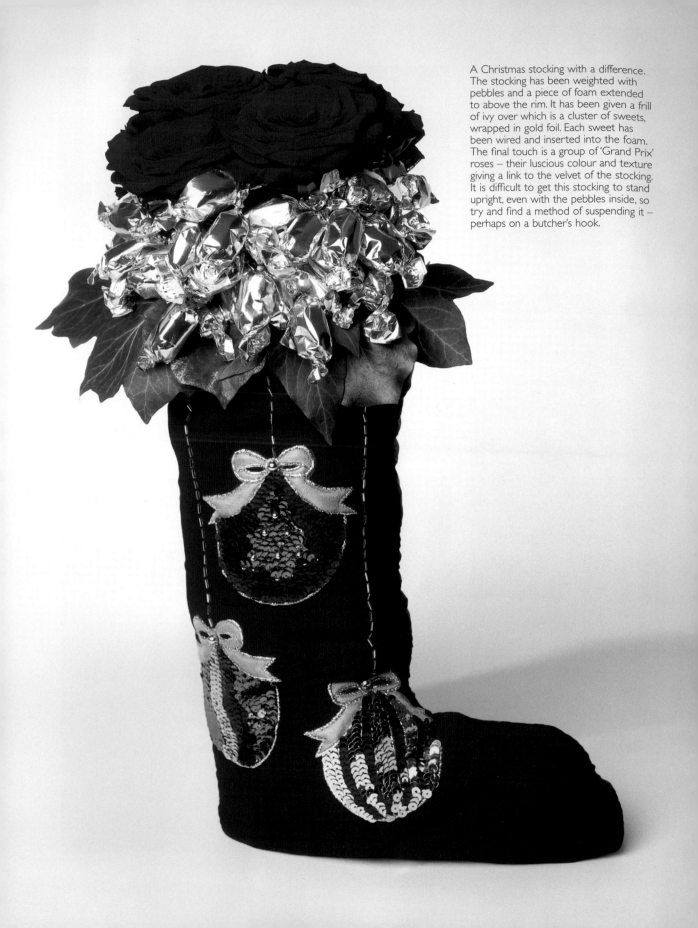

A Christmas stocking with a difference.
The stocking has been weighted with
pebbles and a piece of foam extended
to above the rim. It has been given a frill
of ivy over which is a cluster of sweets,
wrapped in gold foil. Each sweet has
been wired and inserted into the foam.
The final touch is a group of 'Grand Prix'
roses – their luscious colour and texture
giving a link to the velvet of the stocking.
It is difficult to get this stocking to stand
upright, even with the pebbles inside, so
try and find a method of suspending it –
perhaps on a butcher's hook.

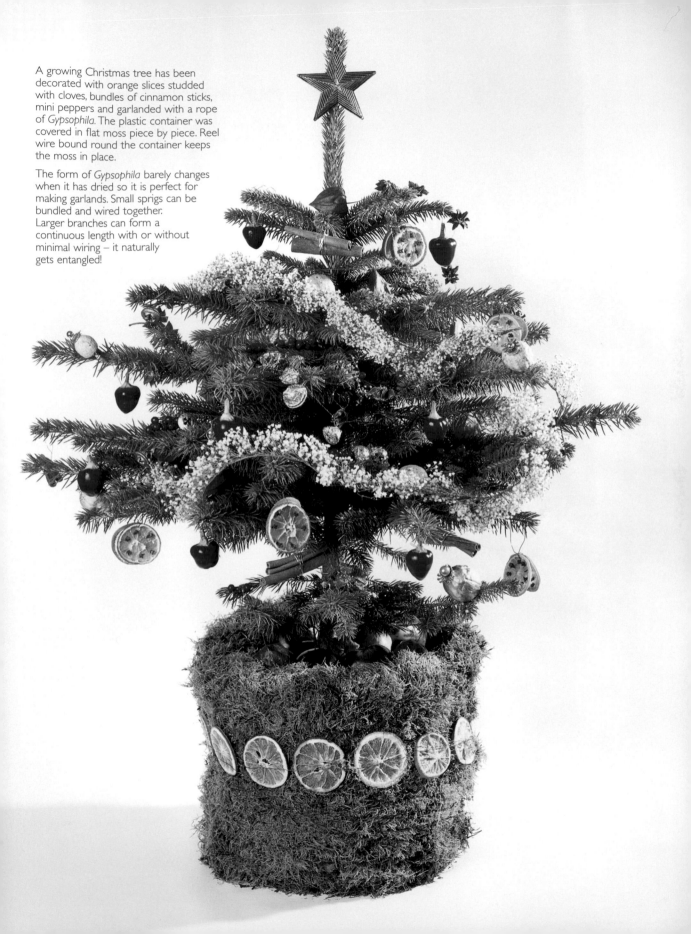

A growing Christmas tree has been decorated with orange slices studded with cloves, bundles of cinnamon sticks, mini peppers and garlanded with a rope of *Gypsophila*. The plastic container was covered in flat moss piece by piece. Reel wire bound round the container keeps the moss in place.

The form of *Gypsophila* barely changes when it has dried so it is perfect for making garlands. Small sprigs can be bundled and wired together. Larger branches can form a continuous length with or without minimal wiring – it naturally gets entangled!

How to make your evergreens last

- For needled foliage and berried foliage – but not for flowers – add one tablespoon of glycerine to 1.1 litres (2 pt) of boiling water. Allow to cool and stir well. Allow about 15 cm (6 in) of liquid in a bucket.

- Regularly mist with water.

- Holly lasts best out of water – keep it under sacking to prevent the birds from taking the berries.

- Sugar pine (*Pinus lambertiana*) and other needled foliage last well if laid flat on the ground, exposed to the elements. It can be difficult to place such bulky foliage in water and seems to last just as long this way.

- Needled and broad-leaved evergreens accumulate a lot of dirt. Swishing the cut foliage in a little soapy water will ensure that it not only looks fresher but lasts longer too.

- The cooler the house, the longer the foliage will last. If you hang a garland on the mantelpiece with a frequently burning fire it will quickly dry out and may need to be replaced during the festive season.

Three cyclamen plants are placed in the centre of a hand made wreath with an integral base. Festive silver baubles are added together with two ribbon bows and a twirl of sisal.

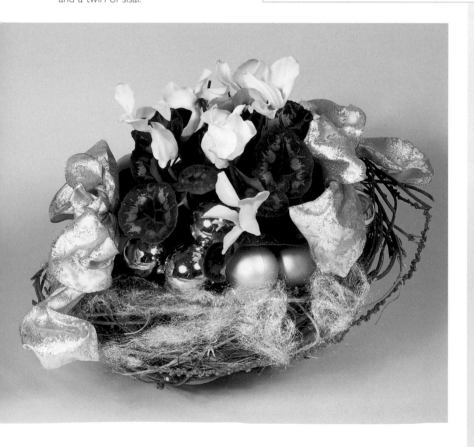

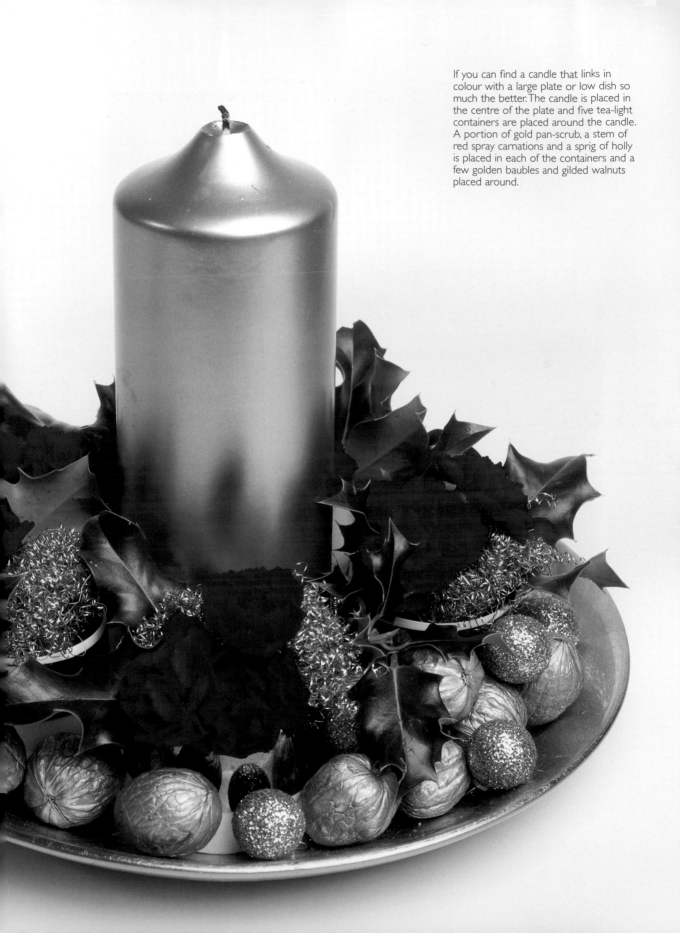

If you can find a candle that links in colour with a large plate or low dish so much the better. The candle is placed in the centre of the plate and five tea-light containers are placed around the candle. A portion of gold pan-scrub, a stem of red spray carnations and a sprig of holly is placed in each of the containers and a few golden baubles and gilded walnuts placed around.

5

A history of flower arranging

The art of flower arranging practiced in Europe before the 20th century is largely unrecorded and it is only by reference to paintings, engravings, tapestries, mosaics, statuary and illustrated manuscripts that we can gain an insight into the changing fashions in flower decorations and flower arrangements.

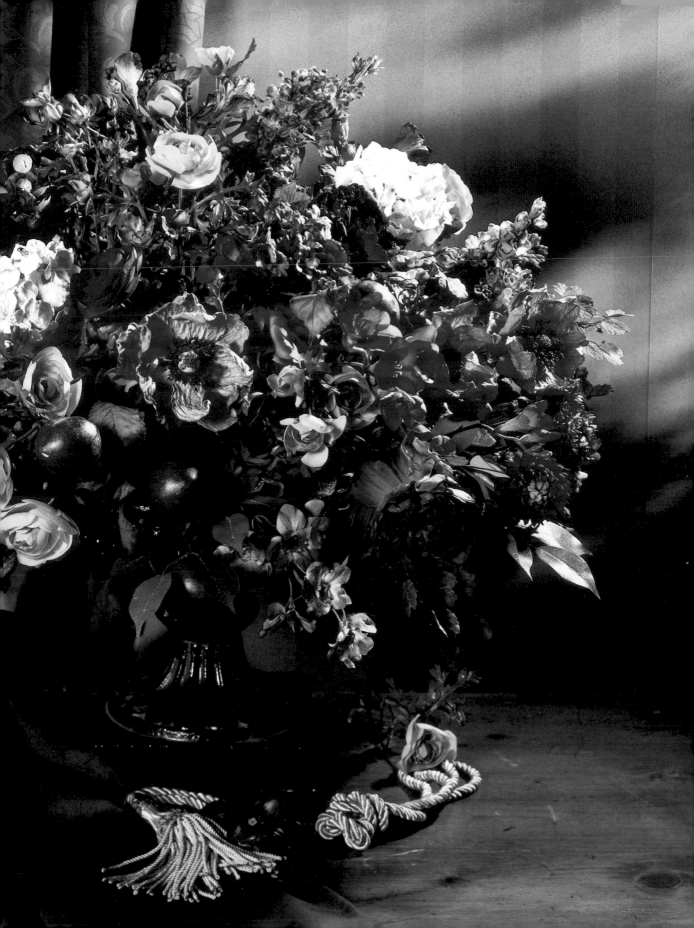

previous page
Fake flowers create the atmosphere of a
massed period design.

One key fact which emerges is that there have been two main streams in the art of arranging flowers. One stream is the linear style practised in Japan and China and the other is the Western style of massed bouquets. The latter continued steadily without much variation until the 1970s and more particularly in the last ten years when sculptural influences led to the current vogue of Contemporary Floral Design (CFD). Here we talk about the Western style of arranging and mention in this brief history what are generally considered the most important periods and influences for Europe.

Europe

Egypt 3000-310 BC

Evidence from wall paintings and bas-reliefs of Egyptian times show that the Egyptians used cut flowers in vases as far back as 2500 BC. Their work was highly stylised and the blossom of lotus flowers (*Nymphaea caerulea* and *Nelumbo nucifera*) were placed in vases without any attempt to 'arrange'. Bowls containing the lotus were placed on tables. Vases filled with lotus were carried in processions.

Flower and floral decorations were an integral part of Ancient Egyptian civilization. Flowers were depicted in wall paintings both for their intrinsic beauty and for symbolic reasons. The most common motifs were the lotus, representing Upper Egypt; and the *Papyrus* sedge representing Lower Egypt. Here lotus and *Papyrus* appear as hand held bouquets – the figures are wearing floral collars and carrying a basket of fruit.

Italy 600 BC – 320 AD

We have evidence from the writing of Plato and Pliny of their knowledge of a wide range of plants and flowers. Although we have learnt that flowers played significant roles in religious and daily life, it appears that whilst they were used for garlands and wreaths and for medicinal purposes they were not placed in vases. However a mosaic of the second century AD (now in the Vatican Museum) shows a basket holding roses, hyacinths, anemones, tulips, red carnations and 'morning glory'. In the declining years of the Roman Empire roses were strewn on banqueting tables and used lavishly at any sort of entertainment.

The Dark Ages

The decline of the Roman Empire and the onset of the Dark Ages has resulted in an absence of information about the use of flowers until the artists and writers of Medieval Europe recorded the use of flowers in their times. It was the church that was the patron of art and stained glass, mosaics, tapestries and religious manuscripts of the period give an insight into the use of flowers as decoration. Lilies, roses, columbine, iris, rocket, heartsease and many others were placed in vases to express symbolic concepts.

The Renaissance

The Renaissance heralded an increased interest in gardening and flowers began to be grown for their beauty as well as for medicinal usage. The gardens provided a source of flowers to fill vases. Instructions on the cutting of stems, and the changing of water every three days were printed. Artists represented flowers in still-life paintings and in them flowers were 'arranged' in a 'bouquet' style. Great use was made of cut flowers and herbs especially in Florence during processions and on feast days such as 'Calendimaggio' – May 1st. Strewn flowers were commonplace on white linen tablecloths at rich banquets. Garlands and festoons grew more lavish and new decorative elements such as corals and exotic fruits were imported from distant countries and were often included. The religious symbolism of the Middle Ages continued and flowers placed in churches or shown as altarpieces contained messages for the populace who could not read. For example lilies stood for purity, *Iris* for majesty and *Dianthus* for human love among others.

A Roman frieze depicting servants carrying sheaves of flowers.

England

Tudor – 15th and 16th Centuries

In England, an era of comparative peace followed the Wars of the Roses and as the need for defensive architecture diminished, the concept of recreational living spaces such as pleasure gardens began to emerge. In these houses there was little occasional furniture so flowers stood on the floor, on windowsills or in the hearth in summer and bottles were used as containers. Small bunches of flowers ('tussie-mussies') were held in the hand. Pot-pourri in bowls and pomanders or oranges stuck with cloves and tied with ribbons are all recorded. They were valued as much for their fragrance as for their appearance. They masked the 'farmyard' smells that pervaded towns and cities. On special occasions flowers were strewn and garlands worn on the head and Morris dancers – popular in the period – wore flower-garlanded hats. The flowers were not 'arranged' but were uncontrived bunches. There were practically no mechanics and the neck of the container held the flowers in place.

If there is a style for the period it is somewhere between the restrained Italian Renaissance use and the exuberance of the Dutch flower piece.

above
An uncontrived bunch of herbs in a pewter tankard.

right
A re-creation of a Tudor room at Christmas.

Holland 1600 – 1800

With the change of economic conditions during the 17th century, the patronage of artists by the Church and nobility began to include the emerging wealthy class of merchants. Seventeenth century Holland acquired the status of a great European power and its society was dominated by rich middle-class merchants whose prosperity came from agriculture, fishing, clay, ceramics, linen, velvet and precious metals. It can be said quite reasonably that Western flower arranging began during this period. Dutch and Flemish painters developed the skill to portray flowers in all their delicacy of form and beauty and to arrange them in association with fruits and every day objects to the delight of their patrons. Many of these representations of flowers were idealistic, with the blooms of all seasons combined. There is however clear evidence of arrangements of flowers in the home for many paintings of domestic scenes show flowers in a variety of containers such as bottle-shaped vessels, green glass 'knobbed' vases, terracotta urns and Delftware bowls.

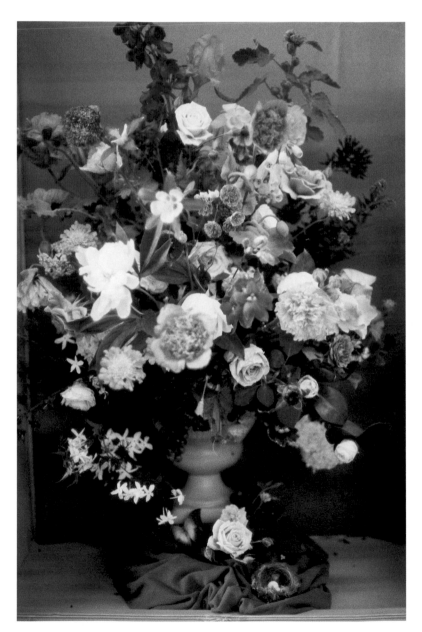

right
A mass design in the style of the Dutch old masters.

below
'Roses, Tulips and Peonies'
Jan Frans van Dael, 1764–1840.

America

1620-1800

The colonization of North America by whole families emigrating from Great Britain and the Low Countries with their possessions – animals, seeds, roots, implements and household goods – heralded a period which, whilst not significant for its styles of flower arranging, to this day provides us with a lesson in husbandry and began an interest in drying and preserving flowers and leaves. Decor and furniture were naturally based on English styles and later in the period European influences became apparent.

Flower arranging would have followed the English traditions of the times with small posies or informal bunches of fresh or dried flowers and later rounded massed bouquet styles.

A contribution to flower arranging has been made by today's occupants of Colonial Williamsburg, which is a recreation of what had once been Virginia's colonial capital. They have used imagination and skill to provide arrangements which accord with the interior decor of the recreated buildings and have produced a number of colourful well photographed publications with titles such as Williamsburg 'Christmas Ideas', 'Entertaining Ideas' and 'Eighteenth Century Garlands'.

A setting in the American Museum, Claverton, Bath displaying an elaborate dried arrangement.

Britain

The Georgian Period 1714 – 1830

The Georgian and Regency periods in England span the years 1714 to 1830 and within this period the design of containers for plant materials and the way flowers were arranged were affected by the Rococo style; free flowing and essentially asymmetrical. Bowls and vases had perforated tops to hold flowers and sand was used to support stems. In summer, bough pots with fan shaped arrangements of branches and flowers were placed in fireplaces. Fresh and dried flowers were used with stems radiating from the container. The earlier Georgian style was Baroque with arrangements similar to the middle period of Dutch/Flemish flower pieces. Later Rococo influences gave lightness and delicacy, restraint and elegance with pastel colours and overall balance and asymmetrical detail in the design. Proportions varied, with the height of the flowers sometimes less than the height of the container, sometimes equal and in stately vases often twice the height.

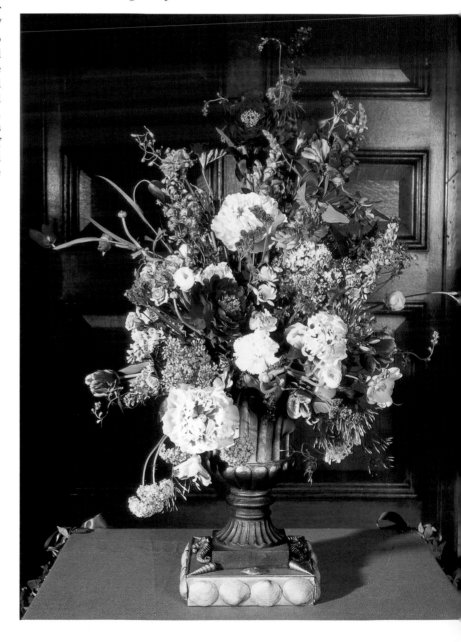

A delicate pastel design presented on sumptuous festooned silk material. The Georgians loved ribbons, gentle colours and a glorious array of stems and flowers, arranged with limited foliage.

The Victorian Period 1830 – 1900

By the early eighteen hundreds much of the flowering material used today was in cultivation and flowers were used anywhere and everywhere. The characteristic style was massed flowers with little space and no obvious centre of interest. The shape was circular or oval and the height of the flowers often less than the container. Vases of massed flowers with trailing ferns and greenery were popular. Ladies carried posies in the hand on social occasions and these were not just a 'hand bunch' but carefully crafted with concentric circles of flowers round a cornet shaped centre-piece, finally set off with a ruffle of lace or small scented or leathery leaves. Skeletonised leaves were displayed against black velvet and dried flowers covered in white wax were used as memorials under glass domes. Massed centrepieces with an épergne or a March stand were placed on dining tables, together with a bouquet for each guest. Trails of smilax, ivy and *Asparagus* fern could be found both on the table top and in scroll or scalloped-shaped patterns down the sides.

A handsome re-creation by Daphne Vagg of a Victorian table setting with garlands, swags of flowers and a tall central display.

Flowers were worn in the hair and on the corsage in posy holders. A 'Language of Flowers' was developed with every flower having a symbolic meaning. Consequently flowers were used to carry messages of love or sympathy in bereavement. Containers were in every conceivable and inconceivable shape. Glass or pottery 'roses' were used to hold stems, and other forms of 'mechanics' were sand, moss and wire mesh frames, with rope and thin lathes of wood used for garlands in churches.

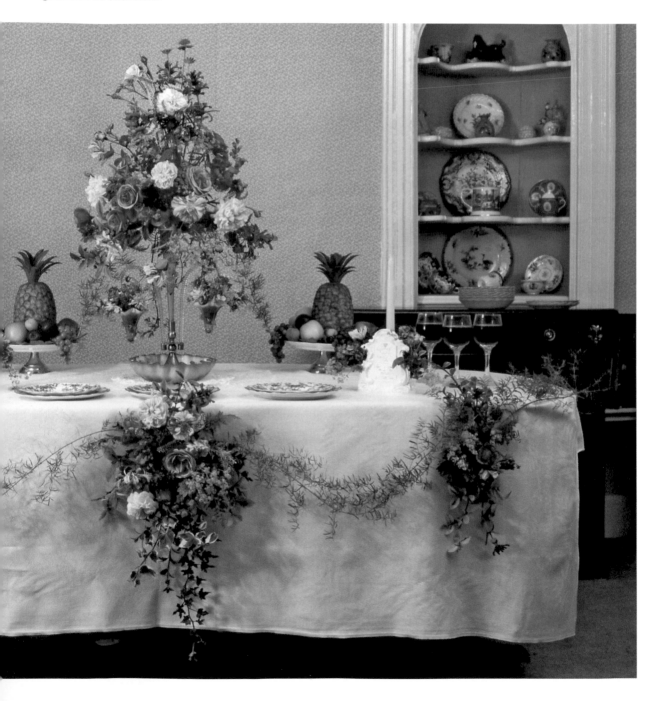

Edwardian period 1900 – 1914

Flowers were used throughout the house and although tables were festooned for grand occasions the trend was for a more simple style. Gradually the tightly massed Victorian style gave way to lighter arrangements often with one kind of flower with its own foliage or *Asparagus* fern. Gertrude Jekyll, the famous garden designer introduced more modern ideas into flower arranging. She preferred more markedly asymmetrical groupings of flowers in tall vases with low bowls filled with fruits to balance them.

Art Nouveau influences further simplified arrangements and the evidence of photographs of the tea rooms in Glasgow with decor by Charles Rennie Mackintosh show simple vases with a few flowers in Ikebana style on tables and mantel shelves. The new perspective saw that the shape of the stem, the bud and curving seed pod and soft colours could stand alone in a satisfying arrangement.

A photograph taken in 1900 by Henry Taunt of *Fritillaria* in a simple stem vase.

Between the Wars 1920 – 1939

The development in the 20s and 30s of large suburban estates of small houses led to a great increase in gardening. Gardening magazines flourished. No longer was the garden and its flowers the prerogative of the wealthy. The flower seller from the barrow gave way to the flower shop. In 1935 Constance Spry opened a flower school in the heart of London and her displays in the windows of Atkinson's perfumery in Bond Street became the new look in flower arranging. All this was communicated to the public through books and gardening magazines and created an aesthetic renaissance which raised the status of flower arranging to an art form in the eyes of the general public. Constance Spry went on a lecture tour to America and surprised audiences with her use of both wild and cultivated material in her free flowing style.

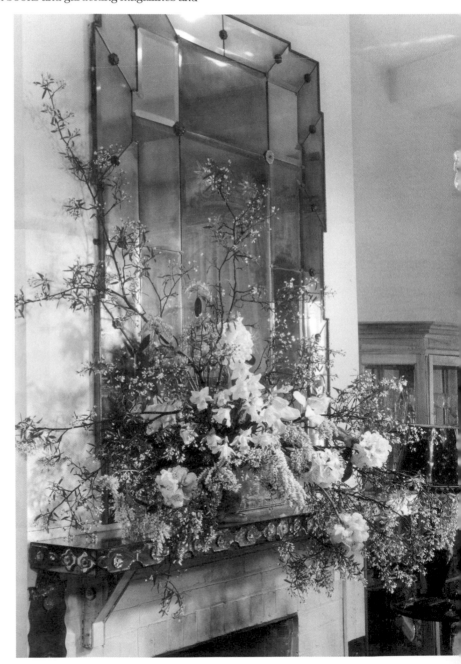

A design by Constance Spry

Popular flowers throughout history

3000 BC – 310 BC
Egyptian
lotus, cornflower, blue iris, *Anemone*, mignonette, *Narcissus*

310 BC – 300 AD
Greek
violet, *Anemone*, *Iris*
Roman
rose, anemone, honeysuckle, iris, cornflower, *Hyacinthus*, lily, carnation

1400 AD- 1500 AD
Madonna lily, musk roses, jasmine, carnation, *Aquilegia*, violet, daisy, blue iris, orange lily

1500 AD – 1600 AD
rosemary, pink, carnation, wallflower, sweet William, stocks, *Iris*, honeysuckle, primrose, *Aquilegia*, daffodil, rose
Introduction – sunflower

1600 AD – 1700 AD
Hyacinthus, *Anemone*, *Auricula*, carnation, crown imperial, hollyhock, rose, *Narcissus*, *Iris*, poppy, morning glory
Introduction – tulip, fritillary, lupin, *Solidago*, Guernsey lily (*Nerine*), *Pelargonium*

1700 AD – 1800 AD
Auricula, *Anemone*, tulip, rose, lily, carnation, peony, lilac, tuberose, *Iris*, *Delphinium*, *Antirrhinum*, *Bellis perennis*
Introduction – *Helenium*, red-hot poker, calla, *Zinnia*, *Dahlia*, *Delphinium*, *Fuchsia*

1800 – 1900
Antirrhinum, *Calceolaria*, bluebell, lily, *Phlox*, pink, sweet William, rose, pansy, geranium, lily-of-the-valley, *Fuchsia*, camellias
Introduction – *Lilium regale*

1900 – 1920
violet, chrysanthemum, *Dahlia*, orchids, lily, cabbage roses, lily-of-the-valley, sweet pea, carnation, *Stephanotis*

1920 – 1945
marigold, *Calendula*, *Tagetes*, *Nasturtium*, *Physalis*, chrysanthemum

1945 – 1960
Begonia, *Impatiens*

After the War 1945 – 1960

The war ended in 1945 but it was not until 1952 that street and shop lighting was reinstated. The lasting impact of the hostilities manifested itself in a feeling of doubt and despair – would we ever recover? Food and clothing was still rationed, building materials on controlled supply and anything else still hard to come by. Flowers were not rationed – they could be grown in the garden or picked from the hedgerows of the countryside. It was Julia Clements who foresaw the need to deliver to housewives a positive do-it-yourself guide to flower arranging in a simple step-by-step fashion that would display their natural beauty. By touring the country and demonstrating to women's clubs, writing articles and publishing a series of books, she carried the torch for flower arranging and achieved a success which has lasted to this day.

The result of the creation of interest in flower arranging was that groups of friends formed flower clubs and in 1952 the first ever exhibition devoted entirely to flower arrangements was held by them in the Royal Horticultural Society's Hall in London.

By 1959 the movement had gained such impetus that the National Association of Flower Arrangement Societies of Great Britain (NAFAS) was formed to be the central co-ordinator of the network of flower clubs and societies which had blossomed throughout the country. There was the establishment of major flower shows whose award winners developed the art form and who set the style for flower club members, as did the arrangements shown by demonstrators at flower club meetings.

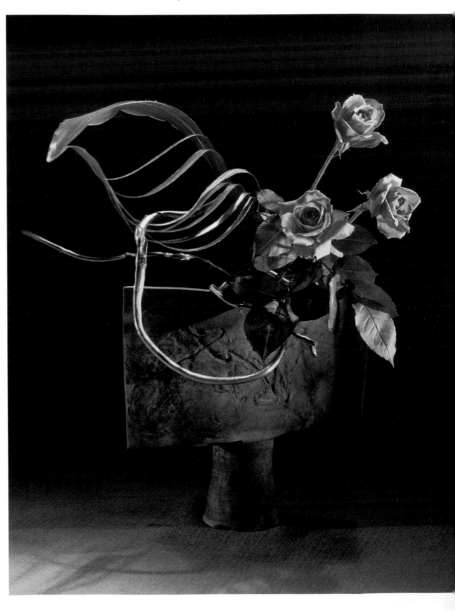

An arrangement by Julia Clements.

6

Design classics

What goes around comes around.
The established classic styles of the centuries
come and go, embellished and tweaked, but
still retaining their essential features. For example
the geometric based styles of the 1950s to
1970s are now having a resurgence in the
21st century. The overall forms remain the same
but space is less evident and plant material is
packed more densely into the designs to give a
fresh new look. There is less emphasis on foliage
and more on florists' flowers.

A good knowledge of the classics will enable
you to understand the basics of good design,
allowing you to move forward in flower design
and develop your own creativity. It is a great
starting point.

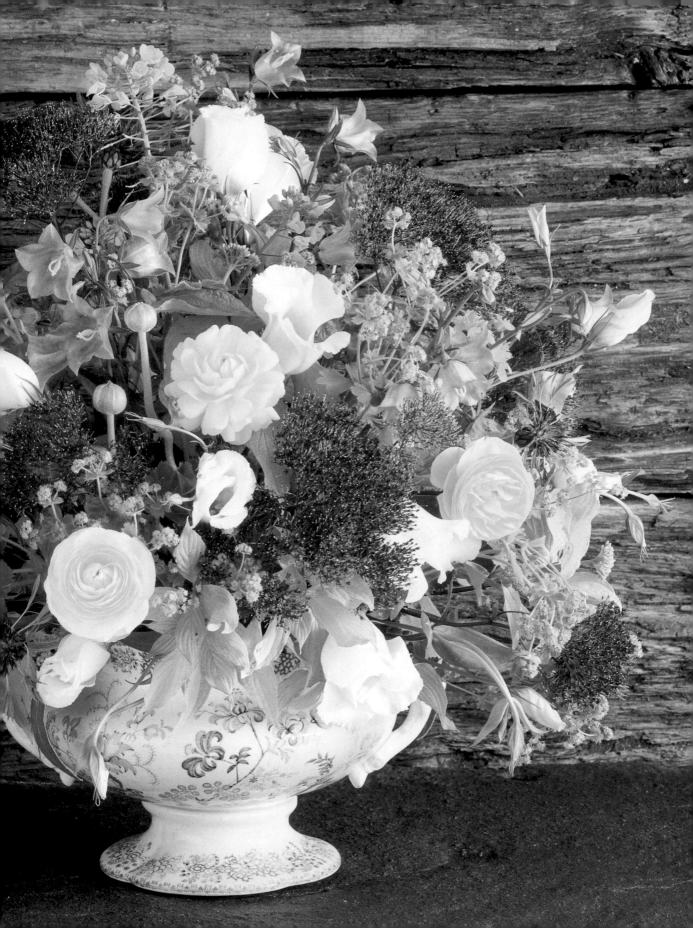

Characteristics

- The different designs are all loosely based on a geometric form or shape, although this chapter also includes some of the more naturalistic styles popular in the 1970s.

- Each design incorporates round and spray plant material and often, but not always, line material.

- In geometric designs every stem radiates or appears to radiate from a central area at the heart of the foam. This is most important if you wish to create a successful traditional design.

- There are no strong surprises or contrasts. Variation is soft and gradual.

- The designs are often dependent on garden plant material, using buds, half-open and full-blown flowers, with curving branches of foliage. In Continental Europe these designs are known as *Le Style Anglais* and are seen as being quintessentially English.

- There is a more dominant area at the base of the tallest stem, approximately two-thirds of the way down the design. This can be achieved with larger forms, stronger colour or the use of a different texture. In arrangements to be viewed all round, such as table arrangements, there are several dominant areas.

- There is a certain amount of space between each element of plant material to show each to advantage. Avoid the temptation to overfill the arrangement in an attempt to hide every minute bit of foam. Space and rhythmic movement are more important in this style of design.

- The plant material is usually woven through the design. Rhythm is created by making flowing lines, through the judicious use of colour and the repetition or graduation of form. Sometimes the plant material is grouped.

- Some of the plant material should be gently recessed (that is, placed on shorter stems) to build up depth and heighten interest.

- Visual and actual balance is achieved by:
 - The use of containers that are as dark as the flowers or leaves.
 - Keeping dark colours relatively low in the arrangement.
 - Making the two sides equally heavy by symmetry, placement or the use of an accessory.
 - Using smaller forms for the outer edges of the arrangement.
 - Correcting a top-heavy arrangement by placing it on a piece of furniture that will act as a base.
 - Keeping the centre of interest approximately two-thirds of the way down from the tip of the tallest placement.
 - Angling some plant material to hide part of the container rim, and to allow the plant material and container to belong to each other and appear stable.

TIP Do not think in terms of specific plant material. Think in terms of the different shapes or forms of material you will need and scale up or down according to the size of design you are creating.

For geometric designs you will need:

a) line foliage to create the outline.
b) plain leaves to give a smooth texture to the design and to reinforce the structure.
c) round flowers to give focus.
d) spray flowers and foliage to support the round flowers, give softness and interest and to fill in the design.
e) In some geometric designs, particularly the larger ones, you will also need line flowers to reinforce the outline created by the line foliage.

NB. Remember there are no rules – only guidelines to get you going.

a)

b)

c)

d)

d)

e)

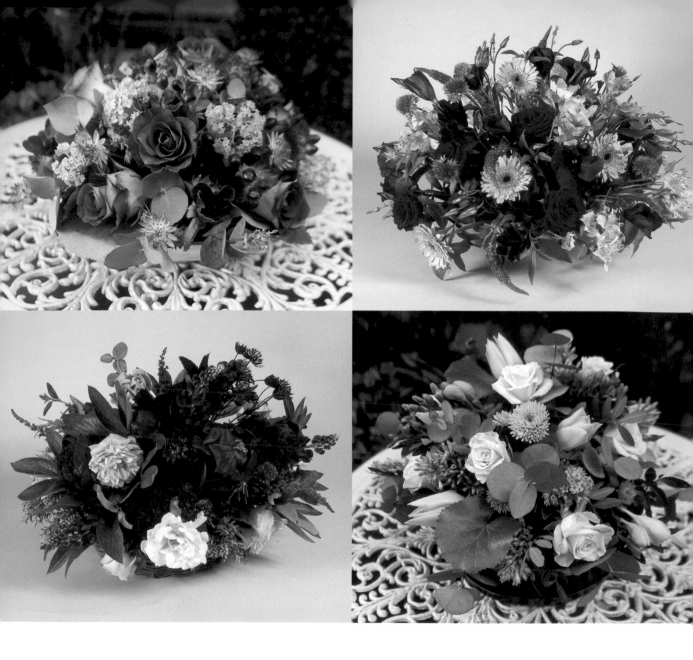

Round arrangements

Low, round table arrangement

This is a highly popular style of arrangement, perhaps because it can be adapted to budget and occasion. An all-round arrangement is easy to create and looks charming, whatever the shape or size of the table, although a round table is ideal. Do remember that a larger table will need a larger design and the plant material should be correspondingly in scale.

For more experienced arrangers size has no limits. Exactly the same method is followed whatever the size – but the scale must be respected.

The container and the mechanics

You can use any small dish such as a plastic dish that will be disguised or a more distinguished low round container that will become part of the overall design.

Use a round cylinder of foam or a square cut from a brick of foam with the four sharp edges gently removed. To secure your foam in position you could use a frog and fix, on which your foam will be impaled, or simply place a length of florists' tape over the foam. Pinch the tape between the fingers in the area over the foam itself so that it takes up less space but still keeps the foam firmly in position.

The plant material

You need:
- line foliage
- smooth plain round leaves
- round flowers
- spray flowers and foliage

- optional: line flowers

The method

1. Soak your foam as described on page 400.

2. Cut all your line foliage to the same length. Keep it quite short, for your first attempts. Your finished design will be larger than you think at this stage. Create a regular framework by radiating all the stems from the central area of the foam. Angle the stems in the lower part of the foam over the rim of the container. The number you need will depend on the size of the leaves. Use sufficient in the lower part so that the leaves closest to the foam touch, or nearly touch.

3. Place your round leaves through the design. Avoid creating a frill by using stems of different lengths and placing them at different angles. Keep within the framework created. The leaves are not meant to hide the foam but to add substance to the framework you have already created.

4. If you are using line flowers place them so that the tips of the flower heads reinforce the same outline achieved with the line foliage. The first stem to be placed should be positioned vertically out of the centre of the foam.

5. Add focal flowers – you may wish to recess some of these to give added interest. If you are not using line flowers see that your first flower is placed vertically out of the centre of the foam.

6. Fill in with spray flowers and additional foliage if necessary until you have an arrangement that pleases. Avoid a compulsion to hide every last bit of foam, because you may forego space, which is an important element in classic design.

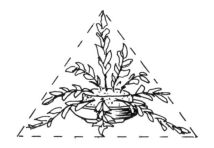

TIP You only need to insert about 1cm (0.5 in) of stem into the foam but ensure the stem is clean of leaves or knobbly bits which will break up the foam.

Creating the design

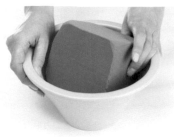

1. Place a piece of soaked foam in a container so that the foam rises above the rim of the container. Allow plenty of space around the foam so that you can add a good supply of extra water.

2. Create an outline with your chosen line foliage. Here we have used *Gardenia*. Angle all the stems so that they appear to radiate from the central area of the foam. First place a stem centrally. Now create a circle of stems all the same length so that they seem to radiate from the centre of the foam. Angle stems so they fill in a three dimensional form. When you have finished, all the stems should be approximately the same distance apart with no big areas uncovered.

4/5. Take round, linear and spray flowers and place them through the design.

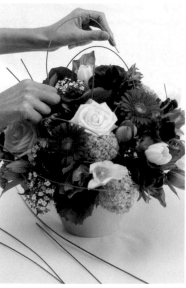

3. Take some round leaves, here we have used *Galax*, and angle them out of the foam to create a stronger framework. When you have completed this stage you will be able to see the foam but it is not obvious.

6. If you wish to add a contemporary touch take lengths of bear grass or flexigrass and insert both ends in the foam to create loops over the flowers.

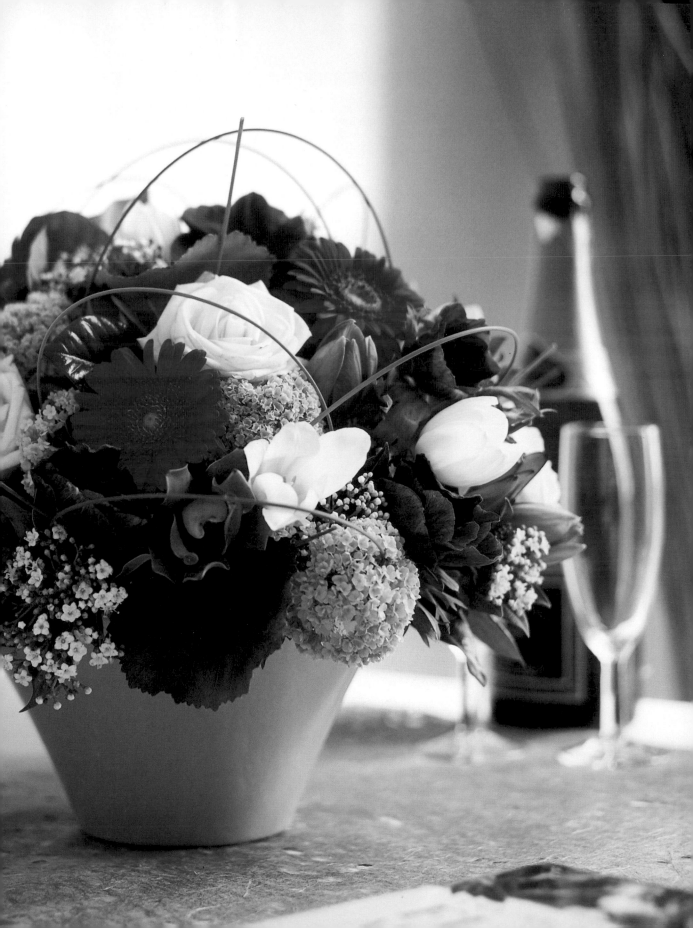

Round arrangement in a tall container

This is a lovely free-flowing design. It follows the same principles as those for the low, round arrangement. Hotels often have a large-scale version of this design in their foyers. For the appropriate impact it is essential to have a strong framework of foliage and round flowers such as *Gerbera*, open lilies, chrysanthemums or dahlias (*Dahlia*).

The container and the mechanics

You will need a tall container that looks, and is, sufficiently robust to support the flowers and foliage.

For the mechanics you will need either:

a) a small dish that will fit into the vase opening plus a suitable amount of foam, or
b) a piece of foam sufficiently large that can be wedged into the opening of the container.

NB. After inserting the foam, fill the container with water so that the foam has a reservoir on which to draw.

The plant material

- outline line foliage – these should be approximately the same length.
- smooth textured leaves such as ivy, baby *Aspidistra*. The larger the arrangement the more ovate these leaves can be.
- linear, round and spray flowers
- filler foliage.

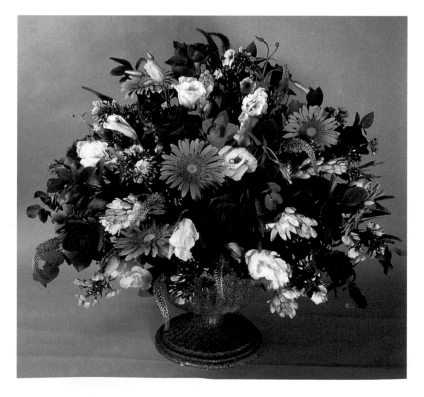

The method

1. Place the first stem of line material centrally in the foam. This should be about the same length as the height of the vase.

2. Angle stems down over the rim of the container and fill in the overall form of the arrangement to create a loosely spherical shape. Radiate all the stems from the central area.

3. Add your smooth textured leaves, line flowers, round flowers and fill in with spray flowers and extra foliage, using a judicious mixture of colour, form and texture.

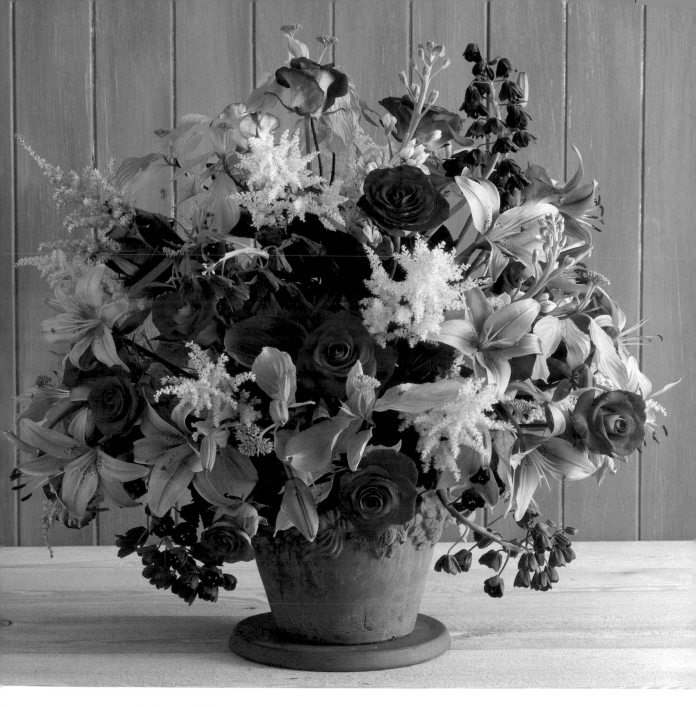

An arrangement of lilies (*Lilium*), Astilbe, stocks (*Matthiola*), fritillary (*Fritillaria*), dogwood (*Cornus*) and roses (*Rosa*) in a lined terracotta pot.

TIP When creating geometric designs, always ensure that the foam rises above the rim of the container.

Where the container is part of the design
As a **very rough** guide, the foam should rise about a quarter to a fifth the height of the container above the rim for small-medium designs. In taller designs about one sixth to one seventh.

Where the container is hidden
Ensure there is sufficient foam above the rim so that stems can be angled downwards over the rim of the container.

Oval arrangements

An oval arrangement looks lovely on an oval or rectangular table. It can cover the length of a large table or simply act as a small centrepiece.

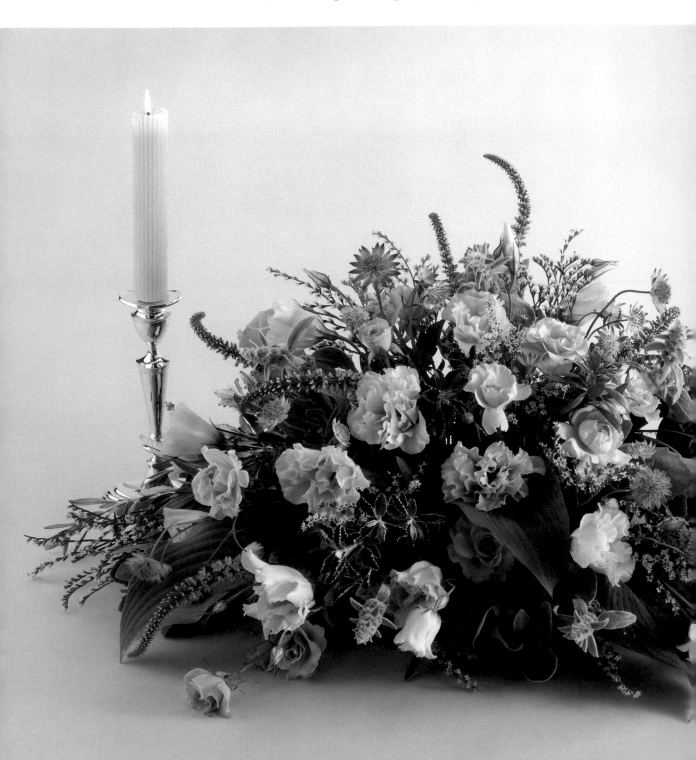

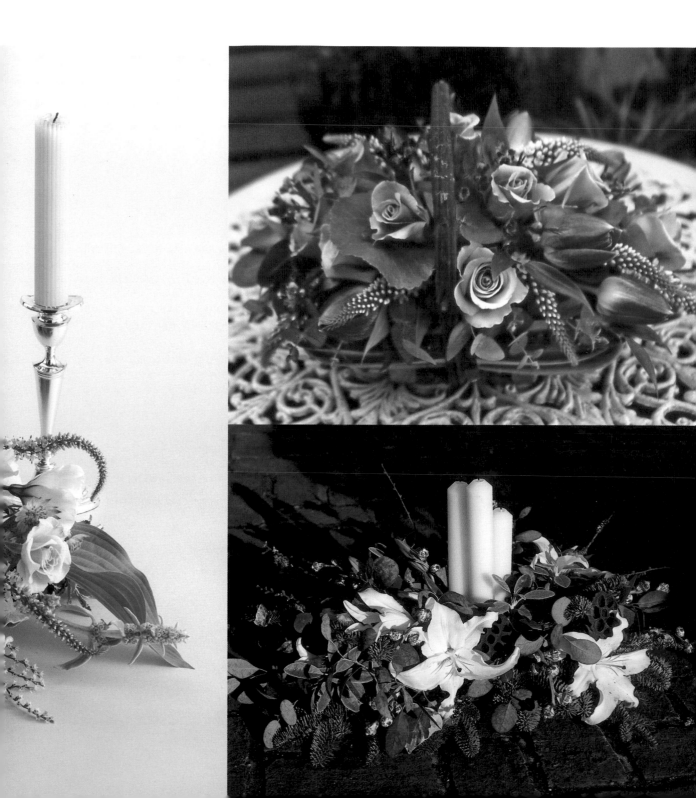

The container and the mechanics

Ideally use an oval or rectangular dish, *not round*, so that your finished arrangement will repeat the shape of the container. An OASIS® plastic dish takes a rectangle of foam and is easy to disguise (as used in the line drawings). If you want a larger design use a low plastic rectangular tray (OASIS® brick tray) designed to take a block of foam.

For the mechanics use a piece of foam. Place a length of florist's tape over the foam to keep it secure. If your container is completely filled with foam, cut away at least a couple of corners from the foam so that water can be added easily.

The plant material

- line foliage,
- smooth leaves,
- line, round and spray flowers,
- filler foliage.

The method

1. Use the larger round plastic dish with a rectangular recess and insert one-third of a block of foam in the recess. Establish the height of the arrangement. Try about 20cm (8in) for your first attempt. Create the overall length of your finished arrangement by placing a stem in each end of the foam. If you wish to use a candle, place this in position first, centrally (see Technique 8 on page 402). Add your central stem so as to rise to half the height of the candle and use this as the top point of the design.

2. Create an oval shape by placing three shorter lengths of stem in the longer sides of the foam on both sides, to create a smooth oval outline. Create a three dimensional form by radiating stems out of the top of the foam.

3. Add your smooth textured leaves.

4. Place a line flower centrally to reinforce the vertical thrust of the design. Use other line flowers to take colour to the outer edges of the design and reinforcing the skeleton provided by the line foliage.

5. Add your other flowers and foliage, recessing some to give depth in the design.

TIP Hold the arrangement up to eye level periodically, to check that you have colour low enough down in the design to give good balance.

Triangular arrangements

The symmetrical triangle

The symmetrical triangle is a graceful way of presenting a mass of plant material. Each flower and leaf can show its individual beauty, and there is the combined appeal of the arrangement when viewed as a whole. Although the symmetrical triangle is to a certain extent stylized, this does not mean that it has to be stiff or awkward. The more it is practiced, the more relaxed the design will become.

A simple triangle design using hard ruscus (*R. hypoglossum*) to create the outline, reinforced with leather leaf, and large ivy leaves which give a smooth texture. Roses and open anemones create round focal interest with tulips and *Iris* strengthening the outline. The delicate spray form of broom (*Genista*) completes the design.

TIP The soft stems of anemones cannot be inserted into foam easily. Take a stronger stem of a similar diameter – such as that of a rose – and make a hole in the foam into which a softer stem can be inserted.

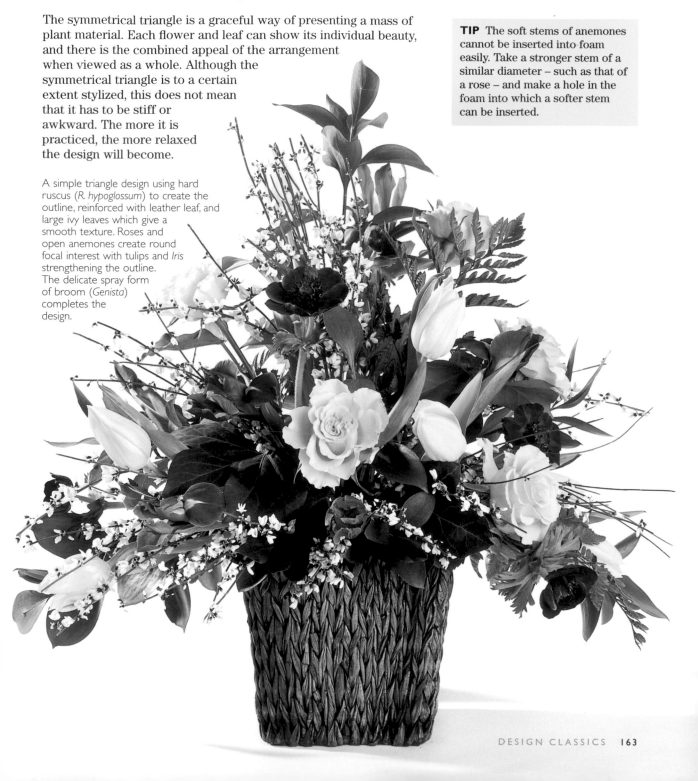

The triangle can be scaled up or down – you just need to consider the scale of the plant material used. The pedestal design, seen at most large functions, has never gone out of fashion and is simply a large version of the triangle.

Whatever the size of your triangle it is to be viewed from three sides – the front, the right and the left. It must therefore have plenty of depth with colour and flowers being taken around to the back.

The container and the mechanics

You will need a container that is raised, as you want the plant material to flow downwards. The piece of foam that you use needs to be square rather than rectangular and placed in the container so that the foam rises well above the rim. Leave sufficient space around the foam for a reservoir of water.

The plant material

The number of stems given is very approximate

- 9 – 11 stems line plant material for the outline such as hard ruscus, *Ribes*, salal tips
- 7 – 11 round leaves such as ivy, *Heuchera*, *Parthenocissus tricuspidata* – the larger the design the more ovate the leaves can be
- 6 – 9 line flowers such as roses in bud, lavender
- 3 – 7 round flowers such as open roses, small sunflowers, mini gerberas
- spray flowers and foliage such as *Phlox*, × *Solidaster* or waxflower.

The method

1. Place a stem or branch of line material centrally, two-thirds of the way back in the foam. This stem (a) should be approximately the height of the container plus the foam.

2. Insert two more line stems to create a triangle ABC. As a very rough guide, these two stems (b) should be two-thirds the length of the first placement and should be angled downwards out of the foam. If it is available, choose plant material that has a natural curve in the direction in which you wish it to flow. The remainder of the line material, which you use to complete the skeleton, will keep within the triangle ABC that you have now created.

3. Place two stems (c) half the length of (b) over the front rim of the container and repeat at the back. Remember that all stems should appear to radiate from the centre of the foam.

4. Place stems (d) in position. It is important that these stems radiate from the centre and fill in the triangle ABC. As a rough guide, they should be approximately half the length of (a).

5. Fill in the shape you have created with more line material to give it form. Add your smooth textured leaves. They should reinforce the outline. They should not be used to hide the foam.

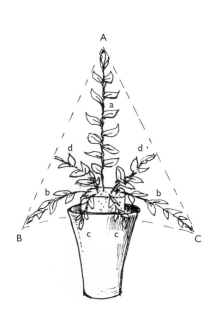

6. Add your line flowers, round flowers and spray flowers to get a pleasingly full arrangement. Ensure that the weight is equally distributed each side of the central axis. The bottom half of the design will be visually heavier than the top half, but it should not be too obvious. There should be no large gaps between the stems of plant material, although there will be more space towards the extremities of the design. Check that you have plant material flowing downwards at the back and that your arrangement is not flat. Filling in the back gives depth and adds interest. Create your focal area close to where stem (a) enters the foam. The more experienced you become in creating the symmetrical triangle, the more relaxed the design will look and the more you will successfully break these guidelines, without destroying the overall triangular form.

Where to place a symmetrical triangle

Symmetrical triangles need to be placed centrally, on a chest of drawers, chest or table, rather than to one side, close to a wall. The balance and outline of the arrangement are equal each side of the central axis and this balance needs to be repeated in the arrangement's setting.

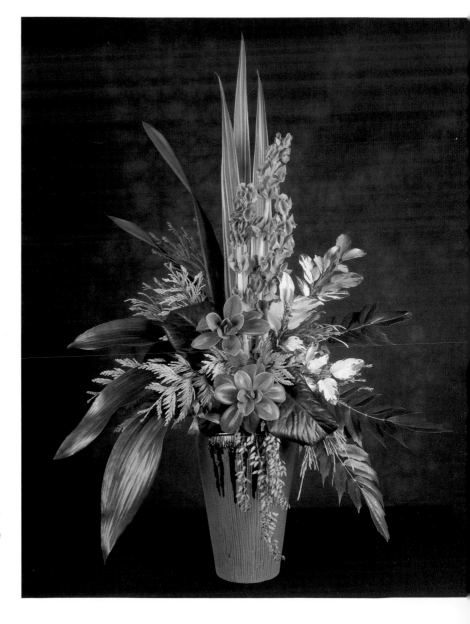

A centrally placed triangular arrangement composed solely of foliage. This includes *Aspidistra elatior*, *Mahonia x media* 'Charity', *Thuja plicata* 'Zebrina', *Griselinia littoralis* 'Bantry Bay', variegated *Cordyline*, *Phormium* 'Sea Jade' and bells of Ireland. Dominance is provided at the focal area by *Bergenia* 'Sunningdale' and by succulents. The fruits of *Mahonia* are trailed down over the front of the pot.

The pedestal

A pedestal arrangement is a large scale design suitable for a church, reception indeed any large space. The height of a pedestal normally ranges from between 6ft 6in (2m) and 10ft (3m) tall.

The symmetrical aspect of a pedestal is important as in a large space it is viewed on three sides – from the front and from both the sides. It must therefore have plenty of depth with colour and flowers being taken around to the back.

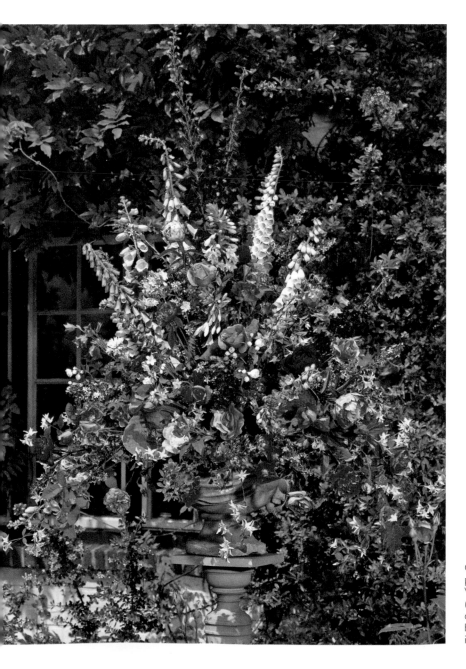

One of my favourite designs – a fabulous pedestal of summer flowers by Françoise Vanderhagen of Belgium – foxgloves (*Digitalis*), delphiniums and peonies are complemented by the bold blue-green hostas. All the elements of this design are in scale.

The container and the mechanics

You need a stand and a container. A plinth is ideal for a pedestal and instructions on how to make a simple plywood plinth are given in 'Large scale arranging' (Chapter 11).

The ideal container is a 25cm green plastic pot bowl. I like to insert one piece cut from a OASIS® Floral Foam Jumbo Brick rather than two bricks strapped together but if Jumbo bricks are difficult to find two bricks are fine. The foam needs to be about 15cm (6in) above the rim of the container. Allow space for water to be added as the stems in a pedestal need a lot of water.

The plant material

For a standard sized pedestal the recipe below provides a good middle priced design:

- one bunch line foliage such as beech, rhododendron, whitebeam *(Sorbus aria)*, Douglas fir, long *Eucalyptus cineraria*
- 5 – 7 stems kentia or *Phoenix* palm
- 10 *Aspidistra* or *Fatsia* leaves
- 5 – 10 line flowers such as *Delphinium, Antirrhinum*, stocks and Chinese lanterns
- 7 – 11 large round flowers such as open lilies, *Gerbera*, bloom chrysanthemums, large open peonies, *Hydrangea*
- 7 – 11 stems spray flowers such as lisianthus *(Eustoma) Solidago*, waxflower
- One other flower of choice may be needed depending on the finished size.

The method

The method is exactly the same as for the symmetrical triangle. One of your objectives is to conceal the plastic bowl. This is easily achieved by angling the plant material down over the rim. As an extra idea take trails of any climber or traling plant such as ivy or *Amaranthus* and drape them around the pedestal stand, ensuring that the arrangement remains well balanced.

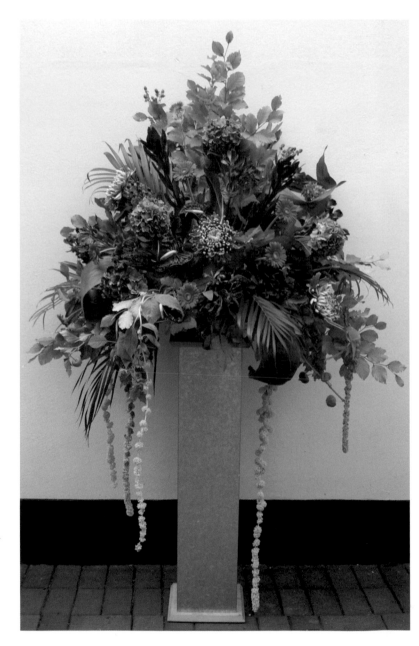

Beech (*Fagus*), *Phoenix* palm and *Aspidistra* leaves give the foliage structure. Linear *Physalis* take colour to the extremities of the design. The round form of *Hydrangea* and bloom *Chrysanthemum* give a strong focal area. *Leucadendron* 'Safari Sunset', *Anthurium, Alstroemeria* and mini *Gerbera* give added interest.

The asymmetric triangle

A good asymmetrical triangle is difficult to achieve, but immensely satisfying when it works. It is ideal for positioning on one side of a piece of furniture, where it will complement and balance a lamp, picture frames or a favourite ornament on the other side.

Asymmetrical balance occurs where the weight and outline each side of the central axis are different. So why does it not appear unbalanced? In a good asymmetrical design sound balance is achieved by scooping out the longer side of the triangle to make it less dominant and with judicious placement or incorporation of an accessory. Alternatively, an accessory can be placed on the lighter side and its additional weight will give visual balance.

The container and the mechanics

You will need a low container. You could use the larger plastic dish with one-third of a block of foam. Alternatively, use a container on a short stem. Chamfer the edges of the foam (see 'Techniques' on page 400).

The plant material

- 3 stems line foliage such as *Escallonia*, *Eucalyptus*, rosemary
- 5 – 9 stems broader foliage to fill in the shape
- 3 – 7 large leaves such as ivy, *Hosta* or *Bergenia*
- linear flowers, ideally with a more flexible rather than a rigid stem to follow the direction of the line foliage
- round flowers
- spray flowers and foliage.

An asymmetric design where a contemporary feel is acheived through the grouping of the plant material.

The method

1. Your tallest stem (a) should be linear, ideally with a gentle curve. It should be placed towards the back of the foam, two-thirds over to one side.

2. Your second stem (b) should be about one-third the length of (a), angled slightly towards the viewer. The third stem (c) should be about two-thirds of (a), also placed towards the viewer. These three stems will create the triangle ABC. Ideally stems (b) and (c) should also be gently curved.

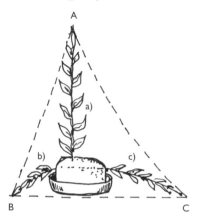 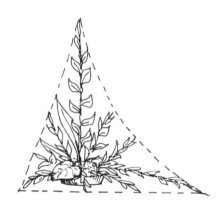

3. Place your heavier smooth textured leaves in the short side of the triangle and your lighter material in the longer side.

4. Create your focal area at the base of the tallest stem (a). Fill in with spray and any other suitable plant material.

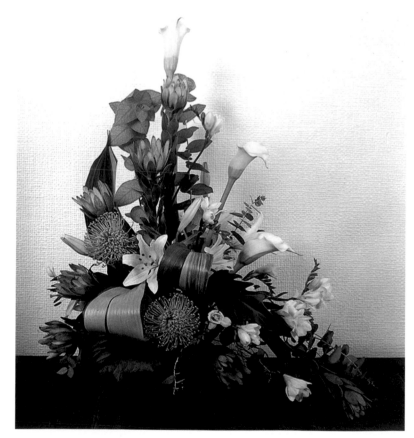

Pincushion protea (*Leucospermum*), *Leucadendron* and rolled *Aspidistra* leaves form the heavier side of the arrangement and the *Freesia* with callas the lighter side.

Curvilinear arrangements

Downward crescent

This is a graceful design using a small amount of plant material, that looks most effective. It is very important to use loose, flexible plant material to create the crescent shape, otherwise the design will appear rigid and inflexible rather than gently flowing.

The container and the mechanics

It is essential that a tall container is used and that you have curved line plant material to create your downward sweep.

If you are using a tall container without an integral dish, fix a candle-cup to the container and then add your foam. A cylinder of foam is appropriate for most candle-cups (see Technique 7 on page 402).

The plant material

- Soft flowing plant material is essential for this design. An outline of rosemary or *Eucalyptus* is ideal.
- Line flowers are important as you want the colour to be taken out to the limit of the design.
- a few round leaves
- round flowers
- filler flowers and foliage.

The method

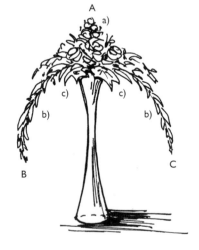

1. Place stem (a) centrally. This determines the maximum height of the arrangement and should be one third the height of the container (approximately).

2. Insert curved plant material from each side of the foam so that it flows gently downwards (b). These stems should be approximately twice the length of stem (a) or about the height of the container, if they were straightened. Avoid positioning the stems so that they appear to be falling out of the foam.

3. Place two short stems (c) over the rim of the container at the back and front. Place stems out of the top (d) to fill in the triangle ABC. Ensure that all stems radiate from the central area. You will be using only a small amount of plant material and it is important that the geometric form is not lost at this stage.

4. Place smooth textured leaves throughout the design. Add line flowers, focal flowers and fill with your spray plant material.

right
In this downward crescent *Eucalyptus parvifolia* and Singapore orchids create the outline, *Heuchera* leaves give smooth texture and a round form, roses and lilies give focal emphasis and *Hebe* acts as the filler.

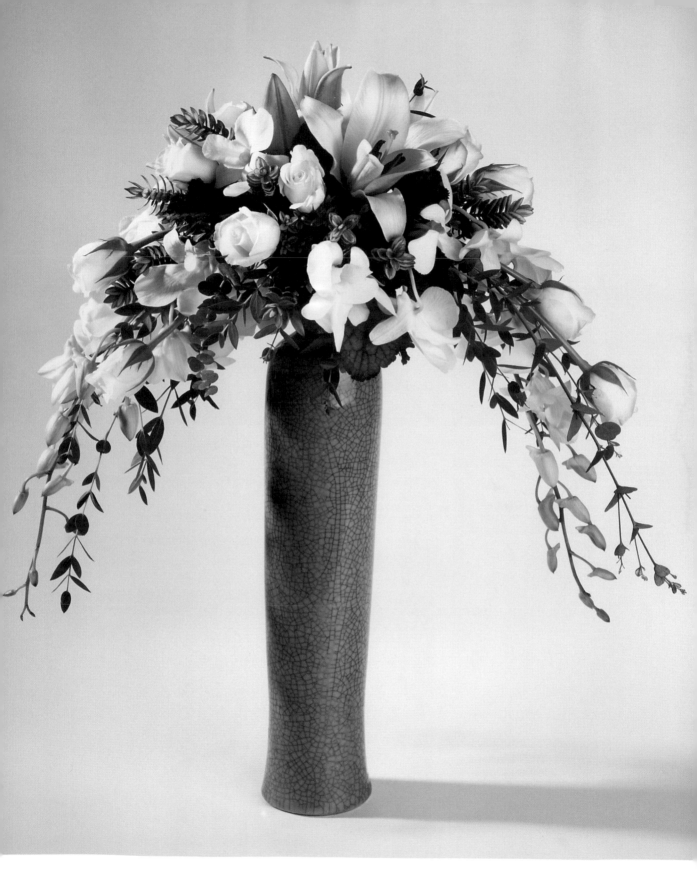

Upward crescent

An upward crescent is a stylized design with plenty of charm. It is particularly appealing when used to complement a special plate, as the shape repeats that of the arrangement. It creates an effective design with a minimal amount of plant material.

The container and the mechanics

For smaller crescents a pin-holder is usually more successful than foam. You are only using a relatively small amount of plant material so the piece of foam is correspondingly small. Stems tend to twist round just when they seem firmly in place. For larger designs where a larger piece of foam is used the stems are easier to control.

The plant material

Curving plant material, such as broom (*Cytisus*), rosemary (*Rosmarinus*) or branches with or without blossom is essential. If you do not have these, try another design. You will also need round smooth textured leaves and round flowers.

The method

1. If you are using a pinholder, place this in a low dish but one that is sufficiently deep to allow water up to the tips of the spikes.

2. Gently accentuate the curve of the plant material, if needed, with warm hands.

3. Make two placements of curved plant material and reinforce without making the curves heavy.

4. Place focal material at the centre of the design.

5. Fill in with other foliage but ensure that you keep an overall crescent shape.

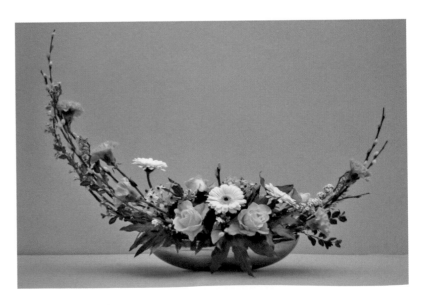

Pussy willow (*Salix*) and *Spiraea* 'Arguta' create the upward curves. To create a curve where none exist, manipulate the stem with warm hands. × *Fatshedera* leaves give smooth texture, roses, mini *Gerbera* and carnations give focal interest and chincherinchee (*Ornithogalum*) gives spray form and completes the design.

The S-curve

An S-shaped arrangement is called a 'Hogarth' curve, named after the great eighteenth-century artist who considered this the most beautiful form of art. If you create an upward Hogarth, you need to consider the fundamentals of good proportion so that you have approximately three-fifths of the arrangement above the centre of the foam and two-fifths beneath. You could also think of it in terms of the upward curve being one and a half times the length of the lower curve.

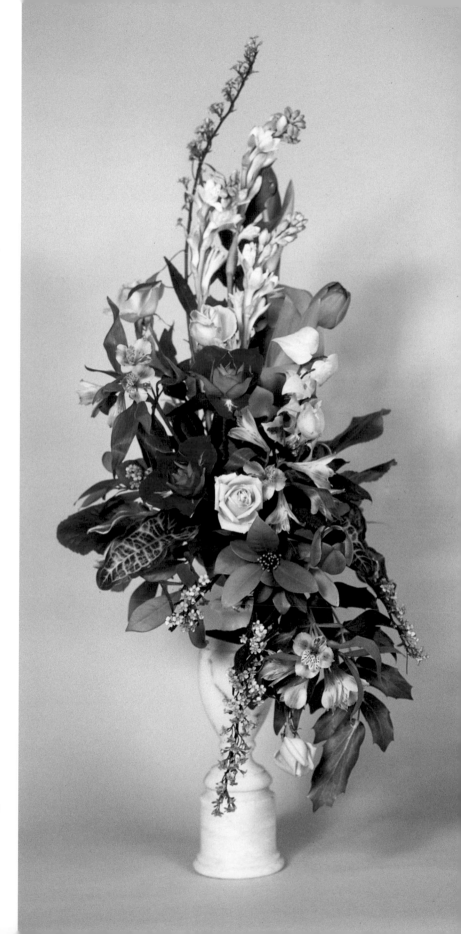

Euphorbia fulgens and tuberose (*Polianthes tuberosa*) create the outline. The leaves of *Arum italicum* subsp. *italicum* 'Marmoratum' give the smooth texture, roses and tulips give focal interest whilst *Alstroemeria* fills in and supports the other flowers.

Upward 'S' curve

The container and the mechanics

A raised container and curved plant material are essential for this design. If a bottle or a candlestick is being used, add a candle-cup containing the minimum amount of foam that will hold your stems in position.

The plant material

- curved plant material to create the 'S' shape
- round flowers for the focal area of the design
- round plain leaves to help cover the foam and to highlight the round flowers
- spray flowers and filler foliage.

The method

1. Place one curved stem (a) towards the back of the foam, so that the tip is in line with the stem of the candlestick. This needs to be about one and a half times the height of the container without the height of the foam.

2. Add a second stem (b) about two-thirds the length of the first stem (a). This should come forward towards the viewer and curve towards the stem of the container.

3. Round smooth textured leaves should be added around the central area.

4. Graduate your flowers from the centre outwards, towards the tips of your line material, placing the most dominant flowers centrally. NB. Do not make the design too wide at the centre – maintain the elegant S-line.

5. Add other plant material to fill in the form so that there is a smooth flow from top to bottom.

As an alternative a more horizontal 'S' curve can be created in a tall container, the proportions, however, remain the same.

Horizontal 'S' curve

The container and the mechanics

For this arrangement you will need:

- a foam ring sawn in two and placed to form an 'S', or
- rectangles of foam wrapped in cling film or thin polythene. For the second method you can reinforce the part that will be making contact with the table with strips of thick black bin-liner.

The plant material

- foliage to cover the foam
- round flowers
- spray flowers.

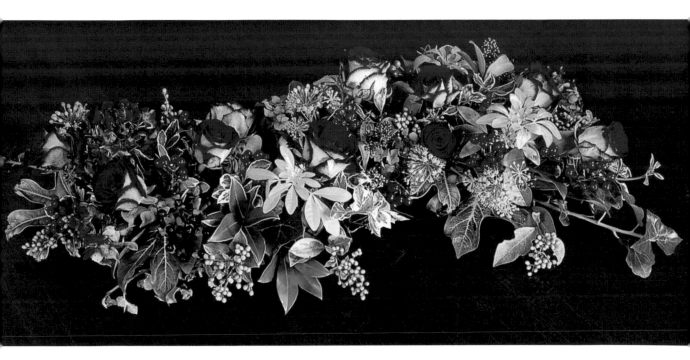

The method

1. Use a mixture of foliage to cover your foam. Keep your stems short and be sure to angle some down over the rim of the ring. You can extend the length of the 'S' by using longer-stemmed plant material at the extremities, but be sure to follow the curve of the 'S'.

2. Add some smooth-textured plant material.

3. Place your focal flowers throughout the design. Keep them reasonably central but avoid positioning them in too regular a line. They are the most visually dominant part of the design and if you place them in the outer limits you will disturb the smooth flow of the 'S'. Fill in with your other plant material.

Vertical arrangements

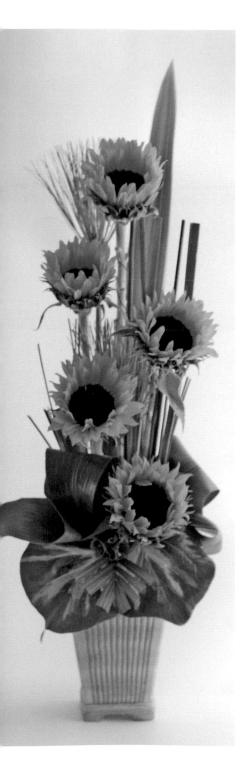

Five sunflowers (*Helianthus*) in a tall container create height in this striking vertical design.

A vertical arrangement is simple and often economical to create. It is ideal when space is at a premium and you want a bold, simple statement of flowers. Depending on your home, it could be the perfect arrangement for an entrance hall, porch or niche. A vertical in a low container is ideal for showing off the lofty stems of iris, sword lilies (*Gladiolus*) and amaryllis (*Hippeastrum*). A tall container is ideal for shorter straight stems.

In a tall container

The container and the mechanics

The container needs to be strong and robust to give good balance. If the container is slender or intricate the vertical will look as if it is about to topple over. Fix a small dish containing foam to the top of the container or wedge foam into the opening.

The plant material

- plant material with straight stems
- plain leaves may be necessary to hide the mechanics
- round flowers.

The method

1. Place your tallest stem centrally. This should be approximately twice the height of the container.

2. Place your focal flowers at angles coming down towards the rim of the container, reserving the brightest or largest flower for the bottom. The bottom placement should be in line with your tallest stem.

3. Fill in the design with foliage, ensuring that there is a leaf underneath the bottom flower otherwise it can give the impression of falling out. Keep the overall form narrow, repeating the upward movement of the container.

TIP With a restrained use of plant material, proportion is adjusted so that in the tall design with the sunflowers the plant material is twice the height of the container. In the low design with the iris, the plant material height is twice the width of the dish.

In a low container

The container and the mechanics

You will need a low dish that will take a pinholder and sufficient water to cover the top of the pinholder. You may wish to place florists' fix on the under-surface of the pinholder which will adhere to the container for extra stability.

The plant material

You will need only a few flowers, but to give contrast they should be in varying stages of development. A few plain round leaves can always be used to hide the mechanics.

The method

1. Place a pin holder in the centre of your bowl and arrange your flowers at different heights and at different angles. If you are using five to seven stems, place the tallest leaning slightly backwards and add the others at different heights. Your tightest bud should be at the top of the design and your fullest bloom reserved for the bottom placement. If you are using lilies you may need only two or three stems.

2. Add large plain leaves and/or flat stones or glass chunks at the bottom of the stems to give textural contrast and to hide your pin holder.

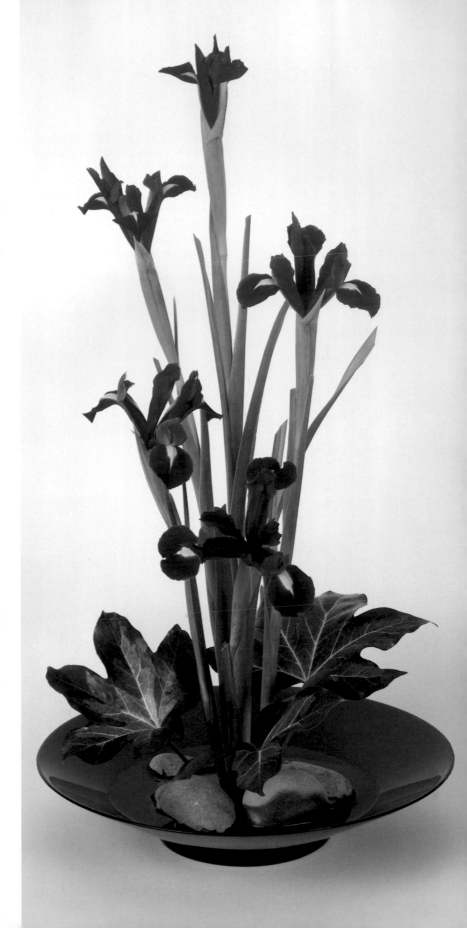

Landscape designs

The effect of this landscape design succeeds through its restraint and careful placing of material – all in scale. The plant material includes the seedheads of large cuckoo pict, *Arum italicum pictum*, love-lies-bleeding (*Amaranthus*), fern, *Sempervirens* and umbrella plant (*Cyperus involucratis*).

A landscape is a naturalistic design, capturing the essence of a lakeside, wood, seashore, mountain or moorland scene. The judicious use of scale is vital for an effective design, for you are taking a particular scene and reducing it in size so that it can be appreciated in the home. For the flower arranger the landscape design is one that can give great pleasure at minimal cost. To quote Jean Taylor in *'Creative Flower Arrangement'* (1973), "The secret of composing a good landscape lies in the use of restraint, for one or two brown leaves suggest autumn, a trickle of sand – the beach, a little moss – woodland."

Enjoy your landscape design. For your first attempt you could ignore all the good advice and just have a go.

The container and the mechanics

Containers are rarely, if ever, seen – for when would you see a container in nature? Water often plays an important part in a landscape design, and where this is evident the container should be of lead, pottery, or any other material that is in harmony. It is rarely left totally exposed for the rim is usually softened with moss, stones or other natural material.

The plant material

Plant material must be chosen with care. If you wish to depict a seascape, the flowers need not be entirely those that thrive by the sea, but they should be of a colour and compatibility with those that do. A hedgerow scene could include old man's beard (*Clematis vitalba*), hips, haws, ferns and berries, and a moorland scene heather (*Calluna vulgaris*), common cottongrass (*Eriophorum angustifolium*), gorse (*Ulex europaeus*) and moss.

The accessories

Accessories should be in keeping. If you wish to add birds or animals to complete the scene, use those which look realistic, with a matt rather than a shiny finish, and endeavour to keep them in scale. Too many accessories will spoil the effect.

The method

- Although you are dealing with an *illusion* of scale, do try to avoid creating a scene where the branch representing your tree is the same height as your flowers.

- A base is important to unite the different elements that will constitute your landscape design. Perhaps you are using a dish for your water, some pebbles and moss, two hidden dishes containing your plant material and a bird or woodland animal. Without the unifying base these various elements could well appear disparate, rather than a well-planned microcosm of an inspiring scene. Avoid over-basing the design, with too wide or thick a base or too many levels of base.

Pot-et-fleur

A pot-et-fleur is a delightful name for a planted bowl of houseplants and cut flowers. The pot plants create a long-lasting framework and the flowers give colour, form and variation. You can alter your designs each week simply by changing the flowers. A 'plants and flowers' design could include extra cut foliage but a pot-et-fleur would not include any additional foliage. You can choose plants that would not survive outside, which give a wonderful range of exotic leaves for gentle snipping.

There are two ways in which you can create the framework for your pot-et-fleur. You can arrange your pots directly in a basket or bowl, so that they can easily be changed, or you can try the following method.

The container and the mechanics

1. Choose a container of a suitable size. If it is porous or of basketry, line it with a piece of thick black bin-liner.

2. Place a thin layer of broken pots or small pieces of expanded polystyrene chips in the bottom of your container.

3. Scatter some powdered charcoal over the crocks or polystyrene. This will keep the pot-et-fleur smelling sweet.

4. If you are taking the plants out of their pots, pour a layer of *Super Natural Multi-purpose Houseplant Compost* or *John Innes no.2* over the charcoal. If they are to remain in their pots, simply place these on the charcoal. This compost can also be used to raise the level of pots that are not as deep as others.

The plant material

If you select a pleasing combination of pot plants, then your pot-et-fleur will be a success. You can either choose a selection of different plants, each complementing the others, or you can create a massed effect using several of the same variety. If you are choosing different plants consider the following:

a) Your plants will be living together in close proximity. They should therefore thrive under similar, rather than contrasting, conditions: that is to say, do not plant a cactus in the same bowl as a plant that needs copious amounts of water.

b) You can start your selection with a pot plant that you already have in your home and choose others to complement it. Alternatively, take your basket or bowl to the garden centre and try out a combination in situ.

c) You will need contrast of form and texture. If you are mixing your pot plants in a traditional design you should consider buying at least one of each of the following:
 – a tall plant for the back, such as weeping fig (*Ficus benjamina*) or one of the palms such as parlour palm (*Chamaedorea elegans*) or areca palm (*Dypsis lutescens*),
 – a trailing plant, such as an ivy (*Hedera*),
 – a more compact or bushy plant, such as a *Begonia*,
and one plant should have a smooth, plain leaf.

d) For a pot-et-fleur, be careful how many flowering pot plants you use, as they may detract from the cut flowers. Take care also that you do not include too many variegated plants as they can create a fussy effect.

The method

1. Prepare your container as mentioned above.

2. Place your plants in a pleasing composition, leaving space into which you can position the jar or pot that will contain the cut flowers.

3. Position your flowers in a jar or on a pinholder placed in a container. You will need only a few bold flowers to complete your pot-et-fleur.

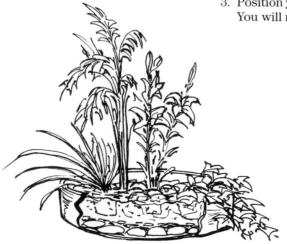

NOTE A planted bowl is a group of pot plants in one container without the addition of cut flowers.

This pot-et-fleur of cut tulips and
Primulus pot plants is easy to make and
long-lasting. Just replace the flowers in
the inner container when appropriate.

7

Contemporary floral design

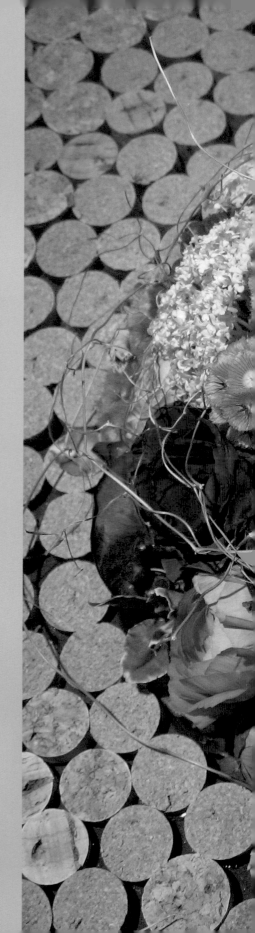

Contemporary Floral Design ('CFD') is the term given to styles that have broken with tradition and represent a new age. In this section I have placed styles that have developed in the past 30 years and follow on from each other. These styles have their roots in different cultures and different countries and have been created both by flower arrangers and florists. The list is not conclusive – other trends have come and gone – but I believe these have a good chance of being around for many years to come.

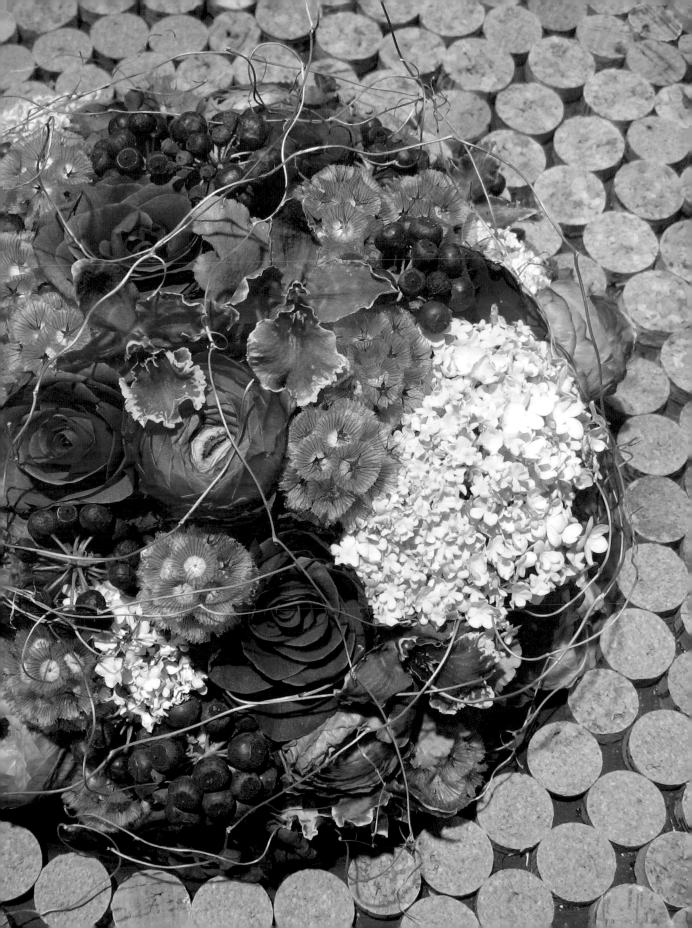

previous page
A tapestry of *Scabiosa* seedheads, *Ranunculus*, roses, *Hedera helix* berries, *Viburnum opulus* and *Cattleya* orchid heads

NOTE Many of these designs originated in continental Europe so their descriptions were in the German, French, Italian, Dutch or whatever. Generally accepted translations of these descriptions into English have not emerged in all cases. I have used what I consider to be the best English word for each. In some cases, I indicate alternative translations where they are in common use.

In Classic Design certain factors are common to all the arrangements. In Contemporary Floral Design, however, nothing works quite so neatly. What is common to all the arrangements, both classic and contemporary, is the good use of the elements of design: colour, form, space and texture as well as the principles: scale, proportion, contrast, dominance, rhythm, balance and harmony.

The first four styles discussed – Free-form, Modern Spatial, Abstract and Still Life – have no set formula that can be laid down. They could be said to lay the foundations for CFD rather than being part of it. I have described general characteristics for these styles. The rest is up to you!

Free-form designs

Free-form or free-style, as it is also known, first appeared in the last half of the 20th century and was influenced by modern Japanese styles of Ikebana and by new trends in home decoration. This style evolved as a reaction to the geometric arrangements which, over the years, had become rather too predictable and static. It gave a freedom to design and led to new and original work.

A free-form design by Marian Aaronson which is not based on a fixed pattern but is guided by the nature of the plant material. The elements used are bold and dramatic in line, colour and texture, to achieve design impact with a restricted number of units.

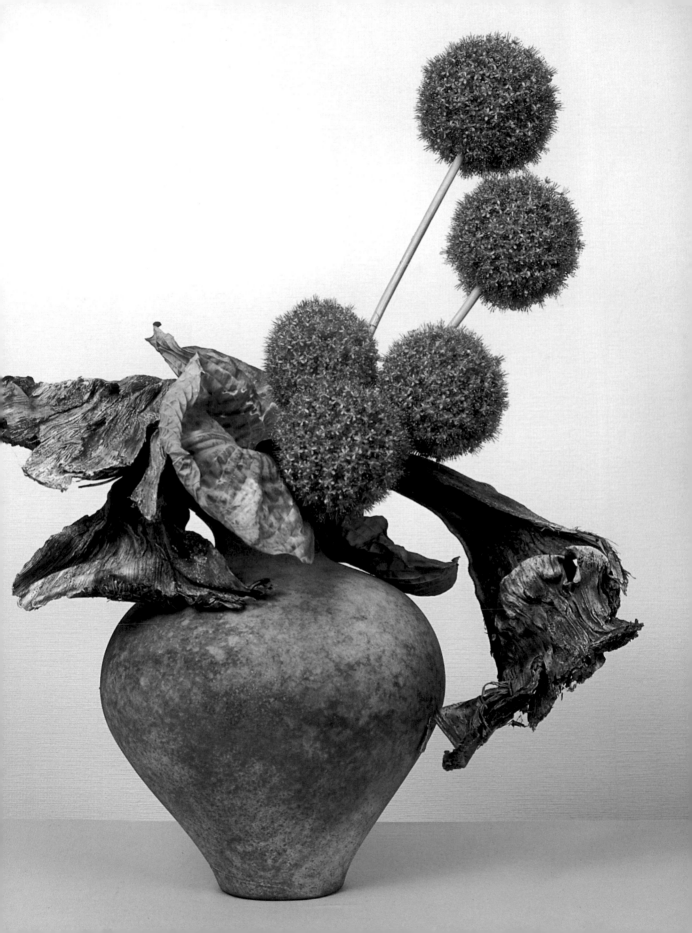

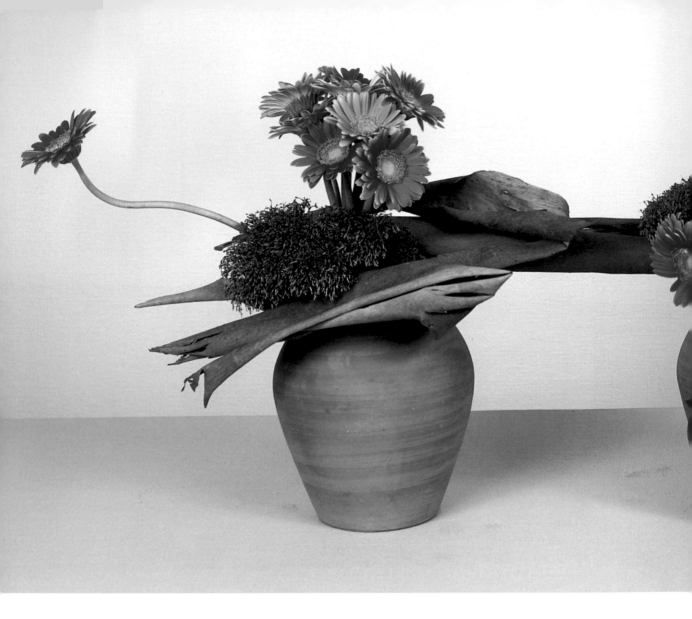

Free-form can be defined as free and imaginative designs inspired by nature's growth patterns. They are created with a more restrained amount of plant material than that used for geometric arrangements. But good examples of free-form design are always harnessed to the elements and principles of good design. Think of free-form as being free from traditional patterns. Just as Picasso was able to paint beautifully in a naturalistic way, so the best free-form designers are still able to create traditional masterpieces.

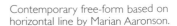
Contemporary free-form based on horizontal line by Marian Aaronson.

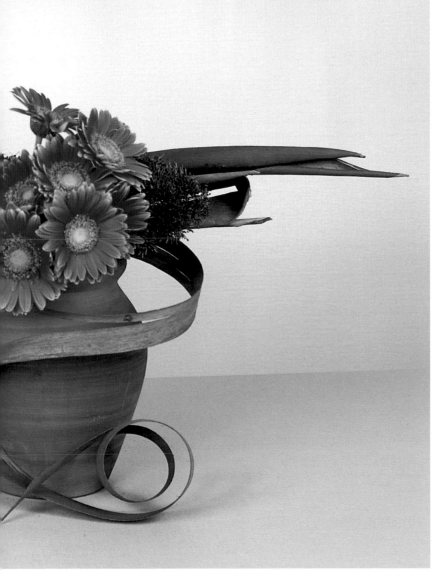

Characteristics

- The shape is determined by the nature of the plant material and cannot be reduced to any sort of discipline or control.
- The designs break completely with geometric designs such as triangles and crescents.
- There should be an emphasis on space.
- There is lots of flowing movement.
- The balance is usually asymmetric.
- Depth is extremely important.
- Leaves and stems can be curved, bent or looped to create new forms and enclose space.
- There is always a feeling of enjoyment and exuberance.
- A wide diversity of containers may be used but generally they are unsophisticated.
- Textural differences create impact.

Modern spatial designs

Modern spatial or modern designs, as they are often called, developed from free-form designs. Marian Aaronson, perhaps more than any other, was the protagonist of this style which at a later point developed into '*Abstract*'. Her first book published in 1971, entitled '*Design with Plant Material*' led the way.

The title 'modern' could now be considered an anachronism, as other styles, such as sculptural and parallel, have evolved that do not bear the same characteristics. I therefore prefer modern spatial design. This style relates to flower arrangements that show a restrained use of plant material and emphasize the use of space.

So how do modern spatial designs differ from free-form? Perhaps it can be best summed up that modern spatial designs have a more structured and controlled form, and that in the main they use less plant material.

Like free-form design before it, modern spatial design came into being to keep up with the ever-changing styles of architecture and home decorating, and with the increasing economy of time and money. It was called 'modern' because at that time it was new, fresh and entirely different.

Characteristics

- Makes restrained use of plant material, in quantity and/or variety, with emphasis on form, texture, colour and space, often with dramatic contrasts.
- Dramatic plant material is important. Flowers can be subsidiary to dried plant material – such as spathes and driftwood – and sometimes are not even included.
- Space is not equally distributed throughout the design.
- Space is often used to balance a heavy solid and becomes even more emphatic when enclosed.
- Each component is appreciated for its own merits and for its contribution to the design as a whole.
- Anything can be used as a container – a bottle lid hidden by a piece of wood, pottery (but not a classic vase).
- Depth is vital.
- Textural contrasts are extremely important.
- There is a lack of transition.
- Good balance is absolutely essential. It is not apparent in the same way it is in classic design but it is always evident.

A modern spatial design by
Marian Aaronson which relies on the
strength of a few carefully chosen
elements for a powerful linear and spatial
pattern. The 'pull' of contrasting lines
creates important areas of space and a
lively rhythm.

Abstract designs

The term 'abstract' refers to an arrangement in which the plant material is used only for its colour, form or texture. The emphasis is on design. There is no attempt to place plant material so that it appears to be growing naturally. Abstract design uses the form, colour and texture of plant material to create a design, rather than a flower arrangement *per se*. Thus a flowering onion (*Allium*) is used because its colour and form give a purple sphere; the form of an open lily (*Lilium*) gives a trumpet; bulrushes (*Typha*) give lines; a teasel (*Dipsacus fullonum*) prickles. A good abstract flower arrangement can only be created by someone with a developed sense of design. Just as the greatest artists and sculptors were, and are, capable of creating both representational and abstract design, only experienced flower arrangers can create the powerful images portrayed by an award-winning abstract design.

It is said that abstract flower arranging will never have the same following as classic design work. Why not? Perhaps because it is bold and dramatic, rather than pretty, and therefore needs a plain dramatic background to reinforce the drama of the design. Dramatic backgrounds are not found in every home. Another factor could be that many abstract designs rely on plant material that is not often found in the garden.

A good abstract design relies on hard work, inspiration and the right materials. Such designs may not always appeal, and readers may not wish to move in this direction, but abstracts should always be respected, as they reflect the innermost thoughts of their creator. For the creator of abstracts a successful design brings immense satisfaction.

Characteristics

- Interest is distributed throughout the design rather than in just one area.
- There should always be strong rhythm throughout the design, achieved by the judicious placing of every element to create a strong pattern.
- Space is integral to the design and should be considered part of it. Enclosed space has a powerful impact and can be used to balance the weight of solid objects. It also connects one side of the design with the other, making it immediately more three-dimensional.
- Plant material is used for its texture, colour or form alone – there is no pretence of presenting it so that it appears to be growing.
- There are no unnecessary additions to the design, which is pruned to its bare essentials.
- Balance is absolutely vital. The focal area may be one of many and placed in unconventional areas of the design. As Julia Berrall says in her *History of Flower Arranging* (1969), "Successful contemporary creations call for a basic knowledge of design used with acute sensibility to the demands of perfect balance."

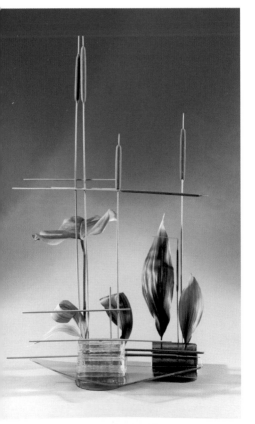

A late modern spatial/early abstract design by Marian Aaronson, circa 1975.

- Contrasts are usually dramatic, and there is little transition.
- Containers are usually hidden or vegetative.
- Plant material is usually bold and arresting. Evergreen leaves such as New Zealand flax (*Phormium tenax*), Japanese aralia (*Fatsia japonica*) and cast iron plant (*Aspidistra elatior*) can easily be manipulated to give exciting new forms. In their own right they give bold form and strong line. Exotic dried material also gives the required form.

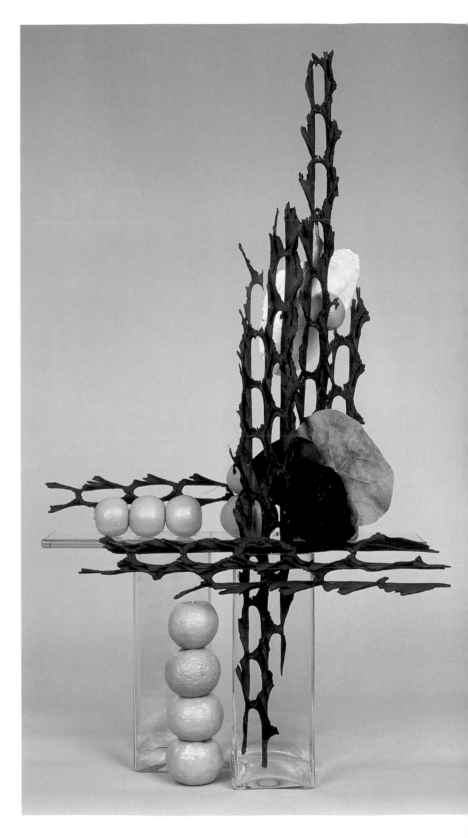

Design itself is the feature of this non-naturalistic, abstract design by Marian Aaronson – with the elements of form, colour and texture presented in a non-natural way – to create a well-defined and visually exciting pattern. As you see, there is no obvious central, or single focus, so that the eye can seek the interest throughout the design, which improves its rhythm and avoids a static effect.

Still life

A still life is where plant materials, either fresh or dried, are grouped with inanimate objects. Its characteristics are use of rhythmic forms, texture, colour and excellence of overall design. Plant material does not necessarily have to predominate in a still life study.

Still life in painting originated in Europe, in particular in the Low Countries and in Spain, during the fifteenth and sixteenth centuries, although they took as their example the frescoes and mosaics of ancient times. They were considered at that time a lesser form of art – after the more prestigious portraiture and landscape painting but still life has proved extremely popular over the centuries. Today exhibitions draw millions of viewers to revel in the almost photographic representations of vegetables, flowers, fruit and game, sometimes with the theme of the vanitas – the symbolic tokens of the transience of human existence on Earth.

In flower arranging today, creating compositions with flowers, fruit, vegetables and inanimate objects is simple yet effective.

Characteristics

Still life by the French impressionist Auguste Renoir (1836-1909).

- The various components which make up the still life should be life-size rather than scaled-down versions.
- The flower arranging placements should be informal, i.e. not triangular in form but a few stems in water with no sophisticated mechanics.
- All the components should be in harmony with each other. For example a kitchen still life could include pans, vegetables, pottery, fruit and foliage, but the inclusion of an ormolu urn would appear incongruous.
- Look at the still life work of Van Keemskerk, De Heem, Picasso, Cezanne and Renoir.
- There should be a feeling of stillness/tranquility conveyed.
- Fabric (a cloth or similar) is often incorporated running through the design and falling over the front edge.
- A base – suggesting a table or tray – is often utilised.
- There may or may not be a theme.
- Inanimate objects can be period or contemporary.

right
Beautiful blue glassware skillfully combined with fruit and vegetables give a simple but stunning 'still life'.

The parallel style

This parallel design can be as long or short as you wish. The tall upright placements of flowers are balanced by visually heavy grouping of flowers and foliage at the base.

This style, sometimes known as a 'continental' design, is very distinctive. Such designs have long been created by Dutch florists, but it was only in the late 1980s and 1990s that they became generally popular and practised in Britain. The style has been adapted to the plant material available in the typical British garden, to which it is well suited. It is ideal for decorating long straight areas that are viewed from more than one angle, such as an altar, windowsill or choir stalls in a church.

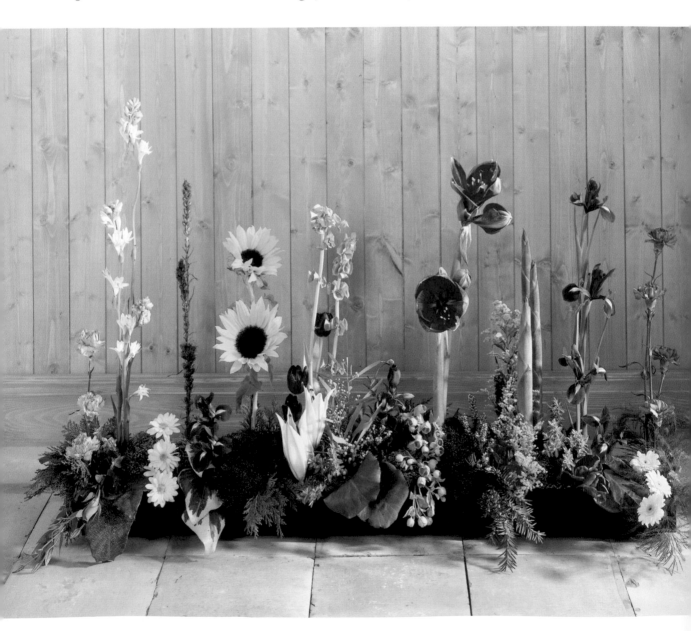

Characteristics

- The principal difference between this and any other design is that there is little or no radiation. The rationale is to make plant material look as natural and unstylized as possible, following its natural growth pattern.
- Flowers are usually grouped, rather than scattered throughout the design.
- There is great emphasis on texture and form. It is sometimes viewed as a patchwork design, creating areas of contrasting texture and form.
- There is a groundwork of short plant material with tall vertical placements of differing heights at intervals.

The container and the mechanics

Although the container can be rectangular or round – try a trough shaped container for your first attempts.

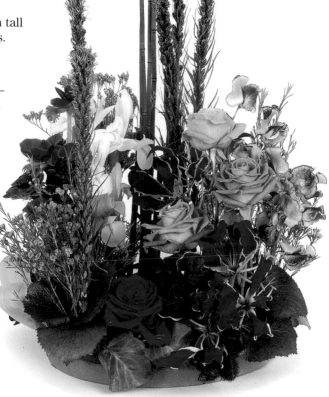

A parallel design arranged on a circular ring of foam.

You could use a foam ring, a 1950s log container, or a shallow plastic foam tray designed to take a block of foam. A plastic foam tray, cut in two lengthways, will give a narrower, rectangular shape to the arrangement. Simply slot one length over the other and then glue the join.

The plant material

- Tall linear plant material and/or round flowers with reasonably straight stems to create your tall placements.
- Round flowers to give interest lower in the design.
- Foliage to give contrast of form and texture and to cover the foam. Short snippets of *Hebe*, box or myrtle combined with layers of smooth textured ivy, *Bergenia* or *Heuchera* leaves work well.
- Fruit, vegetables, lichen, moss, Spanish moss (*Tillandsia usneoides*), sisal, seedheads and fungi all look good in the design. They can fill the design quickly and inexpensively.

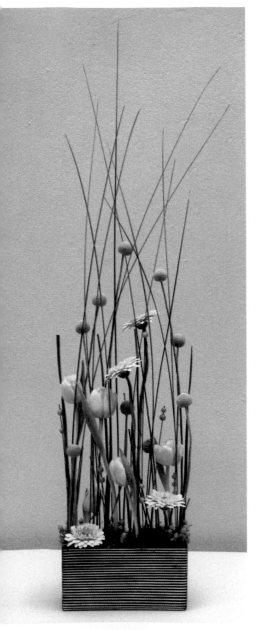

Hedging – The grasses create a frame for the *Craspedia*, germini/mini *Gerbera* and tulips.

The method

1. The foam should rise above the rim of the container but not too high. If the foam rises more than 5cm (2in) above the rim for a medium-sized design, then the arrangement tends to become bottom-heavy and rather leaden. You can pin lengths of flax or *Aspidistra* horizontally onto the front section of the foam to reduce its dominance should this be the case.

2. Gently chamfer the foam. (see 'Techniques' on page 400)

3. To give interest you will need placements at various heights. You could establish the tallest placements first, with line plant material, but avoid having these all at the same height. If you have a circular container try three or five taller groups and if you have a small rectangular container, two or more groups.

4. You will now need to cover your foam with plant material. This is kept short and used in blocks of contrasting form, texture and colour. It is often referred to as 'ground work'. 'Layering' is the term used to describe a mass of overlapping leaves which extend beyond the front and sides of a container. There is little or no space between the leaves which are angled downwards like tiles on a roof.

5. Rather than working your way systematically around or along the container, ensure good balance by moving from one area to another.

6. Contrast your forms and textures, placing smooth, plain leaves such as ivy (*Hedera*) next to more intricate plant material, such as veronica (*Hebe*).

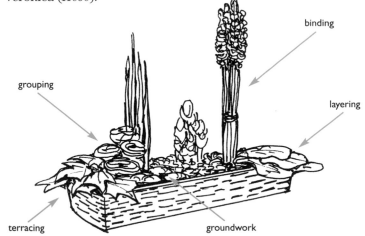

grouping

binding

layering

terracing

groundwork

Hedging

A new version of the parallel has developed in the 21st century and the influence appears to have come from Japan. It has continued the style of using vertical parallel stems but the emphasis is on:

- A limited number of different plant materials which are repeated consistently along the length of the design.
- A rectangular 'hedge-like' form.

Terms and techniques

Bundling

Sometimes the plant material in one of the taller placements is positioned so that each tip rises to the same height. In this instance the stems may be bare and can be bound with raffia, twine or wool. This is particularly suited for soft stemmed flowers.

Binding

If the tie is decorative and/or intricate, it is referred to as 'binding'. When using garden plant material it is more usual to give a softer look with graduated heights of plant material, but still keeping within a roughly linear framework. Some minor radiation may be evident.

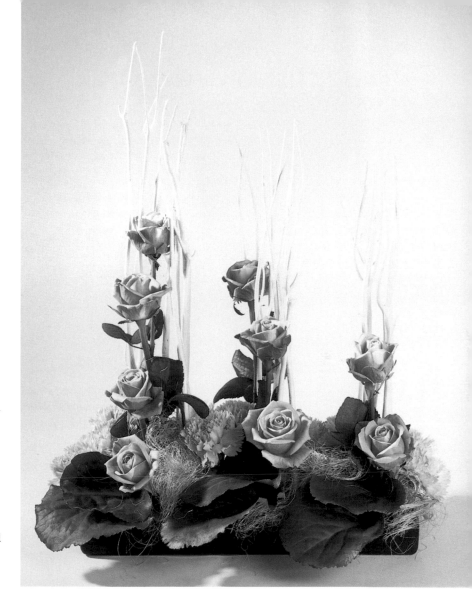

Hedging – Three vertical placements of roses are reinforced with white bleached twigs and with *Bergenia* leaves at the base. The idea is to create a parallel design with a limited number of components to give a modern twist to an established design.

Groundwork

Also known as Basework, Paving, Carpeting, Tuftwork and Patchwork. A mass of plant material usually low-lying, creates a carpet at the base of a design. The plant material forms patterns and trails. Taller or longer plant material may extend from this base.

Layering

This is where leaves of the same variety are grouped together and placed one over the other to achieve repetition and rhythm, often horizontally.

Grouping

This technique is used to create ordered and uniform designs, rather than those with a random effect. This can be achieved by placing numbers of plant materials of the same colour, texture or form together in groups.

Terracing

Similar to layering but with more space between the leaves.

Mass sculptural designs

A mass sculptural arrangement can perhaps best be described as a controlled design in which the plant material is chosen and displayed to create a dried, a living or a dried and living sculpture. The sculpture is created partly through the massive blocking of plant material to create bold, strong areas of colour, form and texture, and partly by the manipulation of foliage to create new forms and to liberate space.

In Britain this style of arranging has evolved from work that originated in Italy and France in the late 20th Century which in turn was influenced by the Grand Japanese Master Houn Ohara, of the Ohara School of Ikebana and Sofu Teshigahara of the Sogetsu School of Ikebana.

right
A mass sculptural design by Carla
Barbaglia using different forms. In this
design the shiny smooth *Aeonium*
contrasts with the rough mass textures of
the container, *Melianthus* and the dates.
The tips of the kentia palm were doubled
over to form a neat massed effect.

Characteristics

- Strong original line, rhythm and colour.
- Mass sculptured designs contain a restricted number of different types of plant material.
- Foliage and flowers can be blocked, excluding space to give strong, bold images.
- Balance is asymmetrical, as symmetrical design is considered static rather than dynamic.
- Good proportions are important.
- Containers are bold, strong and upright, with a simple structure, so that they form a happy marriage with the bulky plant material that is such an important part of the sculptural style.
- Rhythm is achieved by the flow of lines and the repetition of forms, volumes and spaces.
- The plant material is positioned so that it covers the rim of the container.
- Inspiration comes from nature's patterns and the world of art and sculpture.
- Sophisticated manipulation of plant material.
- Strong textural contrasts are essential as the number of elements used are limited.
- The foam must rise well above the container and this can be achieved by:
 a) inserting a plastic plant pot of exactly the right dimensions into the opening of the container. This is then filled with foam and secured with florist's tape, with a reservoir of water in the bottom.
 b) Standing a block or piece of foam upright in the container. If it is insufficiently tall, stand it on a second piece and fill the container with water.
 c) In small designs a small plastic dish can be strapped onto the container opening.
 d) In many of the French and Italian designs chicken wire is used as a support. Secondary placements are made on small platforms which hang onto the main wire piece over the foam.

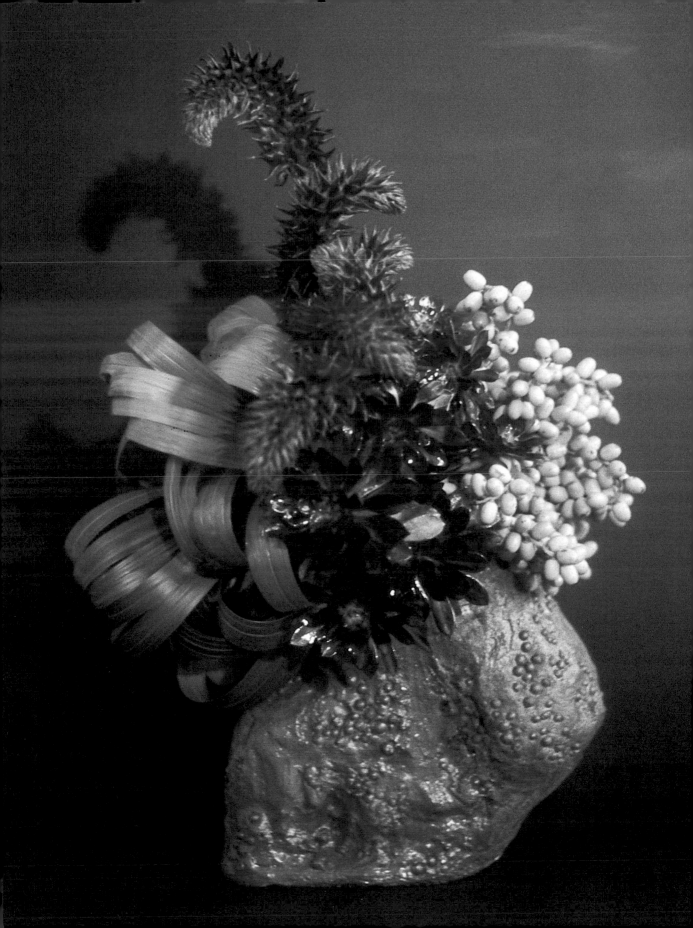

Leaf manipulation

A mass sculptural design of the French influence using internal space and repetition of form, texture and colour. The two New Zealand flax leaves are curled, are fixed together and to the container, with heavy-duty, double-sided sticky tape. The ends are wired to fix into the foam. Three *Anthurium* leaves are rolled and glued to achieve a very strong textural effect. Two green callas are placed looking into the space created by the *Phormium* loops.

You either love it or you hate it! Leaf manipulation became popular after the World Flower Show in New Zealand in 1996 inspired by the work of the indigenous people – the Maori. Now leaves and stems are carefully cut, looped and twisted into every conceivable shape – it has become an art form in itself.

Manipulated leaves can be incorporated into virtually any design but the mass sculptural design uses it perhaps more than any. I have therefore included a section here to get you going – there are no bounds as to what you can do!

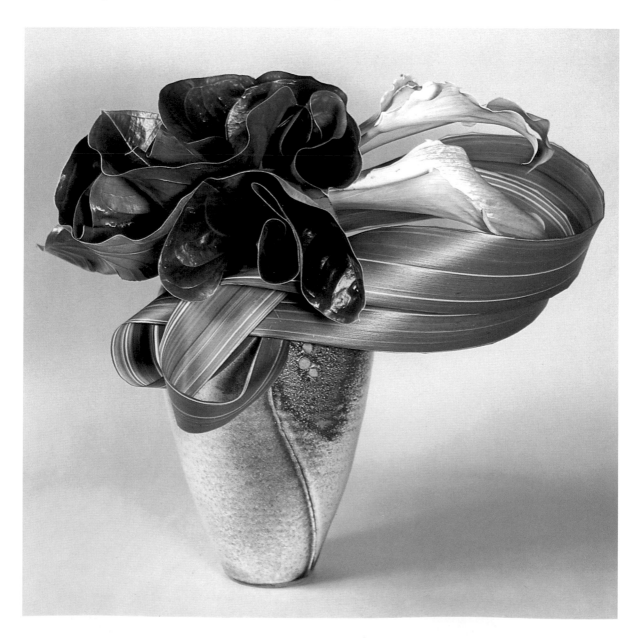

Leaf manipulation is possible with tough, bold, long-lasting, evergreen leaves, such as those of the cast iron plant (*Aspidistra elatior*), cherry laurel (*Prunus laurocerasus*), New Zealand flax, Japanese aralia, *Galax urceolata*, palm, elephant's ear (*Bergenia*) and ivy.

Twisting

Staple the tips of two strong leaves such as *Aspidistra* together then twist one stem against the other. Tape to retain the twist or secure by placing the stem ends in foam.

The leaves and flowers have been chosen and positioned to complement the colour, texture and form of the deep cherry-red vase. The roses have been teamed with rolled *Aspidistra* leaves, *Cordyline*, *Leucadendron* 'Safari Sunset' and tulips which have been arched down over the vase to repeat the line.

Rolling

a) Take a *Galax* or *Bergenia* leaf and roll it into a cone shape. Secure with a decorative pin or florists' tape (pot tape).

b) Alternatively, roll the leaf upon itself horizontally.

a) b)

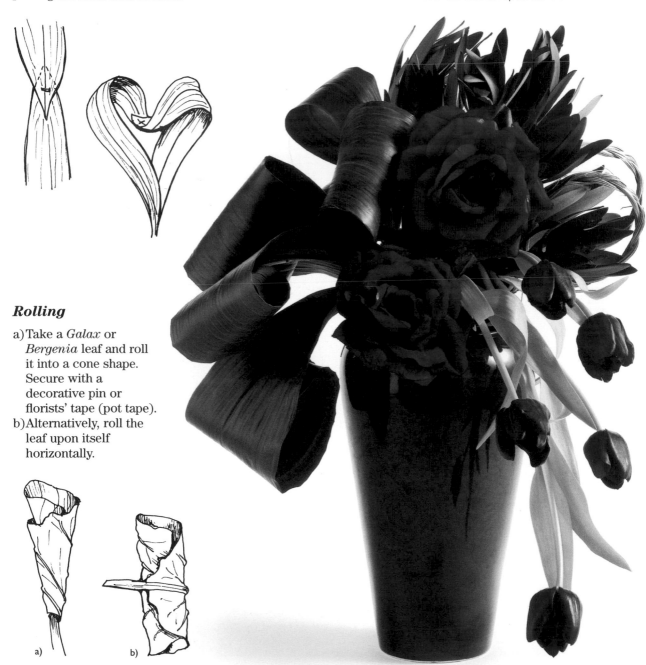

Folding and pleating

Take a large ivy or *Bergenia* leaf. Pleat the tip down and bunch in the two sides. Take a wire and thread it through the pleats of the leaf, then twist around the stem to secure.

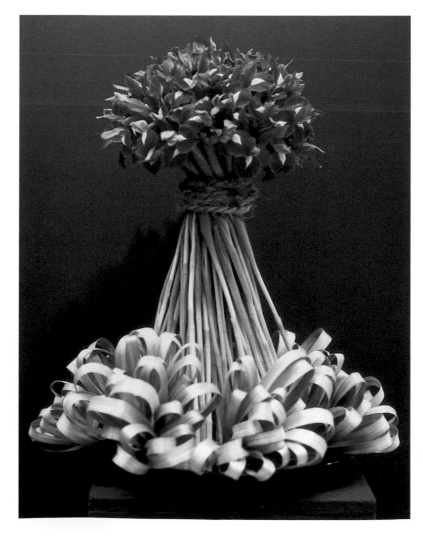

Looping

a) Push the sharp end of a leaf through the lower part of a linear leaf, where it will stay happily in place if the hole is not too big. *Iris*, tulip (*Tulipa*) and *Aspidistra* leaves are ideal.

b) Loop the tip of the leaf down to meet the top of the stem and tie with a short length of wire or secure with a little pot tape.

a) b)

A handtied by Leo Koolen bound with rope. By splaying the stems wide the tied bunch stands up easily. It has been placed in the centre of a large, shallow bowl. The *Iris* leaves have been turned inside out and looped, then massed around the base of the arrangement.

Threading

Roll the tip of the leaf down over
the back of the leaf to the base.
Bend the stalk upwards and
pierce it through both layers.

Clipping

Cut the tip of linear
leaves, such as *Iris*
and flax, to give them
a stronger form.

below
Clipped ivy leaves give a structured and
controlled base to this design.

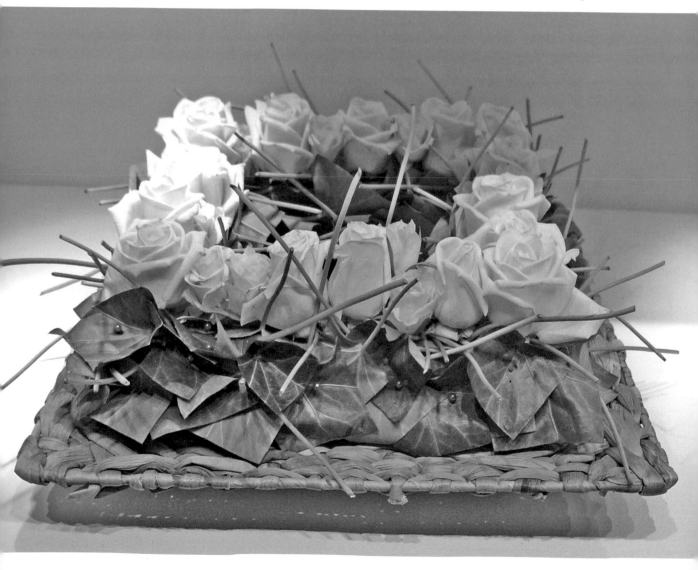

Box Plaiting/Folding

Take a *Phormium* or *Cordyline* leaf and split. Bring one section across the other section at a 90° angle. Take second section across the first. Repeat to last 10 cm and tie the two loose ends together.

French plaiting palm leaves

Dr. Christina Curtis explains here how to french plait a palm leaf. *Howea forsteriana* (kentia palm) and *Dypsis lutescens* (areca palm) give the best results.

1. Take a palm leaf with longish leaflets (at least 7 cm) at the tip. Ideally, there should be one central leaflet (A) and two others (B,C) i.e. one on each side of the stem when viewed from above. However, if the leaflets are shorter, neatly trim away the tip with scissors to give the required length of leaflet (this size is important to form the tip of the plait without it coming undone).

2. Hold the leaf so that it naturally curves towards you with its underside uppermost. The leaf stalk may be held in position between legs or supported on the stomach or a table.

3. Where the short leaflets have been trimmed away or there happen to be a pair at the leaf tip, the two leaflets must be 'faced up' with the undersides together and used as one unit (A) as shown above. In an untrimmed leaf with the ideal configuration mentioned in step 1, the central leaflet (A) is ready for use straightaway.

4. Loop (A) over the first finger of the right hand held parallel to the ground as above and cross the second leaflet on the left (B) tightly over (A) closely beneath the finger. Hold securely between the left thumb and first finger.

5. Remove right finger maintaining the position of the left thumb and first finger. Use the right hand to cross the second leaflet on the right side of the leaf (C) across (B) and parallel to (A). Hold in the left hand as shown here.

6. Take (A) again, as you would in plaiting ribbon for example, turn up and diagonally fold over (C) to finally run along an imaginary middle position between (C) and (B), pressing in place. Hold with left thumb and finger. Take the next free leaflet (D) on the left of the leaf. Place it exactly over the top of (A), keep it there and now treat these leaflets as one unit (A) to maintain a neat plait. This is really French plaiting! Pull tightly with right hand and grip under left thumb.

7. Bring (B) down over unit (A) (ie A & D) along the imaginary middle. Press down the folded area so that the leaflet is caught firmly in the plait and place the next free leaflet (E) on the right of the leaf tightly over the top of (B) as in the drawing above. Grip under left thumb.

8. Bring (C) over unit (B) (ie B & E) and down the middle. Press in place. Bring next free leaflet on the left of the leaf down on top of (C). Use these leaflets together as the (C) unit from now on. Grip as previously.

9. Continue folding over the leaflets in turn, pressing them in place and then adding in a new leaflet from the same side of the leaf as you are working until all the leaflets have been used up. Sometimes there are more leaflets on one side of the leaf than the other so that it may be necessary to plait in an additional leaflet at various points to maintain an even looking plaited form. Make sure that about two thirds of the leaflet is plaited EVERY time after pressing otherwise the plait may come undone. The overall shape of the plaited palm should gradually increase in size down towards the base from the tip, with a maximum width achieved about half to three quarters along the leaf's length. (There may also be further tapering from the maximum to the final binding.)

10. A little downward tension is required throughout to produce an attractive curved form but do not apply too much tension. Only experience will enable you to know what can be done with any given palm leaf. Practice makes perfect!

11. The last leaflets can be plaited as far as possible and either just taped in a 'pigtail' with pot tape or attached to the leaf stalk with tension to maintain a curve.

12. Neaten with green paper stem tape.

Three designs from France using manipulated plant material

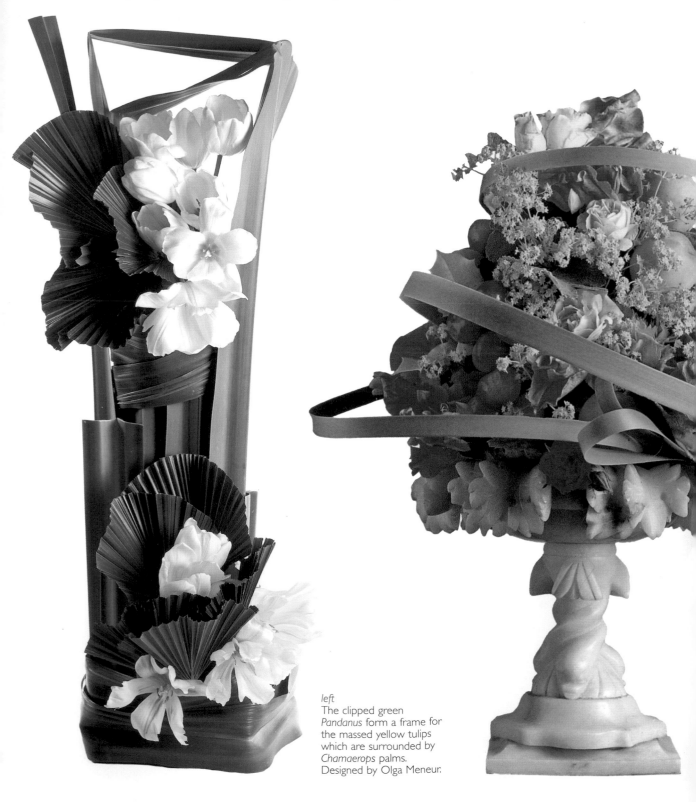

left
The clipped green
Pandanus form a frame for
the massed yellow tulips
which are surrounded by
Chamaerops palms.
Designed by Olga Meneur.

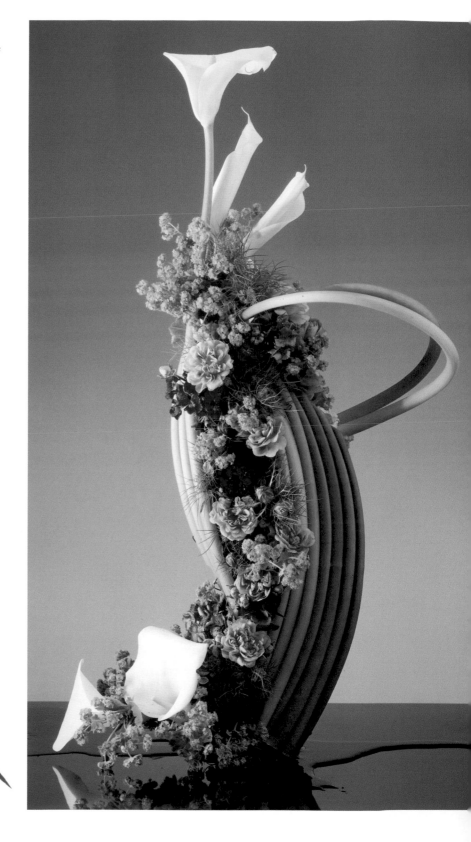

The feature of this design is the
manipulation of arum lily stalks that are
massed to give smooth ridged texture
and enclosed space.
Designed by Monique Gautier.

left
The classic feel of this design is
modernised when encircled by
the ribbon of *Typha*.
Designed by Jacqueline Bogrand.

Wiring

Place a heavy gauge wire along the central rib of an *Aspidistra* or other strong leaf so that one end stops about 4cm (1.5in) from the tip, and the other at the base of the leaf. Make sure the leaf is dry otherwise the tape and wire will come unstuck. Cut to size. Place a length of wide florists' tape over the wire. Manipulate as required.

Binding

Tie the tip of a *Phormium* or *Cordyline* leaf to the top of a piece of long bamboo. Tightly bind the *Phormium* leaves around the bamboo, tying them at the base. Soak overnight and allow to dry. Then remove the bamboo.

Shredding

Cut vertically with a knife along the surface of the leaf keeping the outside form of the leaf intact.

Waterfall or cascade

A style introduced to Britain by the German Master Florist, Gregor Lersch, this has great panache and impact but may not be practical for every home, as it requires a large amount of plant material of varying forms and textures, and careful positioning to show it off to advantage. The objective is to build up an arrangement composed of many levels, which is cohesive despite the numerous varieties of plant material and the many contrasts of texture. The plant material falls to one side of the overall design.

The container and the mechanics

- It is essential that you have a tall, well-balanced container or stand in order to accommodate the downward flow. In the home you could use a tall, glass spaghetti jar with a small dish strapped to the top, a jug with a broad lip standing on a small occasional table or a container standing on a plinth when the container is also an integral part of the design.
- A waterfall design looks good when one is placed on each end of a mantelpiece or altar.

The plant material

As the design is achieved by the build-up of layers there is a need for a large amount of plant material.

1. For the first layer you will need large leaves with some mixed foliage for instance ivy (*Hedera*), *Heuchera* or privet (*Ligustrum*).
2. For the second layer you will need a selection of long, light, flowing plant material, such as periwinkle (*Vinca*), *Asparagus densiflorus* or indeed any of the ferns, honeysuckle (*Lonicera*), gum tree (*Eucalyptus*), *Rubus tricolor* or Alexandrian laurel (*Danae racemosa*). You will also need a few long, bold leaves, such as cast iron plant, New Zealand flax, crotons or *Dracaena* or perhaps painter's palette (*Anthurium andreanum*).
3. The third layer consists of line flowers such as spray carnations, sweet peas (*Lathyrus odoratus*), freesias or lisianthus (*Eustoma*) which will take colour out to the perimeters of the design. The stems should be flexible, rather than the rigid stems of, say, chrysanthemums.
4. The fourth layer is of larger, bold, round flowers, such as peonies, hydrangeas, gerberas, full roses, open lilies. You will need about five to seven.
5. For the final layer you could use the same material used in (3) if sufficiently light, for example *Asparagus* fern or bear grass. Alternatively, you can use baby's breath, sea lavender (*Limonium platyphyllum*), *Rubus tricolor* or split New Zealand flax leaves.

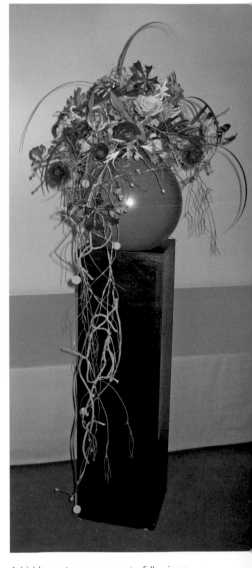

A highly contemporary waterfall using a structure and ties to create the downward flow.

The method

This is just one of the methods for creating a waterfall, but the result is most effective.

1. Set up your mechanics so that they are secure and well balanced.

2. With your large leaves loosely cover the foam.

3. The second layer establishes the form and here you will use your long light flowing plant material. The long plain leaves will give strength and a smooth texture. If these leaves appear too heavy then split them. The back of the design will bear shorter heavier stems and the 'waterfall' side longer flowing stems.

4. The third layer will take colour out to the perimeters of the design. The stems need to be flexible.

5. Place your large dominant flowers in a more central part of the design.

6. The final layer is ethereal to create an extra dimension, so giving greater depth and heightening interest, without obscuring the layers you have already built up. It can be woven into the design or looped. The material can be kept low and in position by tying down the tips with coloured reel-wire or raffia.

Tips

- Balance is achieved by using the following plant material:
 – shorter, denser material to balance the longer, lighter material,
 – visually heavier, flowers closer to the foam to give good balance,
 – placing the finished design at an angle,
 – using a jug – the handle of which will aid in the overall balance of the design.

- Strong contrasts of texture are needed, for example feathery fern (*Asparagus setaceus*), light and bubbly baby's breath (*Gypsophila*), bold, smooth gerberas, or spiky bear grass (*Xerophyllum*).

- The final element is often woven, looped or threaded through the design – this could be bear grass or one of the many ferns.

- There is sometimes a hanging feature composed of a repeated element, such as stones, seedheads, mossed balls or flowers linked by coloured reel-wire, wool or twine. This will often fall vertically from deep within the design.

- Coloured reel-wire is often woven or threaded through the design to add interest.

right
Waterfall design on a tall spaghetti jar filled with reindeer moss.

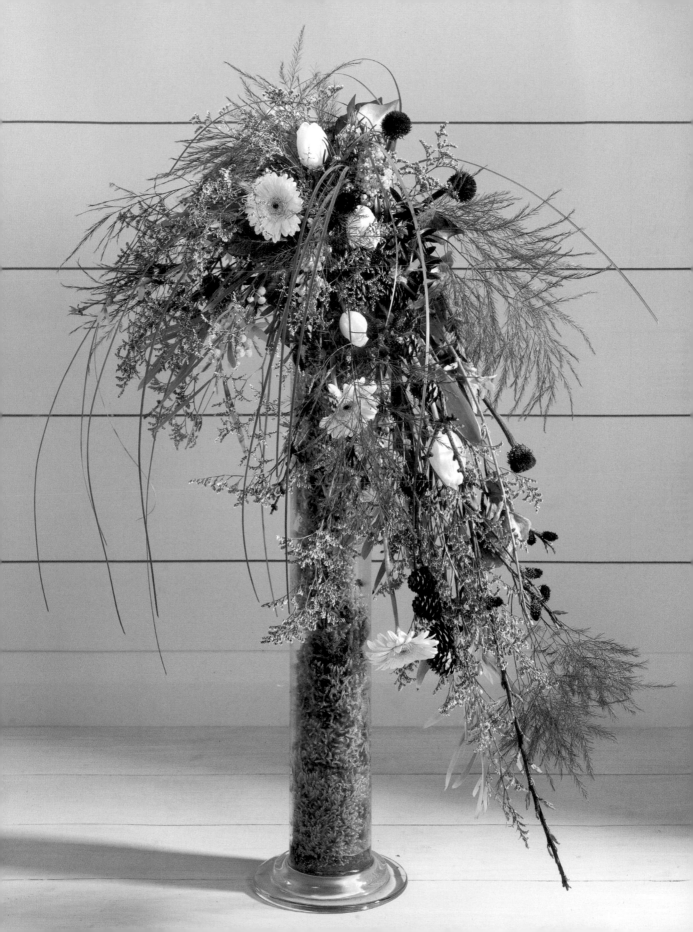

Horizontal designs

The horizontal or layered design conceived by Rosnello Cajello Fazio and promoted by Carla Barbaglia and Luisa de Paulini became popular in the 1990s and quickly became favoured throughout Europe. Natural plant growth rises vertically and because the style uses unnatural features of growth these designs do not often use a large amount of fresh plant material. A large amount of plant material would also tend to take the eye away from the horizontal movement.

Features of the design are:

- a strong contrast of texture and form.
- an emphasis on horizontal placements.
- the basic structure of plant material is often created from dried or long-lasting foliage. This can be kept as a framework and used with different flowers over a period of time to give variety and interest.
- as in the waterfall design layering is important, each layer highlighting the one below.

The container and the mechanics

The container is usually tall with a strong sculptural form. An almost straight-sided container that is slightly wider at the top than the bottom works well as does a strong, rounded container with no indentations or handles which disturb the smooth design of the pot. As the container is an important part of the design the texture and colour must harmonise with the plant material.

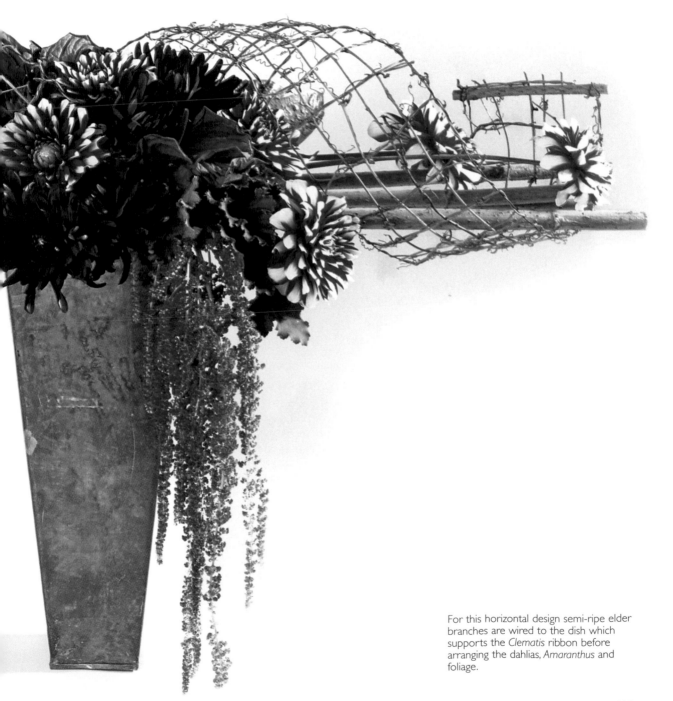

For this horizontal design semi-ripe elder branches are wired to the dish which supports the *Clematis* ribbon before arranging the dahlias, *Amaranthus* and foliage.

You could provide support for your stems by:

- Inserting a plastic container into the opening of the vase. Foam is placed in the plastic container so as to rise well above the rim of the vase. The taller the vase, the taller the piece of foam.
- Using cage mechanics such as those manufactured by Flora Mec which give added support. See 'Useful contacts' on page 409.
- If any of the long-lasting items you are using in the design are heavy, then glue kebab sticks to the item which can then be inserted at a distance into the foam.

The plant material

The parallel horizontal placements which will give you the required width can be created with:

- curls of bark from the *Eucalyptus* tree
- straight branches such as *Cornus*, *Equisetum*
- long cinnamon sticks
- *Phormium* leaves
- straight branches of blossom
- angelica stems
- bamboo
- mitsumata (*Edgeworthia*)
- bundled stripped willow
- linear flowers such as *Gladiolus*
- slivers of driftwood
- wired *Aspidistra* and dried *Strelitzia* leaves.

Bold flowers provide contrast and should complement the basic structure without changing the horizontal movement. *Gerbera*, bloom chrysanthemums, *Anthurium*, calla *(Zantedeschia)* all work well.

Alternatively you could use fruit or vegetables such as lemons, tangerines, ornamental cabbages or even halves of red cabbage in larger designs. You can also include non-plant material such as pan scourers, metal pieces, beads and feathers.

The method

1. Insert the foam so that it is one quarter to one third the height of the container once it is in position. Create length by building plant material out longways and at varying depths. If possible place several lengths along the complete length of the design. To keep these lengths in position wrap a length of wire tightly around each and pin in place with German/mossing pins or hairpins of wire.

2. Take several leaves and cut the stems short. Place these in groups to cover most of the foam. Build up rhythm by overlapping the leaves. You could use the well-conditioned leaves of *Alchemilla mollis, Parthenocissus tricuspidata, Ribes,* x *Fatshedera, Hedera,* trimmed *Fatsia* leaves or looped bear grass to give added depth.

3. Take round flowers such as *Gerbera* or open roses and insert these in the foam so that the foam is covered but the eye is not distracted from the horizontal movement. Place the round flowers at different angles to give more interest.

Tapestry designs

Tapestry designs are sometimes referred to as Pavé designs. In order to use just one word I have chosen tapestry. It was made popular by New Zealand designer, Michelle Skelton.

Tapestry designs involve blocks of colour, form and texture linked by trails from one group to another. There is little space between the elements, limited height and are usually viewed from above. Delightful though these designs are, they do need a greater abundance of plant material, because of the restricted use of space. Space can be incorporated by using twigs, loops of manipulated plant material or flexible trailing stems over the design. The emphasis however is on focal round forms and the effect relies on the juxtaposition of colour, form and texture.

Closed palisade of *Prunus* leaves with a tapestry of roses, echinops, limes, sunflowers, *Achillea*, poppy seedheads and ivy leaves.

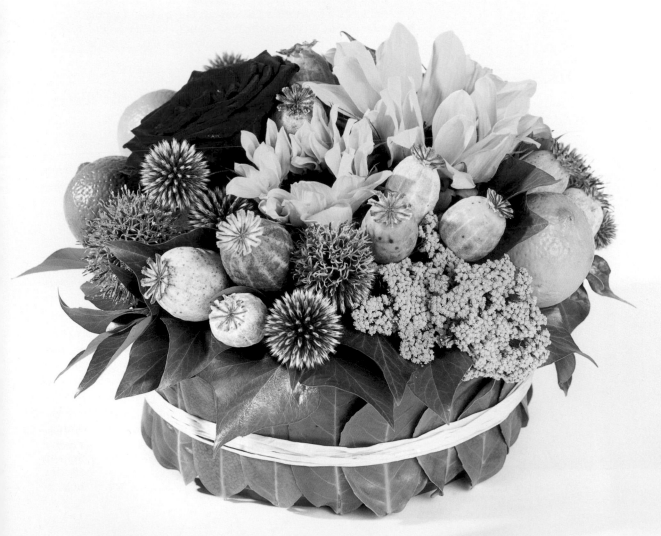

The container and the mechanics

Any container will work, traditional or contemporary. It is usually low – seed boxes, foam rings, posy pads or plastic trays are ideal.

The plant material

- use plant material that has approximately the same life span.
- choose flowers that do NOT quickly change their form as they develop, such as *Iris* or daffodils.
- use sisal, fabric, hessian ribbon, shells, pebbles, moss, dried seedpods to make your flowers go further.
- carefully consider texture, form and colour of all your components.

The method

1. Place your soaked foam in the container so that it rises just above the rim. If it is too tall your proportions will be wrong. Remove the foam edges by chamfering with a sharp knife. You can then angle plant material down over the rim so that the plant material and container will seem to belong to each other.

2. The plant material is grouped together and each type of plant material leads into another placement. The repeated groups can be dissimilar in size. It is therefore important to balance colour, texture and form at all times.

Other techniques associated with tapestry designs

Palisades

Palisades create a fence-like structure which can be closed or open. They can be made from snake grass *(Equisetum)*, bark, cinnamon sticks, cut sections of a long-lasting leaf such as *Pandanus* and stems e.g. *Cornus* or *Salix*. They need to be cut to a uniform size to encircle and protect or may simply be a decorative fence.

Closed palisade
These are also termed **Floral Cakes.** Vegetative plant material encircles and surrounds a topping of plant material arranged in a tapestry design.

Open palisade
These create a line, a curve – in fact any shape that is open ended. They are often decorated with flowers in glass tubes. The test tubes are sewn in the structure. The curved sides of a straight succulent, such as from the *Agave* plant, can rise steeply on both sides to create a palisade.

Sheltering

This is where plant material, usually of one variety, is raised above the majority of the plant material to give the impression of protecting/ sheltering the design from outward forces. It gives a three dimensional quality, shadowing the design from a distance. The sheltering element differs in form from the overall feel of the design as a whole. Sheltering is often achieved using large leaves of dominant form such as *Anthurium* or *Monster*a.

Manipulated pussy willow (*Salix*) shelters a low tapestry design.

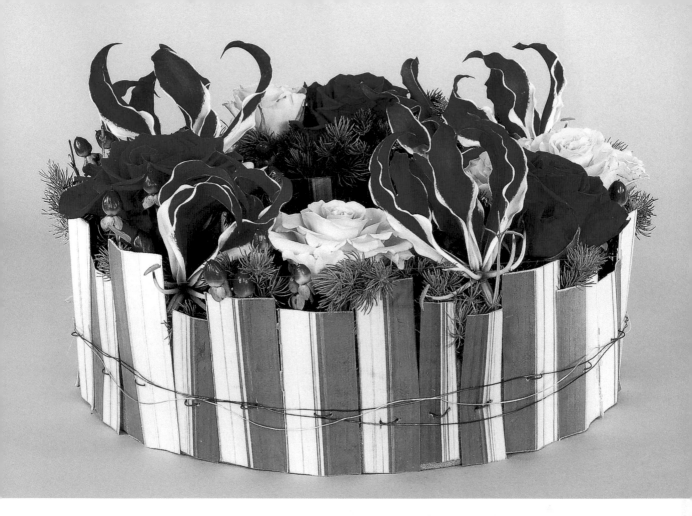

above
A closed palisade or floral cake.

An open palisade fence supporting a mass of roses with rose stems creating ongoing line and rhythm.

Cushion designs

Cushion designs are similar to tapestry designs but where tapestry designs use a pattern of different plant material cushion designs employ one or only a few types of flower perhaps in a different colour, arranged in a mass. Linkage is provided by juxtoposition. Florists' sympathy tributes often use this technique.

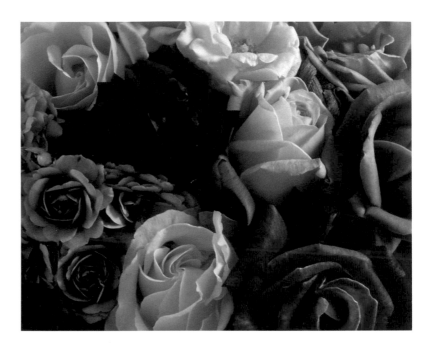

Structures

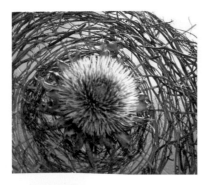

A single bloom of thistle is captured and enhanced in this intricate circular structure of flexible stems.

Structures are where the mechanics, sometimes made entirely out of plant material, are actually a major part of the design. The structure can be decorative and/or act as mechanics. They can be created with fresh or dried material by bending, nailing, tying, threading, weaving, winding or wedging. The stems can be rigid – perhaps to create a grid or an obelisk – or pliant, such as trailing and weeping forms, which can be wound and woven to create spheres, crescents and other curved forms. Thin hollow stems – such as those of the snake grass (*Equisetum hyemale*) – can be bent into angular, geometric structures.

As structures have evolved they have incorporated man-made elements such as electricians' cable ties, wire of all description and even plastic drinking straws with wires inside (as opposite). These enable a greater diversity of structure where there is no limit to the imagination of the designer.

Structures on a large scale are also called installations. First popular in modern Sogetsu Ikebana exhibition work they are now seen throughout the world. In the Western world the greatest influence on this style of arranging comes from Germany and the Netherlands, where structures are also incorporated into simple gifts, handtieds and wedding bouquets.

Pliable stems can be tied into a shape that they will readily take on. If the stems are soaked prior to manipulation they will take on the shape even more readily. The form of the construction can vary.

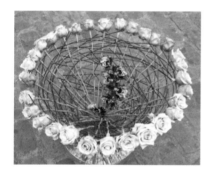

Charles Barnard created this structure from drinking straws. Stub wires were inserted into straws which were then attached to a central aluminium rod. The design then evolved like a cocoon around the basic structure. *Cattleya, Vanda* and *Phalaeonopsis* orchids were used to complement the vivid colours used.

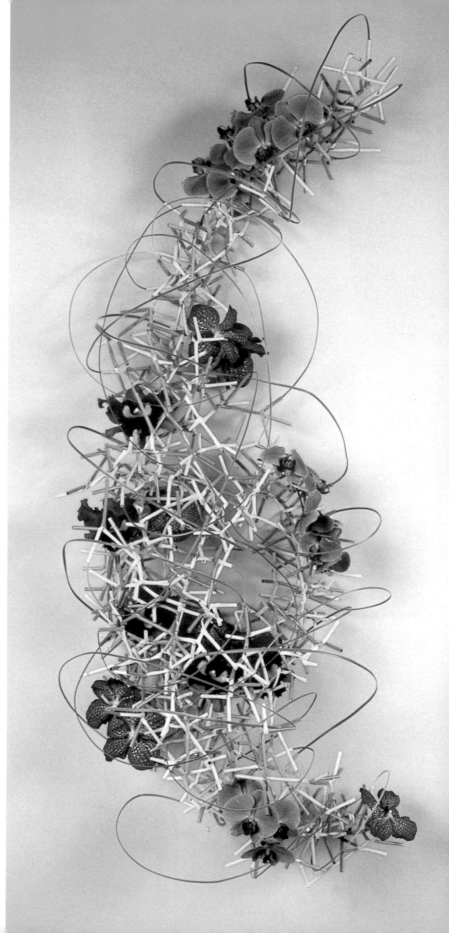

Structure in a low container

For your first structure try creating a grid in a low bowl. The basis of the design is a structure of stems secured with raffia, vine wire or paper covered wire. Then go on and develop your skills to create rings, spheres, obelisks or even an impressive hanging structure.

The container and the mechanics

- a low bowl
- paper covered wire – I have used the one by OASIS® Professional Paper Covered Wire

The plant material

- rigid, linear plant material for creating the grid. You could use snake grass, *Cornus* or any other woody pruning or bamboo.

The method

1. Create the grid. You want your grid to extend beyond the perimeter of the bowl. It is part of the design and you want it to be seen and not hidden. You should take the dimensions of the bowl into account when making your grid. Make the actual grid larger than your bowl, with the free ends extending well beyond it. A square or rectangular container, repeating the shape of the grid, works well.

3. To make your grid, cut a number of stems to the same length and ensure they are stripped clean. Lay them on a flat surface in a grid formation, so that each of the squares formed is approximately equal in size.

4. Take lengths of paper covered wire and tie the stems at the joints, making sure that they are neatly and securely held. This is a time-consuming task but quite enjoyable.

5. Lower your grid onto the container. Thread your plant material through the grid, using a mixture of forms and textures. Start with your foliage, keep the stems short, but angle some in the foam so that the opening of the bowl is filled. Use some bold forms to give focal enrichment to the design or give a repetition of plant material.

6. Add more bold focal flowers and other plant material – flowers, fruits or berries and decorative wire (e.g. boullion) – to give additional interest if necessary.

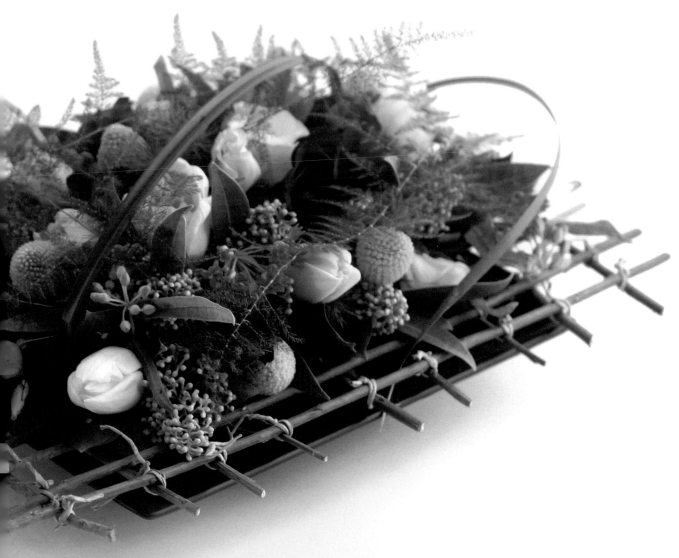

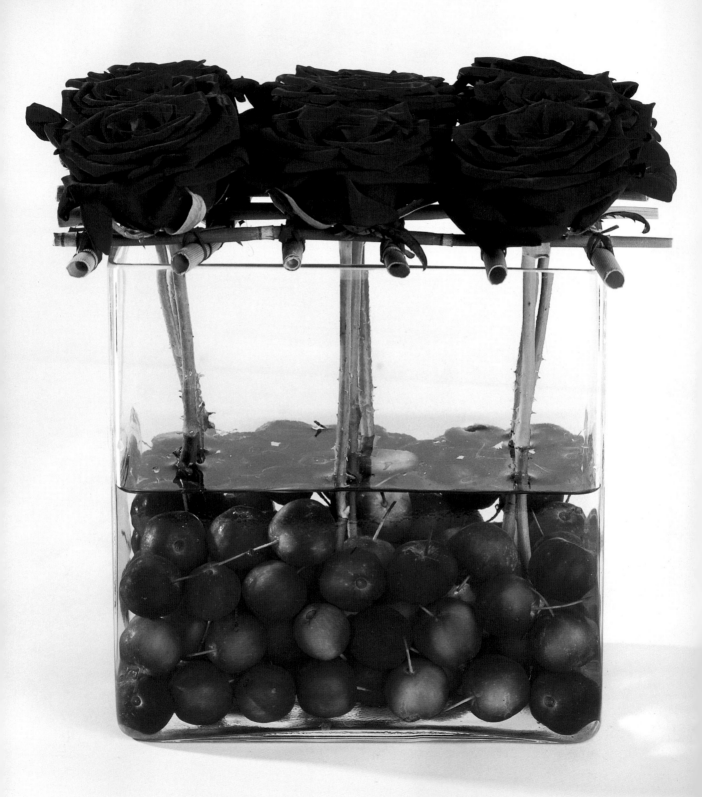

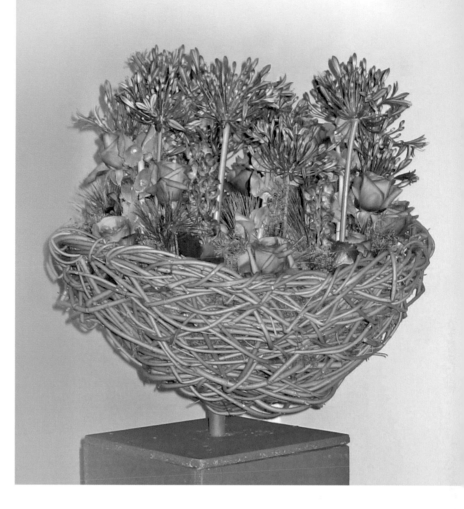

Decorative roses

Another example of a grid design – using *Sansevieria cylindrica* to form the grid is shown below. The decorative roses are made by the following method:

Cut lengths of paper covered wire. Secure each join, in the inner region, by leaving one end free and winding the remaining length under and over each join several times. Bring the paper covered wire up to the top and twist the two ends together tightly to form a knob on top of the join. Wrap the remaining wire (now double) round the knob several times to create your 'rose'.

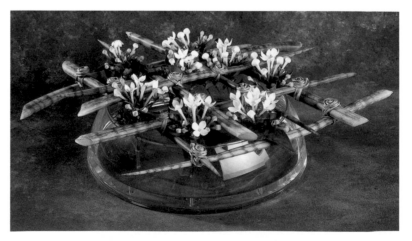

Gridwork

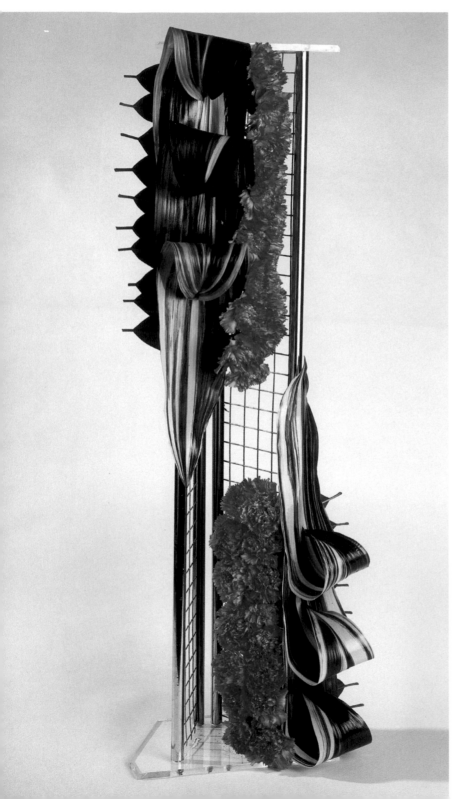

Not to be confused with the grid structures on previous pages using natural plant material, wrought iron grids became popular in the 1990s. They can be a free-standing structure or suspended. Foam cages can be strapped to the grid upon which placements of plant material can be arranged. Alternatively variously shaped glass, or plastic tubes bound with leaves or sisal, can be attached to the grid for the addition of flowers.

This design is based around an adapted CD holder with the disc holders replaced with 2.5cm (1in) wire grid. The design uses rolled *Aspidistra* leaves, carnations, and the underside of *Magnolia* leaves.

Framing

The wrought iron grid evolved into a frame to become a less rigid structure than the grids with uniform units. Innovative designers have created frames – natural or man-made – in which to display their plant material. They can be round or square, contained or viewed in the round. They can be presented on a screen or a background which constitutes a fluid frame or be confined within a more rigid structure where the work is more controlled.

This frame directly equates to a traditional picture frame; the design is painting with flowers, using them as colour units, rather than 'arranging' with them in a traditional manner. It also acts as the anchor for the soft brown bonsai wire that allows the colour to 'float' in the picture.

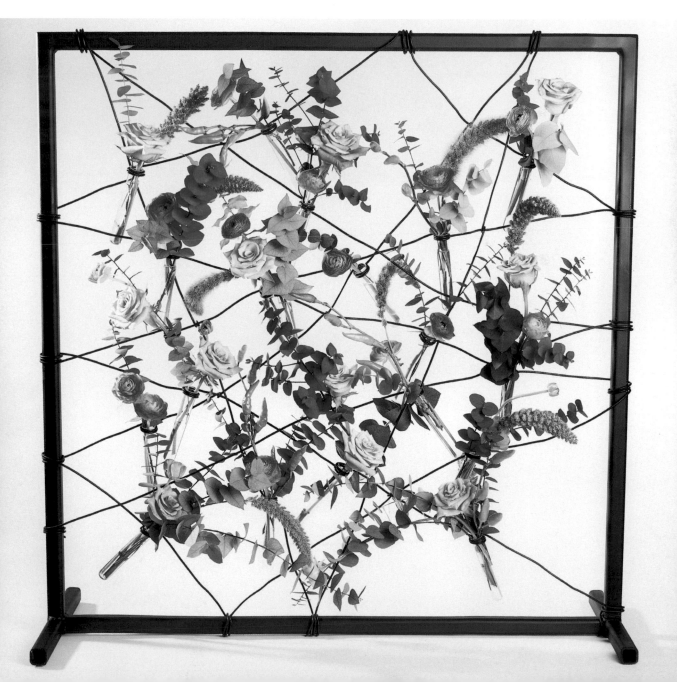

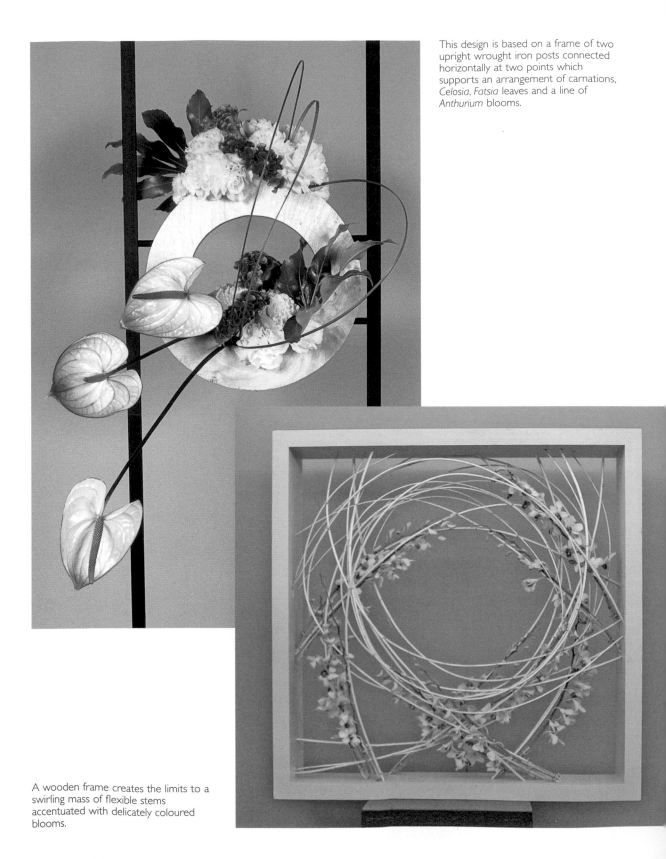

This design is based on a frame of two upright wrought iron posts connected horizontally at two points which supports an arrangement of carnations, *Celosia*, *Fatsia* leaves and a line of *Anthurium* blooms.

A wooden frame creates the limits to a swirling mass of flexible stems accentuated with delicately coloured blooms.

Environmental art

Environmental Art, which has been with us since the 1920s has recently become of interest to flower arrangers, primarily because of the examples of the genre shown in the series of books written and illustrated by Andy Goldsworthy since 1980s.

The concept underlying Environmental Art is that the art object itself relates to an object or objects which is, or are, part of the natural environment, to an area of the countryside, or even to part of the townscape. Examples of such work are often referred to as Land Art or Earth Art.

Environmental Art has strong links with Minimalist Art (which emerged in the 1950s) the sculptural versions of which range from a tree trunk, a pile of bricks or even to a collection of oil barrels. When the work occupies a space in the country or in the town it merges into Environmental Art.

In 1970 Roger Smithson created on the shore of the Great Salt Lake, Utah an enormous spiral jetty out of the soil and rocks he found there and this work has become an icon of Environmental Art.

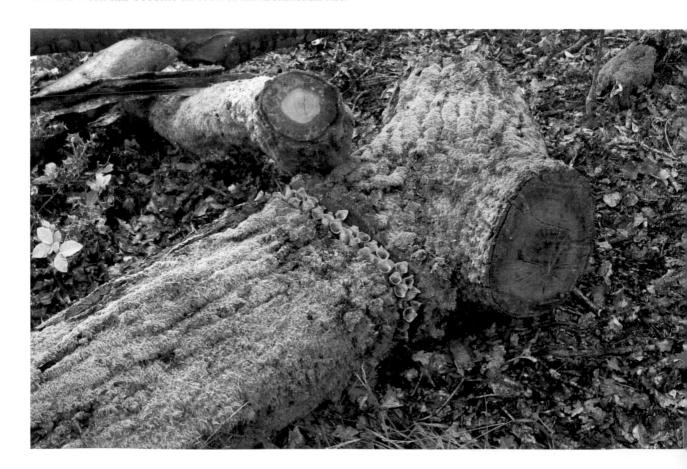

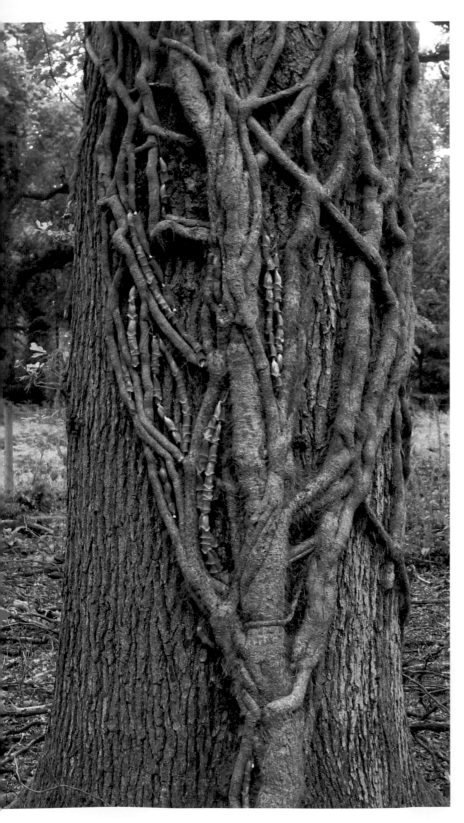

In this country Richard Long has carried out a range of projects in the landscape and has created a number of 'installations' in art galleries, such as stone circles using material found in a particular location. Some of his work consists simply of a diagram or map – the intention being to create interest by pleasing optical stimulation. Another exponent of the genre is Hamish Fulton who uses photographs, diagrams and written text to document his progress through a particular tract of the countryside.

Perhaps the artist of greatest interest to the flower arranger is Andy Goldsworthy. The installations and objects he produces and subsequently photographs for reproduction in his books, are widely diverse in form but are without exception of ephemeral beauty and exploit the shapes and hues of nature to startling effect. He uses as his 'palette' leaves, loose stones, sand, seeds and even ice and snow and wind blown dust. As with flower arranging his work is ephemeral and its images are only retained by the photographs in his books.

The inspiration of natural forms in the countryside has found ready acceptance in recent years by continental designers. They use, for example, birch twigs to form bases and reed stems interlaced with *Kniphofia* to form screening in a manner akin to some of the work of Andy Goldsworthy.

left and previous page
Environmental art. Here the CFD students of Godshill College have taken foxgloves, used them in an unnatural formation but which will allow them to seed and return in their natural environment.

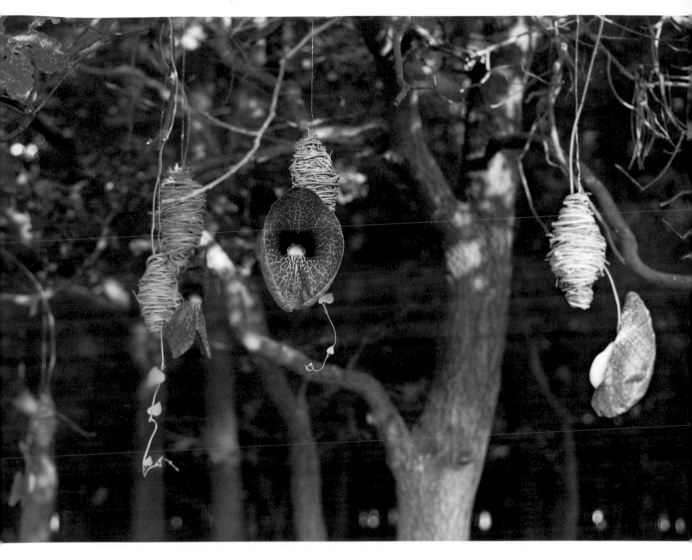

As Contemporary Floral Design has developed in recent years the influences of Environmental Art on its protagonists has been and will continue to be a strong source of inspiration.

'Suspension' – with hanging mottled bladders of birthwort (*Aristolochia*) flowers and decorative round suspended 'mice'.
Designer: Max van de Sluis

The way forward

The world of flowers is such that there will always be excitement in what is to come. There have been so many movements in recent times that no-one need worry that flower design will ever become stale or boring. There are influences from all over the world that can be adapted to the plant material available to you.

8

Inspiration from around the world

There are many great designers around the
world – both flower arrangers and florists.
Their work is inspirational and takes the art of
flower design further forward. I have asked a
few top designers to select a design that they
particularly like for inclusion in this book.
They have been most generous.

Per Benjamin
Sweden

Dr Christina Curtis
United Kingdom

Tomas De Bruyne
Belgium

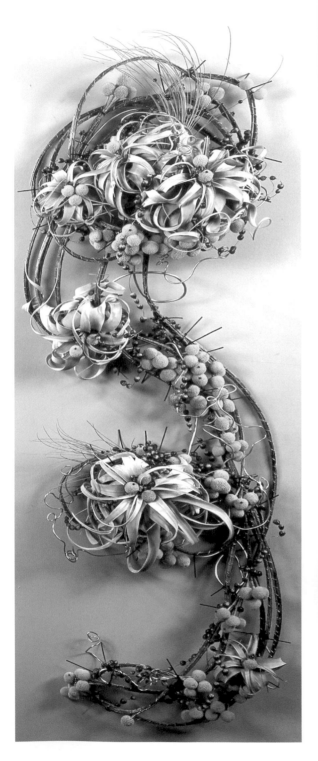

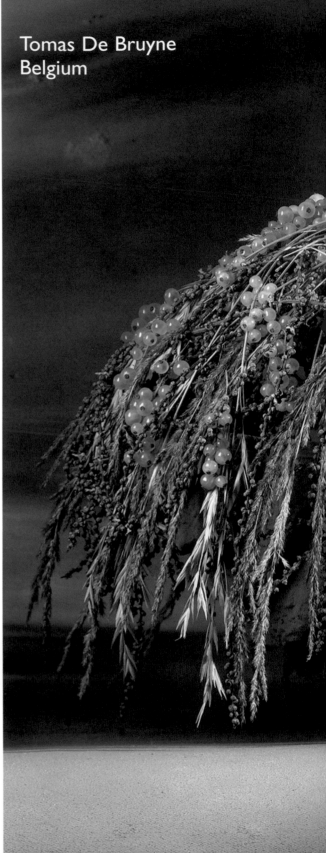

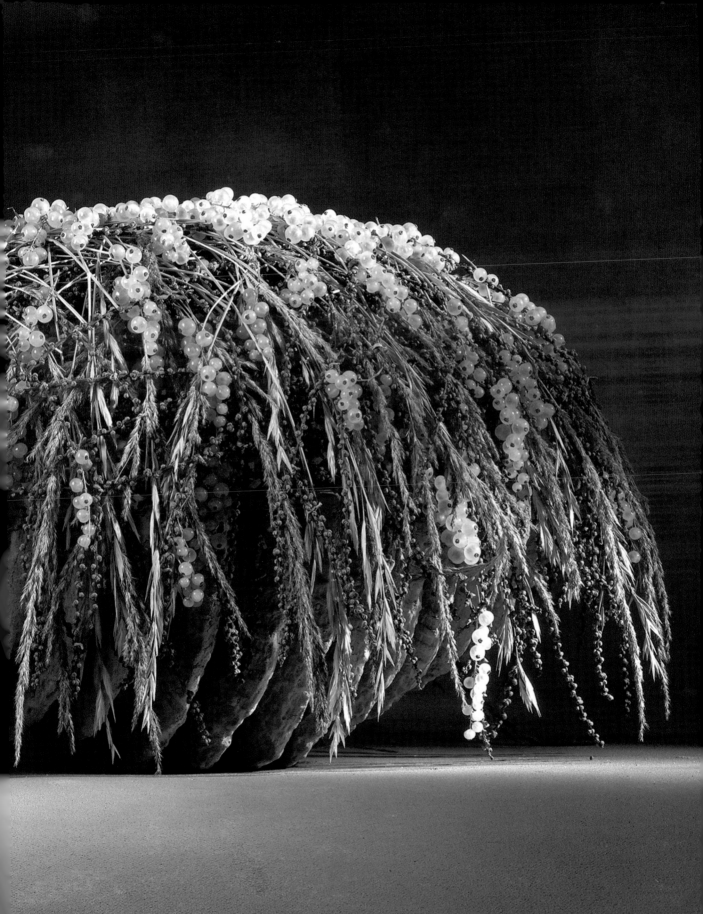

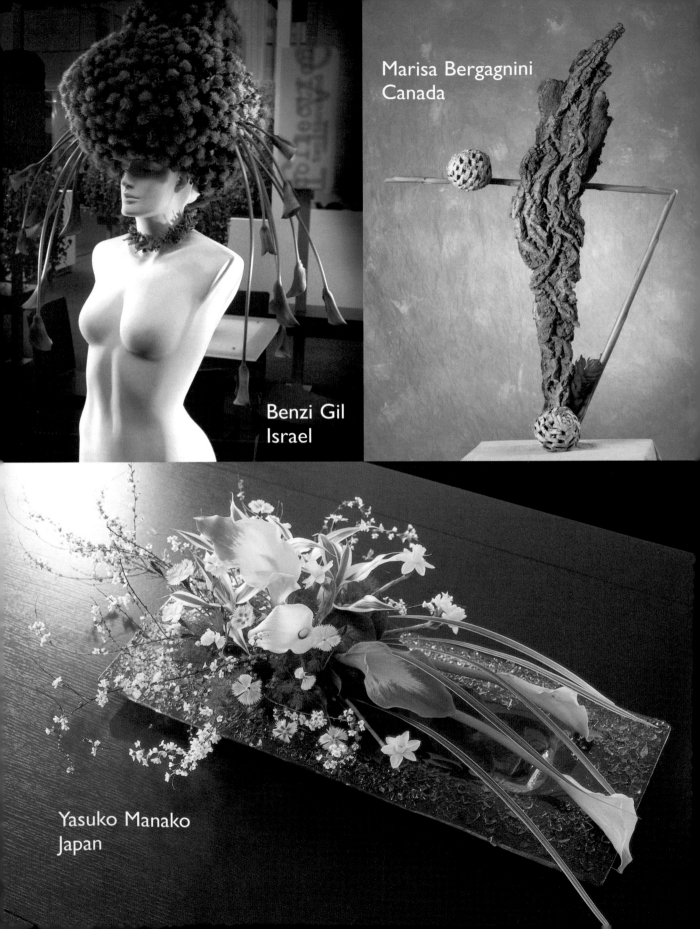

Benzi Gil
Israel

Marisa Bergagnini
Canada

Yasuko Manako
Japan

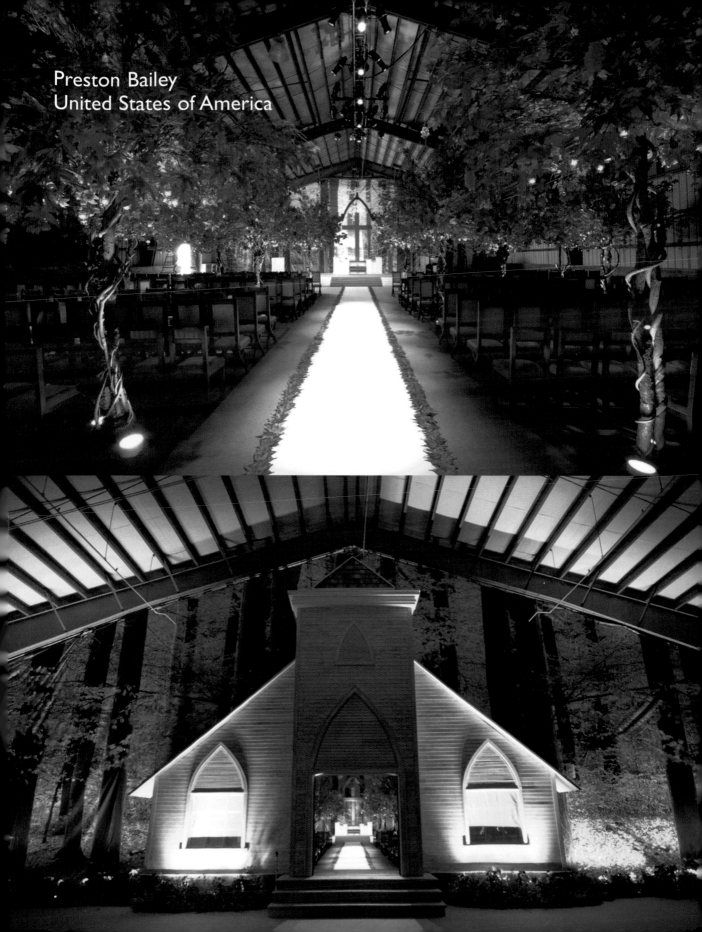

Preston Bailey
United States of America

Carla Barbaglia
Italy

Fumihiko Muramatsu
Japan

Daniel Ost
Belgium

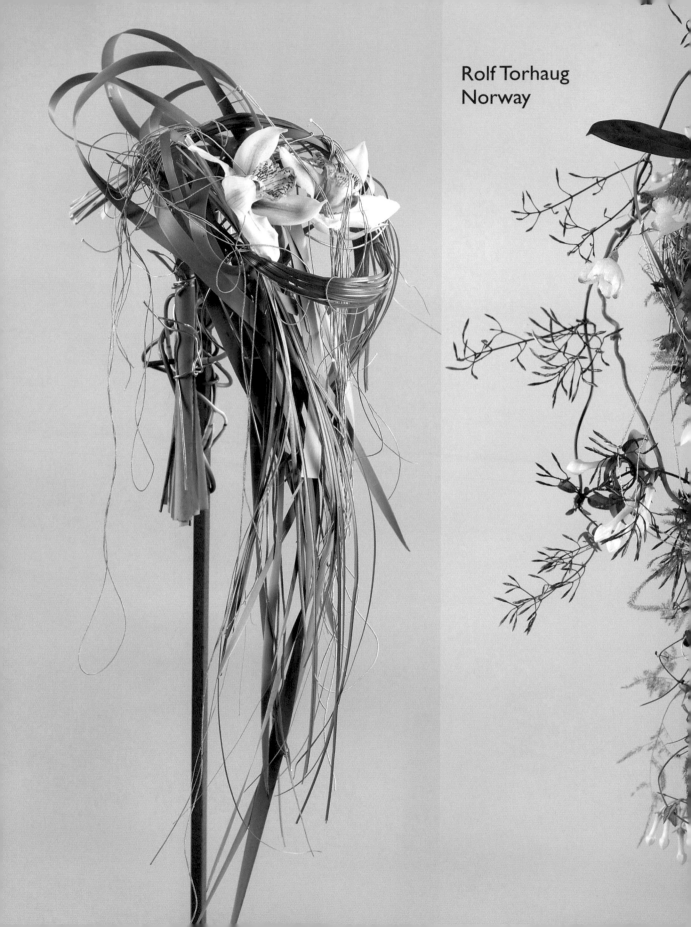

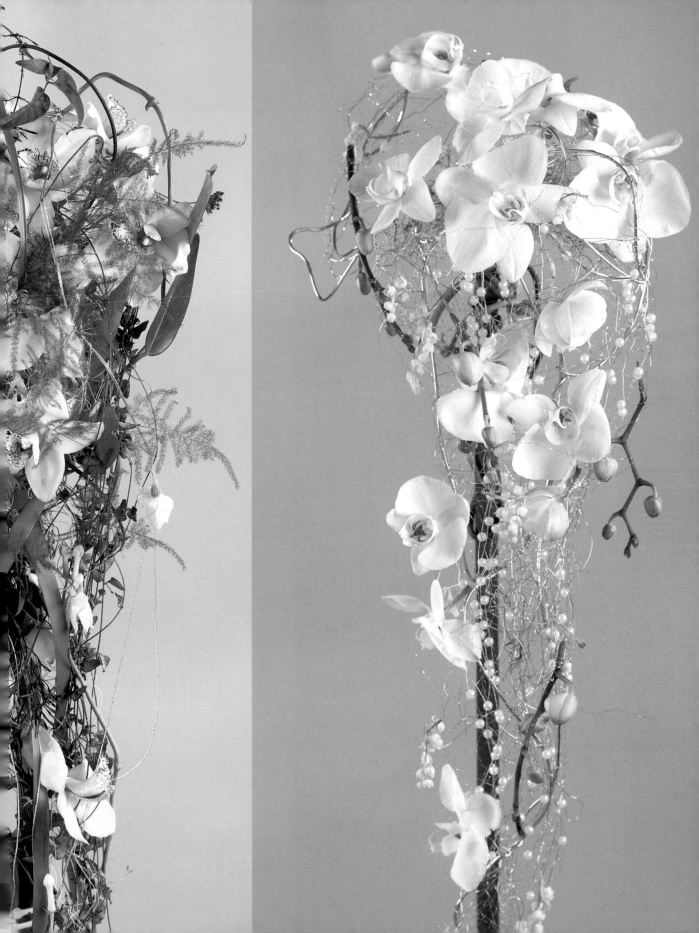

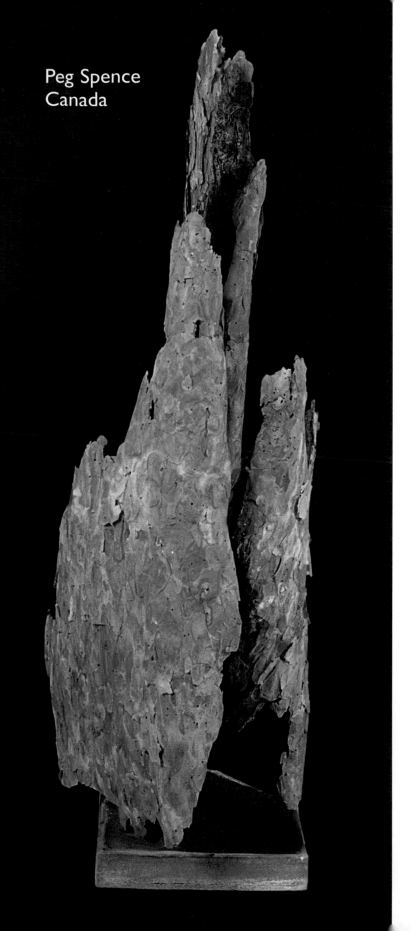

Peg Spence
Canada

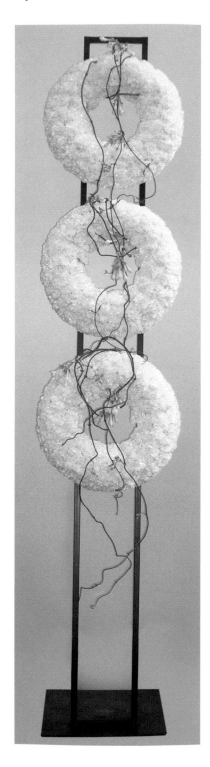

Daniel Santamaria
Spain

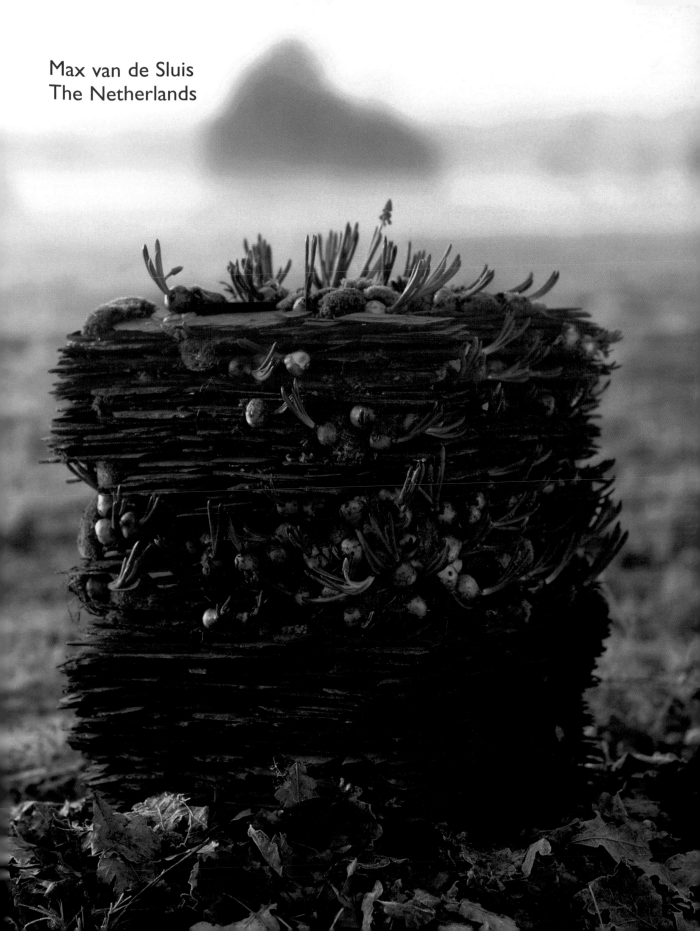

Max van de Sluis
The Netherlands

9

Handtieds and posies

Giving flowers always gives pleasure.
This chapter is devoted to designs
with no mechanics that can be
wrapped in a variety of ways, carried
in the hand, presented and then
require no further arrangement other
than placing in a vase.

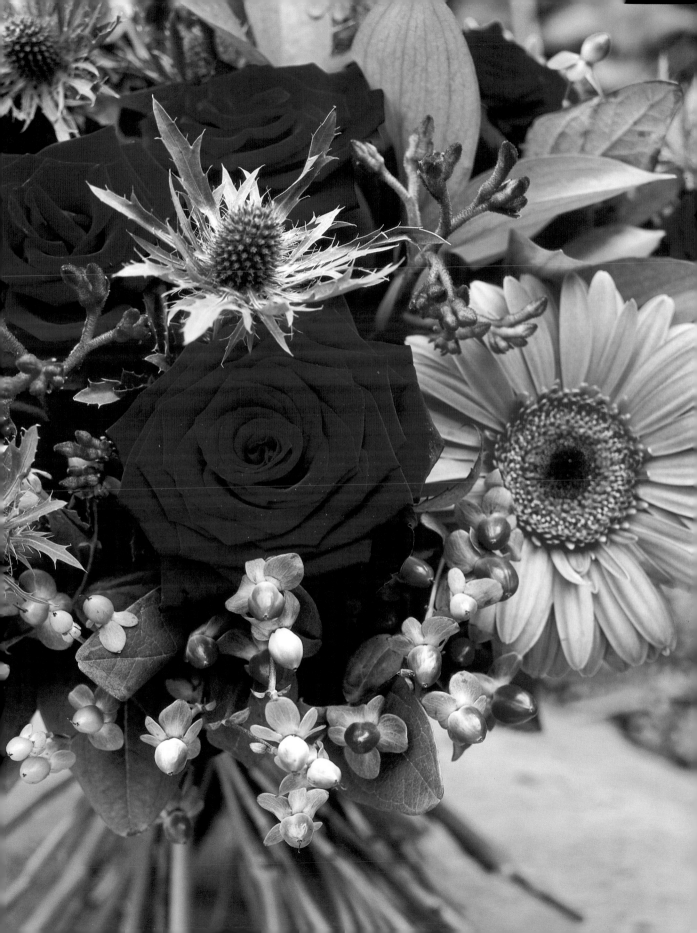

Tussie mussie

A tussie mussie of fragrant garden flowers. Wallflowers (*Erysimum*), Mexican orange blossom (*Choisya ternata*) together with ox-eyed daisies.

This style consists of herbs, foliage and fragrant flowers, combined in a loose, unpretentious manner with a slightly rounded form. These bunches were frequently used in Medieval and Tudor times and are a forerunner of today's handtied.

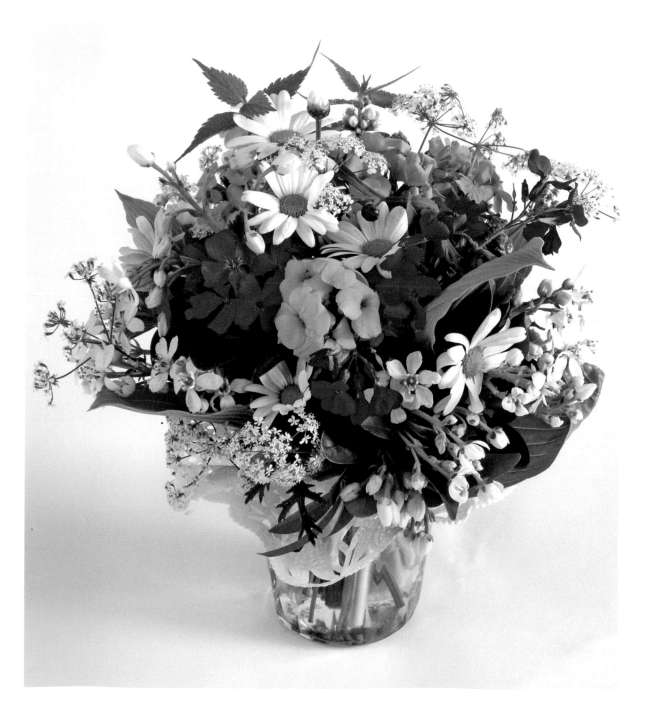

Edwardian posy

This simple posy has a rounded profile around a central focal flower. The posy is held by a handle that can be created using either bound wires or a ready-made holder with a foam top.

An Edwardian-style posy of lisianthus (*Eustoma*), *Ranunculus* and broom (*Genista*). The Edwardians would not have used lisianthus but a similar flower according to the season.

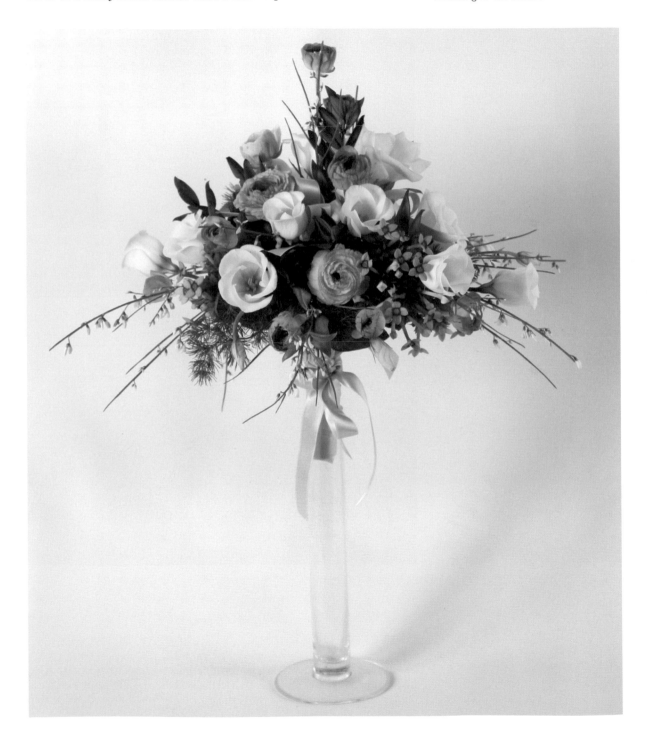

Victorian posy

This fully wired posy is created from a series of concentric circles, each made of a different colour and plant material. The bouquet is finished with a layer of leaves around its outer edge, creating a frill that is often embellished with lace. It was a distinctive domed shape.

A Victorian posy featuring a white rose surrounded with rings of *Eustoma, Limonium* and *Ornithogalum dubium* and finished with a frill of *Galax* leaves.

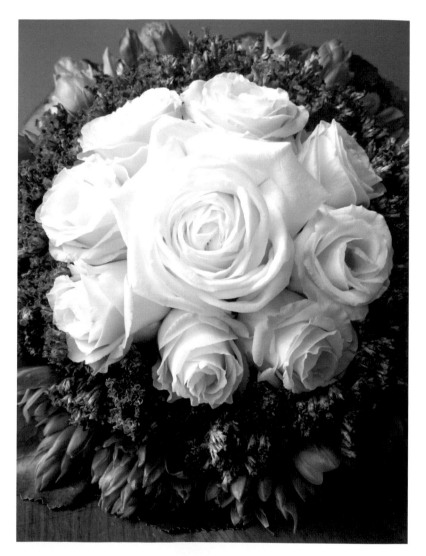

A contemporary approach to the Biedermeier posy.

Biedermeier

Akin to the Victorian posy is the Biedermeier which originated in Switzerland at the end of the 19th century. Like the Victorian posy it is composed of carefully arranged concentric circles of flowers, each ring containing one type of flower.

Handtieds

Handtieds have their origin in the tussie-mussies of the Middle Ages. These were sweet smelling bunches of herbs that detracted from the ugly odours of an age without effective sanitation. Today, handtied or tied bunches have undergone a revival, although European florists have long found tied bunches a popular item.

There are several ways of making handtied bouquets, three of which are described on pages 256–260.

Whatever the style, it is the choice of plant material that will make your arrangement successful.

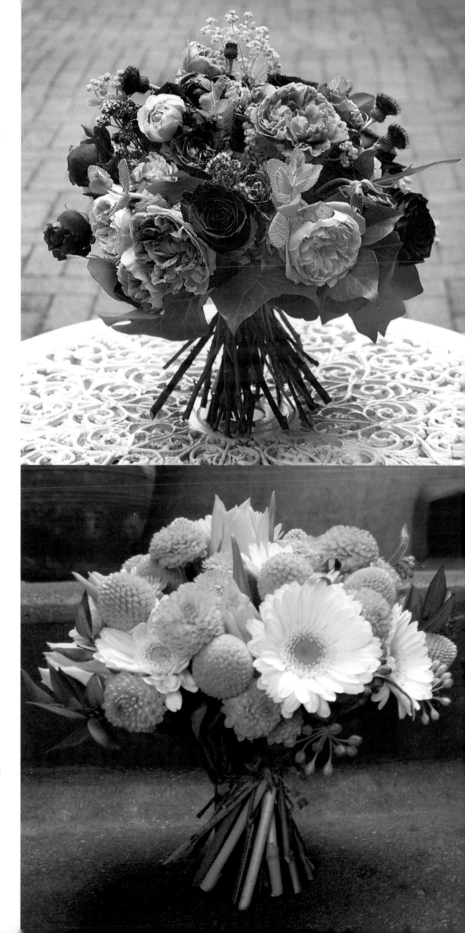

top
Fragrant garden roses, marjoram (*Origanum*), mint (*Mentha*), *Alchemilla mollis* and ivy for a handtied in the height of summer. This handtied was made for the Queen for her Golden Jubilee.

right
Asclepias, Craspedia, mini *Gerbera*, tulips and green chrysanthemums in this handtied which would make an ideal gift.

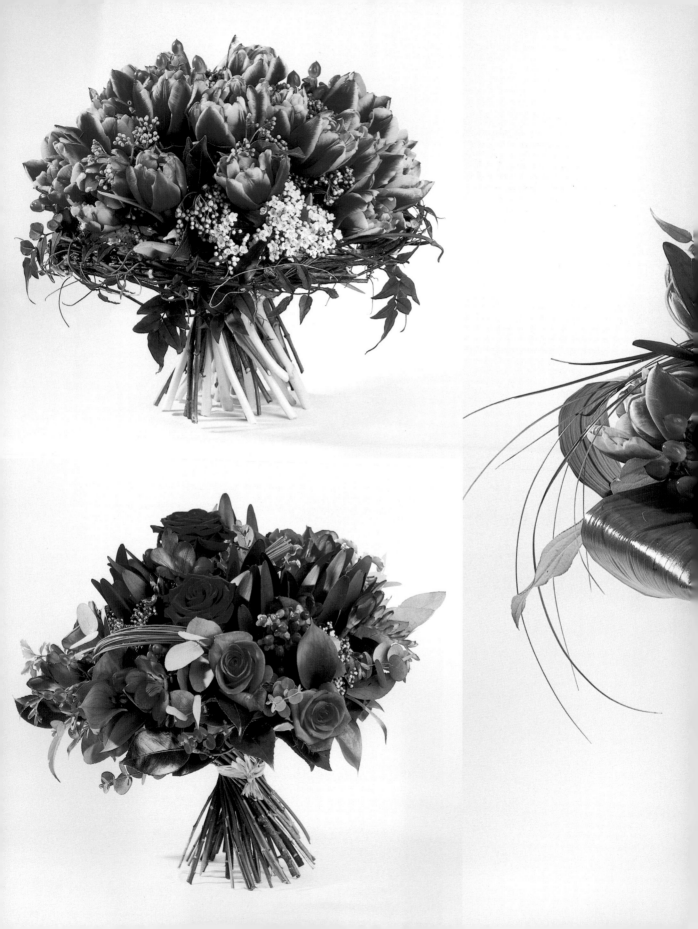

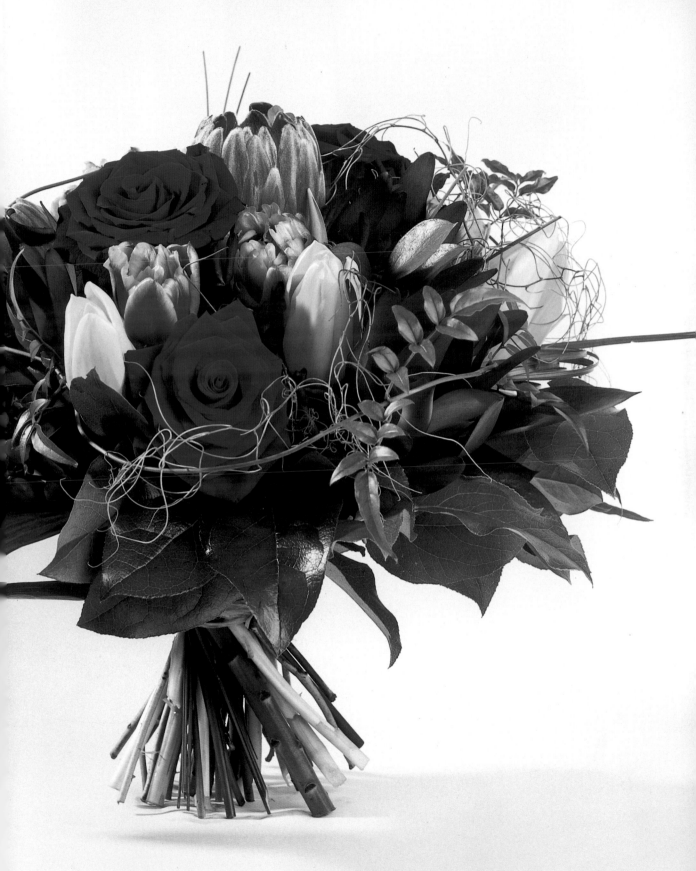

above and right
Structured handtieds in the German
style with diverse material grouped to
make good sense of scale. The textural
contrasts are very interesting.

previous pages

top
A structure of woven flexible branches
frames a handtied of double tulips and
Viburnum tinus.

bottom
Freesia, Leucadendron 'Safari Sunset',
Hypericum, Viburnum tinus and *Rosa*
'Milva' with loops of flexigrass bound into
the handtied.

main photo
A handtied of tulips, roses, *Protea* and
Hypericum. The looped *Aspidistra* leaves
on the left balance the *Fatsia japonica*
leaves on the right.

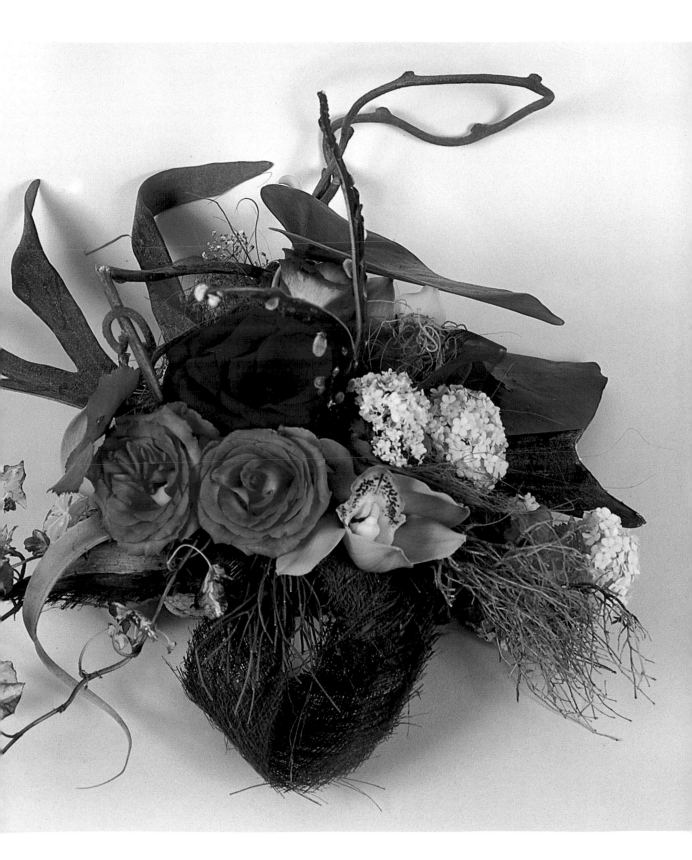

Choosing the plant material

1. Your handtied will need to have immediate impact. Flowers in bud would not have the required effect. The majority of your flowers should have a round form.
2. The stems of the finished bunch will all be the same length, so do not choose a combination of short-stemmed flowers, such as grape hyacinths (*Muscari*), and long-stemmed flowers, such as *Gladiolus*.
3. Avoid stems on which the flowers branch off low down the stem. You will be tying the twine or raffia quite high up the stem and any flowers below this line will need to be removed.
4. You will need at least 15 stems. The longer their length, the more flowers you will need. I like to use about 30 plus stems for an average handtied, but up to two-thirds can be foliage.
5. Soft stems, such as daffodils (*Narcissus*), can get squashed when you tie the bunch, so avoid these.
6. The addition of bear grass (*Xerophyllum*) gives a soft, natural look to the design.
7. Aim to keep the stems short. If they are too long you will detract from the impact of the flowers. As a rough rule of thumb, the width of all the flowering heads needs to be about the same as the height.

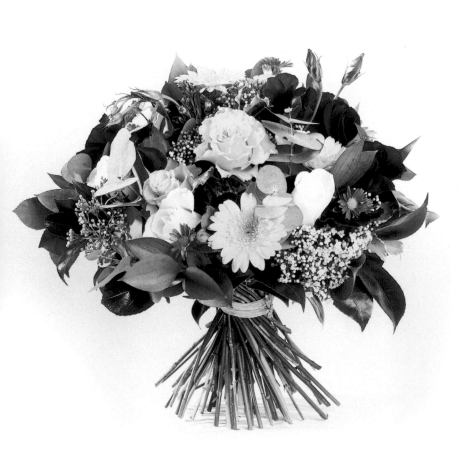

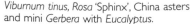

Viburnum tinus, Rosa 'Sphinx', China asters and mini *Gerbera* with *Eucalyptus*.

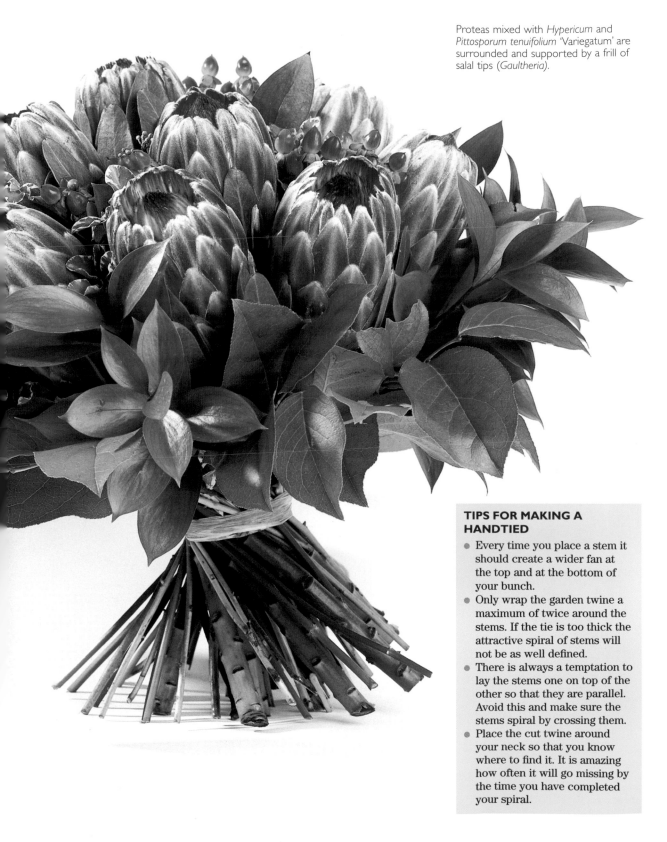

Proteas mixed with *Hypericum* and *Pittosporum tenuifolium* 'Variegatum' are surrounded and supported by a frill of salal tips (*Gaultheria*).

TIPS FOR MAKING A HANDTIED

- Every time you place a stem it should create a wider fan at the top and at the bottom of your bunch.
- Only wrap the garden twine a maximum of twice around the stems. If the tie is too thick the attractive spiral of stems will not be as well defined.
- There is always a temptation to lay the stems one on top of the other so that they are parallel. Avoid this and make sure the stems spiral by crossing them.
- Place the cut twine around your neck so that you know where to find it. It is amazing how often it will go missing by the time you have completed your spiral.

Making a spiralled handtied – method 1

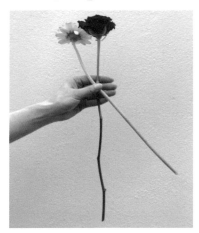

1. Cut a 90 cm (3ft) length of garden twine and place this around your neck before starting (not shown). Remove most of the foliage from your flowers but leave the top leaves on the roses. *Here we have removed all the leaves to demonstrate the method more clearly.* Place your left hand if you are right handed (right hand if you are left handed) in front of you with a curved elbow. Keep your fingers together with your thumb in front of your fingers. You will be sliding your flowers and foliage between your fingers, which will stay rigid, and your thumb which will remain flexible. Place the first stem (here the red rose) vertically. Take the second stem and cross this over the first stem so that the head of the flower is towards the shoulder of the hand which is holding the flowers.

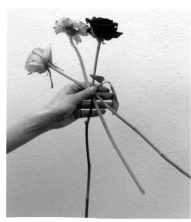

2. Take a third stem and repeat the action in step 1, i.e. cross the third stem over the two you already have in position. Do not lay it parallel with the second stem but cross it over. Each time you add a stem the fan shapes at the top and at the bottom will get wider.

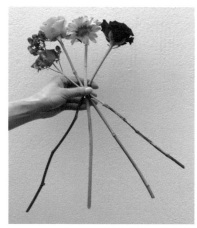

3. Repeat the same process. Mix the flowers and foliage but do not worry about this too much – the balance will come with practice. What is important is to get the technique of creating the spiral.

4. At the point where you think your handtied is looking unbalanced it is time to place a stem behind. This is the only other action that you need to learn. *The aim is to create a spiral and you must not place stems on top, in the opposite direction to the stems already in place. This would break the spiral.*
Push your fingers backwards to allow space for a stem to be inserted **behind** with the head facing **in the opposite direction.** See how the *Hypericum* berries are now facing both directions.

5. Revert to placing the stems in the direction detailed in steps 1 – 3. Only add stems behind when you feel you need a specific flower there to give good balance of colour, form or texture.

6. When you have completed your handtied wrap the twine tightly around the stems as high as possible, immediately below the foliage. Do not wrap the twine too many times around the stems as this will create a bandage and prevent the stems splaying out attractively.

7. Cut the stems short. The height of the bouquet should be approximately the same as the width – no more.

right
'Sphinx' and 'Grand Prix' roses, *Hypericum androsaemum* 'Pinky Flair' and two-tone mini *Gerbera*.

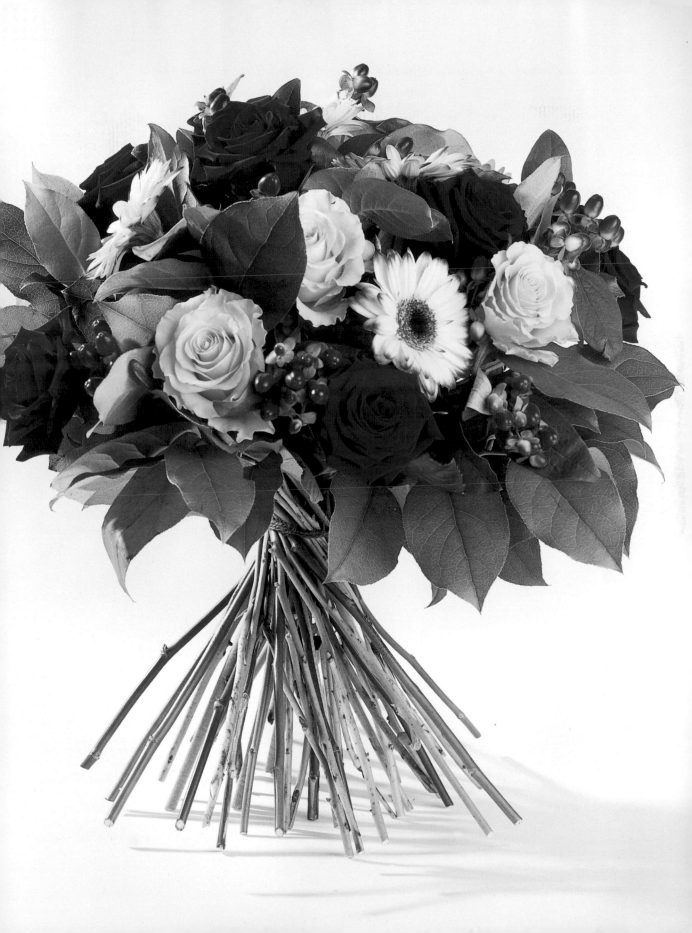

Making a spiralled handtied – method 2

1. Prepare your stems as in method 1.
2. Place 3 stems – mixed or of the same variety – vertically in the hand, gripping them with the thumb and first finger. Stretch your other fingers out horizontally (in the left hand if you are right handed and in your right if you are left-handed).
4. Select 3–4 stems of mixed or grouped flowers and foliage and place these over and across the first placement of stems, at an angle of about 45 degrees.
5. Place your other hand around the stems and twist all the stems round 45 degrees.
6. Continue to add stems in groups of 3 or 4 and twist 45 degrees with every placement.
7. Tie and finish as with method 1.

Making a spiralled handtied – method 3

1. Prepare your plant material as above. Put your thumb and forefinger together to form a hole.
2. Place 10–20 pieces of *Gaultheria*, myrtle, hard ruscus, leather leaf or other strong plant material through this hole, so that the stems interlock and form a receptacle for the stems. Keep the rest of your fingers curved round in a loose fist ready to receive the stems.
3. Start to weave your flowers and other foliage into the design. Keep your fingers loose all the time in order to obtain a relaxed design. Try standing in front of a mirror so that you can see the shape developing.
4. Tie and finish as with method 1.

There are other ways of creating a handtied, for example with parallel stems, see page 291. For each method you will need to practice and then choose the one you prefer.

Wrapping

Aquapack

If you wish to give the handtied with a reservoir of water:

1. Take a square of cellophane and place the handtied in the centre of the cellophane.
2. Pull the four corners up to the centre, making absolutely sure that the stem ends remain in contact with the cellophane
3. Grip the cellophane against the stems very tightly, so that the stem ends continue to remain in contact. Add a tie of garden twine.
4. Add a tie of raffia or ribbon to give extra security and disguise the tying material.
5. Pour a jug of water down the centre of the bouquet so that the water trickles into the cellophane 'bag'.

An aquapack – the cellophane holds water and keeps the handtied fresh.

Paper wraps

Method one

1. Fold two sheets of tissue paper as shown on the right. Wrap these around the bouquet so that the points are alternated, and the bouquet is surrounded by a series of paper 'petals'. This can be achieved using the same or different coloured sheets.

A handtied wrapped in tissue and cellophane.

N.B. The second sheet should hide where the first is joined.

2. Secure with tape, raffia or ribbon.

A mass of white and green roses, *Gypsophila* and *Eucalyptus,* wrapped in cellophane and tissue with a raffia decorative tie.

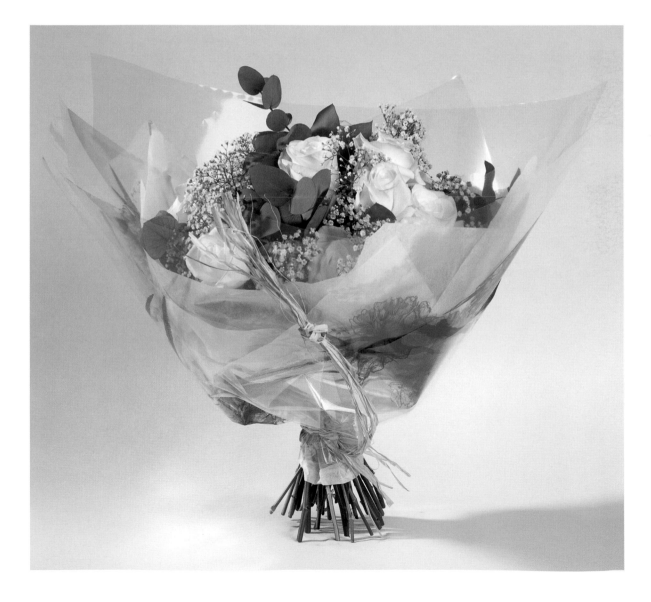

Method two

1. Take two rectangles of tissue paper or paper fabric in contrasting colours, both the same length. They should be long enough to wrap completely round your bouquet.

2. Place one rectangle on top of the other so that the bottom sheet (which will be the outside of your wrapping) is about 5cm (2in) higher than the other, and staple them together at the sides.

3. Bring the two ends around the bouquet and staple them so that they form a cylinder. Gather the paper together at the binding point and secure with tape. Cover the tape with raffia or ribbon.

4. Roll the layers outwards and downwards separately to display the contrast of colour, as shown in the photograph on the left.

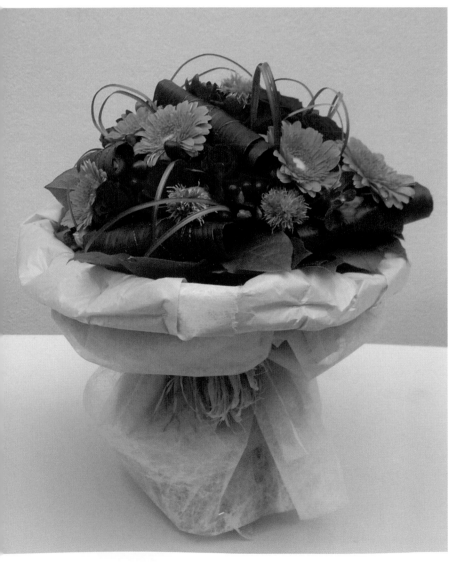

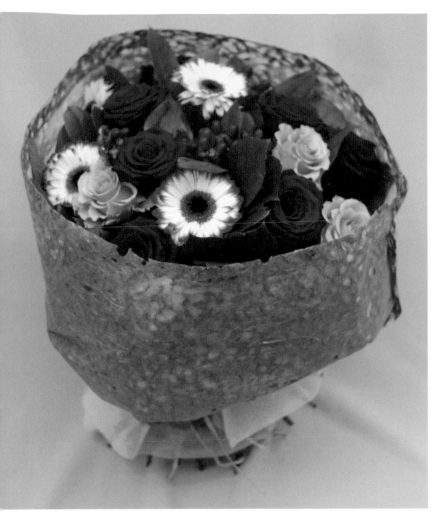

Method three

1. Take two sheets of tissue paper or paper fabric in contrasting colours. Fold the first in half widthways, at a slight angle, so that your paper has four points – as though it were half of an eight pointed star.
2. Fold the second sheet lengthways, a few centimetres from the bottom.
3. Wrap the first sheet around the bouquet at the binding point and secure. Wrap the second sheet around the first, but slightly higher, so that the points of the first are just visible.
4. Gather the second sheet so that the bouquet is entirely visible from the front, but hidden by the paper from the back and sides.
5. Secure with raffia or ribbon.

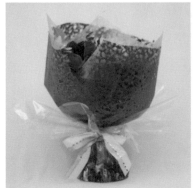

10
Wedding flowers

Flowers are an essential part of any wedding whether you create the designs yourself or wish to take part in the planning. Colour, fragrance and form take an important part, whatever your budget, giving added joy and happiness on this special day.

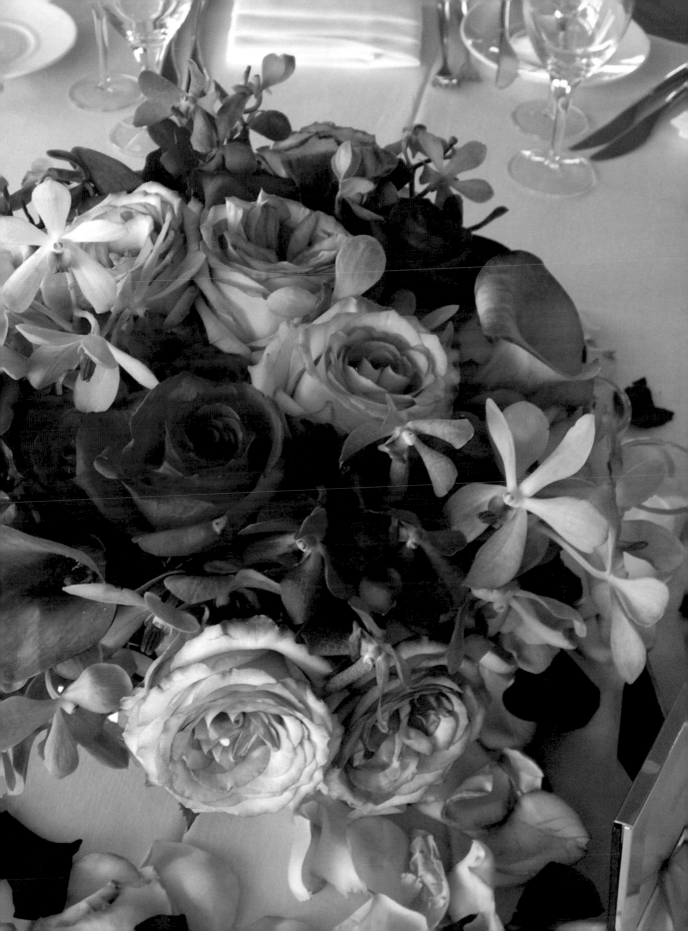

A top table design of callas, roses and orchids. Candles and petals add to the atmosphere.

Creating the wedding flowers can be daunting for the floral designer. To avoid stress and strain I would strongly recommend that unless you are experienced only create the table designs for the reception and the place of marriage and leave the intricate, specialized work of wired corsages, headdresses and wedding bouquets to the professional florist. The table arrangements can be prepared at home and delivered on the day and in most cases the place of marriage will allow you to prepare flowers the day before the event.

If you are the bride or the bride's mother and not experienced in flower arranging it is probably best to leave the flowers in the hands of friends who are flower arrangers as there are so many other things to concentrate on at this special time. I have taught many future brides to create their own wedding flowers but am still concerned if they plan to create the reception flowers and those for the bridal party themselves. Deterring them is rarely successful! I only ask that you make sure that you have everything planned down to the last detail and leave nothing to chance.

A row of topiary trees, waiting to be placed in position.

Choosing and meeting the florist

- Buy magazines and ask around for recommendations before you choose your florist.

- Make a shortlist of no more than three florists that you like the look of. Look at their websites, visit their shops and look at their wedding portfolios and price lists. Is their attitude helpful? Is their style what you want?

- Make an appointment with your chosen florist. Take along a swatch of material from a) the bride's dress, and b) the bridesmaids' dresses.

- Know your budget. The flower budget for a Jewish and Asian wedding is often considerably more than that for a Christian wedding. Have a plan of what you want and then work with your florist to see what can be eliminated in order not to go over budget. He or she will advise on maximum effect for minimum cost.

- The work carried out by professional florists takes time and skill. Quality flowers are never cheap. Do not shop around trying to get the cheapest deal; you will usually get what you pay for. Flowers are an essential part of the wedding but the money allocated to them is often a fraction of that dedicated to food and wine. I can never understand why.

- Be prepared to pay a refundable fee for any serious planning time spent with the florist. Many florists ask for a substantial deposit or payment in full before the wedding.

- Everything including final details should be confirmed in writing two weeks before the wedding and minimal change should be made from this point. This will enable the bride to be sure that everyone is doing the work and she can be worry free.

Special flowers

One of the first things to consider is the date of the wedding. Only a few years ago flowers out of season could not readily be obtained. Now, with new technology, air-freight and sophisticated glasshouses, virtually any flower can be acquired at any time of the year. In the floral world, daffodils can jostle for show in the flower market as early as November; chrysanthemums have been given the name of AYR (all year round) and freesia, orchids and iris seem to 'go short' only occasionally. With notice, virtually any flower may be obtained but this does not make it a good idea to have out-of-season flowers.

Flowers in their natural season will be less expensive and probably stronger. However if you want lily-of-the-valley in your wedding bouquet do not plan on getting married in November. If the blue of cornflowers is the only colour that will link in with the bridal dress

then a mid-summer wedding will ensure that your flowers will be easy to find. Do remember that flowers will be considerably more expensive around Valentine's Day (February 14th), Easter, Mothering Sunday and Christmas (December 25th). In America and Europe there are many other days when flowers are given – think of Secretaries' Day (April 27th) and International Women's Day (March 8th). Because flowers are distributed to all corners of the world from central distribution points an event in one part of the world will affect prices worldwide, so do check if you have flexibility on choosing the day.

Style of the flowers

You need to consider if you, or the person for whom you are doing the flowers, is an 'I have just picked these flowers out of a field' person or a more formal bride. Often people getting married in cities are keen on a loose, garden style – bringing the country to the town, whereas those in the country often prefer a more sophisticated style.

Where to place the flowers

At the marriage ceremony

I strongly recommend that you create all the flowers for the marriage ceremony the day before but of course this is not always possible. If that is the case allow yourself plenty of time on the day – give yourself a generous timetable and then add an extra hour. I do suggest that you visit the church before the wedding takes place and study the placement of flowers (avoid Lent when many churches do not have flowers on display). Ideally choose a Saturday when a wedding is taking place. You will learn as much from what you do not like as from what you do like!

It is perhaps where the marriage ceremony is taking place that flowers are most important. Guests always arrive early to a wedding and flowers are often studied in great depth.

Do remember that if you wish to arrange flowers commercially it is essential to abide by the rules of the establishment in which the flowers are to be displayed. If you leave rubbish, a pool of water on the floor or a mass of decaying vegetation to be cleared up you are unlikely to be welcomed on another occasion.

If the wedding is to be held in a church it is important to make enquiries beforehand regarding these points. Many of these also apply to other places of worship.

A church wedding

1. Find out who is in charge of the flower rota and whether there are any special procedures that must be followed.

2. If you do not worship at the church ask if it is possible to use outside flower arrangers. Some churches are delighted for this to happen while others depend on the income derived from providing this service to fund church flowers throughout the year.

3. Find out if there is a flower arranging room and what equipment is available. Using equipment available at the church means that you will not have to return to collect items. A pedestal is the most common arrangement at a wedding. Check that there is a pedestal stand to your liking in the church and that you can use it. Ideally you want to arrange the flowers in situ the day before the wedding. Do check if this will be possible and find out where you can get keys as many churches are now locked on some days or for a good part of every day.

4. During Lent and Advent many churches do not allow flowers to decorate the church. You may however be allowed to arrange flowers just before the ceremony, on the understanding that they are removed after the service. Many churches do not allow flowers on the altar.

5. Always check what will happen to the flowers after the event. If they stay in the church will you have to clear them away at the end of the week?

6. Many churches understandably object to flowers being removed immediately after the ceremony and taken to the reception, leaving the church bare of flowers for the weekend. If the bride's budget will not run to decorating both the place of worship and the reception, it is perhaps better to use less expensive flowers or to have fewer arrangements. However taking away the pew ends to do a second job as table centrepieces is both easy and practical.

7. Consider the colour of the altar cloth at the time of the wedding. A gold altar cloth would not be sympathetic with pink flowers. See if an alternative is available and permitted.

8. Check if there is another wedding on the same day. Costs may be shared if the colour and style can be mutually agreed.

9. If the bride wants a wealth of flowers ask the vicar, priest, verger or church flower arrangers if pillars and archways may be decorated. If so ask whether small nails can be inserted into the fabric of the building if these are not already in position. This is usually *not* possible. If you want flowers on the window ledges check if they are sloping. If they are you will need an angled wooden block or shelf attached to the window frame. This is complicated unless the church already has this kind of equipment made, so always ask.

1 pedestal by altar

2 pew ends

3 table near entrance

4 in front of the altar

5 windowledge

6 pillars

7 pedestal at entrance

opposite
Not even flowers could embellish the glorious brass work on this pulpit. The purpose-built grid was therefore positioned on the stonework. Stems of soft ruscus (*Danae racemosa*) were threaded through the grid and individually wrapped orchid tubes bound on with decorative wire. Mini *Gerbera*, roses and *Gloriosa* were inserted in the orchid tubes seemingly at random.

For those on a limited budget and with limited experience I would suggest that the best place for flowers in a church would be:

- A pedestal close to where the wedding service will take place (or two pedestals if budget allows).
- Pew end arrangements on alternate pews.

And if you have helpers you can decorate:

- The entrance where the order of service is handed out.
- The foot of the altar – for example the parallel design on page 304–5.
- The arch over the porch. Many churches have the mechanics for this and nails in position. Follow the directions for making a garland on page 407.
- Two giant topiary trees, one for each side of the porch. This is a lovely place to have photographs taken. See the topiary trees on page 268.
- The pillars – a band of flowers around the top of the two front pillars is very effective.
- The font.
- The pulpit.

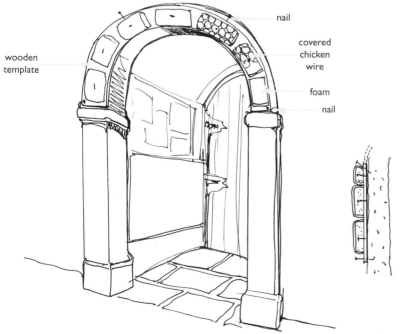

wooden
template

nail

covered
chicken
wire

foam

nail

TIPS FOR WORKING IN A CHURCH

- When creating twin arrangements, say pedestals or altar designs, work on both at the same time and keep going back into the church to view them at a distance.
- Take a couple of black bags into the church and a plastic sheet to place under where you are working.
- Blue and purple are recessive colours and your flowers will just look like holes when viewed at a distance, especially as the lighting in many churches is not good. Yellow and white are the most advancing colours and therefore make most impact. Generally, tints are more dominant than tones or shades.

Decorating the top of pillars is easy.
All you need is a tall step ladder, some
pew ends and a length of fishing wire
from which the pew ends can be hung
without putting nails into the fabric of
the building. Create the circle with foliage
of different forms and textures and then
add round, long-lasting flowers. Here I
have used *Gaultheria*, leather leaf and
ming fern for the foundations and added
Hypericum androsaemum 'Pinky Fair' and
three different carnations, harmoniously
colour linked.

Two tall all round designs that can be viewed from all directions frame the entrance to the church.

A garland of flowers decorating
a lych-gate

Creating a pew end

The mechanics for pew end arrangements are inexpensive. The plant
material can be limited and still remain effective. Ideally the pew ends
should be arranged in situ to ensure that the design is well balanced
and attractive from all sides but they can be arranged in advance and
then attached to the pew ends on the day. Pew ends can double as table
arrangements and be taken to the reception afterwards.

You will need

- OASIS® Spray Tray with handle or a caged pew end
- a piece of foam
- line foliage
- round and spray flowers
- filler foliage.

1. Cut the foam to fit the tray tightly. The foam should rise approximately twice as high out of the container as the container is deep. If you are preparing the pew end in situ, you might find you get a flood of water on the church floor. To avoid this either a) cover the foam in one layer of cling-film, with the folds at the base, or b) wet the foam 24 hours in advance and allow it to dry out a little.
2. Strap the foam firmly in place with floral tape.
3. Create an oval design, using the same method used for the oval table arrangement (see page 160).
4. Ensure that the stems used to create the length cover the handle completely.
5. Suspend the pew end by threading ribbon through the hanging hole and tying around the side of the pew or using a wire hook depending on the shape of the pew end.

Soft ruscus (*Danae racemosa*), ming fern (*Asparagus umbellatus*) creates the outline for this pew end with *Rosa* 'Beauty Oger' and *Symphoricarpos*. Pew end trays can be easily picked up by the handle and taken from the church to the reception to decorate the tables.

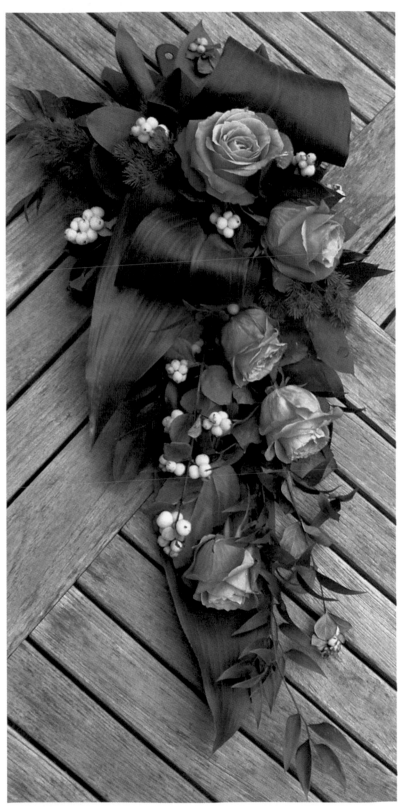

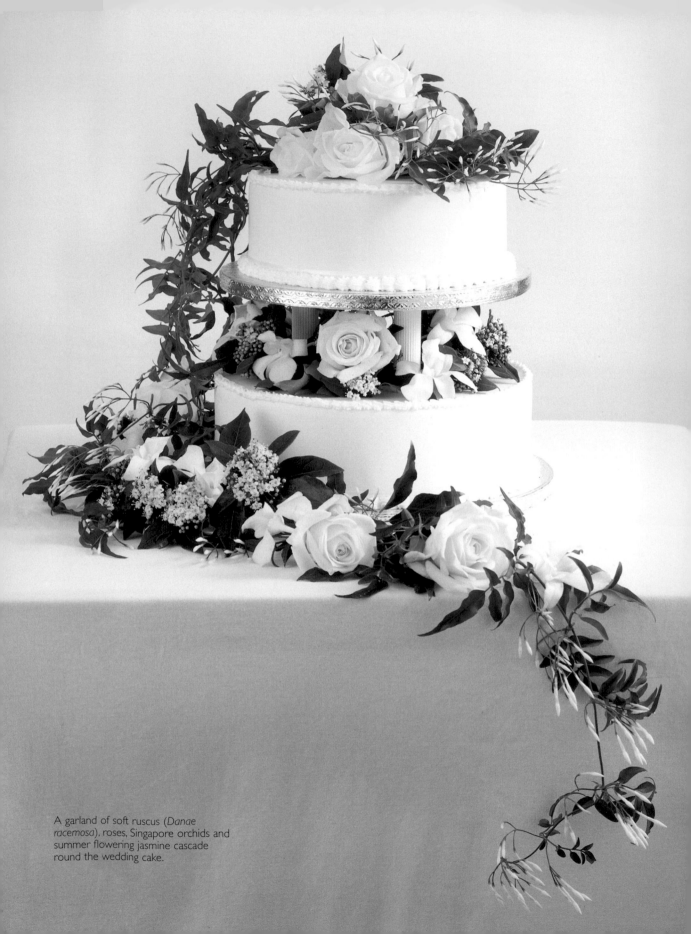

A garland of soft ruscus (*Danae racemosa*), roses, Singapore orchids and summer flowering jasmine cascade round the wedding cake.

The reception

Once the marriage ceremony is over, the bridal party and their guests make their way to the reception, which may take place in a hotel, hired hall, marquee or even on a boat.

It is a good idea to visit the venue first and see where flowers would be most effective. Brides often have a sketchy or unrealistic idea of what can be achieved, so you will need to check for yourself. The following places are where flowers can be best appreciated.

- Long low arrangements on a mantelpiece look attractive. The same shape of design can be used to decorate the front of a drinks table or the top table. It can be created from trails of ivy, mixed foliage and a few bold flowers.
- If there is a sideboard, then a display using fruits, vegetables and bunches of herbs makes a wonderful scented focal point.
- A pedestal or large arrangement in the reception area, or perhaps close to the receiving line, can be very eye-catching.
- Decorate the wedding cake or buffet table with garlands. Flowers are often arranged to enhance the wedding cake. They may be displayed in a small vase on the cake itself, but loose flowers can also be threaded through the cake and on the table. Use flowers that will stand without water for several hours. For health and safety reasons you should ensure that the flowers do not lie directly on the cake. To decorate the table, long sprays of soft ruscus *(Danae racemosa)* can be intertwined perhaps lightly wired together for extra security and the ends stapled to the corners of the table. Orchids or other long-lasting flowers can be threaded through the soft ruscus. Alternatively, OASIS® Mini Decos can be placed on the four corners of the table and decorated with a few flowers, perhaps with some toning ribbon.
- If there is to be a stand up buffet then designs need to be up high, for example on a mantelpiece, or firmly secured.

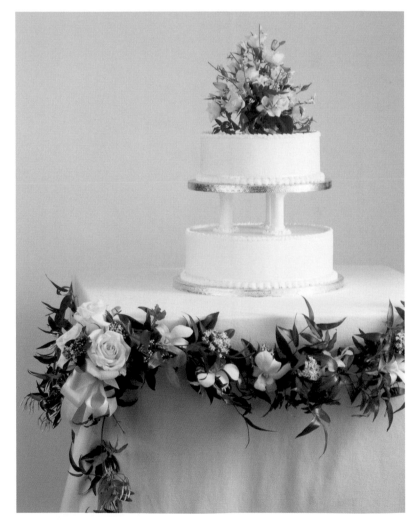

Soft ruscus (*Danae racemosa*) garlands the table with roses, Singapore orchids and *Viburnum tinus*. A small miniature design decorates the top of the cake.

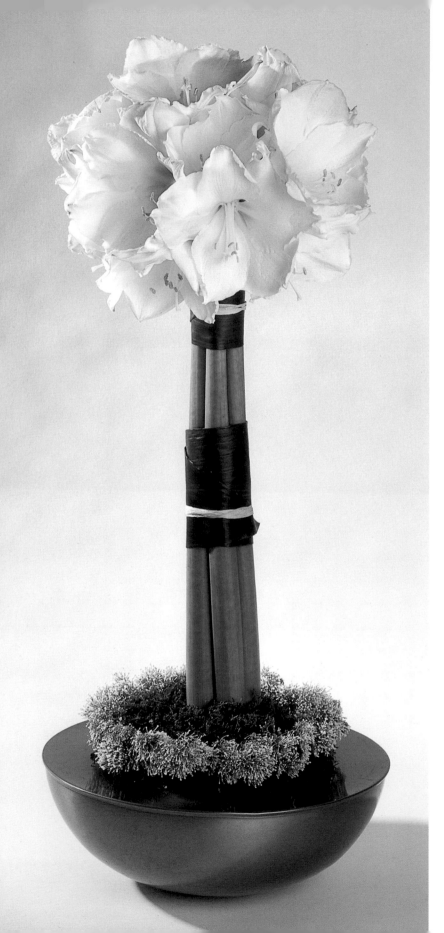

Ideas for the table

Centrepieces are usually for tables seating six, eight or ten. You must be careful not to make an arrangement so tall and wide that one cannot talk over it. A maximum of about 30 cm (12 in) is ideal. An alternative is to make it so tall that guests can talk under it. A fashion is to have low arrangements on half the tables and tall designs about a metre (40 in) on the others.

Arrangements that double as wedding favours are a good alternative. These small designs can be personalized and be taken home. See the single rose design on page 107.

left
Open amaryllis (*Hippeastrum*) bound and placed on a pinholder in a low bowl creates a tall design which can be easily seen around.

opposite page

top
A ridged bowl contains roses and *Gypsophila* on a dark green foliage background.

bottom left
A charming classic design on an 'S' shaped stand entwined with trails of ivy.

bottom right
A two-tiered arrangement using a tall glass vase to display and link the plant material.

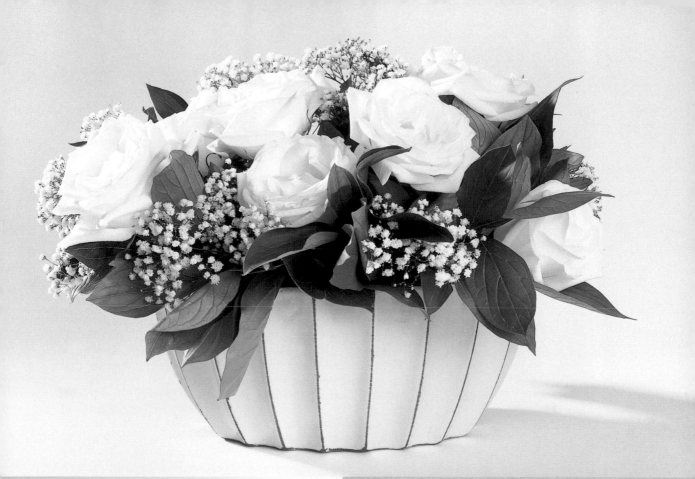
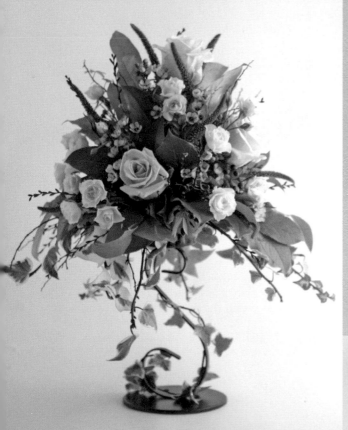
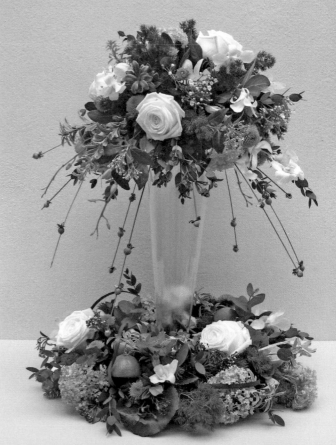

left The top table at a reception is viewed predominantly from the front although you must always make the back interesting for the wedding party. Here colour and interest runs the full length of the table with 'letter box' glass containers holding callas, roses and orchids. Petals and candles help tie the design together.

Tips for wedding flowers

- Lilies are majestic and look lovely in wedding arrangements. Purists dislike removing the stamens but I thoroughly recommend that all stamens be removed as the flowers open. If the stamens remain in place they can cause untold damage by staining which is extremely difficult, if not impossible, to remove completely. (Never wet a stain but lift off with Sellotape® or rub with a Scotch® pad and then put the garment on the line on a windy but sunny day.) Plucking out the stamens rather than cutting them gives them a more natural look. When purchasing lilies choose those on which one flower is beginning to open on each stem. Buy them in bud four to six days before the event and monitor their development. Never buy them the day before the wedding and hope for the best. They will not open whatever the time of year.

- Where economy is the order of the day consider creating arrangements of masses of well-conditioned Queen Anne's lace (*Ammi majus)* or cow parsley (*Anthriscus sylvestris*) in the late spring, perhaps with the addition of marguerites (*Argyranthemum frutescens*). In the summer, lady's mantle (*Alchemilla mollis*) can create a wonderful effect. Great bunches of baby's breath (*Gypsophila*) can be used on its own or with Easter lilies *(Lilium longiflorum*). In the autumn think of Michaelmas daisies (*Aster ericoides*), dahlias from a local grower, hydrangeas and berries. During the winter months use lots of evergreens – there is nothing better than the pollinated berries of the tree ivy (*Hedera helix* 'Arborescens').

- As the seasons vary, so do the flowers that are available at the most competitive prices. White and cream are by far the most popular colours for wedding flowers. On page 285 there is a list of some of the more widely used white and cream flowers in their season. The rose is still the most popular flower and I have named some of my favourites which are beautiful, generally reliable and available most months of the year.

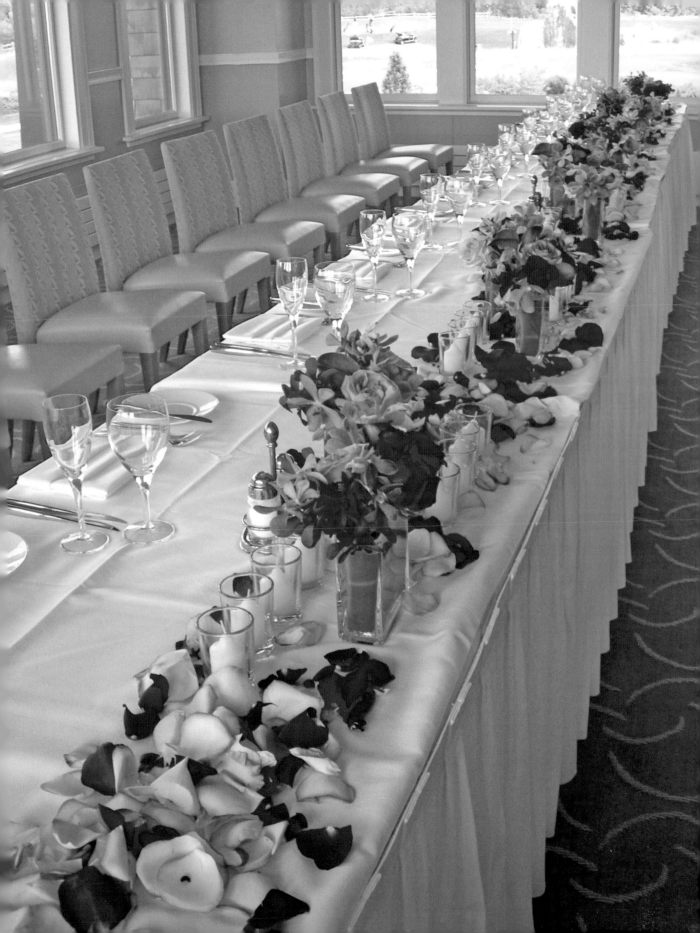

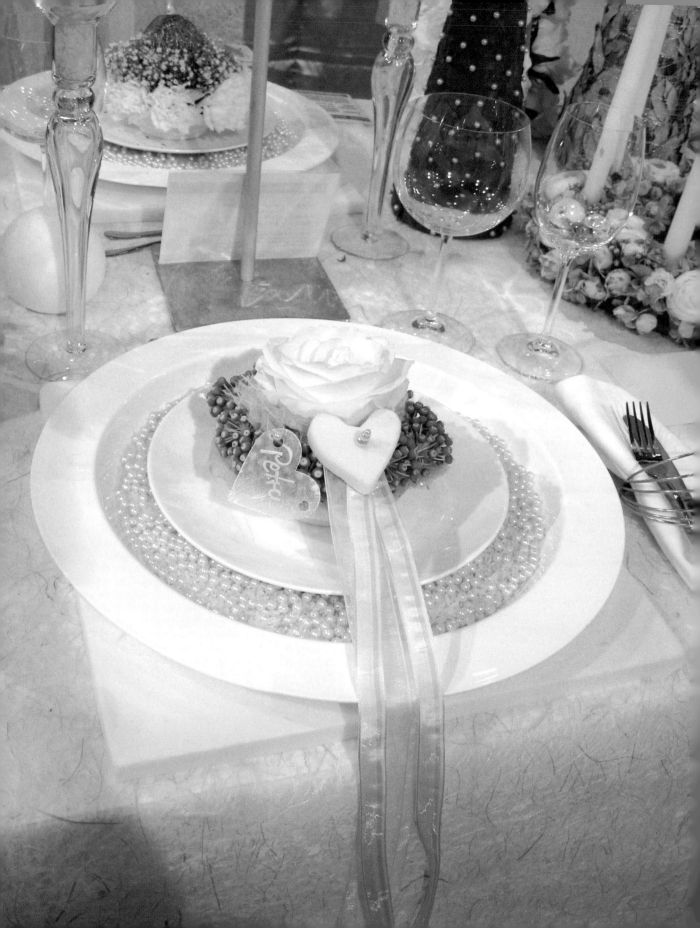

Marquee decoration

Refer to the section on marquees in the chapter 'Large scale arranging' on page 317.

Refer to the section on marquees in the chapter 'Large scale arranging' on page 317.

Fragrant flowers and foliage

Spring
lilac (*Syringa*)
Some varieties of tulip
Prunus glandulosa 'Alba Plena'
lily of the valley (*Convallaria majalis*)
broom *(Genista)*
Muscari
Narcissus various
tuberose (*Polianthes tuberosa*)
Hyacinthus

Summer
lavender (*Lavendula*)
Phlox
snapdragon (*Antirrhinum majus*)
mint (*Mentha*)
stocks (*Matthiola*)
sweet pea (*Lathyrus*)
marjoram (*Origanum*)

Autumn
chocolate cosmos (*Cosmos atrosanguineus* 'Black Beauty')
Chrysanthemum
Amaryllis belladonna

Winter and all year round
Dianthus
Freesia
Lilium (Oriental Gr.) and *Lilium longiflorum*
Rosa 'Extase', *Rosa* 'Jacaranda', *Rosa* 'Silver Sterling'
Stephanotis floribunda
Eucalyptus
rosemary (*Rosmarinus*)
Chamelaucium uncinatum

White and cream flowers

Spring
lilac (*Syringa*)
broom (*Genista*)
tulip (*Tulipa*)
narcissi (*Narcissus*)
Anemone coronaria
Freesia
Iris
arum lily (*Zandesdeschia*)
hyacinth (*Hyacinthus*)
Easter lily (*Lilium longiflorum*)*
lily of the valley (*Convallaria majalis*)

Summer
Achillea ptarmica 'The Pearl'
larkspur (*Consolida*)
gladioli (*Gladiolus*)
snapdragon (*Antirrhinum*)*
Phlox
sweet pea (*Lathyrus odoratus*)
Dahlia

Autumn
Casa Blanca lily (*Lilium* 'Casa Blanca')*
chrysanthemum
Peruvian lily (*Alstroemeria*)*
carnations (*Dianthus*)*
Euphorbia fulgens
Hydrangea
Stephanotis floribunda

Winter
Christmas rose (*Helleborus niger*)
amaryllis (*Hippeastrum*)
Singapore orchid (*Dendrobium*)*
spray carnations (*Dianthus*)*

* Flowers available all or virtually all year round

left A table setting using OASIS® Floral Products

Recommended roses

Cream and white

'Vendella' – long lasting cream rose with medium to large head and regular form.

'Avalanche' – large clean-white rose with guard petals tinged with green.

'Iceburg' – tall-headed large white rose with faint blush of pink.

Green

'Maroussia' – very large white rose, touch of green on guard petals, flat head, long lasting.

'Akito' – pure white, well formed, long lasting rose with medium head.

'Florence Green' – lime green with frilly petals, the dark sepals can give the appearance of being damaged.

'Super Green' – lime green but a touch of dark pink at the centre, frilly petals.

Yellow

'Yellow Sphinx' – long lasting, dependable, daffodil-yellow rose with curvaceous petals.

'Golden Sphinx' – the same rose as 'Yellow Sphinx' but with a stronger 'gold' colour.

'Yellow Island' – large, dependable yellow rose with a fresh lemon colour.

'Ilios' – creamy yellow, large headed dependable rose.

Blue/Blue-Pink

'Avant Garde' – A beautifully shaped rose with delicate mauve colouring.

'Cool Water' – a deep mauve blue.

'Pacific Blue' – a very pale mauve blue.

Blue roses generally are weaker than other colour roses. The petals bruise easily and their life is not as long.

Red

'Grand Prix' – reliable long-lasting rose. Flat, multi-petalled and deservedly popular.

'Passion' – very similar to 'Grand Prix' but smaller and slightly brighter red.

'Black Baccara' – a dark red rose with good form and a long life, very velvety.

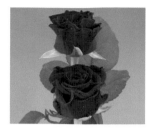

'El Toro' – tomato red rose, long-lasting and reliable with undulating petals.

'Ecstase' – a very dark red rose with a fantastic fragrance and a rather tight form.

'First Red' – an ordinary red rose but reliable with a slightly pointed form.

Pink

'Beauty Ogre' – a large-headed pink rose with graduation to paler pink at the centre.

'Poison' – a beautiful, long-lasting, strong fuchsia-pink rose with good form.

'Heaven' – a soft sugar pink rose, medium head.

'Mi Amore' – a mid pink rose with a large head.

'Tenga Venga' – an up and coming red-pink, vibrant rose.

'Toscanini' – salmon pink rose with a deeper colour to the outer petals.

Orange

'Cherry Brandy' – large orange rose with pink outer petals.

'Naranga' – beautiful orange rose but the large number of thorns make it difficult to condition.

'Milva' – reliable rose similar to 'Naranga' but with fewer thorns.

Wow – Light orange rose , long lasting and reliable.

Flowers for the bridal party

The Groom, Best Man and Ushers

The buttonhole

Buttonholes are easy to make. They are however much lighter and easier to wear if they are wired and taped. Once you have practised using wire and tape you will want to experiment with every type of flower. Anyone can wear a buttonhole or corsage – which is a more elaborate version traditionally worn by ladies – although fashion is such that buttonholes are becoming more elaborate and include berries, grasses, beads and decorative wire. The groom usually wears a flower that is evident in the bride's bouquet thus setting him apart from the rest of the party.

In the photographs you will see various buttonholes. Below I have explained how to wire some of the most popular flowers and leaves with a separate description of how to use stem tape – which applies to all the flowers and foliage – and how to put the various elements together.

NB. For all flowers cut the stem short, about 2cm (¾in) before wiring.

a) Carnation
Cut off most of the carnation stem and insert the medium-gauge wire (0.71mm) up through the flower. Make a small hook in one end and then pull down into the flower.

b) Rose
Insert a wire of the required strength (usually a 0.71mm for most medium to large headed roses) into the calyx, parallel to the stem. This will 'bite' into the calyx and be sufficient to hold the stem.

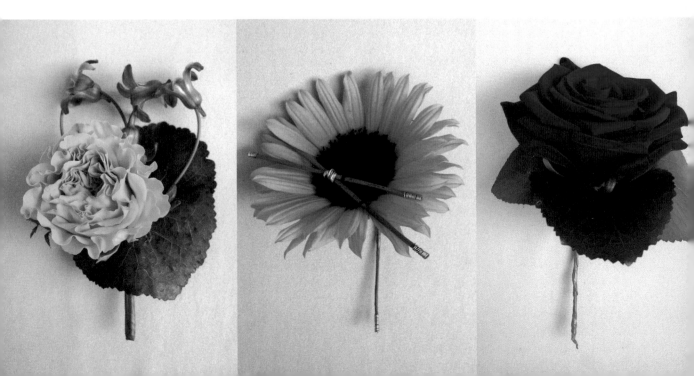

c) Singapore orchid head
Insert a 0.38mm wire horizontally through the stem of the orchid as close to the flower as possible. Bring the ends of the wire down parallel with the stem and twist the wire twice onto the stem. Bring the remaining wires straight down.

d) *Freesia*
Use reel wire or a long fine silver wire and weave this in between the flower heads all the way up the stem to the tip. Secure by one complete circle. You can add an extra stem before adding stem tape to give extra strength.

e) Mini *Gerbera*
Insert one end of a medium gauge wire (0.56mm) up into the stem ensuring it does not come out of the top of the flower head. Take a fine silver wire (0.32mm) horizontally across the top of the stem and wind it twice around the stem and twice under the stem and onto the wire. This will ensure the flower does not spin on the wire.

f) Calla
The same method as for the mini *Gerbera* above, but remember that some callas can be very heavy. A 0.71mm wire gauge could be necessary.

g) *Hypericum*
Using two or three berries on their stems, take a medium silver wire (0.38mm) and make a small loop. Holding this against the berries, between your finger and thumb, wrap the longer end around the shorter end and the stems, three times evenly spaced. Pull the remaining wire down straight.

h) Bear grass
Using two or three pieces of bear grass together follow the same method as for the *Hypericum* berries above. To give a more contemporary look to the ends of the bear grass *Hypericum* berries can be threaded onto them.

TIP Use a cocktail stick or needle to make a hole in the berry. Cut the thin tip off the bear grass and cut at an angle. Thread the berries onto the grass where they will stay obligingly in position.

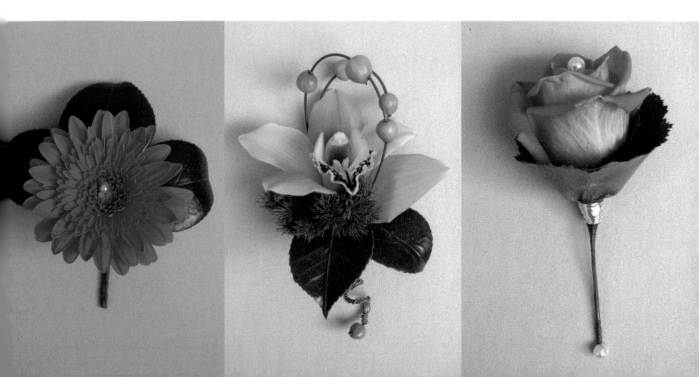

i) Ivy leaf

Take an ivy leaf and reduce the stem length to 2cm (³⁄₄inch). Make a stitch with a light gauge wire two-thirds of the way from the bottom of the leaf. Thread the wire through the leaf onto your tip of your finger. Make a neat return making a small stitch. Hold the stitch in place with your finger and thumb to avoid tearing the leaf around the stitch. Bring the ends of the wire down parallel with the stem. Wrap the longer end around the shorter end, *and the stem*, two or three times, evenly spaced. Pull the two ends of wire down parallel with the stem.

Stem tape and how to use it

Types of stem tape

There are three types of stem tape widely available. All three tapes are used to cover stem ends to:

- seal in the moisture
- give extra hold
- disguise the wire
- give a professional finish

1. Guttapercha – this is a natural product that produces a fine and elegant finish.
2. Parafilm tape – a man-made product which is popular amongst many florists.
3. Stemtex – easy to use when starting out but rather sticky especially in warm weather – the finish is not quite as fine as with (1) and (2).

How to use stem tape

First practise on a straight wire to get the technique which is as follows:

1. Take a strong gauge straight wire and hold it vertically in your left hand if you are right-handed and in your right hand if you are left handed.
2. Wrap the tape one and a half or two times around the tip of the wire.
3. Pull the tape down at an angle of about 135 degrees and pull to make the tape taught – almost to the point of breaking.
4. Twirl the wire around with the left hand. Keep the tape firm with the right and let it wrap round the wire.

NB. When binding a wire and stem together with stem tape start above the join. Each turn should overlap by about a half or less.

The Bride

As previously mentioned, flowers for the bridal party are best designed and created by a professional florist. If you want to be involved create the buttonholes as described and create a single massed flower bouquet.

Wedding bouquets

The massed handtied

This can be made with a mixed bunch or single type of flower with the stems retained, tied with ribbon or raffia. To create this version with the stems parallel:

- remove the leaves from the stems of a round flower such as an open rose. You will need approximately 17.
- hold the first stem vertically in the left hand (if you are right handed) and add others around to create a gently rounded mass.
- add a frill of single wired leaves such as *Galax* or large ivy leaves, or foliage sprays.
- bind with florists tape to secure and cover the tape with quality ribbon.

NB. Alternatively the flowers can be wired and the wired stems covered with ribbon.

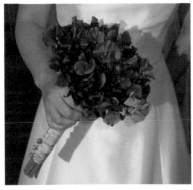

A mass of purple sweet peas bound with co-ordinated ribbon.

Vanda orchids and lily grass in a simple delicate bouquet.

A column of white arum lilies (*Zantedeschia*) bound with decorative ribbon.

A mass of green 'Prado' carnations (*Dianthus*) in a twiggy frame enhanced with beads and steel grass.

right
A mass of wired roses edged with salal (*Gaultheria*) creates a sensational handtied wedding bouquet.

below
A classic shower bouquet of roses, soft ruscus (*Danae racemosa*), ming fern (*Asparagus umbellatus*), roses, *Freesia* and broom (*Genista*).

The shower bouquet

This is often designed on a foam holder. The overall shape is roughly in the shape of a teardrop. The stems that fall downwards rather than upwards are wired into the foam to make them secure.

If the bride wishes, every stem can be wired. The resulting bouquet will be light and elegant. However, the work involved is considerable and the florist must charge accordingly.

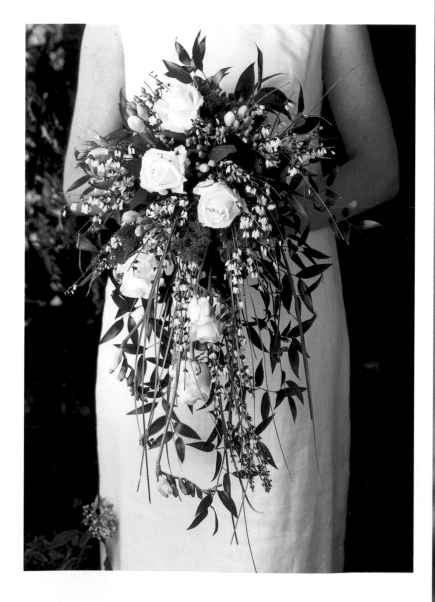

Other bouquet ideas

a) The Carmen or Duchesse rose, crafted from a central rose surrounded by wired petals.
b) A stylish bouquet using five roses, some architectural leaves and some strands of bear grass or lily grass.
c) A massed bouquet of *Cymbidium* orchid heads with extension.

Alternatively the bride may prefer to carry a wand of flowers, a muff or decorated bag.

A modern seasonal bouquet with grouped plant material.

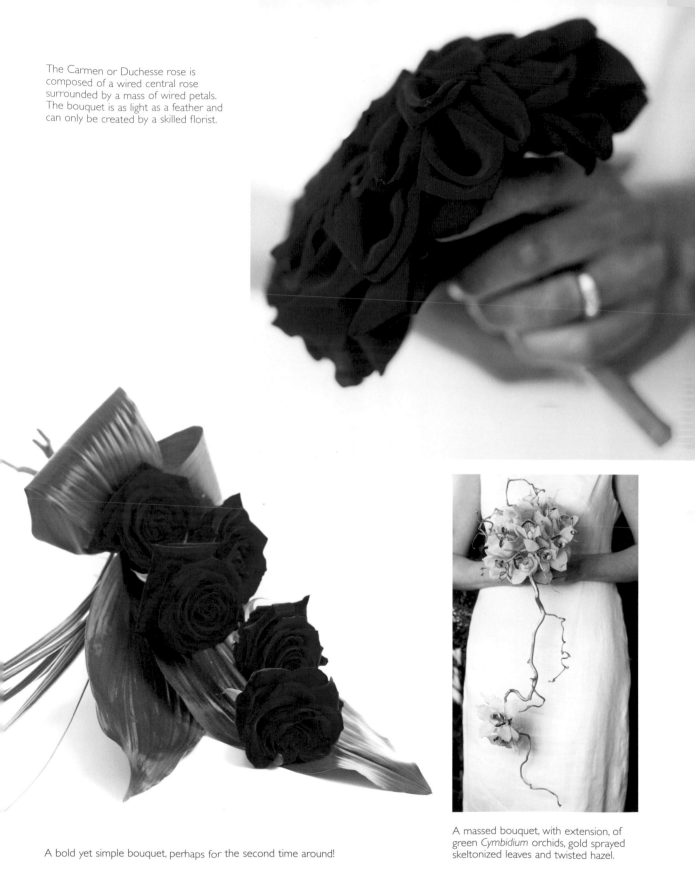

The Carmen or Duchesse rose is composed of a wired central rose surrounded by a mass of wired petals. The bouquet is as light as a feather and can only be created by a skilled florist.

A bold yet simple bouquet, perhaps for the second time around!

A massed bouquet, with extension, of green *Cymbidium* orchids, gold sprayed skeltonized leaves and twisted hazel.

OASIS®

plastic

The Bridesmaids

The circlet

Only light materials should be used for a ring of flowers. A lot of heat is lost through the head and therefore the plant material should be reasonably long-lasting and well conditioned. This is one of the items best left to the professional florist.

The handbag

A handbag can be easily created from an angled slice of OASIS®, a length of bear grass wired at both ends and a few variegated leaves.

decorative wire

bear grass

decorative pins

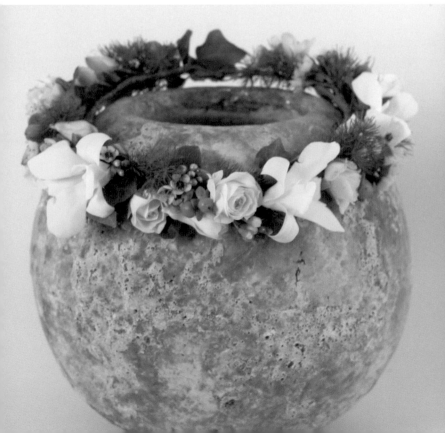

The headband

A headband can be made by simply glueing flowers (dried, silk or fresh) onto a plain Alice band.

The pomander

This is ideal for young bridesmaids but the foam sphere must not be soaked in water as this would make it too heavy. Alternatively it can be made with dried or preserved flowers.

You will need:
- OASIS® Wet Floral Foam Sphere 9cm
- medium gauge (0.56 mm) stub wire
- 25 cm (10in) of ribbon
- 12 stems spray roses OR 12 stems small flowered chrysanthemums OR 15 stems spray carnations – quantities are approximate as they are dependent on the number of flowers on the stem.

Method
1. Dip the sphere quickly in water, or spray it lightly.
2. Double the ribbon into a loop. Make a double leg mount (Techniques, page 405) with the wire, ensuring it has no kinks in it. Push the wire through the centre of the sphere. Both ends should go through together. Bend the two protruding ends back in to the sphere to secure.
3. Cut the flowers from the sprays and pack the sphere. I prefer to move back and forth, here and there, around the sphere rather than working methodically round. You can then add short, neat filler foliage such as ming fern if you find you have insufficient flowers.
4. Spray with water.

left to right

A circlet for the bride or bridesmaid of fresh spray roses, Singapore orchids, waxflower, *Hypericum androsaemum* 'Jade Flair' and ming fern.

Handbag – an easy to make but delightful idea created from a piece of foam, long lasting leaves, a few strands of bear grass and some decorative pins.

A young bridesmaid would love this pretty headband of preserved flowers and she would be able to keep it for many years to come.

A pomander of preserved roses, *Hydrangea* and mixed foliage.

Baskets

Flower baskets are easy to make and easy to carry. Always ensure there is sufficient space for the hand between the flowers and the handle. Insert the stems firmly so there is no chance of any falling out with enthusiastic handling.

A simple spring flower basket

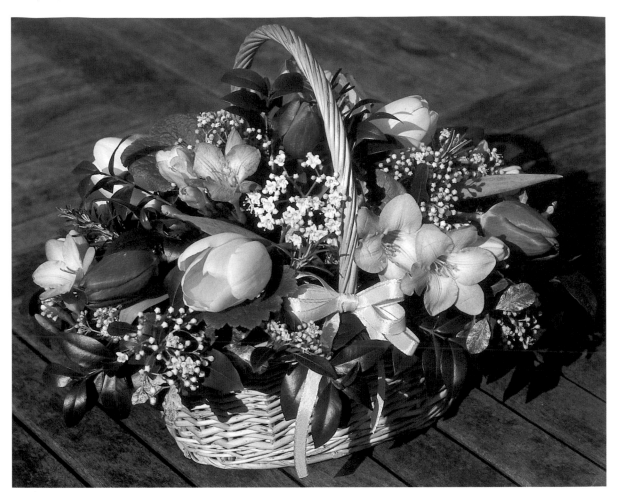

Hoops

Hoops can be made from flexible stems and embellished with long-lasting foliage and exotic flowers. Alternatively hoops can also be hung over pew ends.

Jewish weddings

Traditionally wedding ceremonies are performed beneath the open sky with a Prayer Shawl held above the couple by four men. Today, ceremonies are also performed indoors but amongst observant Jews the canopy is placed below a special opening in the ceiling/roof. The canopy itself can be very simple, a prayer shawl or special velvet/satin square held aloft by four men or attached to four mobile poles. You also see very elaborate constructions to which magnificent canopies are attached. These lend themselves to floral decoration.

Outside Israel, Jewish weddings usually take place in synagogues. In Israel it is most common for the ceremony and reception to be held either within a function hall or outside in its garden surroundings. Outdoor summer weddings can be planned with confidence as there is virtually no danger of inclement weather.

Arranged marriages are an accepted practice in religious circles. The engagement is a big celebration where flowers play a dominant role. This is traditionally the first time that the bride and groom meet. Arrangements are sent to the fiancée from the groom, from one family to the other and to 'the bride to be' from family and friends.

On the Saturday morning before the wedding the groom takes part and is blessed at the Sabbath service in the synagogue. This is known as the 'Shabbath Chatan'. After the service the congregation are invited to partake in the 'Kiddush' which is a reception where blessings are made and food and drink are served.

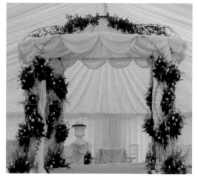

A chuppah in an indoor setting.

The amount spent on the 'Shabbath Chatan' depends on the budget of the families. It can range from the very modest to the most extravagant which would entail the decoration of the Synagogue, arrangements for the reception – both buffet and table centrepieces – and possibly even corsages for the women.

Over the years the floral decorations at weddings have been greatly influenced by western and other religious customs. Most important is the bridal bouquet, often accompanied by a headdress and accessory flowers for the mothers, groom, fathers, bridesmaids and other special guests. Ivy and a sprig of *Myrtus* are of traditional importance as they signify fertility and long life.

At the ceremony there can be floral decorations at the entrance for the pre-reception cocktail party. The reception can have buffet/bar decorations, flowers on the main and other tables, on the divider if required and on the bandstand. Today even the car can be decorated. Family and friends send flowers to the families of the bride and groom on the occasion of the wedding and some even send them to the venue.

If invited to decorate a synagogue it is important to remember that it is not permitted to take food in with you.

Most Israeli wedding ceremonies are held in the evening and a meal is served. They are normally large affairs with many guests including children of all ages. As it is not customary to send invitations with RSVP the families have to guess the number of guests!

Tuesday is the most popular day for weddings because it is written in the Bible that on this day God said 'It will be good' – twice.

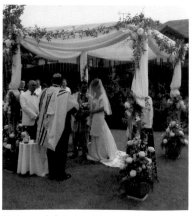

A chuppah in an outdoor setting.

Asian weddings

All Asian weddings differ – from Sikh to Hindu, from Bengali to Muslim, but all include flowers at certain stages.

Sikh weddings

Flowers can mark any occasion and an Asian wedding is no exception, with families going to great lengths to ensure the colour and vibrancy of the flowers match the happy occasion. The Sikh wedding in particular is marked by many ceremonial stages throughout the day and flowers play a vital role in some of these.

The Sikh wedding day begins with a reception of the *Barat* (the groom's family), where they are welcomed by the bride's family at the *Gurdwara*, the Sikh temple. This is followed by a ceremony called *milni* which is where the men on both sides of the family greet each other in turn and exchange garlands. The garlands can sometimes be made out of flowers but otherwise tend to be made of shiny pieces of foil. Once this is complete, the priest reads an *ardas* which is a prayer of blessing on the joining of the two families. The *Barat* are then offered tea and snacks prior to the wedding ceremony.

Some Sikh weddings include another small ceremony which is where the bride and groom meet each other and place a garland around each others neck. This is called a *Jaymala*. The flowers used for the *Jaymala* ceremony are usually in red and white, but this does not have to be the case. Brides may choose a different colour to match her outfit and that of the groom.

At the *Anand Karaj*, which is the wedding ceremony itself, flowers are usually placed in front of the *Guru Granth Sahib*, the Sikh Holy book. The ceremony commences with prayers, followed by *lavan*. This is when the bride and groom walk round the holy book four times, before the priest says his final prayers.

Once the wedding ceremony is over, there is usually a wedding reception. This is sometimes in the temple itself, or can be at a hall, hotel or other venue.

As with all faiths, more and more Asian people are focused on having the perfect wedding and weddings are now more lavish than they have been in the past. Flowers are used for decoration purposes at the venue and are now an essential extravagance. Brides may choose to include flowers in their hair.

The civil ceremony, as a separate wedding function, has become fashionable. The bride and groom will endeavour to colour co-ordinate the flowers.

Muslim weddings

A Muslim wedding is a relatively lengthy process. Depending on the region and the prosperity of the people, there will be various stages comprising proposal, engagement, *manyum*, *mehndi*, *barat*, *nikah*, *rukhsati*, *saij*, *valima* and *chauthi*. *Manyun* entails applying a paste of turmeric, flour, rose petals and oil to the entire bodies of the bride

and bridegroom. *Mehndi* is the occasion when mehndi leaves are mixed with chemicals and applied to the hands and feet of the bride and to the hands only of the bridegroom. There is no fixed time for this ceremony, the main consideration being that the colour should not fade away before the *niakah* or *rukhsati*. *Barat* is the marriage procession, which is led by the bridegroom on a horse, camel, in a car or on foot to the bride's house. *Nikah* is the registration of the wedding and is usually conducted at the bride's house. Both bride and groom will wear *shra* (lots of garlands of flowers), which cover their faces completely until the *nikah* ceremony is completed.

Rukhsati is the giving away of the bride. Flower petals are thrown at the couple as they make their way to the bridegroom's house. *Saij* (or *saje*) is the bridal bed, which will be decorated with flowers. Lots of red rose petals will be scattered on it. *Valima* is the feast given by the bridegroom the day after the *rukhsati*, and *chauthi* is the occasion when the bride goes to her parents' house for a few days.

At all the above occasions, flowers are used in the form of garlands, bouquets and bracelets. They are also thrown over the heads of the bride and groom and their families and friends. Horses and carriages are decorated with flowers.

In some areas Muslim weddings take place in the home, or in a tent or marquee, rather than in the mosque. The bridegroom's family bring the wedding dress to the bride's family the day before the wedding and this is exchanged for other gifts from the bride's family.

A Wedding Stage / Reception Backdrop
Many Asian couples wish to sit on a raised stage or platform. The bride and groom will sit centrally and the family and close relatives will sit alongside or behind. They will greet the guests and then step down for the wedding feast. Afterwards they will return to their seats and talk to guests and have their photographs taken. The stage is decorated with draping, often with extravagant displays of flowers.

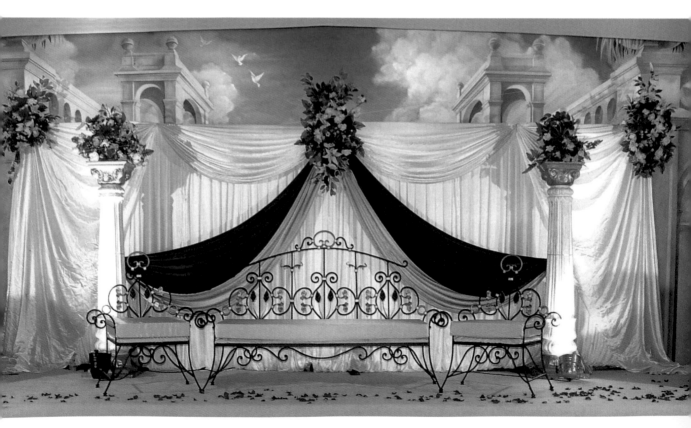

Hindu weddings

The wedding ceremony often takes place in the home or a hall rather than in the temple, and is considered both a religious and social occasion. There are certain days that are considered auspicious for weddings and the family will consult the priest as to which day would be best. Many flowers are used at the wedding ceremony to decorate the place of marriage, and fragrance is of the utmost importance. The bride's family, often the children, are involved, welcoming the guests and distributing flowers to them as they enter. The pandit (priest) has red and white flowers in a dish and as he blesses the bride and groom he puts flowers in the palms of their hands. The bride and groom exchange sumptuous garlands, mainly of red and white flowers decorated with very fine silver strands, strung on cotton, which they wear around their necks as they are married. Jasmine is widely used for its intense, heady perfume, but roses and other sweet scented flowers can be included. *Hibiscus* is also commonly used. In some communities there is a curtain of flowers around the bridal bed.

The female guests at the wedding all wear flowers – just as they do at all special occasions. Garlands are entwined around buns in the hair, along plaits or behind the ears. There is joy and celebration in this use of sweet-scented flowers.

Many of these faiths will involve a civil ceremony first, so it is worth remembering that flowers may be required for that too.

Anniversary flowers

All anniversaries are special, but perhaps the most important landmarks are silver and golden wedding anniversaries.

Silver and grey foliage include:

wormwood (*Artemisia*)
gum tree (*Eucalyptus*)
'silver dust' (*Senecio cineraria*)
Jerusalem sage *(Phlomis fruticosa)*
curry plant (*Helichrysum italicum*)
Ballota
Hosta sieboldiana
Rue (*Ruta* graveolens)
sea holly (*Eryngium alpinum*)
rosemary (*Rosmarinus officinalis*)
Brachyglottis (Dunedin Group)
'Sunshine' syn. *Senecio* 'Sunshine'
Stachys byzantina
cotton lavender (*Santolina chamaecyparissus*)

Silver weddings

A suitable container for such an event could be a silver bowl, a silver sprayed tin or plastic container, a silver candlestick with a candlecup, an aluminium foil container or a low dish that will not be seen. A base could be a silver tray, a cake board or a silver doily. This could then be placed on a white lace cloth over silver foil.

White and silver flowers would portray your theme but be careful of using only white flowers as this can look rather bridal. This could be avoided by adding simple bows of silver ribbon. Alternatively fronds of artificial ferns can be sprayed with white paint and then glitter or silver sequins applied. Poppy seed heads, Chinese lanterns and many other dried flowers and seed heads can also be sprayed silver.

'Sterling Silver' roses that are ideal for mixing in silver wedding anniversary arrangements are available most of the year.

Golden weddings

Fifty years of marriage certainly merits celebration. The warmth and mellowness of gold is found in much plant material such as roses, daffodils and golden rod (*Solidago*), *Fremontodendron* 'Californian Glory'. Candles can be gold, green or golden-yellow. Gold ribbon can easily be incorporated into a design. Dried plant material may be sprayed gold. When using an aerosol spray remember that a smooth texture will shine whereas a rough texture such as that of a teasel will look less effective. Gold paper or material can cover a base or a container.

A low glass bowl sits inside a floral ring of wet foam. Golden floating candles and the mixed array of warm coloured roses makes this design ideal for a Golden Wedding.

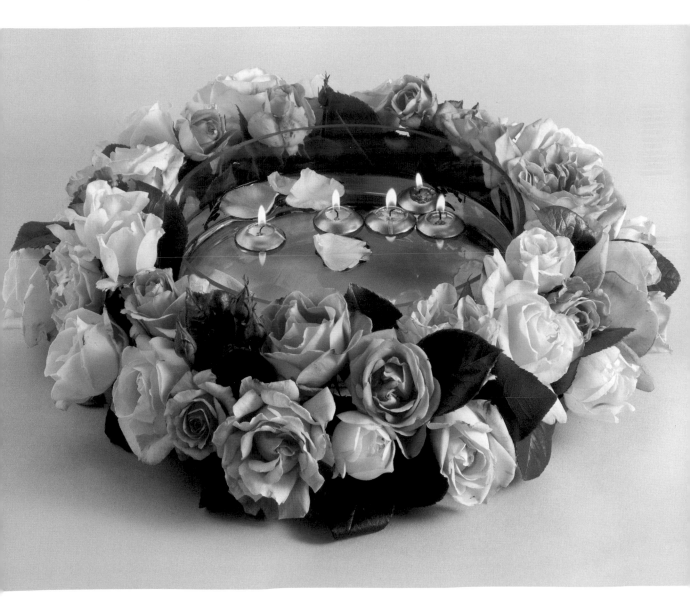

11
Large scale arranging

Sometimes, as flower arrangers, we are invited to arrange the flowers for a very special occasion. This usually means working on a much larger scale than normal and perhaps entails enlisting extra help. Examples are civic occasions, charity balls, the opening of a new building, royal visits, school speech days, concerts and of course weddings and church festivals.

With luck, one is given plenty of time in which to plan for the event, although on some occasions you may be given only a few days' notice. In either case, careful planning and organisation of time and materials are very important.

Inside Grace Episcopal Church with its
ornate candelabras and cross, it can be
hard to create a design in scale that is
also in harmony. Specially made troughs
are at the base of the altar. The foam is
quickly covered with clumps of lime-
green sisal, hydrangeas, manipulated
Aspidistra and very special 'hedge apples'
from Minnesota. In order to complement
but not distract from this display the
ledge behind is decorated simply in the
more subdued colours of the
groundwork in the front design.

Preparation

A preliminary visit to the venue is a must. You need to find out what stands and containers are available to you. If these are not suitable, or unavailable, you will have to borrow or even have the mechanics specially made. The location of displays is also of great importance. Arrangements need to be visible above people's heads, even when standing, if at all possible. This is where pedestals and columns come into play. A local wrought-iron worker may be able to make a larger-sized pedestal than normal. Alternatively, a handyman can make a stand to your specifications out of rigid cardboard tubes or piping from a builder's merchants, finished off with an attractive paint finish.

Wherever you decide to place an arrangement, it must never impede the proceedings of the event in question. Displays may start at ground level or from a few feet up. If working from the ground, consider carefully how much will be seen or hidden by a mass of people. If hidden, then such a design may be better placed in an entrance, where people attending the event will pass it and be able to appreciate it fully.

Sometimes organizers ask you to place flowers in a certain position to mask an unsightly object. This is rarely successful, and a far better option is to place the display in such a position that it draws the eye away from the eyesore and towards the flowers.

On an initial visit you need to find out where the water supply is and where the broom cupboard is located. This will give you a chance to get on the right side of the caretaker, which is no bad thing. He or she is likely to welcome a few leftover flowers!

Once you have decided where the arrangements are to be placed, that they are of a size in scale with both the building and the occasion, and in harmony with the design and decoration of the venue, you need to work out careful costings. Sometimes, albeit rarely, you will be given unlimited resources. On the other hand, many organizations work to very tight budgets and in these cases one has to be ingenious to create maximum effect at minimum cost.

Glorious columns of summer flowers, framing an archway, composed of *Delphinium*, *Dianthus*, lilies, lisianthus (*Eustoma*) and *Limonium* with *Vinca* foliage, *Hosta*, *Bergenia* and other garden plant material.
Designer: Moira MacFarlane

Types of large scale mechanics

Two wrought iron stands of similar form but of differing height with integral containers

A 1m (40in) plinth constructed from 3 ply sides on a 5 ply base and top

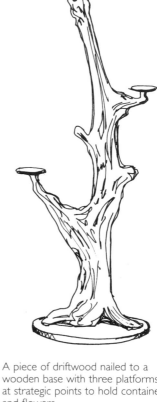

A piece of driftwood nailed to a wooden base with three platforms at strategic points to hold containers and flowers

Columns of flowers are relatively easy to create and they make a great impression. You need a four sided wooden post about 5cm (2in) square firmly attached to a heavy base with steel brackets. Hammer in nails on opposite sides of the post leaving sufficient space between them to allow the hanging of pew ends. Using the pew ends, plant material can be arranged in the foam to create a continuous column or a slim triangle with a wider base gently tapering to a point.

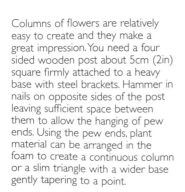

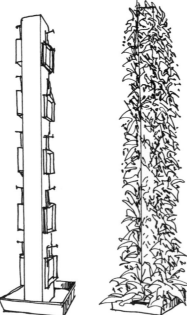

A three placement stand constructed from wrought iron

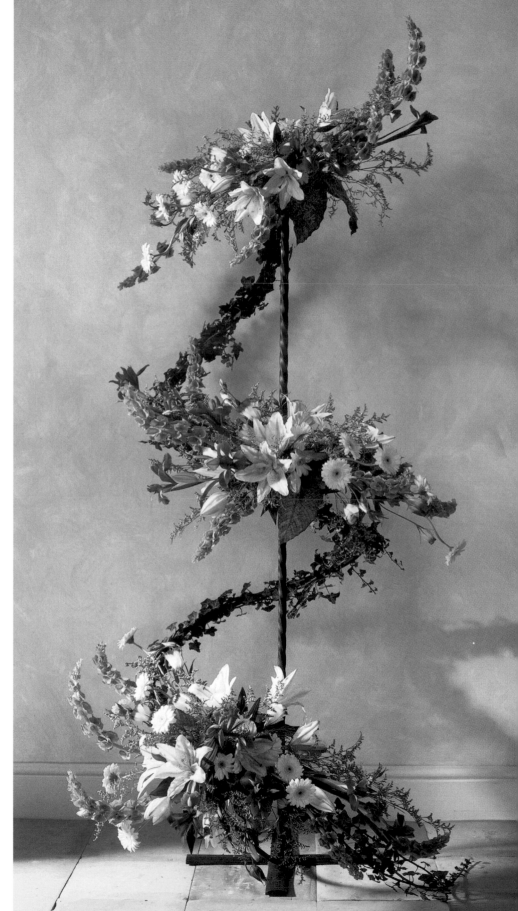

This design consists of three placements on a spiralled wrought-iron stand. Trails of ivy have been bound around the spiral to give it bulk and make it more prominent than the upright, central column. If well conditioned the ivy will last well out of water for several days. The flowers are lilies (*Lilium* 'Joy'), green bells of Ireland (*Molucella laevis*), pale pink peruvian lily (*Alstromeria*) with yellow *Gerbera* picking up the yellow in the dark blue *Iris*.

Choice of flowers

It is worth bearing in mind that at certain times of the year flower costs increase greatly – for example, at Easter, Mother's Day and Valentine's Day. As the flower world is international, events in other countries, such as Women's Day, May Day, can also affect their availability in your own country.

When budgets are tight, look around you to see what is plentiful. Devise displays in spring using masses of *Forsythia* which, when blooming, seems to be growing in every garden in every street. In summer, dahlias are plentiful and large enough to put on a good show. Later in the year abundant supplies of golden rod (*Solidago*) could be employed mixed with Chinese lanterns (*Physalis alkekengi* var. *franchetii*). In late autumn Michaelmas daisies (*Aster novi-belgii*) and chrysanthemums are plentiful and inexpensive.

Colour will also play an important part in your choice of flowers and foliage. Companies, local councils and schools may have particular colours associated with them, which they may specifically ask you to include. Remember that receding colours, such as blue and violet, do not show up well from a distance and can look like 'black holes' in an arrangement. If you are expressly asked to use colours such as royal blue or deep purple, these should be arranged where they can be viewed at close quarters and where the lighting is good. Again, the entrance may well be a good position. If the location is particularly dim, then only flowers with high luminosity will show up well. These are the tones that have a lot of white in them, such as creams, pale yellows and pinks. A walk around the garden at twilight will enable you to pick these out.

Larger displays usually necessitate larger flowers. Suitable garden types would be peonies (*Paeonia*), hollyhocks (*Alcea*), delphiniums, foxgloves (*Digitalis*), larger roses (*Rosa*), hydrangeas, rhododendrons and bear's breeches (*Acanthus*). Even if garden supplies are plentiful, some flowers will probably have to be purchased. Larger flowers available all year round are lilies (*Lilium*) (which are always effective), painter's palettes (*Anthurium*), gerbera and sunflowers (*Helianthus*), whilst seasonal varieties include *Allium*, amaryllis (*Hippeastrum*), African lily (*Agapanthus*), sword lily (*Gladiolus*) and proteas. Flowers such as carnations and roses, which would assume the role of focal flowers in a smaller display, become filler flowers when used in large arrangements.

Once you have decided which flowers to use, the next step is to find out where they are available. Someone with a large garden may be more than willing for you to pick quantities of flowering trees, such as lilac (*Syringa*), mock orange (*Philadelphus*) and *Viburnum*, if you prune carefully and do not ruin the overall shape of the bush. Most people feel honoured that their material will be used at an important occasion.

opposite
Two designs that give impact and height with a comparatively small amount of plant material.

left
Lucky bamboo and longi lilies (with their stem ends in glass tubes) are threaded through a simple but effective wrought iron stand so that the stems are not hidden but are part of the design.

right
A strong structure of striking foliage creates a stunning background for callas. (*Zantedeschia*).

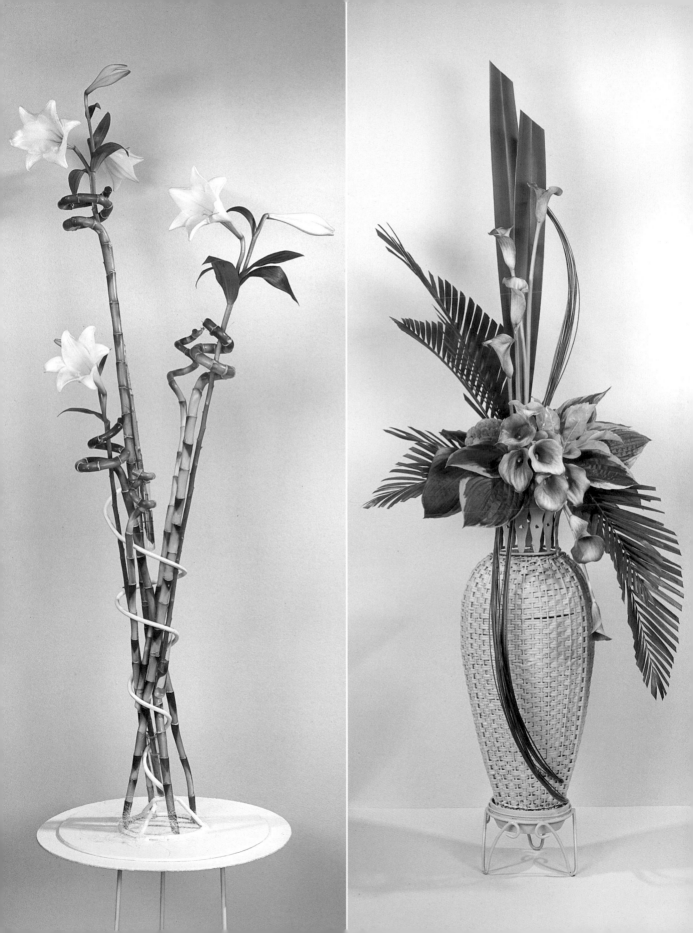

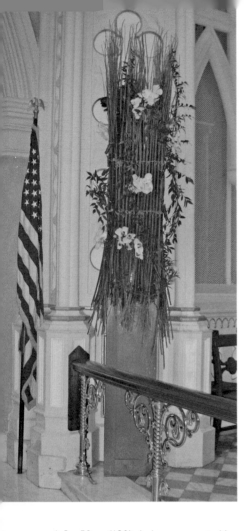

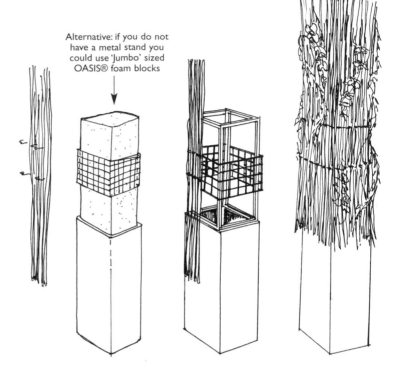

Alternative: if you do not have a metal stand you could use 'Jumbo' sized OASIS® foam blocks

A 3m 50cm (12ft) design was created by placing a metal stand on a 1m 50 cm plinth. Grids were attached to the central area on each side of the metal stand. *Salix* (willow) and *Cornus* stems were bound with raffia covered wire onto the grid, to extend beyond and below the grid boundaries. Soft ruscus (*Danae racemosa*) was threaded through and orchids placed in tubes were attached with decorative wire at intervals. A tall vase, containing flowers such as *Gladiolus*, can be placed in the centre of the stand to take colour high.

If you are buying flowers in large quantities there are several options. You can buy from your local florist or wholesaler, if you have access to one. Flowers can be ordered over the telephone from suppliers at flower markets (such as New Covent Garden in London) and dispatched to your nearest mainline railway station, or you may have a grower or market gardener nearby (this can be useful if buying a large quantity of one type of flower). You will also need to calculate when to pick up your order. Roses need to be collected one to three days beforehand, depending on the time of year. Easter lilies (*Lilium longiflorum*) may need up to a week or ten days before they are at their prime. Amaryllis can take nearly two weeks to open fully in the coldest months of the year. It is always best to let your blooms open up gradually, rather than trying to force them by the warmth of a fire.

Having obtained flowers and foliage, the next step is to condition everything very well indeed. Methods of conditioning various types of plant material are considered elsewhere in this book (Technique 1, page 399). However, it is the scale of the operation that will differ slightly now. Where do you store – or even lay your hands on – upwards of 20 or 30 buckets? Supermarkets may not be able to cope with a specific large flower order, but most of their flower supplies arrive at the store packed into buckets, which are quite often simply thrown away – it is worth asking if they have any spare.

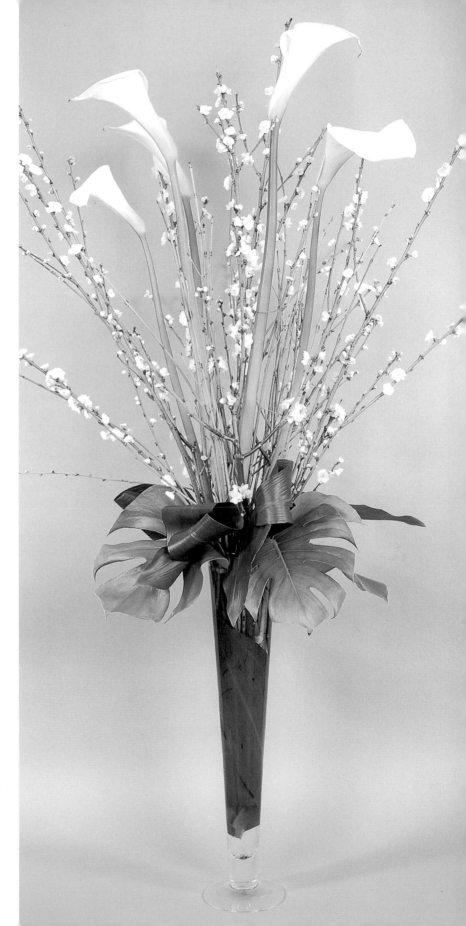

right

Tall designs in glass containers have a strong contemporary look, especially when the inside of the vase is wrapped with flexible long lasting green leaves such as *Aspidistra*. This is the style now seen in fashionable hotels, on the reception desks of modern offices and at weddings where half the tables have tall arrangements and the other low to create a wonderful impact on entering the room. Here soaring *Zantedeschia* and blossom give height which is balanced by the manipulated *Aspidistra* and the massive *Philodendrum* leaves at the top of the vase.

TIP Although *Aspidistra* leaves last well under water, you need to ensure that the water is changed at least every other day. Cut flower food added to the water helps to keep it fresh for longer.

If you do not have the space in your home to store all the materials prior to the event, then the garage may be pressed into use. But beware: after a really cold night you could find that the water has frozen in the buckets, and on a very hot day the temperature inside a garage can become extremely intense. If space is a problem, you may be able to store materials at the venue itself.

Setting up

Transporting everything you require is the next consideration. As well as mechanics and plant material, do not forget to pack some dustsheets, dustpan and brush, as well as your workbox and water sprayer. For a long stint of arranging, body and soul must be kept together and refreshments therefore need to be packed.

Check how easily all the containers, stands and flowers will fit into your vehicle. Will you need help, or perhaps need to make more than one journey?

If you are transporting flowers on a long journey in hot weather it is probably best if the plant material can travel in water. Standing buckets in boxes or plastic crates can prevent them toppling over. Some arrangers with access to a good handyman have special wooden frames made to fit their vehicles, into which buckets can then be placed. Some flowers, such as open lilies, are best transported upright at all times of the year, as their petals break easily when packed into boxes. When packing boxes, the best support for flowers is other flowers. Full boxes prevent them from rolling around. Line the boxes with thin polythene and mist gently before putting the lid on.

Foliage can be packed in dustbin liners, which can then be used at the end of the exercise for all the rubbish.

Even if you have decided to tackle all the arranging on your own, some assistance will probably be needed with fetching, carrying and removing the debris, if you are not allowed to leave it on the premises. Some thought should be given as to what will happen to all the arrangements once the function is over, and whose responsibility it will be to remove everything. Perhaps a local hospital or retirement home would enjoy having the displays.

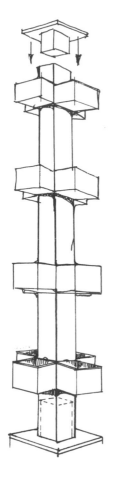

This four placement arrangement on a specially made iron stand is composed of peach amaryllis and tuberose (*Polianthes tuberosa*) outlined with branches of yellow mimosa and the opening buds of *Forsythia*. The iron stand has been draped with fabric which gives a fuller, richer effect. This idea could also be adopted in a marquee, using the same fabric as the lining, to create overall harmony.

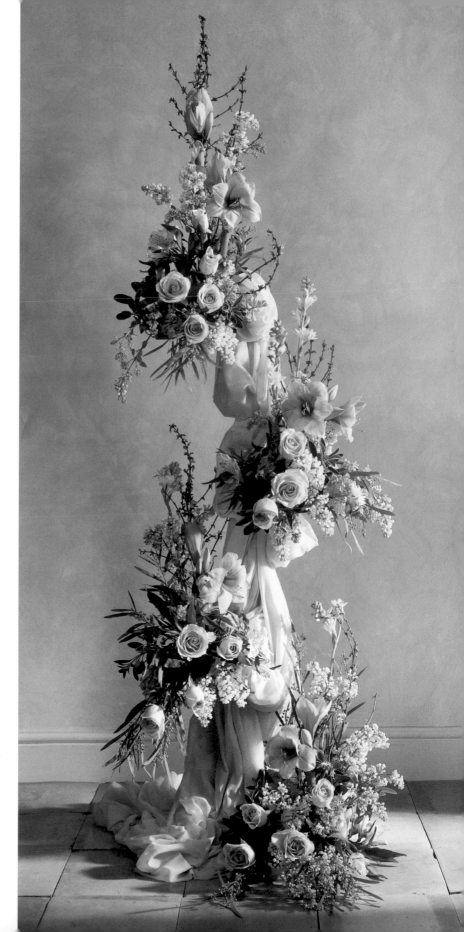

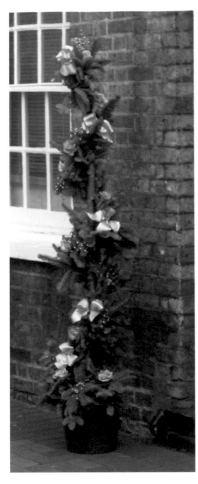

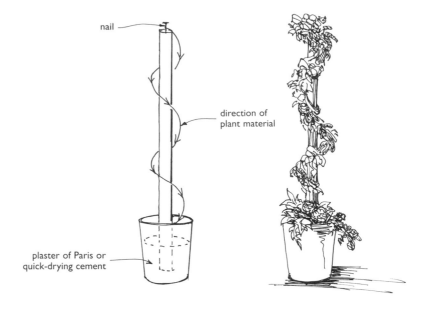

nail

direction of plant material

plaster of Paris or quick-drying cement

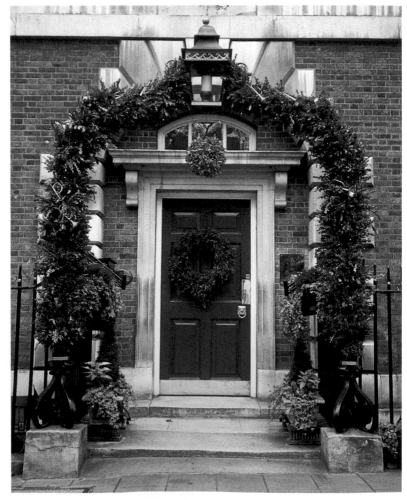

above
This garland topiary creates a tall design that takes up little space. Two would be ideal to frame an entrance. A row of these, linked at the top with thick rope, would make an excellent walkway. You need a birch pole, cut to the required height, set in cement or plaster of Paris in a bucket. Place a nail out of the top and a second horizontally close to the base. Make a garland of spruce or mixed evergreens on a plastic bag (see Techniques, page 407). Attach one end with wire to the nail at the top. Wrap the garland round the pole tightly and attach the other end to the nail at the base. Decorate according to the season or occasion. Alternatively you could wrap a garland of OASIS® cages around the pole.

right
A garland of long-lasting plant material framing the entrance.

Marquees

Stability is the key to any large-scale arrangement, but this is doubly true if you are ever asked to decorate a marquee, as the ground underfoot may well be turf or uneven paving slabs. You may even find that the site is sloping – gently or otherwise – which makes floor-standing designs out of the question. In addition to the usual table decorations, you might like to consider garlands or swags around the edges of the marquee, which prevents the designs from being jostled by the guests and puts them at, or above, eye level.

Hanging arrangements are popular. You could consider huge circlets of flowers arranged in garland cages, attached to a hoop either cut from plywood or made from iron and suspended by four ropes. The finished effect is like a floral chandelier.

Marquee poles lend themselves to other types of decoration. Do make enquiries beforehand, though, as some modern marquees are self-supporting and have no poles. Garlanding poles can be most effective. Work out how many stems of flowers and foliage you need for 30cm (1ft) and then multiply that figure by the total length of the garlands. Spray carnations really come into their own for this, because they can be cut down to individual heads, which will go a long way. For the technique of making garlands, refer to page 407. Do remember that the weight of a finished garland is considerable.

An alternative way of decorating poles is to use foam-filled cages with handles, which are commercially available in three sizes. Three to four cages can be fixed around each pole well above head height. They can either be arranged in situ from a stepladder or made previously and then fixed in place. If you do arrange them prior to the event, remember that they will be looked at from below and should be arranged accordingly. Long trails of foliage and ribbon look good hanging down from the cages, with ribbon loops fixed into the tops.

When planning, find out if the marquee will be lined, and if so, with what. Unlined marquees, although not beautiful, are neutral in colour. Lined marquees can be really sumptuous and will set off your arrangements magnificently but do investigate the colour of the lining material. You may even be offered a choice. Ask whether the poles will be covered in the same material. If you can, ask to see a sample of the material to be used, as the contractor's idea of a suitable lining may not fit in with your floral ideas! Some modern rigid-frame marquees are constructed of a thick plasticized material, which is usually left unlined. Once again, beware. They sometimes come in a very bold white and deep blue stripe, against which only white and the strongest of yellows will stand out, and which requires a good backing of plain foliage.

Sometimes, when decorating a marquee, you are working against the clock, because the marquee may come into existence only hours before the event. This means that your planning will have to be all the more careful. If you intend to hoist hanging decorations and attach items to the poles then befriending the contractors erecting the marquee can ease your task.

12
Long-lasting flowers

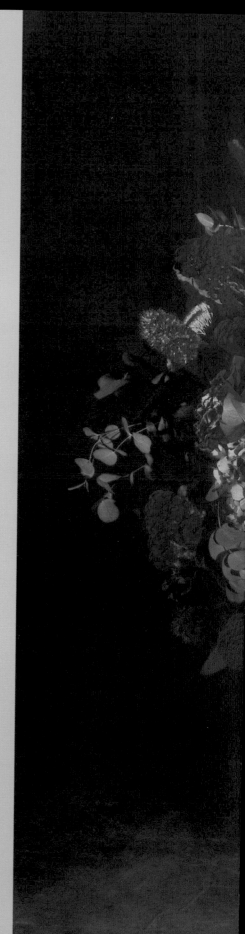

Flowers have been pressed, dried with a desiccant, or simply hung up to dry from the earliest recorded times. The discovery of glycerine has introduced another method of preservation. Recent developments in the manufacture of 'faux' flowers have produced natural-looking blooms that can be used alone or mixed with fresh or preserved plant material. Natural flowers that have been preserved must be considered as long-lasting and not ever-lasting as the colours will fade, especially if exposed to strong sunlight.

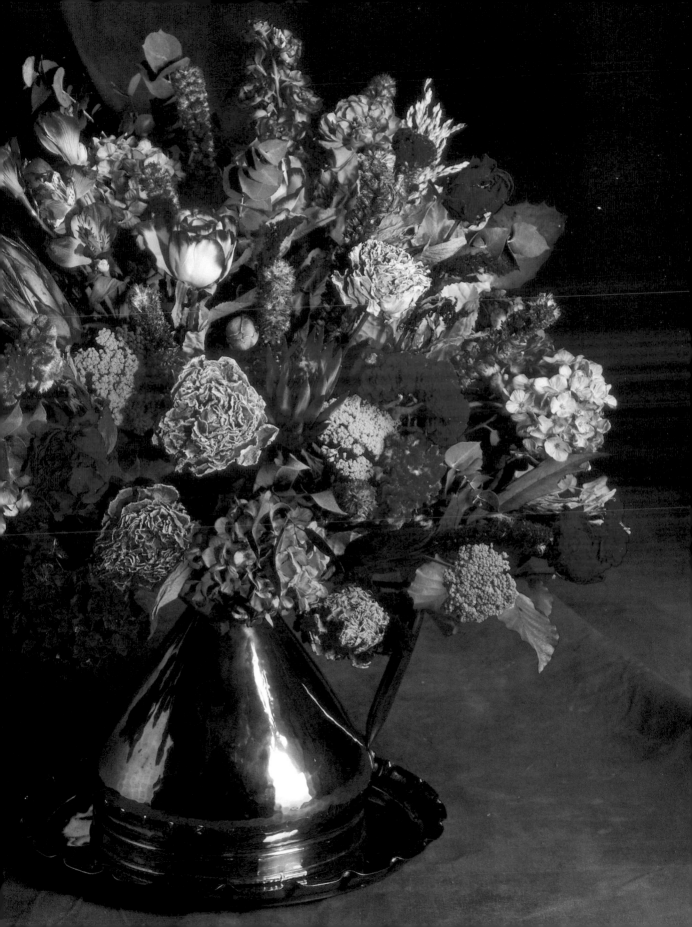

previous page
An arrangement of dried, glycerined,
desiccated and artificial plant material.

Preserved plant material

Preserved flowers are the latest on the scene. Flowers, primarily roses but also carnations, hydrangeas and others are immersed in glycerine in an industrial process. They then become supple but lose their colour and their stems become weak. The stems are removed and the flower is dipped in dye to have permanent colour but false stems need to be added with glue or wire. They are consequently used to advantage in massed designs where the emphasis is on the flower and not the stem.

Preserved roses and *Celosia* create a stunning topiary display.

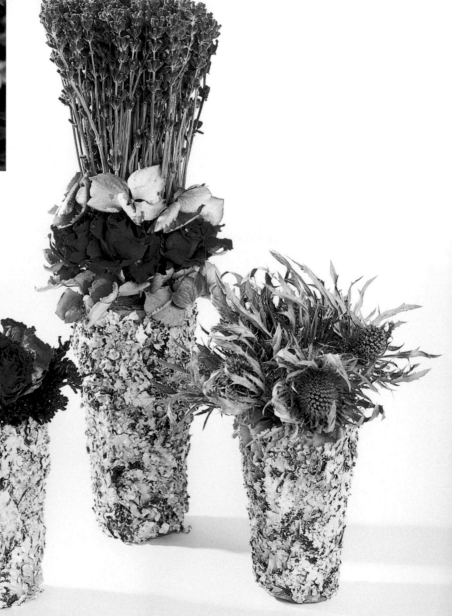

Roses, lavender, hydrangeas and *Eryngium* are excellent for drying. If you choose interesting containers, a simple contemporary look is easily acheived.

Pressed plant material

Flowers lose their form, but not their shape, when pressed. They are ideal for making into cards and pictures of many different kinds. These can range in complexity from a single study of one flower to detailed landscape scenes. It is extremely easy to press flowers and you do not need a flower press – simply an old telephone directory.

Colour

The colour of plant material may change with the pressing process. The following information reveals the changes that may occur.

- Some white flowers remain true, while others turn deep cream. It usually depends on the purity of white in the flower, when fresh. If there is any moisture on the flower when it is pressed, it is likely to turn brown and go mouldy.
- Yellow flowers usually remain true.
- Bright blue flowers retain their colour well.
- Silver foliage is excellent.
- Pinks are generally good, but a very pale colour may brown.
- Reds can darken.

Pressed flower cards

Making pressed-flower cards is immensely satisfying. They are inexpensive, easy to produce and it is unlikely that the recipient will ever want to throw them away! The secret to immediate success is to keep the card simple and small. Do not rush into trying to press large wedding bouquets behind glass. Start with a single perfect flower or leaf. Progress to a card that is a collage of pressed material. This is wonderfully stimulating to create, and you will find that your enthusiasm for the craft will lead you into creating pressed-flower pictures of greater complexity, place mats, paper weights, jewellery, boxes and even fire screens.

Stylish and original cards can be made by adding a few brush strokes, some embroidery or tapestry stitches, or by incorporating tissue paper or hand-made paper. Here are some guidelines:

1. Collect only the best flower specimens for your cards. Their colour will be richest just after the petals have unfurled. Pick on a dry day. A sunny afternoon, when the dew has evaporated, is best.

2. For the card itself, fold a piece of deckel-edged writing paper or a piece of hand-crafted paper in two. Hand-crafted paper can be torn to size by defining the size on a larger sheet with a paint brush and water. Tear whilst the paper is still wet. Alternatively, buy special cards from a craft shop or mail-order company.

3. Play around with the design in a draught-free environment until you are satisfied. Three easy methods of creating cards are:

 - If you are using hand-made or interesting paper, you can simply place a smaller piece of a different-coloured paper onto the card and then glue a single leaf or flower, or even a thin slice of dried fruit, onto this. Gold foil, sweet papers, scraps of photocopied old manuscripts and frayed strips of fabric could also be used.

- Cut out a square frame from the card and machine-stitch two pieces of light muslin with a zigzag stitch either side of the cutout, fixing the leaf, fruit or flower inside the two layers of muslin with a dab of glue. This simple formula produces magical cards.
- Press larger leaves to cover your card completely. These can be cut into smaller areas if necessary. Start with your background and then add the detailing. Round, focal flowers, such as roses, pansies, *Nigella* and *Astrantia*, are ideal for this type of collage. You can place finer, branching plant material over these to create depth and interest without obscuring the beauty of the flowers.

4. Use a glue that will dry clear. A latex adhesive is ideal. You can use a cocktail stick to put dabs of it on the back of your flowers. Place the glue, if possible, on thicker parts of the plant material, such as the central boss of a daisy or the stem.

5. Use tweezers to place and move your plant material. Use a soft painting brush to smooth out any petals.

6. If you do not have an appropriate envelope, take a suitably sized envelope, dismantle and use this as a template. Cut this out of the same paper you have used for the card and glue together. Use sealing wax to seal the envelope.

Preserving plant material by pressing

a) Take an old telephone directory, as these have absorbent pages. Starting at the back, place one variety of flower or foliage (for a uniform thickness) on each page, avoiding the margins. Place plant material between layers of smooth tissues to prevent the print marking the plant material.

b) Turn a few pages and repeat. Label with variety and date.

c) Store in a warm, dry place, with weights on the directory, for at least one week under optimum conditions; otherwise for several weeks. Placing the directories on the top of a Raeburn or Aga or on a double radiator can speed up the process. When dry, remove flowers and leaves from the press and store in a cool dark place.

Hang-dried plant material

Hang-drying is the most common method of preserving plant material. It is extremely easy to get good results this way and is suitable for a wide range of plant material. Material dried by this method is ideal for creating dried flower arrangements, swags and floral rings.

The secret to successful drying is to pick and choose flowers and foliage that are at the right stage of development and to dry them under optimum conditions, so that the process is carried out in the minimum possible time. This will mean that the colours remain truest and the flowers do not soon drop. The following guidelines should help you.

a) Take small bunches of material to be dried and remove any heavy foliage. The plant material should be dry and at the peak of perfection – perhaps just short but never over, as the petals will eventually drop.

b) Place elastic bands or garden twine tightly round the bunches. As an alternative you could use strips of nylon tights or stockings. Delphiniums should be attached singly or in pairs, lavender perhaps in bunches of 30–50 stems. Attach directly to your support. If using elastic bands, attach to butcher's hooks or lengths of strong wire, bending each free end into a hook.

c) Hang in a warm, dry location. The warmer and drier the location, with good air circulation, the quicker the drying process will be, and the brighter the colour. A kitchen, utility or boiler room is ideal. A basement or an unheated garage would be too damp.

This floral ring is created on a dry foam ring. Ribbon is first looped and pinned, backwards and forwards to give movement, texture and to help hide the foam! Moss is then added followed by the large artificial plums that give dominance. Seedheads, glycerined ivy leaves and small bundles of lavender complete the design.

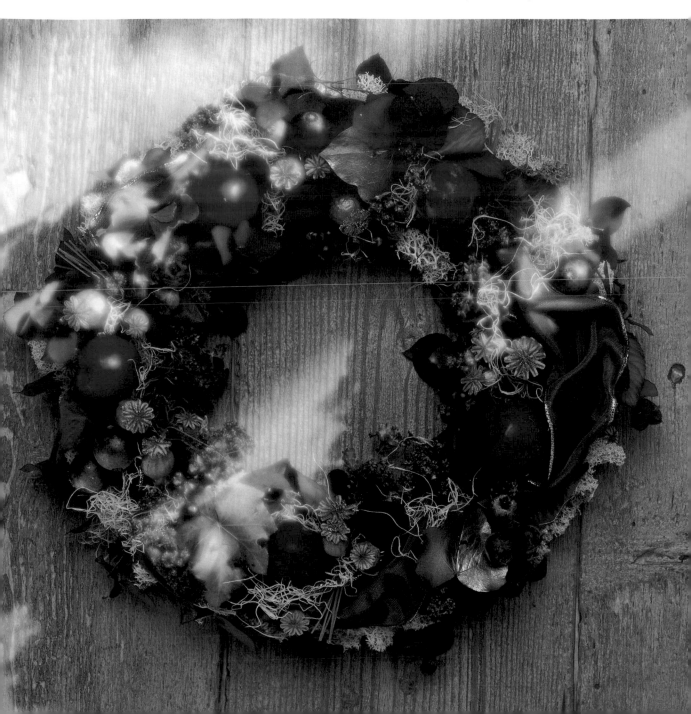

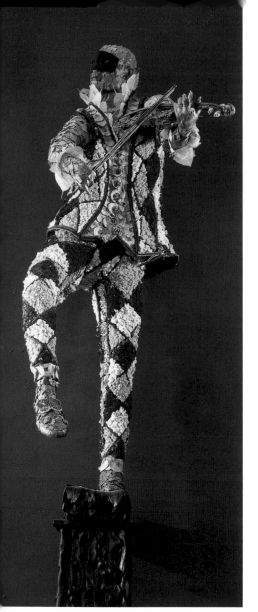

The colourful garments of this harlequin have been created with dried flowers.

Method for drying

Here are a few extra tips:

1. Hang the material out of direct sunlight, as this will bleach the colour from the plant material.

2. Colours that remain truest are those that are closest in colour to the pure hue when fresh (for example, bright red roses, blue delphiniums, yellow sunflowers). Dark-coloured flowers will dry darker and pale-coloured flowers will usually dry paler.

3. Foliage such as *Eucalyptus*, *Magnolia grandiflora*, box (*Buxus*), cherry laurel (*Prunus laurocerasus*) and *Camellia* will all dry well, keeping a healthy green colour for some time. Culinary herbs, such as rosemary and sage, dry well but become very brittle, so they are easily damaged. For this reason it is probably better to dry these yourself rather than buy them already dried.

4. Flowers with woody stems, such as poppy seedheads and *Hydrangea*, will dry if left upright in a jar or vase, rather than hung upside-down. Place *Hydrangea* stems in a little water so that the drying process takes place more slowly, resulting in a smoother texture. *Hydrangea* should be picked for drying when their colour has changed to a more subtle tone, just before the first heavy frosts.

5. Experiment with all the flowers to which you have access. You will have some failures but you will learn a lot and be delighted with most of your efforts. Perhaps the least successful dried material is that which had a volumetric form, such as lilies, tulips and daffodils, although the small-trumpeted *Narcissus* 'Tete-a-Tete' dries remarkably successfully.

6. All dried flowers will eventually fade. Strong light causes more rapid fading. It is obvious that dried flowers will last longer than fresh flowers, but do remember that they will need revamping or changing at least once at year to keep good colour in your arrangement. Sunflowers, larkspur, delphinium, yellow *Achillea*, strawflowers and statice keep their strong colour extremely well.

7. If you need the hanging area for more flowers once the plant material is dry, store it in boxes containing a little desiccant, for this will combat any moisture in the atmosphere that may cause the plant material to become limp or mildewed. Store the boxes in a dry place. Some plant material, such as peony (*Paeonia*), is particularly susceptible to moth infestation. Take the necessary precautions against moths and check your boxes on a regular basis.

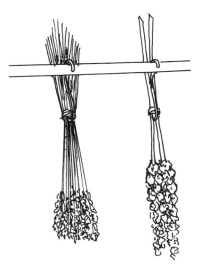

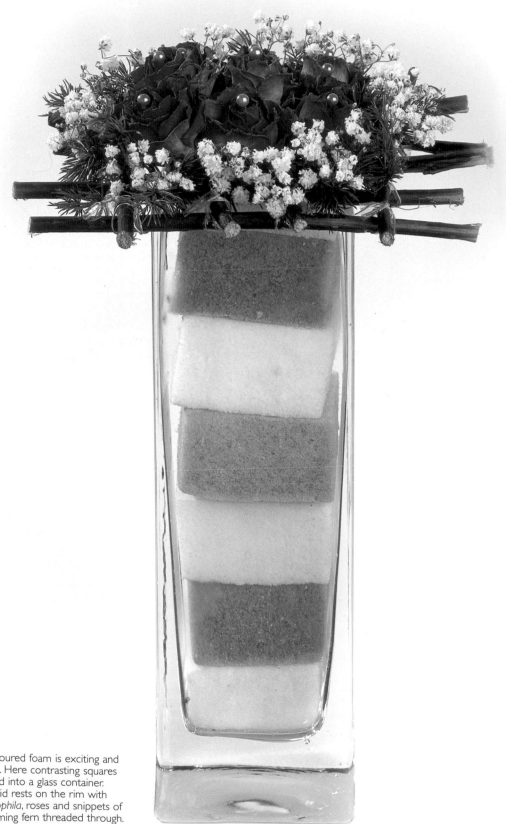

OASIS® coloured foam is exciting and easy to use. Here contrasting squares are dropped into a glass container. A twiggy grid rests on the rim with dried *Gypsophila*, roses and snippets of preserved ming fern threaded through.

Arranging dried plant material

To arrange dried flowers consider the following:

- Do not underestimate the amount of dried flowers you will require. Arrangements can be deceptive in the amount of material they require to look effective. This is because there is frequently less foliage to bulk out the designs, not all foliage being suitable for this method of preservation.

- For those of you wishing to purchase flowers for classic arrangements, you will need a variety of different forms. For classic designs incorporating space you will need at least one or two varieties of each. For parallel designs you may need only one form, such as the linear form of lavender or wheat.

- To increase the size of a multi-petalled flower, such as a rose or peony, hold the head in the steam of a kettle for 30–60 seconds and gently tease the petals to give a fuller form.

- Arranging dried flowers makes a mess. Put a tablecloth or sheet on the floor or resign yourself to clearing up afterwards.

- For the majority of plant material it is the heads of the flowers that provide the volume. The leaves shrivel and often drop and you are left with bare stems, which can be difficult to disguise if the stems are left long. Therefore, if you have limited plant material or for your first attempt, keep your arrangement small.

- Naturally preserved glycerined foliage, or pressed ferns and bracken (*Pteridium aquilinum*), is ideal for creating the skeleton of your larger designs.

- When flowers dry, their texture coarsens and becomes fussier. This is fine when you are working with only one flower, but when you are mixing your flowers you need the complement of a smoother texture in every design. This can be found in exotic plant material like poppy seedheads, in Chinese lantern (*Physalis alkekengi* var. *franchetii*), *Nigella orientalis* and cinnamon sticks. Non-plant material, such as terracotta pots, can also provide this smooth texture.

- If stems are delicate or broken, if there is little space to insert them into the design or if you wish to bunch them together for greater impact, you will need to wire the flowers singly or in bunches. See Technique 10 on page 405, on single and double-leg mounts.

With an interesting selection of dried, glycerined and artificial plant material a large range of long-lasting designs can be created.

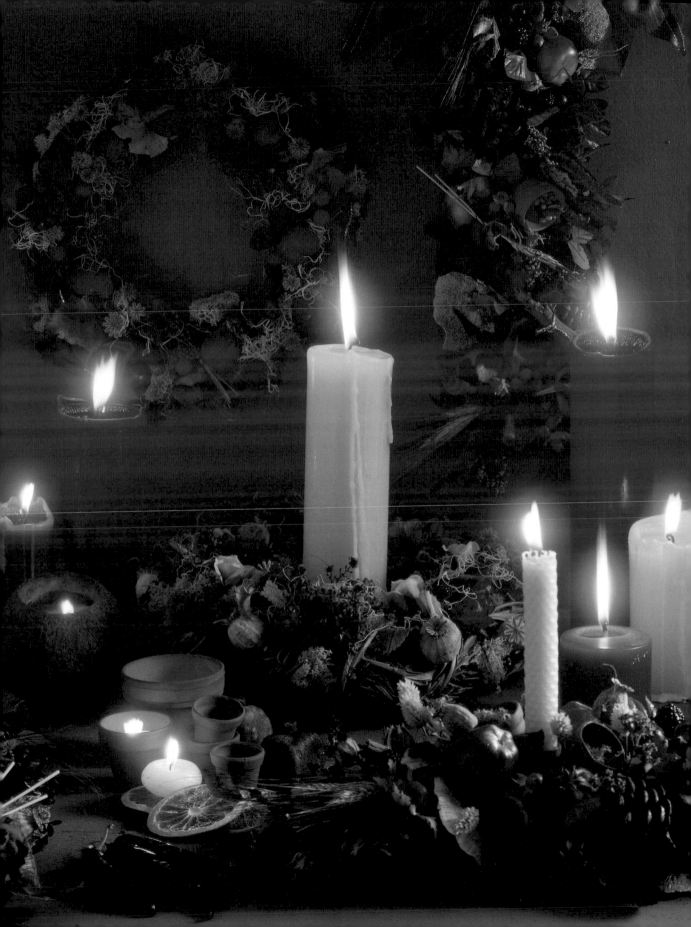

Desiccated plant material

If you use a desiccant you preserve your plant material by dehydration. It was the ancient Egyptians who discovered that plant material could be preserved by immersing it in sand. Today sand is rarely used, as other materials are quicker and probably more effective. If you use sand, ensure that it is scrupulously clean. Desiccation by sand usually takes longer than using silica gel.

Preserving with a desiccant is particularly suitable for volumetric flowers, when you wish to keep their form and colour. Desiccated flowers can then be made into arrangements, jewellery or pictures. Desiccated flowers retain their shape because all their moisture has been removed but moisture can quickly be re-absorbed by the desiccated plant material and this would destroy the form you have carefully preserved. You must spray with a sealant, sold at most art shops, to prevent the re-absorption of moisture or wax in a clear, melted paraffin wax. Keep the finished item or arrangement under airtight glass. Ensure that any desiccant you have used is dried out or regenerated before re-use.

An arrangement of desiccated peonies and roses with dried rose leaves.

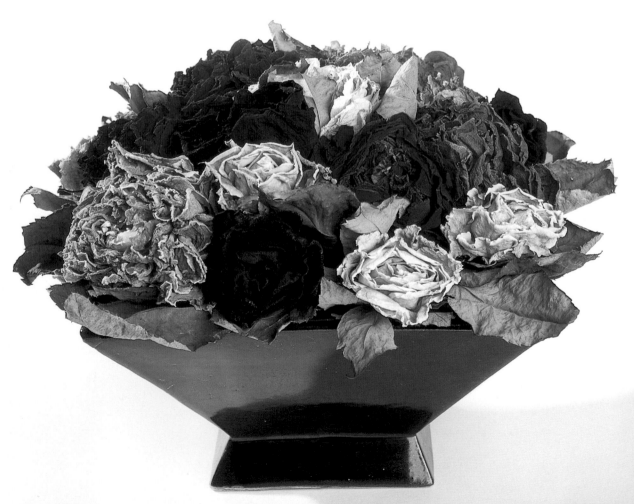

I am going to mention in detail here two desiccants that I believe are reliable and not too difficult to find. The first is silica gel which can be ordered from many chemists. If buying from the chemist, ensure that the grain of the gel is small and fine. The other is 'Flower Dry', which is composed of small clay pellets which, like silica gel, absorb the moisture from the plant material. Flower Dry is available directly from Moira Clinch (see 'Useful contacts' on page 409).

Colours

Strong reds, yellows, oranges and purples retain their colours well, though they can darken slightly. Pale colours are not quite as reliable. Once your plant material has been preserved, keep it out of strong sunlight and prevent moisture re-entering it by spraying with a special sealant designed to prevent this occurring.

Method

a) Cover the bottom of a cardboard or plastic container, which has an airtight lid, with a good layer of dry desiccant.

b) Cut short the stems of dry, unblemished flowers. If the stems are hollow, dry them separately. If you are not using a microwave you can wire the flowers for easier use after the drying process. Take the lightest wire that will support your flower and insert it up the remaining length of stem so that it becomes firm. Coil the extruding wire so that it takes up less space. As the drying process proceeds, the stem shrinks and grips the wire.

c) Place the flowers upright in the desiccant, so that every space and every petal can be filled with desiccant but without the flowers touching.

d) Place the lid on the container to avoid absorption of moisture from the atmosphere. Position in a warm, dry place. Many items take only five to ten days to be preserved. If they are ready they will feel dry and light to the touch.

e) Empty the box through a sieve so that the desiccant falls into another container.

f) Use a paintbrush to remove any residual desiccant from the petals. Follow the instructions on the box as to how to re-dry your desiccant before re-use.

Warning: do not use where food is prepared.

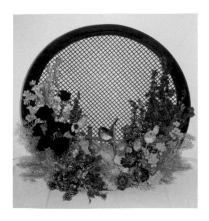

The circular form of the garden riddle is followed with the placement of the beautifully preserved garden plant material.

Desiccant and microwave

a) If using a microwave, do not wire the plant material. Space the flowers widely in the desiccant. Cover with desiccant and a lid. Aim to reach a temperature of 60-70°C/140-60°F. This usually means one and a half to two minutes on full power for 500g (1.1lb) of desiccant, but this will vary according to the microwave. Keep checking the temperature with a thermometer.

b) Allow the desiccant to cool before removing. Seal all desiccated material with artist's spray fixative, nail varnish or hair spray.

NB. Always include a small container of water when drying plant material in desiccant in a microwave and keep checking that there is always water in the container as it quickly evaporates.

With silica gel

1. Aim to reach a temperature of 60-70°C (140-60°F). Depending on the microwave, this will take between one and a half and two minutes for approximately 500g (1.1lb) of desiccant. Once the microwave has been used it will hold residual heat and consequent heatings will take less time. Check the temperature with a meat thermometer.
2. Allow the desiccant to cool to 40°C (104°F) or lower, before you remove the plant material from the desiccant. Fleshy or large items of plant material should be left in the desiccant for several hours in a warm place.

With Flower Dry

1. Place a layer of Flower Dry in a pottery or Pyrex bowl. Place your plant material on this and cover it with more Flower Dry. Do not place a lid on the container.
2. Place in a 650 microwave on high for two minutes. If your microwave is more powerful, adjust the timing accordingly.
3. If the plant material is not completely preserved, leave in the desiccant until cool.
4. Foliage preserves particularly well, with good colour retention. Whichever desiccant you choose to use, remember to keep the desiccated plant material out of strong sunlight and to spray with a sealant. Keep sealed either in a box, a tin or behind glass.
5. Have ready a heatproof dish or metal meat tin into which to pour the hot desiccant.

Waxing

For double-petalled flowers with thick stems try melting white candles and dipping the flowers in the wax for a magical effect. Shake off any residue. Only wax flowers when fresh from the desiccant process and very crisp. Light colours are more effective than dark ones. Waxing also preserves leaves and berries and naturally shiny flower heads, such as those of the hellebore, are very effective. Carnations also take the waxing process well. If they are squeezed at the back of the stem when dipped this will help the petals to hold together.

TIP Do not overheat the plant material as it easily scorches.

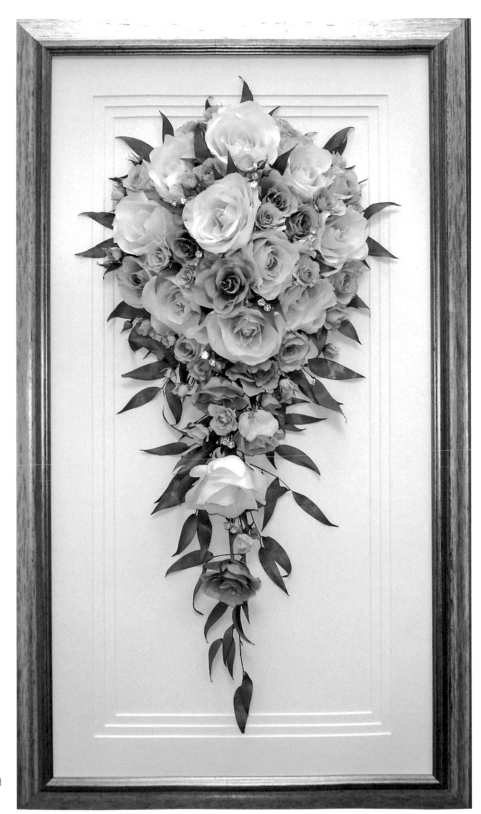

The individual flowers in this bouquet have been preserved with desiccant and re-constructed in a deep frame. If you wish to do this have a trial first and order extra flowers when ordering your bouquet.

Glycerined plant material

The great advantage of preserving foliage in glycerine or antifreeze is that it becomes flexible, water-resistant and can last a lifetime. Another advantage is that the textural surface of the leaf is unchanged, therefore giving a smooth texture, which gives greater volume and a delightful contrast to the busier, more intricate texture of hang-dried plant material. One part glycerine is mixed with two parts boiling water and thoroughly stirred. The mixture is allowed to cool before the stem ends are inserted.

Glycerined material looks lovely mixed with dried and silk flowers, or used on its own to create designs in a colour range from creamy white, browns, blacks and dark greens. Viscous glycerine takes the place of water in the cell structure. It is first mixed with water to enable its uptake into the stems.

Suitable plant material

This method of preservation is much more suitable for foliage than for flowers, because foliage is stronger and the inevitable change of colour is more suited to green leaves than colourful flowers. Foliage that is particularly suitable includes smooth-textured leaves, long-lasting evergreens and, perhaps best of all, beech, tree ivy and *Eucalyptus*. Heather is one of the few flowers that takes up the glycerine solution without changing the colour of its flowers.

The plant material will change colour – slightly or dramatically, depending on the type of foliage you are preserving – and all colours will be more subdued than their fresh counterparts. If you wish to add colour you should include the requisite amount of food dye in the solution. Glycerine may be purchased from most chemists.

You can now buy preserved plant material that has been commercially glycerined and dyed. The range of plant material includes ferns, conifers, hydrangeas, carnations and orchids.

A mass of commercially preserved roses in a hand-painted, tin trough.

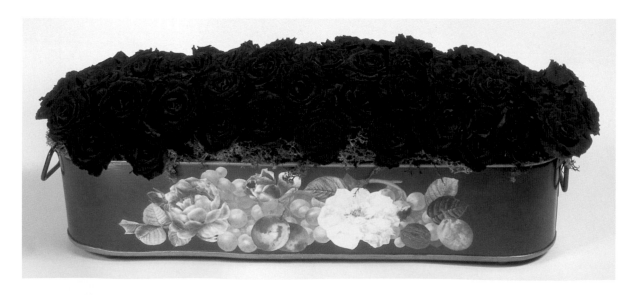

Preserving plant material by the glycerine method

a) Mix two parts boiling water with one part glycerine and combine well in a jam jar or other container warmed to prevent breakage. A plastic container is rather light and may fall over easily. If using antifreeze, use equal parts antifreeze and boiling water. If you wish to add dye, add this to the mixture according to the instructions on the bottle.

b) Trim your chosen stems to a good shape, removing any damaged leaves. Cut the stem ends on the slant to aid absorption of the glycerine mixture and place in water for several hours to become turgid.

c) Place your stems in the glycerine, ensuring that no leaves remain below the level of the mixture. You may wish to place your container in a larger outer container so that there is less likelihood of it toppling over. Place in a warm, dry place for quickest absorption. Mould may form if it is left in a damp location. Pass any remaining mixture through muslin or a sieve and re-use.

right
A topiary of mixed glycerined foliage and a few 'faux' flowers.

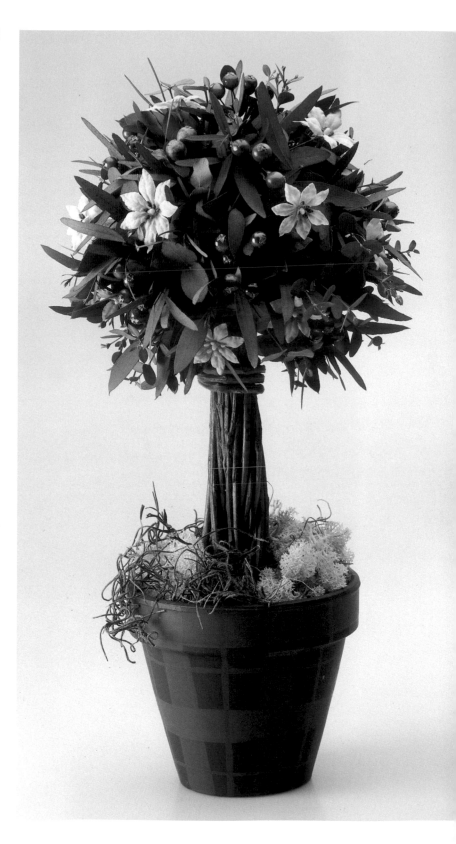

Artifical plant material

Artificial flowers have come a long way in the last few years. Some appear so naturalistic that, if used with flair and style, they can be almost indistinguishable from the real thing.

Tips for arranging artificial plant material

- When you start to arrange artificial flowers you have to make a certain investment. One or two flowers in a vase are not particularly effective unless you try something like the design in the bowl below. You are probably better off buying seven to ten of the same variety and massing them in an arrangement, or mixing them with dried or fresh flowers and foliage. Then you can add to the display or to your collection by buying other varieties.

A glass bowl holds a jumble of slender dried stems and three grouped artificial roses. Thread fresh hydrangea florets onto bear grass and loop these over and through the stems. These will dry in situ.

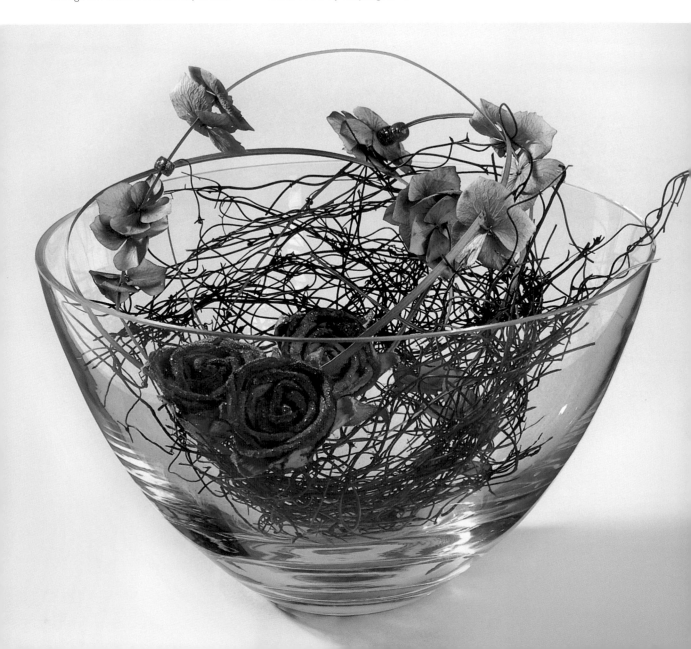

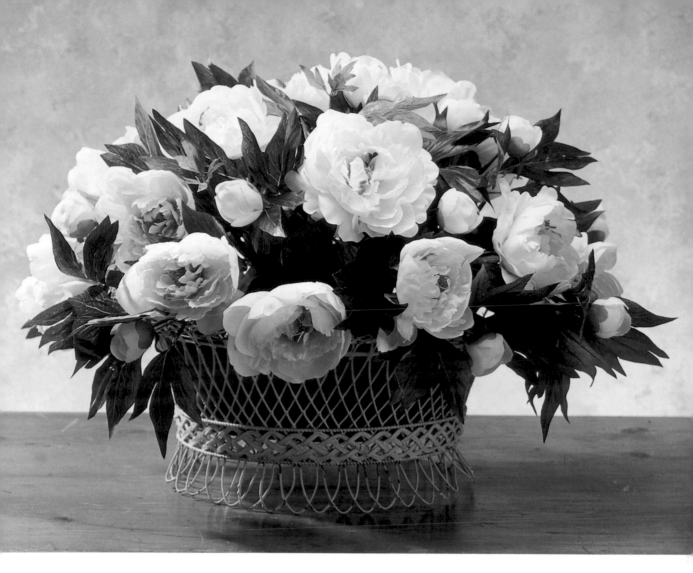

A mass of white artificial peonies inserted in dry foam in a woven metallic basket with an integral container.

- Decorating hats is extremely satisfying. It is simple yet effective. Sew a few flowers, with short stems, onto a plain hat so they are pleasingly grouped.

- Dry-look polyester flowers are superb when mixed with dried flowers.

- If you wish to make swags or garlands, you will not need long stems. You could therefore purchase dry-look polyester flower heads on short wire stems which are less expensive. Garlands need copious amounts of dried plant material. If you wish to make a full, generous garland use long lasting fresh foliage for the base and then add some large, bold, artificial flowers and everyone will assume that they are fresh.

- Try artificial flowers in clear resin that looks like water in a glass for a stunning natural appearance that could fool anyone!

13

Show work

Competitive exhibiting is a unique part of the art of flower arranging. It started as a purely decorative art, but soon shows and competitions were organized. In competitive exhibiting, importance is placed on communicating a theme. This type of arranging has a particular logic and it often takes the arranger time to enter into the frame of mind necessary for 'showing'. This chapter is designed to assist this process by breaking it down into easy stages, which, like a game of charades, are needed to communicate clearly an idea or theme.

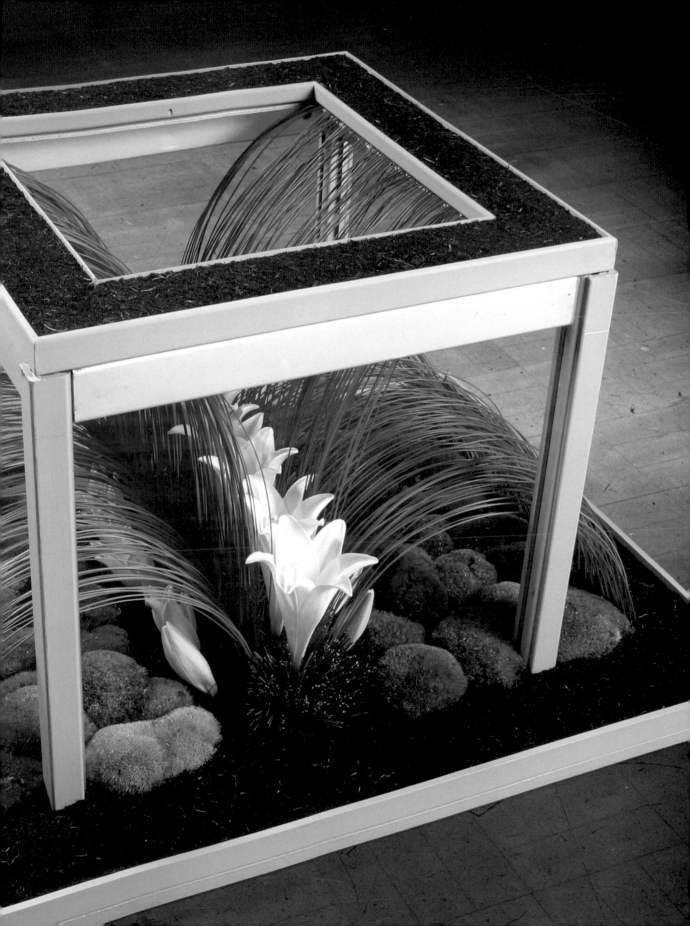

There are a couple of misconceptions that should be abandoned at the outset. The first is that there is an overriding competitive streak and a great deal of aggressive behaviour among competitors. This is generally untrue, for there is considerable camaraderie in show work. Many creative people who work on their own greatly enjoy meeting the like-minded. For many competitors, the staging period is the most important part of the competition, not the prize-winning. Until you have experienced this, it is perhaps hard to believe it. The second great misconception is that to win prizes you have to spend large amounts of money. It is the creative use of plant material, in any form, that is rewarded by a prize, not the abundance or exoticism of the material itself.

You may ask why people want to enter shows. The answer varies enormously from person to person. It could be self motivation, the desire to win praise from others, to become accepted by the 'establishment', getting to know other arrangers and making new friends, wanting to learn from others, or the sheer enjoyment of creating and interpreting with plant material.

Getting started

Before entering your first show, visit as many shows of varying standards as possible – this will give you a head start. Plan as you view the exhibits. Are there types or styles of exhibit that particularly appeal to you? What was the outcome of the judging? Did the judge give comment cards and, if so, was there a common thread? Making good use of such opportunities before entering your own first show, can give you a great deal of experience without being side-tracked by an exhibit of your own.

Choice of show to enter is important. Start with a local show in order to gain experience. Choosing a local show where the judge(s) are qualified by NAFAS is also a good idea. The show will then be judged in accordance with the latest Competitions' Manual produced by NAFAS, which has spent many years devising and creating standardization for competitions. Being judged by an unqualified person often means that more of the judge's taste is applied, rather than an objective approach. By reading the Competitions Manual it becomes clearer what is meant by any particular terms used.

In many other parts of the world there are organizations similar to NAFAS, for example the Garden Club of America. For addresses in other countries contact NAFAS in the UK for information. Contact details for NAFAS are on page 409.

How to choose a suitable class title

This is the interesting part. All competitors get excited when the schedule drops through the letterbox, although the problem they often find is that either all the titles appeal or none do.

When you first enter a show, look for a class that has wide appeal and allows an open interpretation. Try to create a design that you are comfortable with, or choose one for which you already have a collection of accessories to incorporate into the design. In the past a class might have been worded 'My Favourite Book' or 'A Song Title'. Such classes are still going strong at many shows. A more up-to-date approach to this kind of class would be to describe it as 'Inspired by ...', leaving the inspiration to the arranger.

Another approach is to choose a title where interpretation is linked to one of the principles or elements of design. 'Captivating Colour' or 'Nature's Harmonies', for instance, means that the exhibit will rely mainly on design skills and less on interpretation.

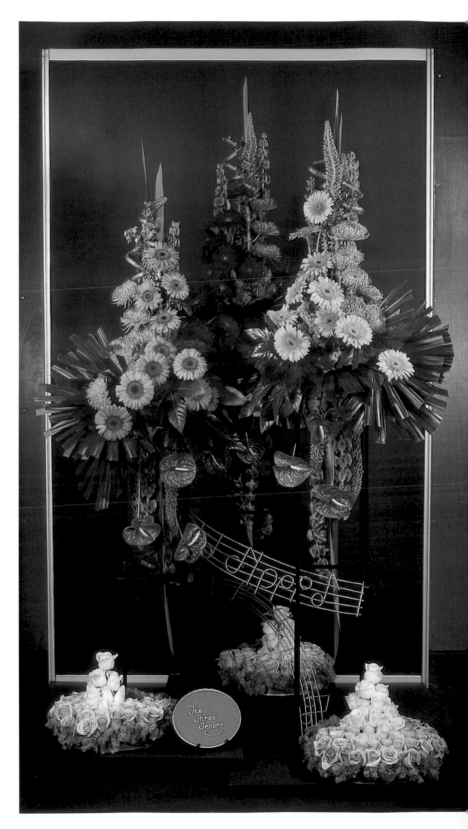

The title 'Gala Performance' offers broad scope for the competitor. Jenny Paddock and Glyn Spencer chose to interpret 'The Three Tenors'. They wanted to celebrate their individuality within the overall design with the colour chosen for flamboyance and passion. The vertical line of *Phormium, Molucella* and *Eremurus* drew the eye up from the 'spotlights' of roses at the base to the dazzle of *Gerbera* and the 'Shamrock' chrysanthemums and extended the height to give the feeling of soaring into the air. The gold music gave the exhibit movement and the smokey anthuriums added 'notes of music' floating in the air. Although this exhibit did not win a prize it caused much interest.

This simple arrangement shows an excellent interpretation through the thoughtful use of colour and the simple but effective inclusion of Brownie badges.

An approach to interpretation

Having made your choice, how do you interpret the title? You might consult a thesaurus for words and associations, or a dictionary for the exact definition of the words in the title. You might ask someone who is not connected with flower arranging, for they will have a mind which does not immediately translate the title into flowers. Remember it is the title (not the source) that is of prime importance, unless the schedule actually states where the quotation comes from. Some people get so carried away with the source, or with some deep meaning associated with it, that they forget that, however intellectual, well-read or well researched the judge is, he or she can never be an expert in all fields.

One underlying rule for competitors is that 'the judge is a fool'. At first this sounds disrespectful, but in this communication game, simplicity is often the key to interpreting the theme. When judges look at an excellent piece of show work, they feel that the competitor has 'hit the nail on the head'. The interpretation seems obvious in retrospect and it makes one think, "Why didn't I think of that?"

Some titles are very open, giving the individual competitor maximum creative space. Sometimes, as in charades, you can 'do the whole thing', but on other occasions you have to (as it were) 'break it down into syllables'. In such cases you may give a title card to the judge to establish which part you are interpreting. Take, for example, a class called 'The World's Wild Places'. If you decide that you are going to create all the wild places, or as many as you can fit into the space allowed, then you may well be heading for a design that is divided into sub-sections and an exhibit that does not have unity. A more arresting approach is to concentrate on one wild place and to give it a title card so that the onlooker and judge do not have to rack their brains to understand what on earth the exhibit is trying to convey. For example, the title could be on a stone *not* on a card for a more natural approach and look.

Check that the title you have chosen does not have a specific inclusion or exclusion in the class description that does not suit you. For instance, a class entitled 'Cargoes' might state 'featuring dried plant material', when you have a greenhouse full of exotic plants and foliage that you want to use.

Remember to look in your schedule definitions if you are unsure of the meaning of a term used in the schedule. If it is not covered in the schedule definitions, check the dictionary definition and with the secretary of the show, to cover yourself. Remember that plant material must always predominate except with a still life exhibit or if the schedule states otherwise.

One class title – 'Beauty in Simplicity', two interpretations. One strictly contemporary, the second more classic in the use of flowers and foliage. Charles Barnard was awarded 1st (right) but both exhibits were much admired.

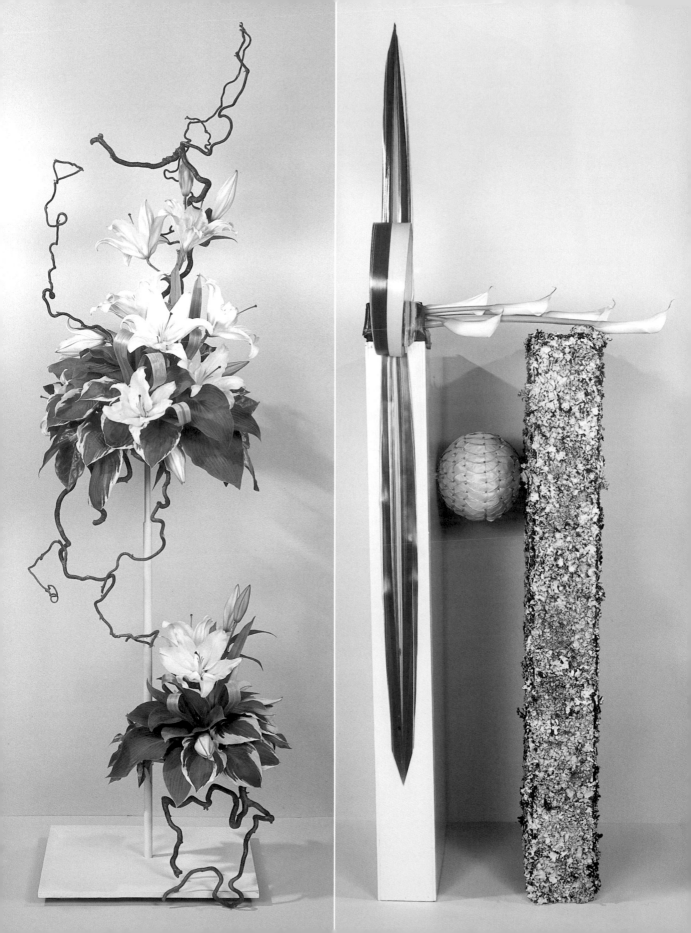

Inspiration

Where does inspiration come from? This is often a difficult question and the answer is likely to be different for each of us. You soon realize that the possibilities are boundless. Inspiration could come from sculptors, painters, land artists, poets, writers, dancers, other flower arrangers, the theatre, nature, architecture, and so on. Often you are not inspired at the time of choosing an exhibit. It may be weeks, months or years before you see a schedule when inspiration first fuels a floral idea for an exciting class title. Different titles will appeal to different minds.

Sometimes no inspiration comes ("can't think of a thing") and the more you seek it, the more it seems to evade you. But then it hits you, all of a sudden, out of the blue, at a time when you least expect it. The most important thing is always to be receptive, keeping your eyes open.

Backgrounds, bases and accessories

In the 20th century backgrounds were de rigueur to enhance the interpretation and creation of atmosphere. A background should not be used, however, if it does not contribute to the overall exhibit. With the improvement of staging materials and the move away from man-made accessories they are now rarely seen.

Although bases are also out of fashion they can bring together and unify a collection of separate arrangements. Again, it is essential that, if used, a base must contribute to the overall exhibit.

Similarly accessories have been used to aid the interpretation. In the past problems arose when these were made from non-plant materials. Today plant material itself is used in many different ways, through the broader range of styles and the use of plant manipulation, to aid interpretation. Greater reward is always given by the judges for this extension of creativity with plant materials. Accessories should look genuine, even if they are not.

Title cards

Many an exhibit has been spoiled by a poor title card. You will see some competitors create a most attractive exhibit and then place upon it a title written badly and on white card, almost as an afterthought. That is exactly what a title card should not be. It should be in keeping with the whole exhibit, in both atmosphere and context. The style of script should also follow these criteria. Consider how the same title can be made to look quite different, using different scripts and cards.

Computers make the production of such title cards possible without taking a course in calligraphy. If you do not have access to a computer, dry, rub-on lettering has its uses, if you can still find it. This also comes in handy when wanting to inscribe letters directly onto a stone or a leaf, which might be rather difficult to pass through the printer!

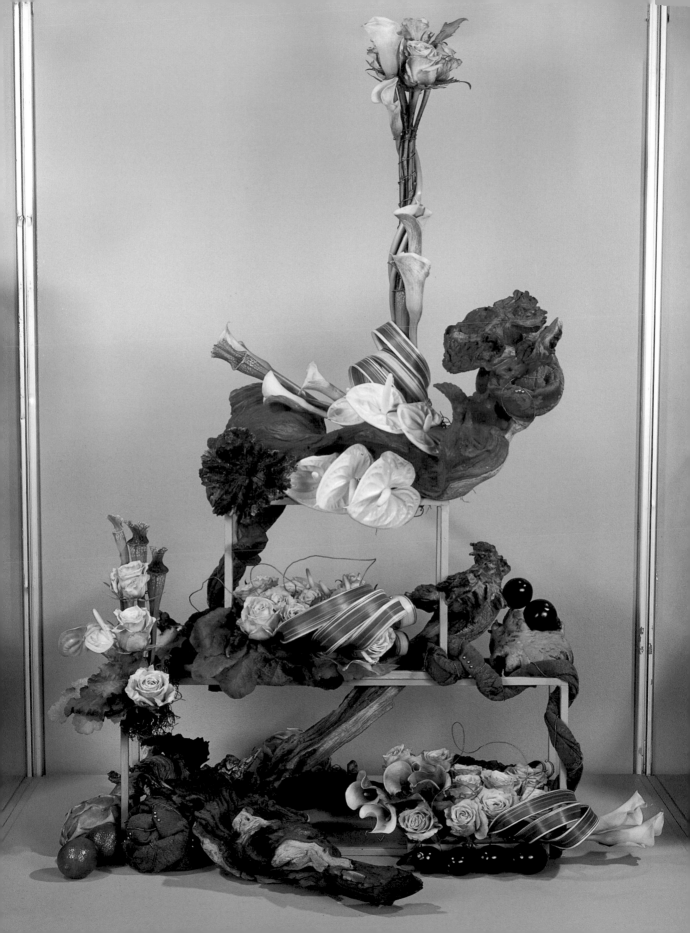

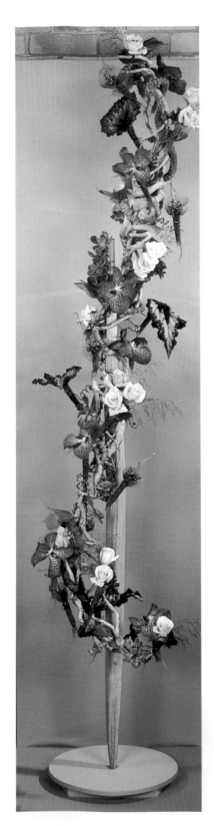

What does the judge look for?

Before considering what the judge looks for, ask yourself what first-prize winners have in common.

They often fall into one of two camps: either they have excellent design skills or they show strong and clear interpretation. Over the years, judges have differed as to whether design or interpretation is more important, so it would seem that if you concentrate on both these issues and create an exhibit with clear interpretation and excellent design, you are in the running for a high award.

To help you understand what it is that the judge is looking for, look at your copy of the NAFAS Competitions Manual. Here are some of the questions that the judges ask when looking at the exhibits before them:

- Is the exhibit according to schedule?
- Does the exhibit interpret the title of the class?
- Does the exhibit use well the elements and principles of design?
- Is the exhibit well staged, groomed and presented?
- Are all the materials used in good condition?
- Has the exhibit got distinction?

You may ask what distinction is – a difficult question to answer. Some dictionaries define it as a distinguishing mark or mark of special honour, so this seems to be the place to say that there is room in show work for a more subjective outlook from the judge and, judges being human, that is the way it is.

Practical points

The 'mock-up' is a most important stage of the exhibit. This is where all your ideas come together and possibly where paring down has to take place. This stage will raise many more questions about the mechanics, for example: how do I hold that up there? Make sure at this practice stage that the size of your exhibit is carefully marked out in all three dimensions. Do not feel that you have to use the exact plant materials that you intend to use in the completed exhibit. When you do the real thing it is often difficult to repeat the exact materials, and you may be tempted to feel that it was better in the mock-up than it is on the show bench.

You must give careful thought to the type of plant material you need and can obtain. Order any florist materials well in advance to be as sure as possible to obtain them. Make a list of all the suitable plant material from the garden that should be available at the time of the show. Do not get upset if some materials are not available; rather, be excited by the things you know you have. A positive approach is a much firmer foundation on which to build. Condition all your plant material well so that there is no chance of it wilting. If in doubt, do not use it.

'Frivolous Frolics' was the title of this class and Jan Norman gained 2nd prize. The design is immaculate. The plant material is imaginative, positioned to give original, dynamic rhythm but the design remains spontaneous and full of excitement to fulfill the demands of the title.

Prepare a checklist of all your exhibit and competitor's requirements so that nothing is forgotten. Place all your materials carefully, so as not to damage anything on the way to the show. Do not forget your toolbox and, if you are using it, your floral foam. It can be a help to put a label with your name on all your boxes and kit. This can save any confusion.

The way in which you work when you get to the show is totally personal, but do allow yourself time for a break, especially as you may return with what seems to be a fresh pair of eyes.

Just before you leave, take time to look around your exhibit and check such things as water, whether your exhibitor's card is on the exhibit (your name facing the table surface) and within the size allowed, and give yourself a last opportunity to assess the exhibit as a whole. If permitted, you might at this stage wish to photograph it, not only to remind you of the completed exhibit but also to enable you later, in the cool light of day, to judge the exhibit yourself.

With sufficient preparation you will, hopefully, have thoroughly enjoyed the experience and be well pleased with the result – whatever the judges may think!

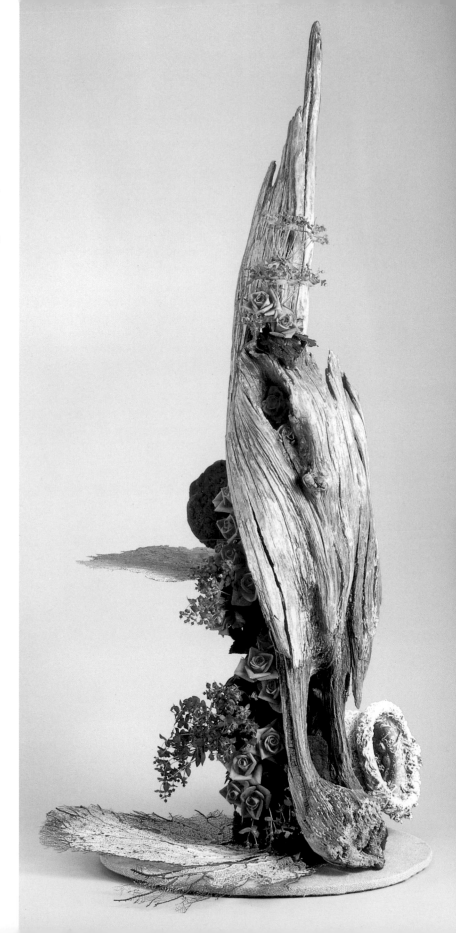

Contemporary seascape by Craig Bullock. The colours and textures of the *Euphorbia griffithii* 'Fireglow', *Rosa* 'Lombarda', *Fagus sylvatica atropurpurea* and *Cimifuga purpurea*, combined with the stunning driftwood and encrusted squid pot, convey an air of mystery and the unknown, associated with the sea.

International competitions

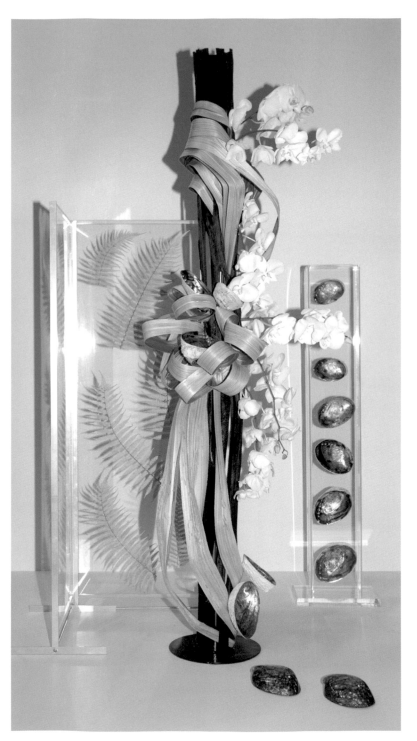

Competing on the international show bench is somewhat different. Interpretation is a more difficult area to convey, with the hurdles of different languages and differing cultures to be overcome. The judges may well come from another part of the world. It seems therefore that in this type of competition, design and innovative arranging are particularly high on the agenda.

For the World Flower Show in Japan, it was Lois Montgomery's desire to represent her country with a simple design to let New Zealand's wonderful indigenous plant material interpret the title. Silver fern (*Cyathea dealbata*) is the symbol of all the new Zealand sports teams and is recognised internationally so she decided that this would be the basis of the overall design. She knew that the fronds of the fern would need some sort of protection to keep them from shrivelling so she used Perspex boards to capture and display the fern. Silver spear (*Astelia chathamica*) and skeletonised trunk (*Cyathea meduliaris*) complemented the silver fern in terms of form and colour. She incorporated the New Zealand paua shells in a Perspex tower as another element to enhance the overall design. This shell is used extensively in the souvenir industry and is much sought after by tourists. She chose the *Phalaenopsis* orchid as an accent plant (although this is not an indigenous plant).

The World Association of Flower Arrangers (WAFA) came into existence in 1980s and held its first competition in the UK in 1984. WAFA has just a few rules but no schedule definitions. The inventiveness and creativity of all competitors can be fully appreciated. At this type of competition there is much outstanding work, which will excite and inspire even the most experienced of exhibitors. Contact NAFAS for details (see page 409).

The two exhibits here were from the International Exhibitors' class, at the World Flower Show, Japan, 2005. This class was non-competitive.

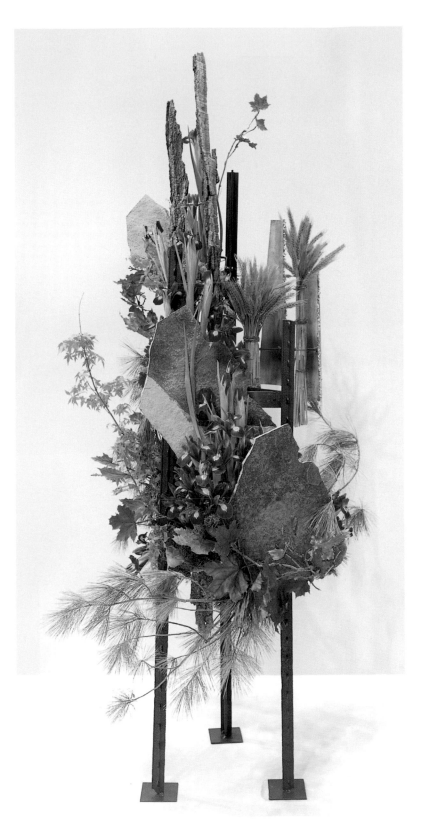

The objective behind Dawn Suter's 'Essence of Canada' at the World Flower Show in Japan was to express the diversified make-up of Canada itself, wherein seemingly incongruent elements meld together to create a strong and unified whole. Canada's natural resources provide the framework for the design both figuratively and literally. A strong steel and aluminium base runs vertically through the design and reflects industrial strength. Igneous rocks represent the mineral wealth and provide a contrast to the rustic elements of pine boughs, bark and wheat. *Iris* represents Canada's inherent French connections as well as its vast bodies of fresh water. The maple leaves – Canada's national emblem found from the Atlantic to the Pacific – are displayed in their autumn glory and provide a strong rhythm that carries through the arrangement and unites the other elements.

14

Flowers around the house

Flowers make a house a home.
They do not have to be grand.
A bunch of daffodils in a jug,
a plant in the kitchen, a single
flower – all will create a sense of
well-being.

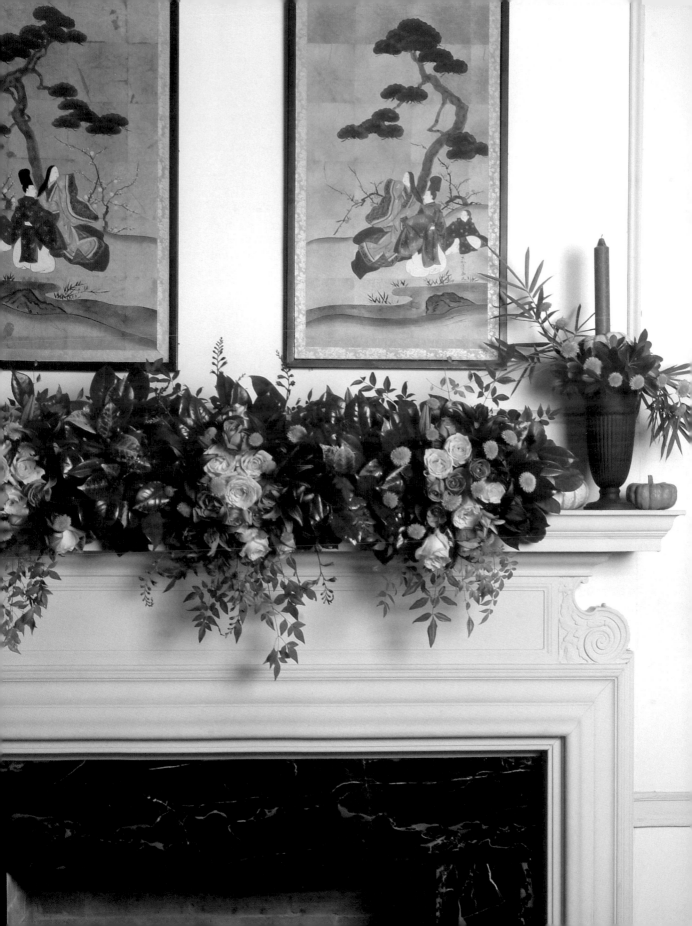

Crocosmia, yellow and orange roses, red lilies and small green santini chrysanthemums are combined with *Camellia*, *Nandina* and *Fatsia* leaves. Ornamental white and orange pumpkins give seasonal accent in this strikingly attractive arrangement by Theresa Ritchen and Nancy Allen. The flowers and foliage are arranged in a long narrow box to fit the length of the mantelpiece which is lined with heavy-duty plastic and filled with floral foam which rises above the rim of the container.

Beautiful though they may be, flowers do need replacing regularly. Less high-maintenance but equally rewarding are the wide variety of houseplants available. Many feel that they are incapable of keeping plants alive, but this is usually a question of over-watering rather than neglect. If you know the conditions that your plant needs it will be a long-lasting and beautiful addition to your home. If watering from the top it is important to allow the plant to drain, rather than sit in a puddle of water for days. However some plants, such as African violet (*Saintpaulia*), azealeas and *Cyclamen*, prefer being watered from the base. Many prefer soft water (rainwater, filtered or boiled and cooled.)

Much of plant care is common sense. If your plant originates from tropical conditions, such as cacti, it will need warmth and humidity, whilst *Cyclamen* and spring bulbs prefer cool situations. Remember that no plant enjoys draughts so make sure they are away from doors and single glazed windows.

Quite apart from the aesthetic advantages of plants and flowers in the home, many house plants are also beneficial to the health. They boost oxygen levels and absorb harmful toxins from the air – at no detriment to their own growth. Chemicals such as carbon monoxide from car fumes and cigarette smoke are significantly reduced by plants, in particular the spider plant, ivy and many palms and ferns.

House plants can also help to alleviate stress and studies show that people perceive interiors containing plants to be 'more extensive' looking (source **www.flowers.org.uk**).

For those with little time, there are some areas in the house where plants make a bigger impact.

Even the busiest person should make time to place some flowers around the house. As a minimum, always enhance the most the most important area that is the entrance hall. Always make sure that the hall table has a bowl of flowers in season or a flowering pot plant so that you and your visitors can be refreshed and comforted as they enter. The kitchen table is another place where I have flowers. All it takes is a few blooms to give instant pleasure. I have a sea grass wall basket from Charleston, hanging close to the sink, where a few flowers make an instant picture.

For more formal occasions a massed arrangement in the dining room is essential. A single flower in the downstairs lavatory is always welcome.

Some arrangements – such as ten oriental lilies in a glass vase – will look good in any home whatever the season but I do believe that where you try and fit the furniture to the period of your home you should do with same with your flowers. A Victorian house looks good with massed cushion designs. An Edwardian house is best with ferns and carnations. Television films generally give a good indication of the style of the day, though eagled eyed botanists will usually find an anachronism or two. Turn to the chapter on the history of flowers for more inspiration.

Colour is an important factor to success. Link to your decor. If you have pink walls do not choose orange tulips but think of *Ranunculus* in tints of red, lime green *Anthurium* or a mass of *Alchemilla mollis*.

If your curtains are lemon do not go for shades of pink but think of mimosa, *Iris*, in the spring, sunflowers in the summer and blue hydrangeas in the autumn. The same rules apply when combining colour within an arrangement as to co-ordinating it with its surroundings so go back to the colour wheel on page 17 to see what works.

The other elements and principles of design are also important when placing flowers in the home. Just as you must consider scale and dominance within the design, make sure that your arrangement is in keeping with the size of your room and its furniture and play around with the wonderful contrasts of tone and texture that fabrics, leathers and floor coverings can offer. Also remember to consider the size of your plants in relation to the size of the room – too big and a small space will seem smaller.

This chapter gives some ideas for designs that you can create in the home.

Maybe not a design to have in place for a dinner party but a wonderful way to decorate the dining table with a repetition of low bowls containing a mass of flowering *Muscari* bulbs with moss to give a contrast of form and texture.

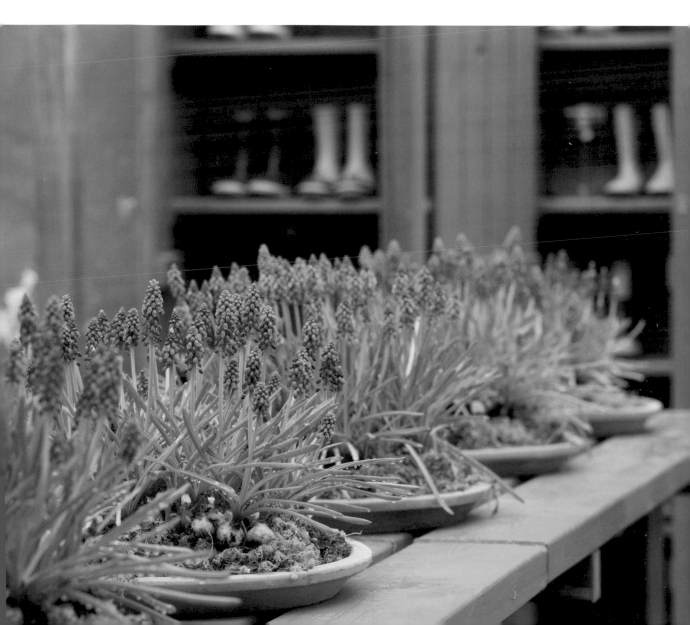

The entrance hall

The hall is where first impressions are formed. A single specimen of a flowering plant will give long lasting beauty with little attention. The *Phalaenopsis* orchid will flower for three months and if cut back will flower again the following year. Also attractive is a bowl of planted bulbs for example hyacinths or narcissi. These are both wonderfully fragrant blooms and will fill your senses as you enter the house.

This is also the case with a vase of oriental lilies though some find their scent overpowering. Buy them in bud and over the course of ten days they will open and fill your house with their rich scent. But remember – in a narrow hallway be sure to remove the stamens of your lilies or you risk staining your carpets, curtains and/or clothes. Removing them by hand creates a more elegant look than cutting with scissors, which can look blunt and harsh.

Jam jars filled with posies of lisianthus (*Eustoma*) are a cheap and simple way to decorate the hallway for a party. Simply create a loop from some wire and hang from existing coat or picture hooks.

The dining room

The table can be decorated in many ways. You could make five or seven 'Single Rose' designs (page 107) and place them in a line down the centre of the table or in a circle with nightlights in between. For a round table, the arrangements on page 154 would be suitable and for an oval or rectangular table the oval designs on pages 160–161.

Traditionally it was considered that table arrangements should be either no more than 30cm (12in) high so that guests could talk over the flowers or higher than 60cm (24in) so that guests could talk under them. Although this still holds true from a practical point of view these rules are often broken for the sake of grand effect!

For formal dinner parties a massed arrangement in the dining room will really mark the occasion. Make sure that if you are using perfumed flowers they do not overwhelm the aroma of your meal but complement it. A vase of herbs with a few non-scented plants will look elegant and smell appetising.

right
This magnificent display in the Charleston home of Mrs Lewis Smith created by Theresa Ritchen and Nancy Allen might not be the most practical for dining conversation, but it certainly creates an impact. Fragrant oriental lilies, yellow roses and *Dendrobium* orchids combined with *Asparagus* fern, *Pittosporum* and *Camellia* leaves to link the colours to the room's decoration.

below
Two multiple groups of round glass vases hold tulips and longiflorum lilies. The stems are held in place through the medium of sand.

The sitting room

A design for a low table always looks good. Consider the tapestry and cushion designs in Chapter 7. If there is a mantelpiece one of the easiest but most effectual designs is a long, low arrangement, in a low plastic dish, spreading the length of the mantelpiece.

Colour co-ordination is possible even using plants that do not flower. The red markings of the *Codiaeum* (croton) lend themselves to any colour scheme of red, black or white.

above
These azaleas give a burst of colour. They are accented by coordinated cushions. Azaleas are difficult to manage; the secret is to water copiously with soft water, and place somewhere cool and bright. Remove the flowers as they die and the plant will reward you by keeping healthy and flowering again the next year

right
This *Alocasia* × *amazonica* is hard to manage and needs misting regularly but it is worth it for the impact of its beautiful markings which create a statement in a minimalist room.

opposite page
The vibrant colours of the sumptuous silk drapes call for flowers of similar vitality.

The kitchen

The kitchen table is another place I like to have flowers. A small Japanese basket with an inner container in which to place one or two short flowers is all it takes to give instant pleasure. Do be aware that the heat from an oven or the cold from an open fridge will not suit many flowers and plants.

left
Some arrangements of food are flower arrangements in themselves. At the Japanese Ambassador's residence in London, the chefs created an ice igloo to surround some of the finest sashimi.

below
On a granite surface, ten tulips surrounded by loops of bear grass and a frill of *Fatsia* leaves are bound and placed in a vase containing silver sprayed pebbles.

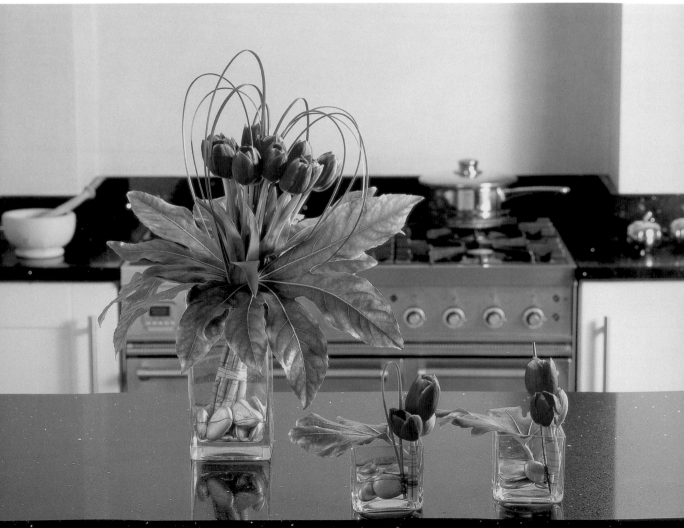

The bedroom

Flowers in a guest bedroom always make a friend or relative feel welcome. A couple of flowers in a stem vase or a small design on a breakfast tray will show appreciation to those visiting. Remember that plants also absorb moisture from the air so you may need a shallow dish of water in the room to replace it.

Dried flowers such as lavender placed close to the pillow can aid sleep and relieve tension and headaches.

This *Philodendron* should be positioned out of direct sunlight and kept moist when the temperature is high.

A petite design, ideal for the guest's tea tray.

The bathroom

This might seem a novel idea but not an inconsiderable time is spent in this room. Your family might not appreciate a permanent display of petals in the bath water but what an exciting extension of the party theme for visiting guests.

The bathroom is the ideal place for a pot plant but make sure that you pick those that thrive in a humid atmosphere such as tree ferns, *Codiaeum* or marsh grass. The steam created by the shower will only need to be supplemented by occasional watering.

Pink lily heads are sheltered by a canopy of *Anthurium* to give a bold look in a bathroom.

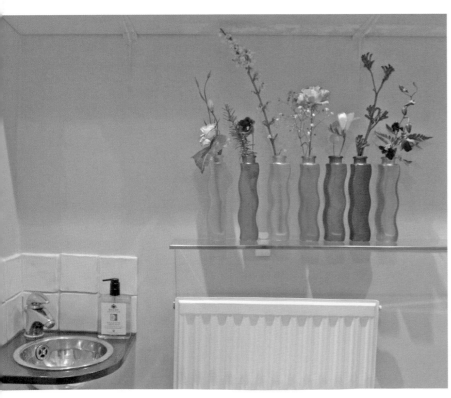

above
A row of inexpensive and brightly coloured glass bottles, with a few stems in each, gives accent in an otherwise neutral room.

right
Tulips in glass vases of various sizes complement the petals strewn in the bath.

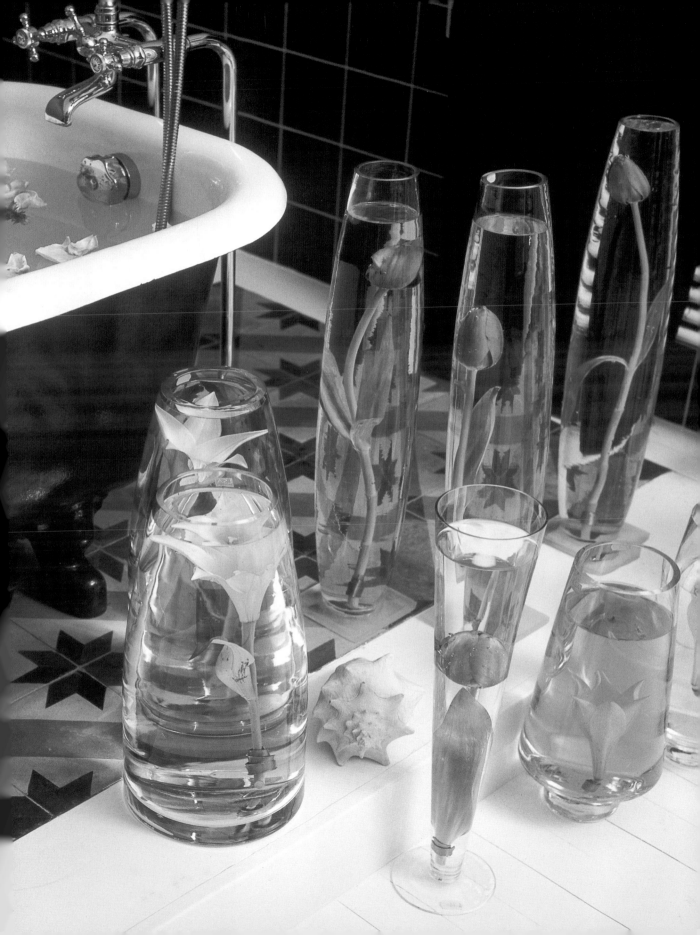

The garden

For a party why not cut a few flowers and arrange them simply on an outside table. Alternatively, use your imagination to create dramatic designs such as the one illustrated here.

right
A hanging container in the garden of Mrs Henrietta Miles in Charleston holds a magnificent array of summer flowers. You would need a strong branch from which to support such a large display but it would be easy to attain a similar effect using a hanging basket from the garden centre.

below
Bulbs don't need to be underground! Here they are used as part of the design giving colour, form and texture in harmony with the flowing parrot tulips.

15

Flowers and foliage

One of the hardest decisions when working with flowers is deciding which flowers go well together. I always advise students to pick a round flower in the general colour scheme in which they wish to work. I then suggest that they choose a complementary spray flower that when combined together will offer a pleasing colour scheme. These two flowers will form the basis of the composition. Other flowers can then be chosen using form, texture and colour as the guidelines to provide a pleasing bouquet.

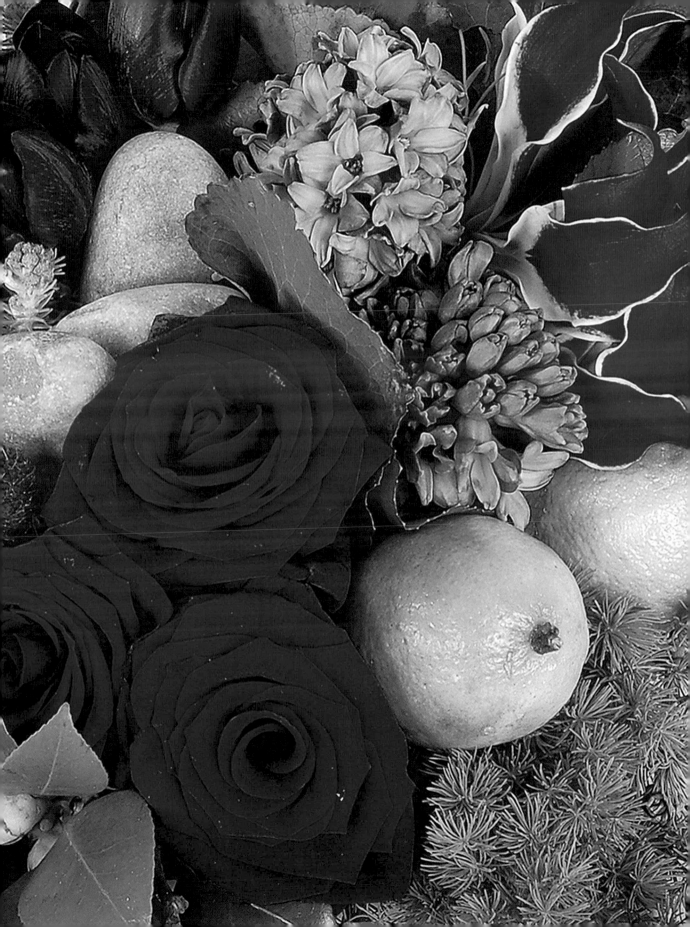

previous page
Hypericum 'Dolly Parton', 'Grand Prix' and 'Milva' roses with 'Shamrock' chrysanthemums give a rich tapestry of colour, texture and form.

This chapter shows you many of the cut flowers and foliage available. Each entry is classified as follows:

- The **botanical names** – these are standard across the world
- The most popular **common names** – there are, of course, many others
- Indication of **availabilty** of the plant material
- The most commonly available **colours**.

During the summer months foliage from the Northern Hemisphere can be soft as a consequence of the new growth and may have limited availability. Foliage from South America tends to be soft during the European winter.

When purchasing flowers and foliage always ensure that you purchase from a sustainable source.

below
A mass of 'Grand Prix' roses with a surround of *Gaultheria* leaves.

Flowers

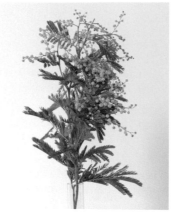

Acacia
(mimosa)
March – May
Yellow

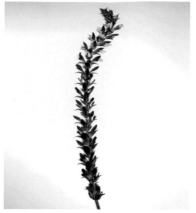

Acanthus
(bear's breeches)
July – September,
Purple and white flowers

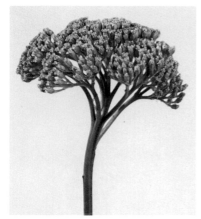

Achillea
(milfoil, yarrow)
April – July
Yellow, gold, white, peach, pink, terracotta

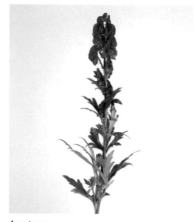

Aconitum
(monkshood)
July – Oct
Blue, Purple

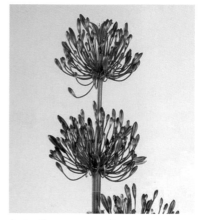

Agapanthus
(African lily)
All year round
Blue, white

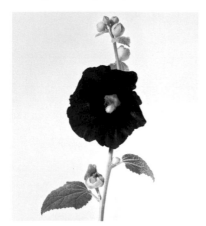

Alcea
(hollyhock)
July – November
Many colours

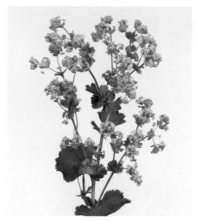

Alchemilla mollis
(lady's mantle)
April – November
Yellow, green

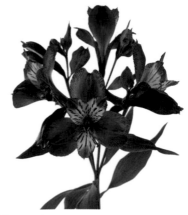

Alstroemeria
(Peruvian lily)
All year round
All colours

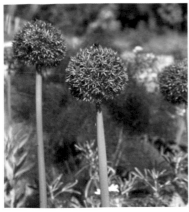

Allium
(onion)
June–September
Purple, white

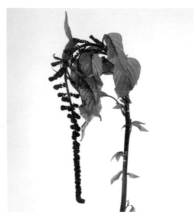

Amaranthus caudatus
(love-lies bleeding)
July – Oct
Red, green

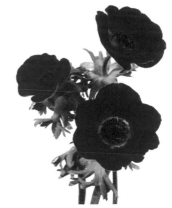

Anemone coronaria
(anenome)
Aug – May
Blue, red, purple, pink, white

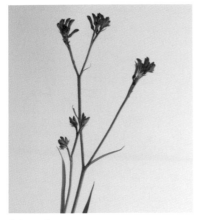

Anigozanthos
(kangaroo paw)
March – December
Red, orange, yellow, pink, black-yellow

Anthurium andreanum
(flamingo flower)
All year round
Most colours

Antirrhinum majus
(snapdragon)
Most of year
White, yellow, pink, orange, peach, red

Asclepias tuberosa
(butterfly weed)
All year round
Orange

Aster
(michaelmas daisy)
All year round
White, pink, purple, mauve

Astilbe
(false spiraea)
April – November
White, pink, red, peach

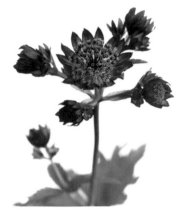

Astrantia
(masterwort)
December – Aug
Wine/pink, pink/green

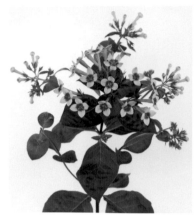

Bouvardia
(bouvardia)
All year round
White, red, pink, cream

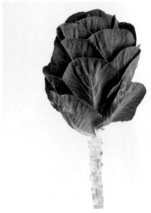

Brassica oleracea
(ornamental cabbage)
Most of year
Pink, white, dyed

Calendula officinalis
(pot marigold)
Most of year
Bright orange, shades of yellow

Campanula
(bell flower)
Most of year
Shades of purple, white

Carthamus tinctorius
(safflower)
All year round
Orange, yellow

Celosia argentea var. cristata
April – December
Pink, red, yellow, orange

Centaurea cyanus
(cornflower)
May – September
Blue, white, pink

Chamelaucium uncinatum
(wax flower)
Most of year
White, pink, yellow

Chrysanthemum
All year round
White, pink, yellow, orange, green, peach,
terrcotta, red, two tone coloured

Craspedia globosa
(billy buttons)
All year round
Yellow

Crocosmia
(montbretia)
February – September
Red, orange, yellow

Cymbidium
(cymbidium orchid)
All year round
Lime green, pink, white, yellow, terracotta

Cynara cardunculus
(cardoon)
May – September
Blue, yellow, purple

Dahlia
(dahlia)
June – October
Red, orange, pink, yellow, white, peach

Delphinium
(delphinium)
Most of year
White, blue, pink, purple, peach

Dendrobium
(Singapore orchid)
All year round
Pink, white, purple

Dianthus caryophyllus
(carnation)
All year round
Red, white, yellow, orange, green, pink,
purple, two tone

Eremurus
(foxtail lily)
March – August
Yellow, peach, white

Eryngium
(sea holly)
All year round
Blue

Euphorbia fulgens
Most of year
Orange, red, white

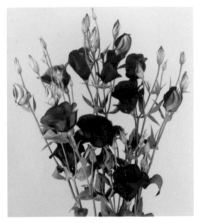

Eustoma grandiflorum
(lisianthus)
All year round
White, pink, blue, purple, green, two tone
coloured, yellow

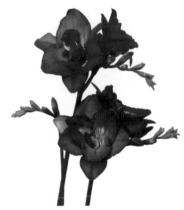

Freesia
(freesia)
All year round
Many colours

Genista
(broom)
Oct – May
Yellow, peach, pink, white

Gentiana
(gentian)
May – October
Blue, purple

Gerbera
(gerbera)
All year round
Many colours

mini Gerbera
(germini)
All year round
Many colours

Gladiolus
(sword lily)
April – October
White, pink, purple, red, orange, yellow, green

Gloriosa superba 'Rothschildiana'
(glory lily)
All year round
Red and yellow

Gypsophila paniculata
(baby's breath)
All year round
White, pink

Helianthus annuus
(sunflower)
All year round
Yellow, yellow/brown

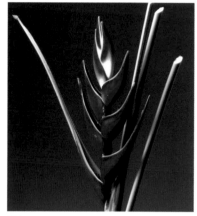

Heliconia
(lobster claw)
All year round
Red, pink, yellow, orange

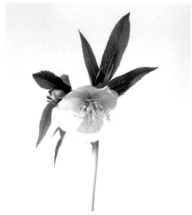

Helleborus niger
(Christmas rose)
November – January
White, creamy green

Hippeastrum
(amaryllis)
October – March
Red, pink, white, peach, two-tone

Hyacinthus orientalis
(hyacinth)
November – May
White, blue, lilac, pink, yellow

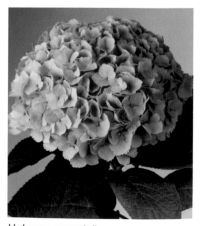

Hydrangea macrophylla
(mophead hydrangea)
March – November
White, pink, green, blue, purple

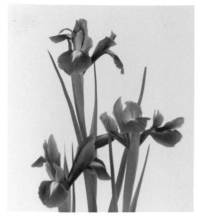

Iris
(iris)
All year round
Blue, purple, white, yellow

Kniphofia
(red hot poker)
April – September
Orange, red, yellow

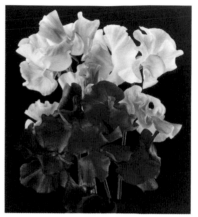

Lathyrus odoratus
(sweet pea)
February – July
White, pink, red, orange, cream, blue, peach

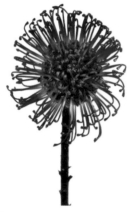

Leucospermum
(pincushion protea)
All year round
Orange, red, coral, yellow

Liatris spicata
(gay feather)
Most of year
Purple

Lilium
(lily)
All year round
White, pink, red, orange, yellow, peach

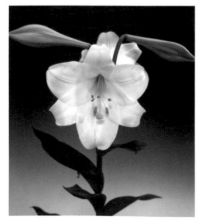

Lilium longiflorum
(longi lily, Easter lily)
All year round
White

Limonium sinensis
(sea lavender)
June – November
Pink, yellow, white, mauve

Limonium sinuatum
(winged statice)
All year round
Purple, pink, yellow, white

Lysimachia
(loosestrife)
January – November
White, yellow, pink

Matthiola incana
(stock)
February – August
White, pink, purple, cream, red, yellow

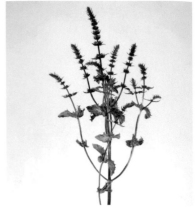

Mentha
(mint)
April – September
Blue, mauve

Molucella laevis
(bells of ireland)
All year round
Green calyx, white petals

Muscari
(grape hyacinth)
September – June
Blue, purple, white

Narcissus
(narcissus)
December – April
Yellow, white, bi-colours

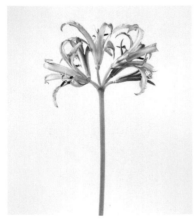

Nerine
(nerine)
All year round
Pink, white, peach, red

Origanum vulgare
(marjoram)
July – September
mauve

Ornithogalum arabicum
(Arabian chincherinchee)
All year round
White

Paeonia lactiflora
(peony)
April – July
White, pink, red, yellow

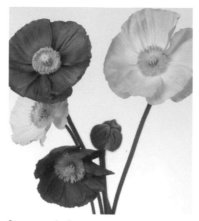

Papaver nudicale
(Iceland poppy)
Most of year
Orange, red, yellow, white, peach

Phalaenopsis
(moth orchid)
All year round
White, pink, two-tone, yellow, purple, peach

Phlox paniculata
(phlox)
All year round
Pink, white, purple

Polianthes tuberosa
(tuberose)
January – March
Cream

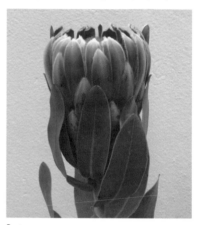

Protea
(protea)
September – March
Pink, white, red

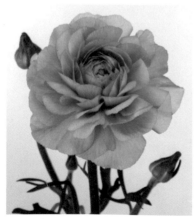

Ranunculus
(turban flower)
October – May
White, pink, orange, yellow, red

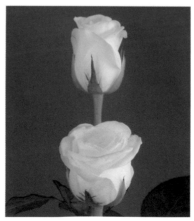

Rosa 'Akito'
(rose)
All year round
White

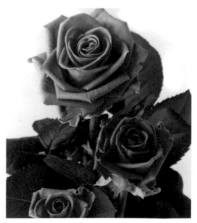

Rosa 'Aqua'
(rose)
All year round
Pink

Rosa 'Cezanne'
(rose)
All year round
Pink

Rosa 'Cherry Brandy'
(rose)
All year round
Orange

Rosa 'Passion'
(rose)
All year round
Red

Rosa 'Sun City'
(spray rose)
All year round
Yellow

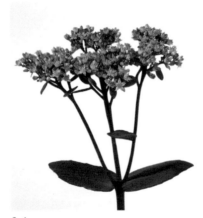

Sedum
(ice plant)
June – October
Green, pink, white

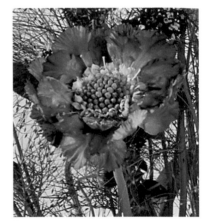

Scabiosa
(scabious)
All year round
Purple, blue, white

Solidago
(golden rod)
All year round
Yellow

Strelitzia reginae
(bird of paradise flower)
All year round
Orange/blue

Syringa vulgaris
(lilac)
January – May
White, mauve, purple, lilac-pink, cream,
white-purple

Trachelium caeruleum
(throatwort)
All year round
Purple, white, pink

Tulipa
(tulip)
November – May
Many colours

Vanda
All year round
Purple

Veronica
(speedwell)
All year round
Purple, blue, pink, white

Viburnum opulus 'Roseum'
(snowball tree)
January – May
Green

Zantedeschia
(calla)
All year round
White, pink, green, yellow, orange, peach,
burgundy, almost black

Foliage

Abies procera
(noble fir)
November – December
Grey-green

Acer palmatum
(Japanese maple)
July – October
Green, orange, wine

Agave americana
(century plant)
Sporadic, all year round as pot plant
Green, variegated

Ananas commosis
(ornamental pineapple)
All year round
Orange or pink fruit

Arachniodes adiantiformis
(leather fern)
All year round
Green

Asparagus densiforus 'Myersii'
(foxtail fern)
All year round
Green

Asparagus setaceus
(asparagus fern)
All year round
Green

Asparagus umbellatus
(ming fern)
All year round
Green

Asparagus virgatus
(tree fern)
All year round
Green

Aspidistra elatior
(aspidistra)
All year round
Green, green and white

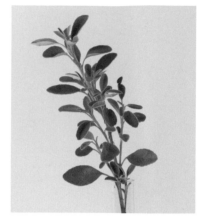

Brachyglottis (Dunedin Group) *'Sunshine'*
All year round
Silvery grey

Brassica oleracea
(ornamental cabbage)
Aug – Dec
Purple/white, green/white, dyed

Brunia
September – March
Brown stems, green foliage, silver foliage

Buxus sempervirens
(box)
All year round
Dark green

Camellia japonica
(camellia)
All year round
Dark green

Capiscum
(ornamental pepper)
September – December
Green, red, orange, yellow fruits

Chamaedorea elegans
(parlour palm)
All year round
Green

Chamaerops humilis
(European fan palm)
All year round
Green

Choisya ternata
(Mexican orange blossom)
All year round
Green, yellow-green

Cocculus laurifolius
(laurel leaf cocculus)
All year round
Dark green

Codiaeum
(croton)
All year round
Variegated, green, red, yellow

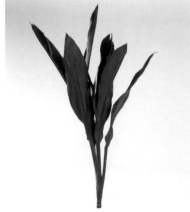

Codyline fruticosa
(ti tree)
All year round
Green, wine/cerise

Cornus
(dogwood)
October – March
Red, lime green, black stems, leaves small/none

Corylus avellana 'Contorta'
(contorted hazel, corkscrew hazel)
All year round
Brown contorted stems (no leaves)

Cotinus coggygria 'Royal Purple'
(smoke bush)
May – September
Purple

Cupressus
(cypress)
All year round
Green, gold

Cycas revoluta
April – February
Dark green

Cyperus involucratus
(umbrella grass)
All year round
Green

Danae racemosa
(soft ruscus)
All year round
Green

Dracaena fragrans 'Compacta Purpurea'
All year round
Purple/wine

Dracaena glauca 'Massangeana'
All year round
Green striped

Dracaena sanderiana
(lucky bamboo)
All year round
Green

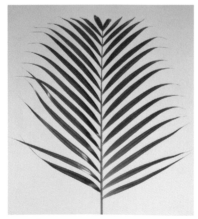

Dypsis lutescens
(yellow cane palm)
All year round
Green

Elaeagnus x *ebbingei*
(elaeagnus)
September – April
Green above, silver beneath

Equisetum hyemale
(snakegrass)
All year round
Green

Erica carnea
(heath)
All year round
Green with white or pink flowers

Eucalyptus cinerea
(silver dollar gum)
All year round
Grey

Eucalyptus gunnii
(cider gum)
August – May
Grey-green

Eucalyptus parvifolia
(small-leaved gum)
August – May
Grey-green

Eucalyptus populus
(poplar gum)
August – April
Grey with small fruits

Eucalyptus pulvenulenta
(baby blue gum)
All year round
Grey-blue

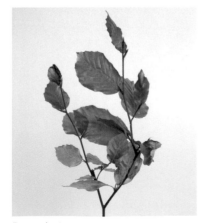

Fagus sylvatica
(beech)
June – October
Green, brown

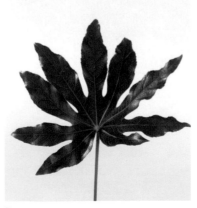

Fatsia japonica
(aralia)
All year round
Green

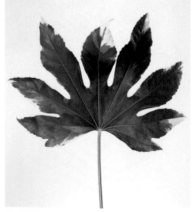

Fatsia japonica 'Variegata'
(aralia)
All year round
Green and white

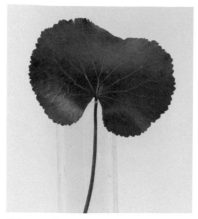

Galax urceolata
(beetle weed)
All year round
Green, burgundy, red/green variegated

Gardenia
(gardenia)
All year round
Green

Gaultheria shallon
(lemon leaf, salal)
All year round
Green

Gleichenia polypodiodes
(coral fern)
All year round
Green

Grevillea aspleniifolia
(fernleaf grevillea)
September – May
Green above, silver beneath

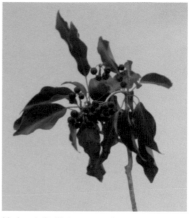

Hedera helix 'Arborescens'
(tree ivy)
November – March
Green foliage with black berries

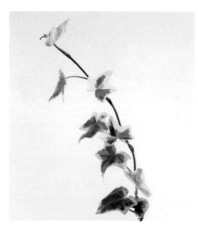

Hedera helix 'Chester'
(ivy)
All year round
Green and cream variegated

Hedera helix
(ivy)
All year round
Dark green

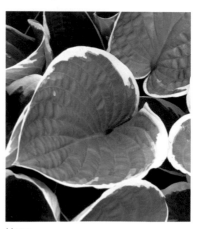

Hosta
(funkia)
April – October
Green/variegated

Howea forsteriana
(kentia palm)
All year round
Green

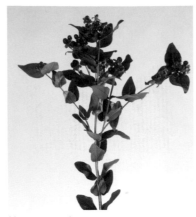

Hypericum androsaemum
(St. John's wort, tutsan)
All year round
Red, green, ivory, brown, orange, peach berries

Ilex x altacleaeasis 'Golden King'
October – December
Variegated foliage, red berries

Ilex verticillata
(deciduous holly)
October – December
Red, yellow berries

Leucadendron 'Safari Sunset'
All year round
Wine. burgundy

Liriope gigantea
(lily grass)
All year round
Green

Malus
(crab apple)
September – December
Orange/yellow fruits

Monstera deliciosa
(cheese plant)
All year round
Green

Myrtus communis
(common myrtle)
October – May
Green, black berries

Nephrolepis exaltata
(sword fern)
All year round
Green

Parthenocissus tricuspidata
(Boston ivy)
June – October
Green turning yellow, orange in autumn

Philodendron selloum
(tree philodendron)
All year round
Green

Phormium tenax
(New Zealand flax))
All year round
Green, variegated

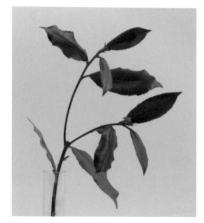

Photinia x *fraseri* 'Red Robin'
(frazer photinia)
October–February
Bright red young foliage

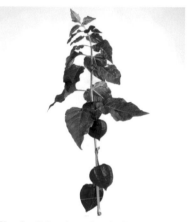

Physalis alkekengi var. *franchetii*
(Chinese lantern)
July – December
Orange lanterns

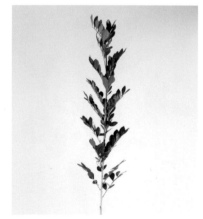

Pistacia lentiscus
(lentisco)
All year round
Green

Pittosporum tenuifolium
(kohuhu)
All year round
Green and cream

Pittosporum tenuifolium 'Atropurpureum'
(purple pittosporum)
All year round
Purple-brown

Pittosporum tobira 'Variegatum'
(Japanese pittosporum)
All year round
Green and white

Pittosporum tondosoglia
June – March
Green and cream

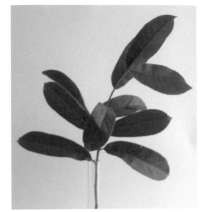

Prunus laurocerasus
(cherry laurel)
All year round
Green

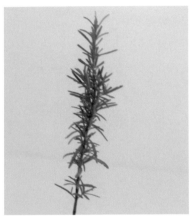

Rosmarinus officinalis
(rosemary)
All year round
Green-grey

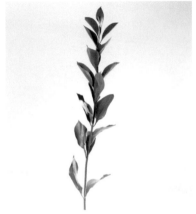

Ruscus hypoglossum
(hard ruscus)
All year round
Green

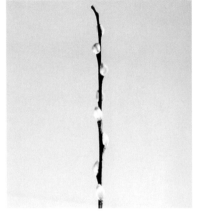

Salix fragilis
(crack willow, pussy willow)
February – March
Black stems, white-grey silky catkins

Schoenus melanostachys
(flexigrass)
All year round
Green

Setaria italica
(foxtail)
Most of year
Green, red

Skimmia
Most of year
Green foliage, red berries

Skimmia japonica
Most of year
Green foliage; red-green flowers

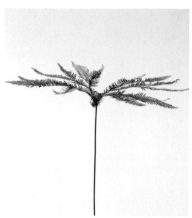

Sticherus flabellatus
(umbrella fern)
From time to time
Green

Strelitzia reginae
(bird of paradise)
All year round
Green

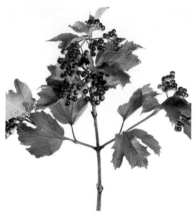

Viburnum opulus 'Compactum'
March – May
Red berries

Viburnum tinus
(laurustinus)
May – January
Green foliage, black berries

Xanthorrhoea australis
(steel grass)
All year round
Green

Xerophyllum tenax
(bear grass)
All year round
Green, grey-green beneath

16

Equipment and techniques

Knowing the techniques and equipment that make life easier will also make your designs look more effective. The equipment mentioned here can be found at garden centres, by mail order or from specialist shops.

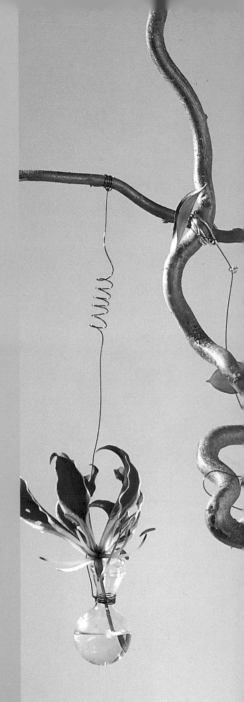

right
Gloriosa Superba 'Rothschildiana' in glass containers suspended from twisted hazel (*Corylus avellona* 'Contorta') branches.

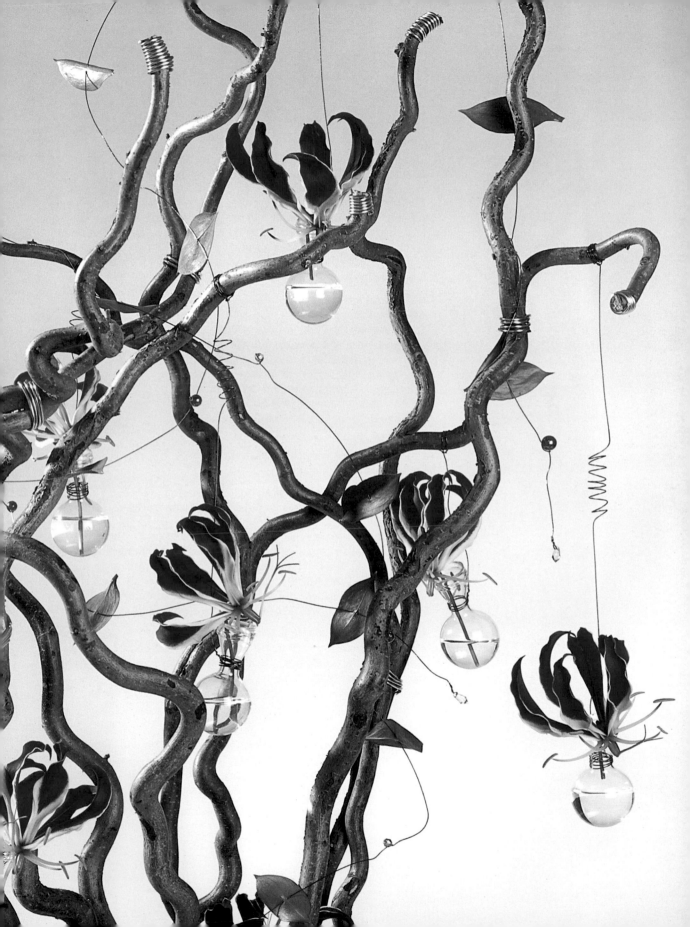

Equipment and how to use it

Beginner's equipment

Block and cylinder of wet floral foam (green)

Foam that is intended for fresh flowers should be placed in water that is deeper than the depth of the foam. A block will take 60 seconds to be submerged. It will not sink to the bottom but will lie level with the water. When your foam has been positioned in the container always have a reservoir of water in the container and add water daily. This foam contains an anti-bacterial substance to prevent a build-up of bacteria and plant food to make designs last longer.

Block and cylinder of dry floral foam (grey)

Dry foam has a harder, firmer consistency than wet foam. It will not retain water, however long it is immersed. It is intended for preserved and silk flowers. It is best to wear safety goggles when cutting a dry foam block. Avoid rubbing the eyes after hand contact with the dry foam, as it is immensely painful.

Chicken wire

Chicken wire, or wire netting as it is sometimes known, can be used:

- As a cap over foam, thus giving extra support. A 2.5cm (1in) mesh is ideal. A larger mesh can cut into the foam too easily like a cheese cutter.
- Crumpled into several thicknesses and used on its own as a support, or in conjunction with a pinholder. Five cm (2in) mesh is ideal. A small mesh when crumpled gives holes too small for easy insertion of the stems.
- As a base for swags and garlands, used in conjunction with damp moss or foam – 5cm (2in) mesh is the easiest to disguise.

Galvanized chicken wire is inexpensive and is easily hidden when used in conjunction with moss. The green plastic-coated chicken wire is easier on the hands but is usually more expensive, and it can be harder to disguise as the green plastic coating makes it thicker. Coloured chicken wire is now available for decorative use in contemporary work.

Plastic dishes

There are three types of inexpensive plastic dishes widely available, in black, green and white. Green is the best choice, as it is the easiest to disguise. White dishes can be sprayed a less obtrusive colour. These dishes are not designed to be decorative.

 a) A small round dish designed to take a round cylinder of floral foam.
 b) A larger round dish with the inner area moulded to take one-third of a block of floral foam.

c) A rectangular trough designed to take a complete block of foam, useful for long table centrepieces, to decorate a top table or for a trough design in the parallel style.

OASIS® is now producing a large range of coloured containers in many different sizes and shapes.

Foam holder (frog)
Small, light plastic discs with four prongs. They are ideal for keeping smaller pieces of foam in place, in conjunction with florist's fix.

Pinholders
A pinholder is a more substantial article, consisting of numerous pins embedded in a lead base. These are ideal for use with hollow and woody stems and in arrangements where the form depends on the minimum use of plant material, such as an upward crescent arrangement (see page 172). Choose one that is heavy, with brass pins close together. For your first purchase select a medium-sized pinholder about 6.25cm (2.5in) in diameter.

Candle-holders
Specially designed plastic pieces designed to hold a standard candle securely and to create little damage to the foam.

Thick rubber bands
These are ideal for keeping the foam firmly attached to its container and can be used instead of florists' tape.

Raffia
This may be purchased in a natural tone or in a wide range of dyed colours. Raffia can be looped, made into bows, incorporated into 'constructions' or tied round containers and bunches to give a natural look.

Ribbon
The range of ribbons available is enormous. The following types of ribbon are those commonly available: polypropylene, wired ribbon and paper ribbon.

Florist's scissors
Chose sharp scissors with a serrated cutting edge, which will grip the stems. Loop a colourful distinctive tag around the handle, as scissors are so easy to misplace.

Secateurs®
These are invaluable for cutting thick woody stems. Good-quality Secateurs® will last you many years. They need to be of a size that fits the hand comfortably.

Florist's fix
This is rather like Blu-Tack or chewing gum and is excellent for fixing two dry, clean surfaces together – for example, the bottom of a frog to a container.

Florist's tape/Pot tape
This is a strong tape that can be purchased in varying thicknesses. Unlike Sellotape® or Scotch® tape, it adheres to wet foam. It is used primarily to keep foam securely attached to its container. It is also ideal for many household jobs.

Cut flower food
Cut flower food allows the flower to develop fully and last longer. Add it to the water according to the instructions on the packet.

Candle-cups
Round dishes with a protrusion from the base, designed for inserting into candlesticks and bottles in order to create a raised arrangement. An alternative is to glue a cork to the bottom of a round plastic dish.

Candles
The range of candles is immense. If candles warp, put them in a bowl of hot water and then roll them.

Other equipment

Garland and wreath cages

These cages can be filled with dry or wet foam and linked together to create a wreath or garland. In order to hang these as a garland, ensure that the wire used to hang them is wrapped round the heavier plastic struts of the cage.

Stem tape

This is used to disguise wires that have been added to extend or give support to the stems of fresh plant material. It also conserves the moisture in the stem. Stem-tape is useful when working with dried and silk flowers if the stems need to be lengthened with wire, which would be unsightly if not covered.

Bouquet holder

This is the easy way to create wedding bouquets. A fresh foam holder should be soaked for a short time and the excess water shaken off before use.

Mini-decos

These are 5 cm (2 in) diameter half-spheres of wet or dry foam in white plastic trays with self-adhesive pads on the bottom. Dip the wet foam in water, then remove the tape backing to reveal the adhesive. They can be stuck onto mirrors, bottles, presents, tables and so on, and can easily be decorated with a few flowers and leaves to great effect.

Stem supports

Glass nuggets may be used in glass containers to support stems, while also being decorative. You can purchase granules that turn to a viscous jelly after water is added. This will support the stems. Food colourant may be added to the water. There are colourants on the market specially for this too and ready coloured gels. Be careful on disposing of these as they are non-biodegradable.

Glue

When you require strength of adhesion, use a special formula glue which comes with its own integral brush or use a glue gun. For pressed flower work you will need water-based glue such as UHU or Copydex. Spray glues such as Tack 2000 are good for sticking leaves to spheres and glitter to plant material.

Glue gun

Hot glue guns heat sticks of glue to a high temperature and eject a blob or stream of glue when you pull the trigger. These have a strong adhesive quality. Beware of getting glue on your skin, as it does burn. There are also cold glue guns, which heat the glue to a lower temperature. The adhesive quality is not as great, but it does not burn to the same extent. Be sure to buy the correct glue sticks for your type of gun.

Spheres of dry and wet foam

These are available in a vast range of sizes. The larger dry-foam balls can be coated with a tough outer crust to make them more resilient. Wet-foam spheres are sometimes made from denser, less porous foam, to make them stronger. Spheres are ideal for topiary trees or for hanging arrangements, such as a bridesmaid's pomander.

Bases

A base under an arrangement protects your surface from possible water damage. It can give stronger visual weight to the base of the design and therefore provide stability in a top-heavy arrangement. It can also add colour and textural interest and give added height. A base may be any shape, material, size or colour, but it should always be in keeping with the arrangement. A base is not necessary under baskets.

Picks

These are used to support plant material and fruit. You could also use cocktail or kebab sticks for this purpose.

Plastic tray and cages with handle

These plastic dishes are ideal for hanging on a wall or pew-end. Also shown is a more elaborate version with its own cage. If using the former for a fresh flower arrangement, wrap a well-soaked piece of foam in clingfilm and strap it in securely to hold in the moisture. The handle can easily be covered but still used for carrying.

Spray paints and surface sealant

Spray paints can be used not only to give brightness and glitter at Christmas but add depth or a change of colour all year round. Sealants are protective sprays, which help prevent moisture re-absorption in dried plant material and enhance colours. When spraying, place the object in a cardboard box to minimize the mess. Use in a well ventilated location.

Wires

a) Florist's wire is used to support, lengthen stems and reduce weight. Always use the lightest wire that will achieve your purpose. Florist's wire can be purchased in cut lengths or on a reel. The wires vary in thickness and in the metric system the thicker the wire, the higher the number. For the flower arranger new to wiring, I would suggest that you acquire three thicknesses, or gauges, of cut wire:
 1. A heavy wire of 1.25mm or 1.00 mm (18g or 19g) gauge,
 2. A medium wire of 0.90mm or 0.71mm (20g or 22g) gauge,
 3. A light wire of 0.56mm or 0.46mm (24g or 26g) gauge.
 (Where these are referred to in the book I have only given the mm thickness, not the gram gauge.) Coloured stub wires are also now on the market.

b) Binding wire comes on a reel and is excellent for fastening moss onto a frame. The 0.56mm gauge is ideal for this purpose. It is often referred to as reel wire.

c) Decorative reel wire is available in copper, brass, metallic red, green and other colours. It is used to create decorative effects, particularly in modern work.

d) German pins or mossing pins are rather like open hairpins. They are ideal for pinning moss to foam.

e) Bullion or boullion wire is a fine decorative wire with a curl or bend to it and gives a fine shimmer to work.

f) Mizuhiki – Japanese paper coated wire of 0.7mm (22g) gauge, 70cm long is available in a wide range of colours for use in contemporary work.

Dry-foam rings

These are suitable for dried and silk circular arrangements. They can be hung on the wall or placed in the centre of a table.

Dry-foam cones

These are an easy way to create a cone of dried or silk flowers. Ideally, place the cone on a raised dish to show it off to advantage. Cones are only available in the dry medium. To make a fresh cone, carve a cone from a suitably sized block of wet foam.

Wet-foam rings

These should be placed under water for a short time but not over-soaked. They are ideal for a circular arrangement of fresh flowers for the table. They can also be hung on a door or wall, but take care that water does not drip and damage your furnishings.

Glass tubes and bottles

Glass tubes and mini bottles, with a rounded base, provide the perfect mini vase for one or more of stems. Although they cannot stand on their own they are lovely filled with water and either strapped to a structure or grid or suspended by a hanging wire which can be wrapped just under the rim.

Orchid tubes

Orchids are sold with the individual stem ends in a plastic tube. They may also be purchased on their own. The small plastic cap, with a hole for the stem, is ideal for use when the tubes are attached or suspended at an angle as it helps to keep the water in. They are an inexpensive alternative to the glass tube and can be easily wrapped with moss or a long-lasting leaf or leaves, kept in place with decorative wire and thus be totally hidden. They can also be a feature of the design in CFD.

Beads

Designers have long been using beads to give decorative interest to arrangements. They can still be purchased for the local bead shops but flower wholesalers are now selling beads in bulk. They can give shine and glitter, decorate bear and steel grass to great effect and be used in a myriad of ways.

Thick aluminium wire

Thick but flexible wire in metallic colours such as lime green, purple and silver give substance and interest to contemporary designs.

Aggregates

Gravel and small stones give crunchy texture and hide mechanics at little expense.

Coloured foam (OASIS® Rainbow® Foam)

Coloured foam is used as part of the design. The only disadvantage is that stems must be placed once and only once as otherwise the holes are markedly visible. Coloured foam also comes in powder form and in multi-coloured cubes. It takes longer to soak than ordinary wet foam. Coloured foam does not contain food or anti-bacterial substances so you should top up with cut flower food added to the water.

Ornamental pins

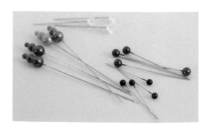

Ornamental pins come as small corsage pins with a coloured head and as longer 'hat pins' with a more decorative head. They can be used to keep leaves in position or to give interest to a design.

Glitter

Glitter is used in modern work to add shine ('bling') or lustre to fresh and dried plant material. Adhere using spray or OASIS® glue.

Natural accessories

Bracket fungi and golden mushrooms
Bracket fungi have a rough, lined texture on one side and a smooth texture on the other. They can easily be given a stem by using glue and a length of kebab stick. They can be broken into smaller pieces and, whether large or small, used in wreaths, swags and garlands. Golden mushrooms give the polished texture of turned wood.

Cones
Pine (*Pinus*), cedar (*Cedrus*), larch (*Larix*), alder (*Alnus*) and beech (*Fagus*) nut cases give exciting form and texture.

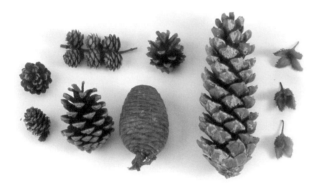

Cinnamon sticks
Cinnamon sticks are inexpensive if bought loose from health food shops. They can be wired or tied together to give bundles for adding to wreaths, swags and garlands. Long sticks can be impaled in plaster of Paris to provide the 'trunk' for topiary trees. Their smooth texture is very appealing in dried flower work. Wired in series sticks can create attractive pallisade edging for floral cakes.

Shells
These are widely available commercially and commoner shells may be found on your local beach. Shells can be easily wired or glued and may be incorporated into swags and wreaths or even made into containers.

Wood, bark and cork

Wood, bark and cork from the seashore, woodland or lakeside, is ideal for incorporating into designs. It can give interest, texture and height.

Stones and pebbles

These are ideal for covering pinholders in low dishes or for supporting stems in glass vases, giving smooth form and texture. You can also use them in pot-et-fleurs and planted bowls.

Lotus seedheads

The dried seedheads from the short-lived lotus (*Nelumbo*) are easily given a stem. Push a wire through the underside so that it projects through one of the holes containing the seeds. Make a hook and insert the wire back in to the hole. They give an exciting addition to dried and fresh flower work.

Fresh fruits and gourds

Fresh fruits are easily mixed with flowers. Two wires can be pushed through the fruit at right-angles and then brought down together. This will give a strong, flexible support but will render the fruit inedible. Wooden or plastic sticks can also be inserted into the fruits (see Techniques on page 405). Dried gourds can be wired but a little more effort is required as they will probably need to be drilled.

Dried fruit

Cut fruit or vegetables into thin slices, place on absorbent paper on a baking tray and bake slowly in the oven or microwave. Citrus fruits can be slit and baked whole. Pomegranates can be easily emptied of their seeds and dried.

Nuts

A wire or stick may be pushed through the soft base of a walnut. Most other nuts will have to be drilled.

Sphagnum moss

This comes from boggy areas and can absorb vast amounts of water. In inexperienced hands, binding wire can cut through it easily and it is therefore not entirely suitable for making wreaths, swags and garlands. It is however ideal for use in hanging baskets.

Carpet or flat moss

This is perfect for covering shaped areas of foam, such as spheres and cones, as it covers thinly and neatly. It can be purchased fresh or dried. The dried carpet moss is excellent for covering containers.

Reindeer moss (*Cladonia rangiferina*)

A soft, spongy moss that has usually been treated with a softening agent such as glycerine and to which a dye is sometimes added. The natural and green colours are to be recommended. They are wonderful for incorporating into wreaths and swags, which they cover quickly and inexpensively, giving a soft texture.

Down or grass moss

Grass moss comes from the downs. It comes in layers and binds well, and is therefore the best moss to use for making wreaths, swags and garlands. It is useful for covering dry foam before you insert your dried plant material.

Bun moss (*Leucobryum glaucum*) and (*Grimmia pulvinata*)

Soft mounds of bun moss can often be found growing in shady, damp places in woods, on roofs and paving. It can easily be removed with a sharp knife – take some of the soil backing, too. It can easily be dried or may be purchased ready-dried. The colour of the dried moss is more muted. It is ideal for using at the base of topiary trees and in designs where the rounded form will be appreciated.

Sisal

Sisal is produced from *Agave sisalana* leaves. It comes in a multitude of colours but it is natural and lime green that are particularly useful. It gives excellent texture and can be used as a filler in so many designs. Other colours include shocking pink, lilac, blue, burgundy, red and yellow.

Skeletonized leaves

Once the only way to get skeltonized leaves was to go through a most arduous and long process in the home. No longer! Skeletonized leaves can be purchased in wonderful colours although I do think that the natural or cream is most useful.

Feathers

Chicken and turkey feathers are sold in bags in a multitude of colours. They give wonderful texture, interest. Feathers wired together make attractive garlands.

Techniques

Technique 1: Conditioning plant material

a) The ends of all stems that have been out of water, however briefly, seal up. In order to allow a supply of water to enter the stem it must be cut cleanly, at a sharp angle, with clean, sharp scissors, secateurs or a knife. Take off 2–5cm (1–2 in), according to the length of stem. Any foliage that would lie below the water-line or that might enter the foam should also be removed. The stems should be placed immediately in clean containers with fresh, tepid water.

b) Add cut flower food to the water, following the instructions on the sachet. Cut flower food allows the flowers to mature fully and last longer. Keep the vase or foam constantly topped up with water. Spraying also helps to keep the plant material fresh. Never hammer the stems nor remove thorns as this encourages rapid bacterial growth.

Mature foliage can be left under water for an hour or so. Immature and grey foliage quickly becomes waterlogged and should be treated as in (a). If the foliage is dirty, add a drop of liquid soap but rinse well.

c) Stems such as poppies (*Papaver*) and *Euphorbia* (including poinsettia *E. pulcherrima*), which contain a milky sap, need to have the stem end charred. Hold the freshly cut stem end over a candle, gas or lighter flame until the sap bubbles. Place the stem in tepid water and repeat the process if you wish to shorten the stem.

d) Wide, hollow stems, such as amaryllis and *Delphinium* can be filled with water with a long-spouted watering can and then plugged with cotton wool, to keep the water in the stem.

e) Daffodils (*Narcissus*) exude a toxic substance, which is severely detrimental to other flowers and in particular to tulips. Once the daffodils have been conditioned in their own containers or had special food added to the water, they may be used with other cut flowers.

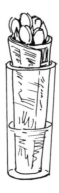

f) The tulip stem will assume whatever shape it has when it absorbs water during conditioning. If you wish your tulips to curve, place them in a low container in relation to their length, with the flowers resting over the rim. To keep them upright, wrap the tulips tightly in newspaper and place in a tall vase or bucket of water for several hours during the hardening process.

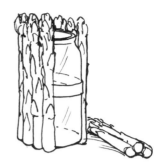

g) Fruit and vegetables emit ethylene gas, which shortens the life of flowers. At a greengrocer's avoid buying flowers that are positioned too close to the vegetables. As a general rule, keep the fruit bowl away from the flowers, unless fruit is being used as part of the design.

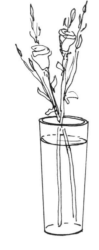

Technique 2: Reviving wilted plant material

Blockages usually occur in the bottom 10 per cent of the stem. Remove this amount from the bottom of the stem, with a clean cut at a sharp angle, and then place in 5–10cm (2–4in) of very hot water, protecting the flowering head if the stem is short or the flower delicate. If the stem is soft, use water of a lower temperature. Transfer to deep tepid water and leave in a cool place for 12 hours.

Alternatively, cut 2–4cm (1–2in) off the bottom of the stem, depending on length, and immerse lengthways in a basin of water for at least 30 minutes.

Technique 3: Preparing wet foam

a) Cut the piece of foam you require and let it sink under its own weight in water that is deeper than the piece of foam you are soaking. Do not push the block down into the water. The soaking process takes approximately 60 seconds, depending on size. OASIS®Rainbow® foam takes much longer.

b) When in position chamfer the edges of the foam. This means removing the angles of the foam with a sharp knife to increase the surface area and soften the outline of the form. Do this very gently.

c) Store unused foam that has been wetted in a tied plastic bag. In this way the foam will remain wet and keep for several years. If foam that has been wetted is left in the open air it will dry out and never again retain water with the same efficiency. You can try pouring boiling water, to which a little liquid soap has been added, over used dried foam. The soap reduces the surface tension and helps absorption.

Technique 4: Using foam

In a specially made container

a) This readily available, inexpensive green plastic dish has been designed to take a cylinder of foam without any extra support.

b) This larger plastic dish takes one-third of a block of foam neatly and securely without any extra support. Ensure that you place the foam with the embossed name uppermost. This enables the capillaries in the foam to absorb the water more efficiently.

In a shallow, heavy dish

a) For a dish that is not specifically designed to take foam, place fix on the base of a frog, first ensuring that both surfaces are dry and clean. Place the frog firmly in the centre of the dish.

b) Impale your foam on the frog.

c) For additional support, bind florist's tape around the foam and down the sides, or use a thick rubber band, which if too noticeable can be cut, once the arrangement is complete and in position. A thin rubber band would slice through the foam.

In a vase

a) Place an exact-fitting plastic plant pot, plant-pot holder or small dish in the opening of the vase. Place a little fix or Blu-Tack around the rim of the vase to secure the container. Place foam inside the inner container.

b) Place a tall piece of foam on top of one you have first inserted horizontally. As a very rough rule of thumb, the foam should rise approximately one-fifth to a quarter of the height of the vase above the rim.

c) If you need added height, use specially manufactured cones, which will raise the height of the plant material. If your cone does not have an integral pick, attach a length of garden stick to the cone with florist's tape. If you pack the inside of the cone with wetted foam it will also support short, heavy, multi-flowered stems, such as those of Casa Blanca lily (*Lilium* 'Casa Blanca').

Technique 5: Using a pinholder

a) Place a coil of fix or four pea-sized blobs on the base of the pinholder and position it firmly in the dish. Alternatively, cut a piece of rubber, or the packing that is placed under packaged meats from the supermarket, to fit under the pinholder.

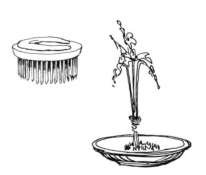

b) Cut stems at a sharp angle. For woody stems make one short slit up from the base. The angled cut of the stem should face away from the direction in which the branch is to lean. Tie thin-stemmed material, such as freesias, together with wool before placing on the pins.

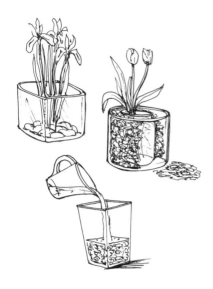

Technique 6: Other mechanics

a) Use pebbles stones or glass nuggets in a clear vase. Insert only a few before placing your stems. Add the others later, as it is difficult to position the stems once the stones are in place.

b) Put a jar inside your glass container and disguise it by filling the gap between the two with moss, shells, fruit or pot-pourri. Place your plant material in the inner container.

c) Take specially formulated granules which expand to a jelly-like substance when water is added, rather like frogspawn. Allow the solution to stand until full expansion of the granules has taken place. Colour dyes may be added to the solution if desired.

d) Create a grid of adhesive tape across the opening of a vase. This works particularly well if you have only a few stems of plant material and do not wish them to fall into the corners of a rectangular or square container.

Technique 7: Using a candle-cup

a) Choose a candle-cup that matches your candlestick or bottle, or spray one to match. Wrap a coil of fix or Blu-Tack around the protrusion and insert into the opening. Not all bottles have an opening that is large enough.

b) A do-it-yourself candle-cup can be made by gluing a cork to the bottom of a small plastic dish.

c) If your container is metallic, silver or brass, for example, it could be marked by the fix. To prevent this, place a ring of plastic tape in the opening so that the fix will not mark the actual container.

d) Place a frog with fix on its base in the candle-cup, add foam and secure with florist's tape or a thick rubber band.

Technique 8: Securing candles

a) Use a specially manufactured candle-holder, which is widely available and suitable for standard table candles. If your candle is a little wide, shave off a small amount with a warm knife.

b) Secure your candle in the foam by placing three, four or five cocktail sticks or a short length of wire bent into a hair-pin shape on a piece of florist's tape. Wrap this tightly around and insert the ends of the sticks or picks in the foam. Slim taper candles can be inserted in the foam without further support.

c) If you wish to have candles at different heights, you can lower the height of an area of foam by cutting it out with a knife.

d) For thicker candles you can heat the ends of three heavy-gauge wires (1.25 mm) and then ease them into the base of the candle. The heat will soften the wax and allow easy insertion.

WARNING Never leave lit candles unattended.

Technique 9: Making bows

Figure-of-eight wired bow

Take a length of wired ribbon.
Find the central point and bring
the ends over across the centre.
Take a length of medium-gauge
wire (0.90mm) and wrap it
around the central area. Because
the ribbon is wired and has
volume, it can be manipulated so
that the wire will not be seen.

Inexpensive polyethylene ribbon bow

a) Take a long length of ribbon – about 1.5m (5ft). Make a coil of ribbon
about 10cm (4in) long if extended. Take a second length about 30cm
(12in) long. It needs to be only about 1cm (half in) wide, so tear a strip
off and use the wider piece to create another bow.

b) Flatten the coil very slightly.
Find the central point, make
a slight indentation to mark the
spot and cut an open 'V' into
each side.

c) Wrap the second length around
the narrow part of the ribbon
and tie.

d) Pull the loops out from the
centre, one from each side,
giving a half-twist as you
do so.

Technique 10: Wiring

Refer to buttonholes on pages 288–290.

Wiring a small cone

a) Take a medium-gauge wire (0.90mm) and thread the centre of the wire round the scales of the cone at the lowest possible point.

b) Bend the wire round, pulling it tight, then twist and take under to the central base of the cone.

Wiring a large cone

a) Take two medium-gauge wires and thread each halfway round the circumference of the scales.

b) Twist the wires together at each side and bring them down under the base of the cone.

Wiring lotus seedheads

Push a wire through the underside of the lotus seedhead, so that it projects through one of the 'holes' in the head. Make a small hook and pull the wire back down into the 'hole' so that it cannot be seen. Alternatively, glue the wire to the side of the seedhead.

Wiring walnuts

Walnuts have a soft spot in their base. Take a wire and simply push it through the soft spot into the centre of the nut. Add a drop of glue for extra security, if desired.

Wiring a mini-terracotta pot

a) Take a medium or heavy-gauge wire (depending on the size of the pot) through the hole in the base, up over the rim, and then twist so that the wire ends protrude from the top or the bottom, depending on which end of the pot you wish to show.

b) Alternatively, use a glue gun to stick the wire to the side of the pot.

Wiring a dried mushroom

Take a piece of dried mushroom and decide if you wish the smooth or the ridged side to show. Place a dab of strong glue at the base of the side to be hidden. Place a wire on the glue and leave until it sets. Alternatively kebab sticks can be used instead of wires. If it is a bracket fungus simply push the stick into the flesh.

Drying and wiring fruit slices

a) Choose fruits that have a firm flesh and few, or no, pips. Slice as thinly as possible. Place on kitchen towelling on a baking tray and cook in a slow oven – the bottom of an Aga or kitchen range is ideal – turning occasionally until the slices are firm. They can be varnished with a clear varnish, but this is not necessary if all the flesh is firm.

b) To wire single slices or bundles of slices, take a medium-gauge wire through the slice, as close to the pith as possible, bend over and twist as close to the fruit as you can. If desired, spray with gloss varnish.

Wiring fresh fruits

a) Take a medium (0.90mm) or heavy-gauge wire (1.25mm) through the fruit and out the far side, about one-third of the way up the fruit. Repeat with a second wire at right angles to the first. Bring the wires down and twist together.

b) Alternatively, insert wooden or plastic sticks into the fruit. The advantage of not using wires is that you can eat the fruit afterwards.

Extending a stem with a single-leg mount

Take a medium-gauge wire and bend approximately one-fifth of the way along the wire. Place the bent wire against the stem you wish extended, so that the short leg extends to the end of the stem. Wrap the longer wire around the shorter wire and the stem, leaving one wire end free for inserting in your foam.

Extending a stem with a double-leg mount

For heavier stems, use a medium or heavy-gauge wire, and bend it one-third of the way along. Place the wire so that both ends project well beyond the stem end. Wrap the longer wire around the shorter wire and the stem, so that both wires project the same length beyond the stem.

Technique 11: Making a topiary tree

a) You will need plaster of Paris, a plastic plant pot, a trunk of several branches, twigs or cinnamon sticks or a single thick branch, and a sphere or cylinder of foam.

b) Place some stones in the bottom of the pot to stop the plaster of Paris oozing out, to give stability and to save on the amount of plaster needed. Mix the plaster of Paris with water in a glass or disposable bowl, using a disposable stick. Fill the plastic pot about two-thirds full with the plaster of Paris mix.

c) Impale the branch, twig(s) or cinnamon stick(s) into the centre of the plaster of Paris and hold until the plaster begins to set. This will take 2–5 minutes.

d) When completely set, place a thick rubber band tightly over the stem tip and roll down so that it is 5 cm (2 in) from the tip. Place a square piece of wet foam that you have soaked 24 hours earlier on the free end of your branch so that it rests on the rubber band. This will prevent the ball from slipping down the stem.

e) Create a sphere with plant material. Place one stem vertically out of the top of the foam, a second downwards, close to the 'trunk'. Place other stems out from the centre of the foam and fill in the spaces in between. All the stems should radiate from the centre of the foam to create a ball of foliage. The final 'ball' of foliage and flowers should have approximately the same volume as the base. Spray chrysanthemums are the ideal flower for topiary. They have an attractive open form, strong sturdy stems and are long lasting. Use these with mixed foliage from the garden and you will be amazed at the effect.

f) It is very easy to make a giant topiary following the same method described above but increasing the scale of all the components used. The container could be a bucket, the branch a broom stick or a length of birch pole. Quick-drying cement may be cheaper than Plaster of Paris though it takes longer to dry and set. Place the bucket in a more attractive container before you start arranging the foliage and flowers in order to get good proportion.

Technique 12: Making a mossed wreath

You will need
- a wire frame or a coat-hanger bent into a circle
- a bag of wreath moss (about 6 large handfuls)
- 2 branches blue spruce (*Picea pungens*) or noble fir (*Abies procera*).

Method

1. Tease out the moss, removing any stones or twigs.

2. Fix the twine or reel-wire to the frame where its structure is strongest.

3. Form 11 – 13 tight balls of moss and pack each one in to a hard ball, about the size of an orange, and place on the concave side of the ring, close to the tying point.

4. Wrap the string or wire tightly round the moss at approximately 2cm (1in) intervals. Push another tight ball of moss close up against the first ball and repeat. Continue until the ring is evenly covered. Do not cut the wire.

5. If desired, cover the back of the ring with a neat ring of cherry laurel (*Prunus laurocerasus*) leaves, or a strip of black bin-liner, kept in place with medium or heavy-gauge wire bent into hairpins, or with German pins.

6. Take a branch of spruce and cut all the pieces off the main stem. Wire small, less attractive pieces to the inner and outer edges, keeping the best pieces to cover the more dominant central area. Add baubles, fruit and ribbon as desired.

Technique 13 – Making a garland

Method A
You will need rectangles of foam, a length of thin plastic (such as that used by dry cleaners) or cling film and fine-gauge wire. Place the rectangles of foam on a long length of the plastic. Wrap the foam with as little double layering of plastic as possible, so that insertion of the stems will be easier. Pass a warm iron over the join to make a seal. Tie between the foam with plastic ties or fine gauge wire.

Method B
You will need a long length of 2.5 or 5cm (1 or 2in) gauge wire netting and a large amount of wreath moss. Place tight, hard bundles of moss on the chicken wire to make a continuous length. Roll the chicken wire into a sausage over the moss and secure. The length of chicken wire will elongate as it becomes heavier when decorated.

Method C
Use the 2.5 or 5cm (1 or 2in) gauge chicken wire and place rectangles of foam at intervals along it. Catch the two sides of the chicken wire together so that the foam is securely in position, twisting extra lengths of stub-wire through the chicken wire if necessary. Use lengths of stub- or reel-wire to squeeze the chicken wire together and divide the pieces of foam.

Method D
Use plastic cages called OASIS® 'Simply Garlands'. Cut a block of foam into 12 rectangles and place a rectangle in each of the cages. Attach wire, for hanging, to the part of the cage that will bear the weight.

Technique 14: Making a swag

Method A

Take a thin rectangle of pegboard of the desired size and glue narrow rectangles of foam onto the board. Create a hanging loop by passing wire through one of the central holes.

Method B

Take a length of carpet grip and firmly strap rectangles of foam onto the larger nails with florist's tape. Attach a hanging wire round one of the larger nails left exposed.

Method C

Place a rectangle of foam on 2.5cm (1in) gauge chicken wire. Cover lightly with moss and wrap the chicken wire firmly around it. Create a loop attached to the chicken wire for hanging. Cover the back of the swag with a piece of black bin-liner, using hairpins of wire or German/mossing pins to secure.

Useful contacts

International designers

Preston Bailey – USA
www.prestonbailey.com
info@prestonbaileydesigns.com

Carla Barbaglia – Italy
Telefax: 00 39 019616721

Per Benjamin – Sweden
www.perbenjamin.com
info@perbenjamin.com

Marisa Bergagnini – Canada
maber@bellnet.ca

Tomas de Bruyne – Belgium
www.tomasdebruyne.com
info@tomasdebruyne.com

Dr Christina Curtis – UK
ronald@curtis1912.fsnet.co.uk

Benzi Gil – Israel
gil-flowers@bezeqint.net

Yasuko Manako – Japan
manako@big.or.jp

Fumihiko Muramatsu – Japan
www.muramatsu.ne.jp

Daniel Ost – Belgium
http://www.danielost.be/
info@danielost.be

Daniel Santamaria – Spain
dbsantamaria@hotmail.com

Max van de Sluis – Holland
max@life3.net

Peg Spence – Canada

Rolf Torhaug – Norway
kreativ.flora@interflora.no

Suppliers and contacts

Cameron-Shaw – designer dried
and preserved flower arrangements,
retail and to order.
279, New King's Rd, London, SW6 4RD
Tel. +44 (0) 20 7371 8175

Erby Enterprises – online service
offering a range of beautiful high
quality ribbons.
Waylands, Pound Lane, Nailsea,
Bristol, BS48 2AT
www.ornamento.co.uk
Tel. +44 (0) 1275 852 123

Flora Mech – a small specialist
company providing innovative
mechanics for the floral artist that
manufactures and exports a range of
brass pinholders/kenzans and wire
mesh foam 'cages' in a variety of
shapes and sizes.
Jerry and Althea Higham
P.O. Box 438, Hillcrest, 3650,
South Africa
floramech@cdrive.co.za

Flornamental – ornamental iron
work made to order by
Pam Lewis
petelewis4128509@aol.com

The Flower Arranger – the leading
flower magazine sold worldwide by
subscription.
www.nafas.org.uk

Flower Dry – a company selling a
superfine dessicant to preserve
flowers and foliage in their natural
form
Moira Clinch
64 Hackney Road, Matlock
Derbyshire, DE4 2PX
Tel. +44 (0) 1629 581026

**The Flowers and Plants
Association** – the UK's promotional
organisation for cut flowers and
indoor plants
www.flowers.org.uk

Metz BV – wholesale flowers in
quantity, Trade only.
www.metz.nl
Tel. +31 (0) 174 747430

**The National Association of
Flower Arrangement Societies
(NAFAS) and the World
Association of Flower Arrangers
(WAFA)**
Osborne House, 12 Devonshire
Square, London EC2M 4TE
flowers@nafas.org.uk
www.nafas.org.uk
Tel. +44 (0) 20 7247 5567

Ronald Porter and Sons – Ronald
Porter offers perhaps the greatest
range of foliage available anywhere
in the world.
Door 4, New Covent Garden Market,
Vauxhall Bridge Road
London, SW8 5NX
Tel. +44 (0) 20 7720 3015

Precious Petals – wedding bouquet
preservation service
The Flower Preservation Centre
Unit 10 Cufaude Business Park
Cufaude Lane, Bramley, Hants,
RG26 5DL
enquiries@preciouspetals.co.uk
Tel. +44 (0) 1256 882422

Pressed Flower Guild
www.pressedflowerguild.org.uk

Smithers-Oasis U.K. Ltd – The
worlds leading manufacturer of
floral foam and associated floral
foam items. They also offer a
complementary range of sundry
products.
www.smithersoasis.com

Verdi Preserved Flowers
(preserved flowers wholesaler)
Verdi UK Ltd
65 Byfield Road, Woodford Halse,
Northants, NN11 3QR
sales@verdi-uk.co.uk
www.verdi-uk.co.uk
Tel. +44 (0) 1327 264888

Acknowledgements

A grateful thanks to all who helped me put this book together and offered support, in particular:

Amanda Hawkes, my accomplished designer for whom nothing is too much trouble.

Dr. Christina Curtis whose botanical knowledge and attention to detail is second to none.

John and Daphne Vagg who helped so much with the history of flower arranging and environmental art. John is a constant source of sound advice.

Marian Aaronson for generously allowing me to use the timeless photographs of her work.

All the photographers who have taken so much trouble to produce the perfect shot and in particular Mike Pannett and Lyndon Parker.

Gill Roker for her clear line drawings.

Craig Bullock and Sheila Rodgers for their input into show work.

Michael Bowyer for his input into large scale designs.

Victoria Houten and Sue Clarke who helped on wedding flowers.

Caroline Yarborough and other members of Grace Episcopal Church Flower Guild in Charleston, South Carolina.

Rachel Petty whose help with sorting out the photographs and captions has been invaluable.

Chika Yoshida for her invaluable help to me at the Flower School.

Thanks also to Lucas Borel at the Netherlands Flower Bulb Information Centre, all at the Flower and Plants Association, the Flower Council of Holland, Nina Ghautura for her advice on Asian weddings, Gina Eting for her advice on Jewish weddings, the Kempele School of Floristry, Finland, Pippa Bensley and Andrew McIndoe at Hillier's Garden Centres, Hans at Metz BV, Pat Cherritt at NAFAS Enterprises Ltd. and Mo Duffill and members of *The Flower Arranger* Editorial Board.

I would also like to thank all those who have helped me at the School, especially when I have been working on other projects and in particular Chika Tanaka, Izumi Sato, Hyun Jung, Shari Plegt, Rachel Vanderheide, Jane Ferris, Gabbi Banks, Lynda Clare and Anna Reddings. Above all my family – Joan Ward, without whom I would never have entered the world of flowers, my husband David and children Charles and Jane. If anyone has been left out I apologise – they will be included in the next edition.

Arrangers

The designs are by Judith Blacklock except those listed below.

page

12 Mo Duffill
13 Marian Aaronson
15 Izumi Sato
18 Stephen Collier
22 Matthew Dickenson
23 Anne Blunt
28 Tineke Robertson
33 (right) Dawn Jennings
36 Doreen Fox
47 Jochim Sieben
55 Barbara Collier
63 Kevin Gunnell and
 Nick Nicholson
67 Chika Yoshida
78 Dawn Jennings
85 Lynda Clare
105 Izumi Sato
111 Dawn Jennings
112 (top) Stein Are Hansen
112 (bottom) Deborah Richardson
114 Chika Yoshida
115 (bottom) Chika Tanaka
121 Ann Cotton
124 Ann Reid
125 Leo Koolen
127 Kathy Wade and Ginger Shealy
140 (left) Daphne Vagg
141 (right) Daphne Vagg
143 Jan Matthews
144 Daphne Vagg
147 Constance Spry
149 Julia Clements
165 Nuala Hegarty
166 Francoise Vanderhagen
167 Judith Blacklock Flower School
 students
168 Dawn Jennings
169 Joan Ward
171 Gillian Roker
172 Sue Flight
173 Joan Ward
175 Mary Law
176 Emma Webster
178 Ilona Barney
185 Marian Aaronson
186 Marian Aaronson

189 Marian Aaronson
190 Marian Aaronson
191 Marian Aaronson
193 Marilyn Williams
194 Michael Bowyer
195 Gail Bearman and Iris Woollard
196 David Ragg
197 Gillian Roker
199 Carla Barbaglia
200 Margaret McSheehy
201 Joan Ward
202 Leo Koolen
206 (left) Olga Meneur
206 (right) Jacqueline Bogrand
207 Monique Gautier
211 Michael Bowyer
212 Robin White
217 David Ragg
218 Kempele School of Floristry,
 Finland
219 (left) Stein Are Hansen
219 (right) Charles Barnard
221 Chika Yoshida
223 (top) Sue Philips
223 (bottom) Wendy Andrade
224 Jean Plaskett
225 Pippa Bensley
226 (left) Annette Stoker
227 CFD Students Godshill College
228 CFD Students Godshill College
229 Max van de Sluis
249 Anne Bridge
250 (left) Christina Curtis
250 (right) Dawn Jennings
254 Jochim Sieben
255 Jochim Sieben
264 Chika Tanaka
265 Chika Tanaka
267 Jordan Gladow
268 Betty Murray and Flora Nimmo
275 (bottom) Grace Episcopal
 Church Flower Guild
276 Joan Ward and Eileen Milligan
278 Victoria Houten
279 Victoria Houten
281 (bottom left) Emmie Cunningham

281 (bottom right) Wendy Andrade
283 Jordan Gladow
288 Dawn Jennings and Chika Yoshida
289 Dawn Jennings and Chika Yoshida
290 (top and middle) Victoria Houten
290 (bottom) Izumi Sato
291 Jackie Mara
294 Dawn Jennings
295 (top and bottom right) Dawn
 Jennings
297 Verdi Nature Preserved
299 Margaret Mason
310 Z's Party Services
307 Moira MacFarlane
309 Michael Bowyer
310 (left) Brenda Palmer
310 (right) Helen Ross
313 Chika Yoshida
315 Michael Bowyer
317 Jackie Mara
321 (top) Denise Stirrup
322 Denise Stirrup
324 Cameron Shaw
330 Anne Blunt
331 Precious Petals
332 Denise Stirrup
336 Kate Edwards
339 Jenny Paddock and Glyn Spencer
340 Lorraine Budgen
341 (left) Rita Oddy
341 (right) Charles Barnard
342 Bunty Stannard
344 Jan Norman
345 Craig Bullock
346 Lois Montgomery
347 Dawn Suter
348 Theresa Richen and Nancy Allen
353 (bottom) Theresa Richen and
 Nancy Allen
355 Diane Faunch
356 (bottom) Gillian Slater
357 (bottom) Joan Ward
358 (bottom) Rachel Petty
360 Henrietta Miles
364 Deborah Richardson

Photographers

The author would like to thank the following photographers and organisations for permission to reproduce their work.

Barbaglia, Anna 199
Blunt, Anne 330
Brown, Dr. Robert 268, 307
Constance Spry Ltd. 147
© Corel Corporation 141, 192
Davis, Neil 156, 157
Dewilde, Robert 240, 241
Dauwe, Thierry and Niewenhoff, Bob 166
Forrester, Scott 12, 49, 111, 112 (bottom), 176, 177, 249, 258, 259, 264, 265, 281 (bottom right and left), 296 (bottom left), 358 (bottom), 364
Gladow, Jordan 267, 283
Graham, Harry 169, 173, 201, 357 (bottom)
Israel, Danny 55
Joye, Celeste 121, 127, 273, 304, 349, 361
Langford, Tom 94, 95, 97, 101, 129, 132, 135
Loveday, Ken 13, 185, 186, 189, 190, 191, 344
Mason, Margaret 299
Nakata, Harry 346, 347
Noble, Jackie 244 (left)
Nutt, Howard 63, 149, 193, 219, 234, 311, 339, 341, 343, 344
Pankhurst, Jenny 227, 228

Pannett, Mike ARPS, DPAGB 18, 25, 36, 47, 59, 86, 89, 96, 123, 124, 134, 158, 175, 178, 200, 226 (left), 248, 290 (top middle), 332, 340, 336
Parker, Lyndon 20, 21, 22, 23, 24, 27, 33, 38, 41, 43, 44, 45, 48, 56, 57, 61, 67, 75, 76, 77, 78, 79, 80, 81, 83, 84, 85, 87, 91, 92, 93, 98, 99, 100, 104, 105, 106, 107, 133, 143, 163, 171, 181, 212, 215, 222, 223 (bottom), 224, 225, 247, 250 (bottom), 252, 253, 256, 257, 262, 263, 280, 281 (top), 292 ,293, 294, 295 (top, bottom right), 320, 325, 328, 334, 355, 356 (bottom)
Payne, Roddy 319, 323, 333
Petty, Rachel 249, 250 (top), 288, 289
Rosolani, Ramiro 238
Smith, Tobias 6, 14, 46, 115 (bottom), 195, 217 (top), 313, 363, 304
Stirrup, John 321 (top), 322
Tanaka, Chika 39
Tanner, Steve 9, 28, 29, 51, 53, 58, 66, 70 (top), 110, 115 (top), 117, 119, 150, 159, 160, 194, 201, 211, 248, 261, 278, 279, 290 (top and middle), 303, 309, 315, 345
Taunt, Henry 118, 146
Tweedy, E. 276
Vagg, John 140 (left), 141 (right), 144

Van der Maden, Pim 229, 245

Also courtesy to the following organisations:
The Flower Arranger 23, 55, 83, 93, 143, 193, 212, 223, 224, 225, 250 (bottom), 320, 325, 336, 346, 347, 356
NAFAS Enterprises Ltd. 63, 193, 234
Woman and Home magazine (photographer: Mark Scott) front cover, 65, 68, 69, 71, 73
News of the World 94, 95, 97, 101, 129, 132, 135
English Heritage 118
American Museum, Bath 142
Oxfordshire County Council 146
Constance Spry 147
Period Living Magazine (photographer: Nigel Hudson) 156, 157
Kempele School of Floristry, Finland 218
Metz BV 286, 287
Verdi Nature Preserved 297
Z's Party Services 301
Precious Petals 331
Flower and Plants Association 352, 354, 357 (top), 358 (top)
Japanese Embassy London 356 (top)
Flower Council of Holland

The Judith Blacklock Rose

Launched at Hampton Court Flower Show 2006, the Judith Blacklock rose is a gorgeous cherry-red multi-petalled rose with superb foliage. It is extremely fragrant, disease resistant and suitable for the patio or garden. The proceeds of the rose are being donated to Alzheimer's Society.

The rose is available from

World of Roses
www.worldofroses.com
Tel. +44 (0) 8452 606888

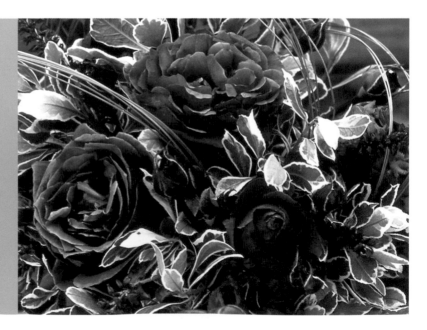

Index

Aaronson, Marian 188
Abstract designs 190f.
Accessories 179, 342
Adjacent or analogous colour
 schemes 20
Advancing (colour) 14, 24, 274
Advent 271
Aggregates 48, 394
Anemones 70
Anniversary flowers 302f.
Aquapack 260
Area – dominant 36
Arrangement form 12
 line 12
 line mass 13
 mass 12
Arrangements
 curvilinear 170ff.
 geometric 152ff.
 hanging 317
 large scale 304ff.
 oval 160ff.
 pedestal 166f.
 round 154ff.
 table 280ff., 353
 triangular 163ff.
 vertical 176
Arranging dried plant material 326f.
Art Nouveau 146
Artificial plant material 334f.
Ascending (movement) 39
Asian weddings 300ff.
 Hindu 302
 Muslim 300f.
 Sikh 300
Aspidistra 79, 313
Asymmetric balance 28f.
Asymmetric triangle 168f.
Autumn 74ff.

Backgrounds 342
Bailey, Preston 237
Balance 28ff., 152, 188, 190, 198, 210
Barbaglia, Carla 212, 238
Bark 396
Base 33, 342, 392
Basework 197
Basket, hanging 360f.
Baskets 54, 70, 298
Bates, K F 8
Bathroom (house) 358f.
Beads 394
Bear grass 79, 289
Bedroom (house) 357
Belgium 234, 240

Benjamin, Per 233
Bergagnini, Marisa 236
Berrall, Julia 190
Best man 288
Between wars 147
Biedermeier 250
Binding 197, 208
Birch 85
Black holes 310
Bonfire night 125
Bottles (glass) 394
Bouquet, shower 292
Bouquet (wedding) 291ff.
Bouquet holder 391
Bows 403
Bride 291ff.
Bridesmaids 296ff.
Britain 143
Bun moss 397
Bundling 197

Cages, for garlands and
 wreaths 391
Cake, Floral 96, 216
Calla 289
Canada 126f., 236, 347
Candle-cups 390, 402
Candle-holders 389
Candlelight (lighting) 25
Candlemas 110
Candles 390, 402
Cards, flower 321f.
Cards, title 342
Carmen rose 294
Carnation 102, 288
Carpet moss 397
Carpeting 197
Cascade (design) 209
CFD 182
Chicken wire 388
Christmas 101, 128ff.
Christmas stocking 132
Christmas tree 133
Chroma (colour) 16
Church 194, 271, 272
Cinnamon sticks 46, 395
Circlet 296
Classic designs (dried plant
 material) 326
Clements, Julia 149
Clipping (manipulation) 203
Closed palisade 216
Cloves 82
Colour 14, 16ff., 190, 198, 310, 350,
 354

 advancing 14, 24, 274
 contrast 35
 dominant 35
 luminosity 25
 psychology 26
 receding 14, 24, 274
 rhythm 38
 size 26
 warm and cool 23
Colour schemes 18ff.
Colour wheel 17
Coloured foam 394
Column 306,
Competitions' manual 338, 344
Competitions, international 346
Complementary colour schemes 22
Conditioning plant material 399
Cone, festive 94
Cones, dry foam 393
Cones, natural 46, 395, 404
Container 33, 40ff., 198
 baskets 54
 dominance 36
 glass 46, 79, 98f.
 metal 52
 organic 56
 sculptural 42
 terracotta 58
Contemporary floral design 182
Continental design 194
Contrast 34f., 212
 colour 35
 form 35
 texture 35, 198
Cork 396
Cream and gold foliage 303
Crescent (downward) 170f.
Crescent (upward) 172
Curtis, Christina 234
Curvilinear (designs) 170ff.
Curvilinear (movement) 39
Cushion designs 218

Daffodils 72
Dahlia 90
Dark Ages 139
De Bruyne, Tomas 235
Decorative roses 223
Depth 14, 188
Desiccant and microwave 330
Desiccated plant material 328ff.
Diagonal (movement) 39
Dining room (house) 353
Dinner parties 353
Dishes, plastic 388

Dominance 35f.
 area 36
 colour 35
 container 36
 flowers 36
 form 35
 movement 35
 texture 35
Double leg mount 405
Downward crescent 170f.
Dried plant material, arranging 326f.
Dry foam ring 393
Duchesse rose 294
Easter 116f.
Edwardian 8, 146, 249
Edwardian Posy 249
Egypt 138
Entrance hall (house) 352
Environmental art 227ff.
Equipment 386ff.
Ethylene 123

Fazio, Rosnello Cajello 212
Feathers 95, 398
Flat moss 397
Flexigrass 79
Floral foam (dry) 388
Floral foam (wet) 388, 400
Floral foam, using 401
Florist 269
Florists' fix 390
Flower cards 321f.
'Flower Dry' 329, 330
Flower food 390
Flowers 10, 60ff., 286ff., 362ff., 365ff.
 dominance 36
 fragrant 285
 garden 62
 language of 145
 wand of 294
 white and cream 285
 wild 62
 Autumn 82ff.
 Spring 64ff.
 Summer 74ff.
 Winter 92ff.
Foam – coloured 394
Foam ring 86, 100, 195, 393
Folding and Pleating (manipulation)
 202, 204
Foliage 11, 362, 376
Foliage, cream and gold 303
Form 8ff., 190
 contrast 35
 dominant 35
 flowers 10
 foliage 11
 line 8ff.
 round 8ff.
 spray 8ff.

Fourth of July 120f.
Fragrant flowers 285
Framing 225f.
France 206f.
Free-form designs 184ff.
Freesia 289
French plaiting (manipulation) 204f.
Frog 389, 401
Fruit, dried 397, 405
Fruit, fresh 396, 405
Fulton, Hamish 228
Fungi 395

Garden (decorating) 360f.
Garden (flowers) 62
Garden Club of America 338
Garland 279, 317, 391, 407
Garland topiary 316
Geometric designs 152ff.
Georgian 143
Gerbera, Mini 289
German pins 393
German style 254
Gil, Benzil 236
Gladiolus 84
Glass container 46, 79, 98f.
Glass nuggets 402
Glass tube 394
Glue 391
Glue gun 391
Glycerine 74, 134, 332
Glycerined plant material 332f.
Golden mean or golden section 32
Golden wedding 303
Goldsworthy, Andy 227f.
Gourds 396
Gravel 46
Grid 220
Gridwork 224
Groom 288
Ground work 197
Grouping 197
Guttapercha 290
Guy Fawkes 125
Gypsophila 106

Hallowe'en 124
Halogen (lighting) 25
Handbag 296
Handtied 246ff., 251
 massed 291
 spiralled 258ff.
Hang dried plant material 324f.
Hanging arrangements 317, 360f.
Harmony 39
Harvest 90
Harvest Festival 122f.
Headband 297
Hedgerow (design) 178
Hedgerows (material) 90

Hedging 196
Helleborus 70
Hindu weddings 302
Hogarth curve 173ff.
Holland 141
Holly 95, 96, 134
Home 348ff.
Hoops 298
Horizontal movement 39
Horizontal designs 212ff.
Horizontal S-curve 175
House 348ff.
 Bathroom 358f.
 Bedroom 357
 Dining room 353
 Entrance hall 352
 Kitchen 356
 Sitting room 354
Houseplants 350
Hue (colour) 16
Hyacinth 64
Hydrangea 77
Hypericum 78, 289

Ikebana 198
Indirect lines 37
Inspiration 342
International competitions 346
International Women's Day 270
Interpretation 340
Israel 236
Italy 138, 238
Ivy 74, 96, 290

Japan 236, 239
Jekyll, Gertrude 146
Jewish weddings 299
Judge 340, 344

Kitchen (house) 356

Landscape designs 178
Landscapes 31
Language of Flowers 145
Large scale mechanics 308
Lavender 74
Layering 197, 212
Leg mount
 double 405
 single 405
Lent 270, 271
Lersch, Gregor 209
Lighting 25
Lilies 282
Line (form) 8ff., 198
Lois Montgomery 346
Long lasting plant material 318ff.
Long, Richard 228
Looping (manipulation) 202
Lotus seedheads 396, 404